COLOR WHEELS

FOR THE ARTIST

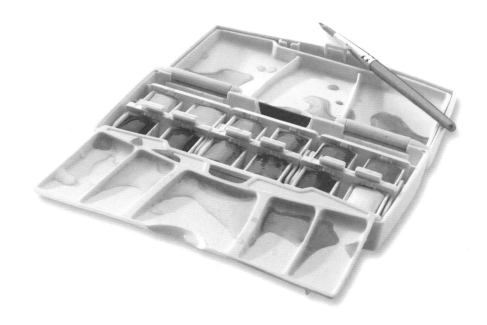

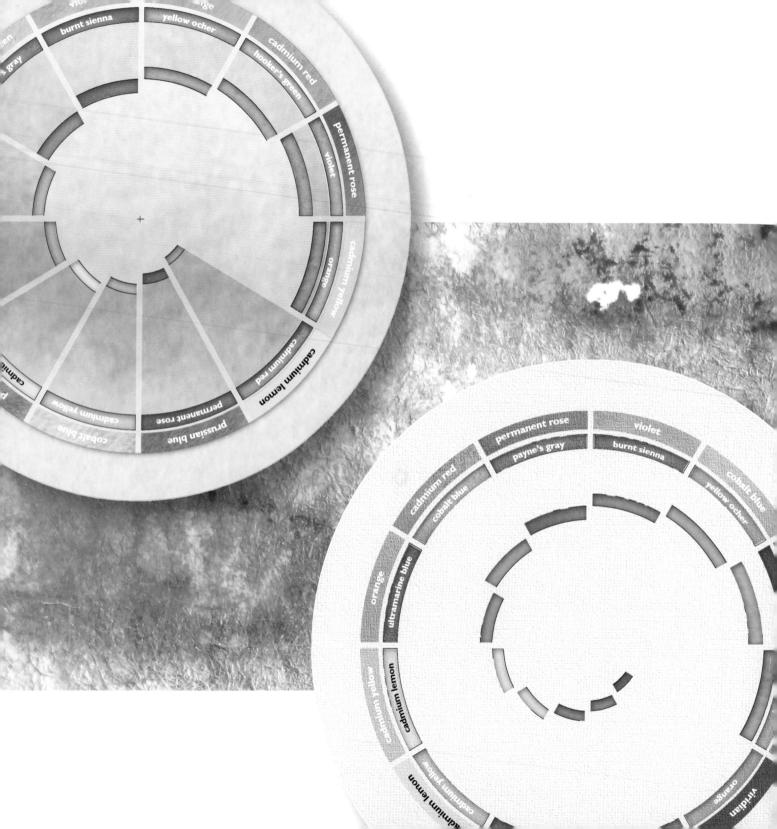

COLOR WHEELS
FOR THE ARTIST

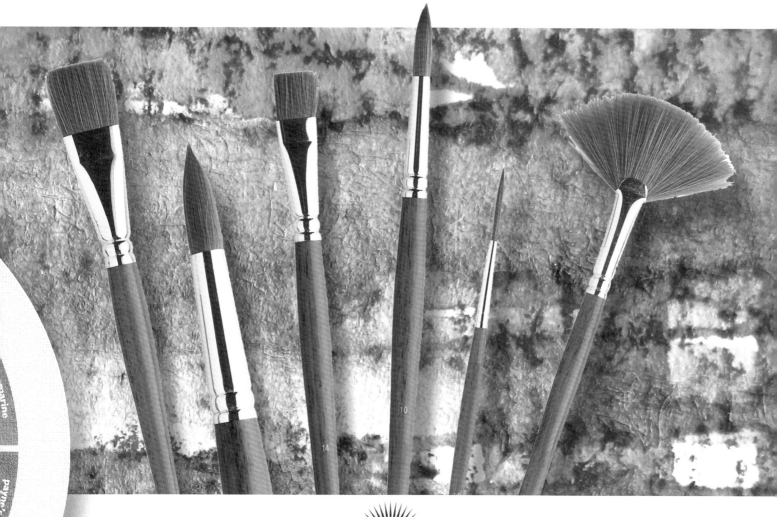

THUNDER BAY
P·R·E·S·S

San Diego, California

Thunder Bay Press
An imprint of the Baker & Taylor Publishing Group
10350 Barnes Canyon Road, San Diego, CA 92121
www.thunderbaybooks.com

All notations of errors or omissions should be addressed to
Thunder Bay Press, Editorial Department, at the above address.
All other correspondence (author inquiries, permissions) concerning
the content of this bookshould be addressed to:

Axis Books Limited,
8c Accommodation Road
London NW11 8ED
United Kingdom

ISBN-13: 978-1-60710-299-1
ISBN-10: 1-60710-299-4

Printed in China.
1 2 3 4 5 15 14 13 12 11

contents

introduction

Using watersoluble pigments for painting is a prehistoric practice. Ground minerals and soot were mixed to produce the colors seen on cave walls around the world.

But the sophisticated art of China was where painting with pigment and water was brought to perfection. The pigment was usually a block of black or red paint held in a small tray that was then diluted by water on the brush, in a similar way to modern "pan" watercolors.

classic color usage

The history of watercolor painting in the West really starts in the 18th century. Watercolor as a medium developed from topographical drawings drawn in monochrome gray or brown ink. The ink was usually sepia or "bistre," which was made from beechwood soot ground into powder. From this beginning, artists such as Paul Sandby (1725–1809) emerged, using delicate gray and blue washes to achieve his poetic images. Sandby was influential on Thomas Gainsborough (1727–88), Thomas Girtin (1775–1802), and J.M.W. Turner (1775–1851), the latter using watercolor as a full-color medium for large works. Turner either borrowed or invented almost every technical trick that we use today, but it is in his sketches that we see the economy of means used to achieve his effects. It was also Turner who developed watercolor painting into a serious competitor to oil painting. His skies and seascapes showed how the whole spectrum of colors could be used in a new, magical, and kaleidoscopic way.

Meanwhile, John Constable (1776–1837) showed how watercolor can describe the weather with small broken washes and swift brush strokes. His color schemes were much more realistic than had been seen in the earlier monochromes, using broken touches of pure blue and red in his open air sketches. Also at this time, Samuel Palmer (1805–81) was developing his rich stippling method, while Richard Dadd (1819–87) and John Frederick Lewis (1805–76) took meticulous detail to its limits.

In the late 19th century, several American artists came to the fore. James McNeill Whistler (1834–1903) produced minimalist, atmospheric landscapes, while his compatriot John Singer Sargent (1856–1925) painted bold and colorful landscapes, notable for the sweep of the brush strokes and a warm palette. Winslow Homer (1836–1910) is one to study for bold, effective watercolors. Nearer our own time, the Swiss artist Paul Klee (1879–1940) was a great color theorist—his work provides an excellent guide to color selection.

understanding color

What the great artists showed is that successful watercolor painting often depends as much on the effects created by your color choice as on composition, which is where an understanding of how color works comes in.

THE COLOR WHEEL

The color wheel is great reference for artists. The three colors in the center are the primary colors. Primary colors are the ones that cannot be obtained by mixing other colors together. The middle ring shows the colors that are created when you mix two of the primaries. Red and yellow make orange; blue and yellow make green; blue and red make purple. These are called secondary colors, and show the colors you can expect to create when you mix primary watercolors in your palette. All colors can, in theory, be created by mixing varying amounts of the primaries. The outer ring breaks down the secondary colors further into 12 shades.

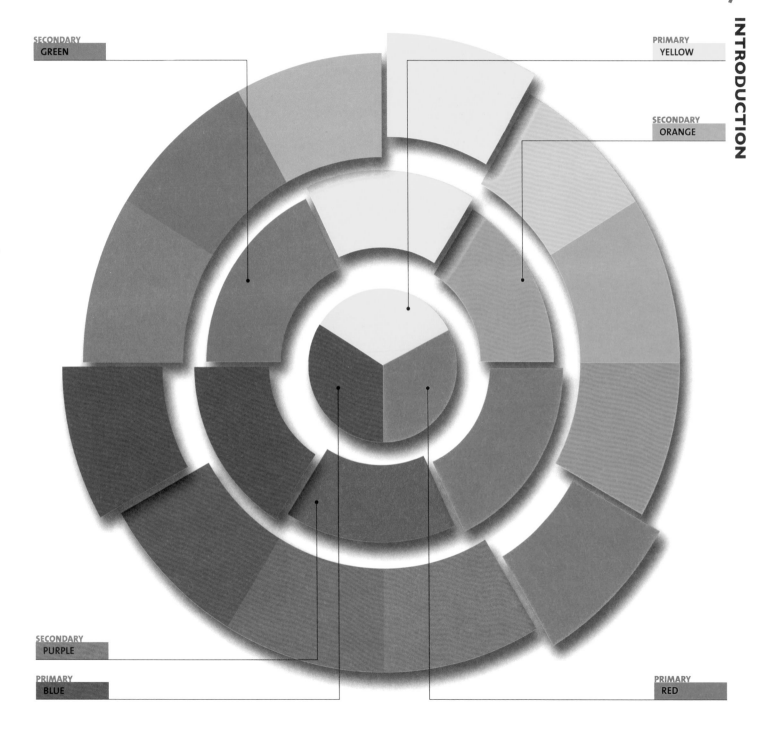

SECONDARY
GREEN

PRIMARY
YELLOW

SECONDARY
ORANGE

SECONDARY
PURPLE

PRIMARY
BLUE

PRIMARY
RED

COMPLEMENTARY COLOR

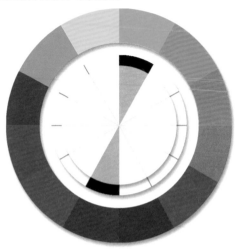

The colors that are opposite each other on the color wheel are called complementary colors. These work together to create a harmonious reaction. Try using them side-by-side in your work—they will each appear to be stronger by contrast, bouncing off each other.

COLOR TERMS

HUE

Hue indicates the strength of a color from full saturation down to white. In practical terms, if you buy any color labeled "hue" it means that the color is less than full strength. This is used as a way of reducing the cost of expensive pigments.

TONE

Tone is the degree of darkness from black to white that creates shade and light. For example, in a black-and-white photograph you can see and understand any object independently of color, solely by its graduation from light to dark. The word "shade" is often used instead of "tone."

COLOR

Color results from the division of light into separate wavelengths, creating the visible spectrum. Our brains interpret each wavelength as a different color. The color wheel is an aid that helps us understand how colors are arranged in relation to each other.

TRIADIC COLOR

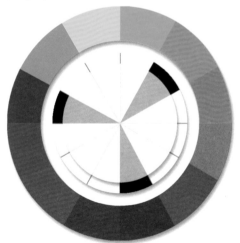

Triadic color occurs when a "chord" of three colors is used in combination. A mixture of any two colors of the triad used next to a third, unmixed, color will give many different effects. A triad of colors from any part of the wheel is the basis for a good color composition.

SPLIT COMPLEMENTARY COLOR

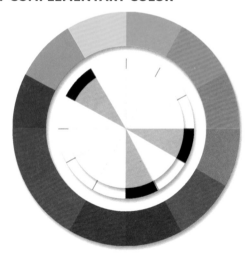

Split complementaries create three colors: the first color, chosen from any point on the wheel, plus the two colors that come on either side of the first color's natural complementary color. These three colors will give plenty of unexpected color schemes.

Look at the color wheel (page 7) to see how colors are grouped. For each picture you paint, you will need a watercolor to represent each of the primary colors so that by mixing them, you can obtain all the secondary colors. The primary colors you choose should be determined by the scene you wish to paint. For example, if you are painting cool clear skies and distant hills, choose cobalt blue to represent blue in the color wheel; permanent rose to represent red; and cadmium lemon to represent yellow. All three colors are cool, enabling you to maintain a consistently cool palette—no clashing "hot" colors will appear. Likewise, when painting a warm scene, use a warm blue, red, and yellow for your primaries. This idea, along with using complementary colors, which appear opposite each other on the color wheel and produce harmonious contrasts, will help you keep your colors balanced.

A good exercise is to make your own color wheels for warm and cool colors. Draw several circles 4in (10cm) in diameter and divide each circle into six pie slices. Paint your three primaries in alternate slices and then mix them: red with yellow for orange, blue with yellow for green, and blue with red for purple. Place these secondary colors in between the primaries and you will see exactly which ones work out well for your picture. Keep this worksheet as a reference palette.

taking style cues

Look at all artists' work, old and new, for ideas and inspiration. Research as many examples as you can, learning each artist's methods and techniques. This does not mean that you should try to produce exact copies of their work, but by your review you will develop your own knowledge and taste.

This book goes hand-in-hand with your own research by providing a wealth of instruction on just what can be achieved with watercolors. Highly accessible, practical, and instructional, what you will gain from it in technical skill will give you the competence that leads to confidence. It is this confidence that will enable you to express your thoughts in paint—it is easy to forget in the struggle to master materials that the real aim of painting is the expression of ourselves. Good technique and practical skill make this expression easier.

INDOOR/OUTDOOR TEST

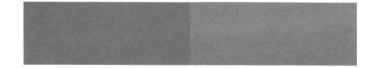

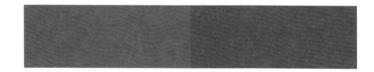

The indoor/outdoor test is designed to show the effect that artificial or subdued lighting has on colors when compared to daylight. If you look at the four strips indoors you can see hardly any difference between the colors on the right compared to the ones on the left. Step out into the daylight and you will be able to see that the right-hand side is noticeably darker. This sort of phenomenon plays an important part in how we perceive color and all artists have to be aware of it. Although it is never quite as obvious as in the experiment, it does help to explain why art studios are built with high skylights, ideally facing north. For artists whose pictures depend on great color accuracy, good daylight is an essential need.

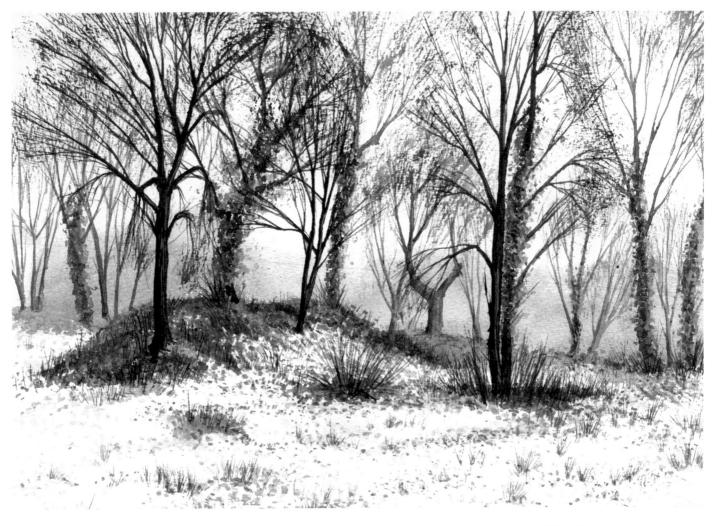

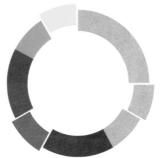

This chilly winter scene is created around four colors—cobalt blue, Hooker's green, Payne's gray, and burnt sienna. The most important element is the cool gray background, which establishes that this is a misty day. The dark trees make a series of verticals that create the stillness of the scene. The clever use of the burnt sienna makes the other colors look even cooler. This is the complementary blue-orange effect.

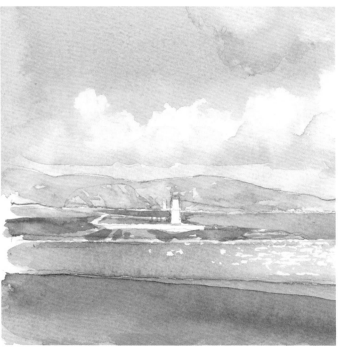

This sketch of the coast of Ireland, with its sparkling waves and fleecy clouds, was painted with a narrow palette of cool blues and grays that suggest pale sunlight and the distance of the coastline. It was created with just three colors—cobalt blue (blue is the coolest color on the color wheel), Payne's gray, and yellow. The effect relies on single color washes and not overpainting the overall light tone or "high key" colors. In some places, the paper is left untouched to enhance the cool quality of the light.

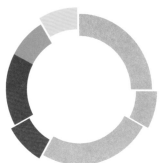

This is a richly painted still life, with warm oranges, reds, and yellows in the flowers, a wide range of greens in the leaves, and a solid rectangle of deep blue in the watering can. The pink wash over the table and far wall brings in purple shades. The blue color of the can is taken up into the background leaves to make a soft, turquoise green. This vibrant still life uses most of the colors of the color wheel to create an overall feeling of warmth.

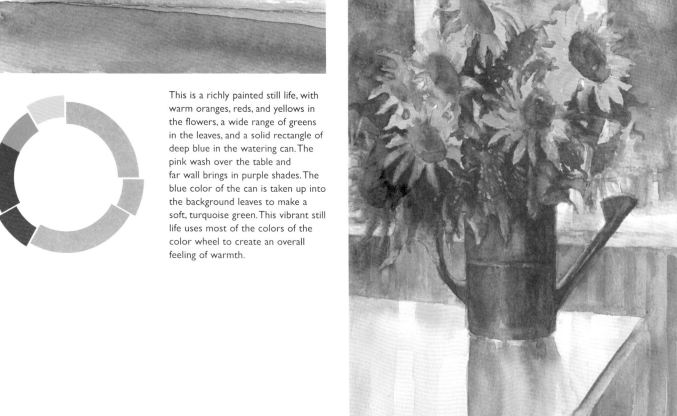

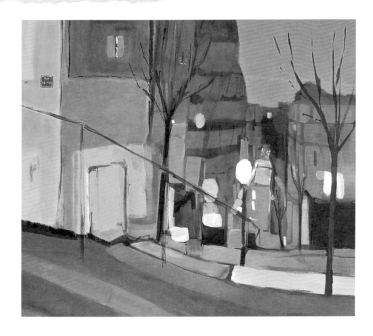

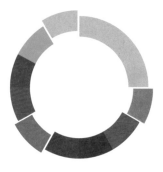

The atmosphere of this picture is created by the all-pervading red of the underpainting. Even the greens and blues are brought back toward the warm end of the spectrum, with all sorts of subtle purples holding the harmonies of color together to beautifully evoke a mysterious Parisian twilight.

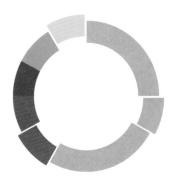

This detailed scene contains a wealth of texture and modeling, but the dominant color note is the cool gray of the cock bird's back and, in combination with the bright yellow-greens and the blue-gray of the rocks, hardly leaves the cool blue end of the palette, except for the blush of sienna on the bird's throat.

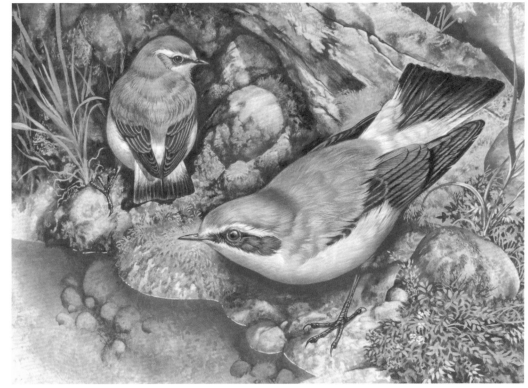

The woodland trees in winter filter the weak sunlight into patches on the forest path. A dominant motif of thin vertical lines gives the picture a feeling of repose while the blurring of the trunks by the low sun adds the element of infinity.

Ultramarine and raw umber keep all the tints cool, and weak yellow ocher warms the snow color where the sun penetrates the mist. This painting amply demonstrates the value of using only a restricted palette of colors in some of your works.

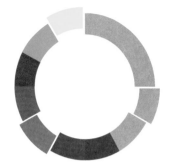

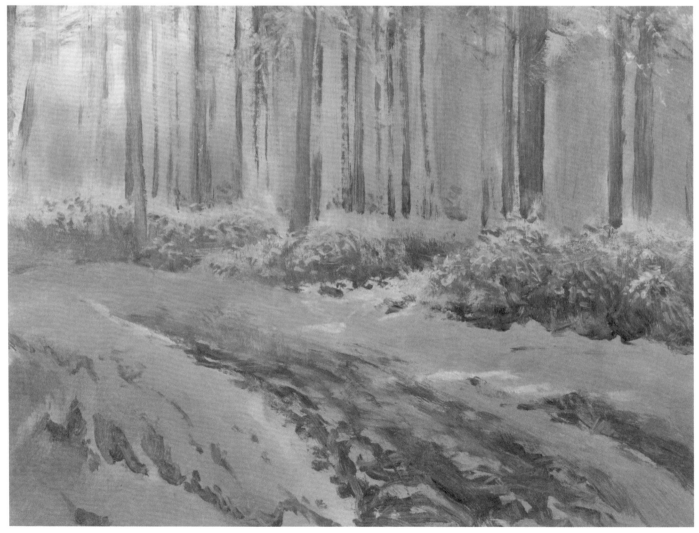

how to use this book

The jacket of this book features a unique color-mixing wheel that will show you the shade that will result when you mix equal quantities of two colors. The colors have been chosen as the ones that are most useful to watercolor artists. A glance through the projects in this book will give you an indication of the enormous range of colors and tones that can be achieved using these colors. Each project lists the colors you will need and highlights how to mix them to achieve the shades you need.

USING THE COLOR-MIXING WHEEL

The color-mixing wheel can be used to help you determine what the result of mixing any two colors from your selection will be. It can also be used if you are unsure of how to achieve a shade you wish to create, from nature for example. Turn the wheel until you find a shade in one of the inner windows you like and read off the two colors you need to mix to achieve it.

COLOR WHEELS
FOR THE ARTIST

violet
orange
burnt sienna
yellow ocher
hooker's green
cadmium
payne's gray
hooker's green

WATERCOLOR
WHEEL

yellow ocher
cobalt blue

permanent rose

① turn the wheel to align the desired color combination

② the resulting color will be seen in the indicated window

burnt sienna
prussian blue

cadmium yellow
violet

eight step-by-step
watercolor projects and a unique
watercolor mixing wheel

payne's gray
cadmium lemon

cadmium lemon

cobalt blue
prussian blue
permanent rose
cadmium yellow

turn

outer color wheel
The colors on the outer wheel are the standard watercolors that will get you started.

inner color wheel
Colors on the inner wheel repeat those of the outer wheel.

mixed color
This window reveals a swatch of the exact result of mixing equal quantities of the colors on the inner and outer wheels.

turn the wheel
The wheel turns so that you can line up the two colors you intend to mix and see the result in the window.

finished painting
The project begins with the completed painting to give a sense of its overall scope and complexity. This is then broken down into several steps, gradually building the work.

picture details
The title of the finished piece of work, together with the artist's name are given. Also included is the size of the work, to give you an indication of scale.

what you will need
All the materials and equipment you will need to complete the project are highlighted at the start so that you can have everything to hand.

130

131

6

bridge at pont-y-garth

john barber
16 x 20in (400 x 500mm)

This project is a great exercise in painting that most fleeting of subjects—moving water. First, you will see how to mask out areas of paper to create the sparkling reflections that make water so fascinating, as it picks up light from the sky and the color of the dark tones of the river bed. You will also learn how to create a brooding, dramatic sky. Working wet-in-wet is the best way to get high-quality results for both water and sky, since the paint is allowed to run (in a controlled way) in a variety of directions. However, as you will see, it is best not to overuse this technique, since capturing the impression of what you are looking at is more important than replicating every detail.

WHAT YOU WILL NEED

Rough surface watercolor paper
Graphite pencil, 6B
Masking fluid and wax candle
Old, small round brush, synthetic
Flat brush, 1in (2.5cm), sable or synthetic
Round brushes, no. 5 or 6, sable or synthetic
Kitchen paper and eraser

COLOR MIXES

1 Payne's gray
3 Cobalt blue
4 Violet
10 Yellow ocher
11 Burnt sienna

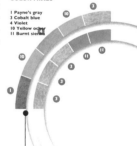

TECHNIQUES FOR THE PROJECT

Masking out with masking fluid and wax
Working wet-in-wet
Working wet-on-dry

techniques for the project
Different techniques are used in every project to build up your experience and confidence.

color mixes
The colors used in the project are shown, together with the colors they are mixed with, to create the finished work.

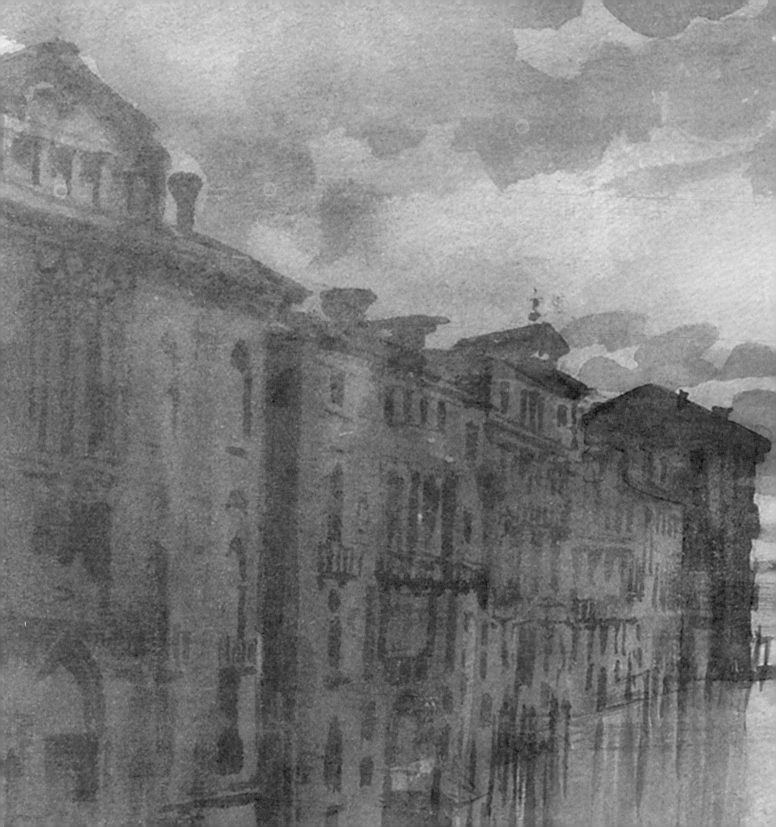

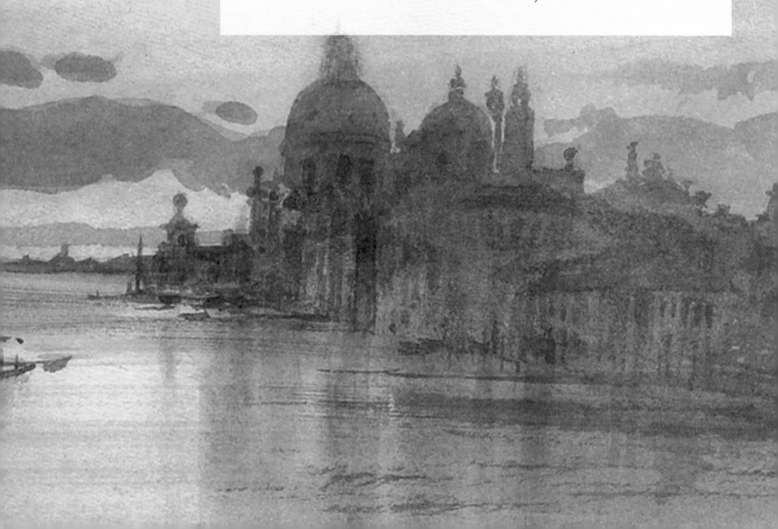

materials & equipment

Watercolor or acrylic, artists choose their equipment with care. This section explains what you need in order to create successful results and examines the range of materials you will find in your art store or online. Paints, pencils, papers, canvases, brushes, and all the essential accessories are described and fully illustrated.

materials and equipment—watercolor

One of the great attractions of watercolor painting is that the materials required are very simple. Buy a brush, a small selection of colors, and some paper; add water, and you are ready to start. You can work almost anywhere and the results are very durable—the great J.M.W. Turner carried his sketches from France to England rolled up in his pocket. Experimentation is another exciting aspect of this medium, so try different combinations of brushes, paints, and paper—Turner himself sometimes painted on writing paper—to find out which ones best suit your style.

watercolors in "pans"

Most watercolors are available in "pans," which are small plastic trays into which paint has been squeezed and dried. Pans are available as "half" pans, or larger "whole" pans. Pan colors quickly dissolve when touched with a wet brush, even when they are many years old. The advantages of pans are that they are dry, making them convenient to handle and transport. Their color is instantly visible and they can be stored indefinitely. However, they are small, making it difficult to produce large amounts of paint quickly, although this can mostly be overcome by using a wide, flat brush and whole pans.

watercolors in tubes

The paint in tubes is the same as in pans but is mixed with gum arabic and glycerine to make it liquid. In fact, most manufacturers sell the same color range in both tubes and pans. Tubes give a large amount of color quickly, which is ideal when you have large areas of paper to cover. Also, if you squeeze out more paint than you need, you can leave it on the palette till the next time you paint. However, you cannot see the true color of the paint till you open the tube, and you have to remove and replace lids, which can interrupt your work flow.

paint boxes

Most paint manufacturers produce box sets, from pocket-sized versions (see left) to large studio sets containing both pans and tubes. Boxes often work out less expensive than buying colors separately and the selections contained in them are usually sensible. If your favorite color is missing, you can easily insert it in place of one you would use less often. If you intend to sketch outdoors, look for a box that has a handy thumbhole or a ring underneath.

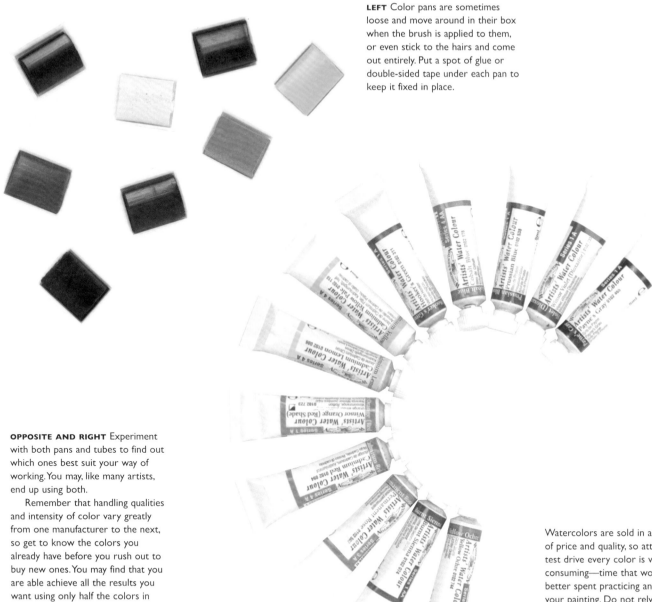

LEFT Color pans are sometimes loose and move around in their box when the brush is applied to them, or even stick to the hairs and come out entirely. Put a spot of glue or double-sided tape under each pan to keep it fixed in place.

OPPOSITE AND RIGHT Experiment with both pans and tubes to find out which ones best suit your way of working. You may, like many artists, end up using both.

Remember that handling qualities and intensity of color vary greatly from one manufacturer to the next, so get to know the colors you already have before you rush out to buy new ones. You may find that you are able achieve all the results you want using only half the colors in your first box.

When using your tube colors, put out plenty of color so you do not have to keep opening and closing tubes, which can be disrupting.

Watercolors are sold in a wide range of price and quality, so attempting to test drive every color is very time consuming—time that would be better spent practicing and enjoying your painting. Do not rely too much on the names given to colors by different manufacturers. Trying the color on your paper is the only sure way of knowing what it really looks like.

SELECTING WATERCOLOR PAPER

ROUGH SURFACE (R) PAPERS

Rough surface paper, as its name implies, has an uneven texture with many pits and mounds that break up the brush marks. This gives a free, open texture to your work. Rough papers are best for bold, vigorous brush strokes and quick effects.

COLD PRESSED (CP) OR "NOT" PAPERS

These are smoother papers than rough surface ones, but still have a definite texture that affects the way the brush marks appear. Cold pressed papers are very useful if you want to work freely but then finish in considerable detail.

HOT PRESSED (HP) PAPER

Hot pressed papers are created by crushing the texture of rough paper to produce a smooth surface. These are the papers to use if your work is finely detailed. Botanical drawings, animal illustrations involving fur and feathers, in fact any time fine, continuous brush marks are required, use hot press paper.

STORING WATERCOLOR PAPER

The best watercolor papers are expensive, so storing them carefully is worthwhile. Keep your papers flat in a dry drawer or cupboard—paper absorbs moisture from the air and this causes buckling. Although this is not a problem if you are going to soak and stretch your paper anyway, it can make small blocks awkward to use. Sketch books are also less likely to buckle if laid flat. Stored properly, good paper can be kept indefinitely.

working with papers

Papers designed to hold watercolors, such as the types listed on the left, generally produce the best results for finished work. They are either machine- or handmade, ranging from 100 percent wood pulp to 100 percent cotton, or usually a mix of the two. Handmade papers are the most expensive, but are rewarding to work on as they have special qualities of texture and handling. These types of papers are usually only obtainable in large sheets.

However, you are not limited to these alone. In fact, you may find a non-art paper, such as a good-quality white cartridge paper, works well, particularly for studies and sketches. Glossy or semi-glossy papers made for printing, such as those found on the backs of calendars, can produce interesting effects. If you see a surface that you think may take watercolor, try putting a few washes on it—you might just be pleasantly surprised by the results.

paper weights

The thickness of a paper is called its "weight," which is measured in "gsm" (grams per square meter) or "lbs" (the weight of a "ream" of 500 sheets). Although paper weight is always less important than the painting surface, there are good reasons why weight does matter. Lighter papers (80–100lbs) should always be "stretched," that is, soaked in water before being taped to a board to prevent buckling. Heavier papers (120–300lbs) can be used in small sheets without stretching, although stretching is recommended for all papers intended for serious work.

book sheets or blocks

For outdoor work, you will need a spiral-bound sketch book that will lie flat. Choose one that is around 4 x 6in (10 x 15cm). Alternatively, use "blocks" of paper, which have glued edges to prevent buckling. Usually these work well, but if too much water is used, the whole block may twist.

Besides having surfaces from rough to smooth, papers can also be tinted, speckled, or "gummed," where extra "size" (glue) has been added to the surface so that lifting off color becomes easier.

As with your paint, do not be mean with your paper. Saving your best paper for that "special" subject can mean you are inhibited when you come to paint it. Use one paper for some time and get to know its characteristics.

working at an easel

Once you have chosen your paper, you will need something to hold it in place so you can work freely. If you are working indoors at a desk or table, a drawing board or a simple desk easel, such as the one below, work best. Buy one that is fully adjustable so you can work comfortably. You can also use an outdoor sketching easel, with your work held at a slight angle. For outdoor work, use an outdoor easel. These easels hold the paper at the right height and angle leaving both hands free—one to hold the paints, the other to hold the brush. These easels need to be lightweight so they are easy to transport and there are many excellent metal or fiberglass models available, but visit your art store to do some research before buying one.

outdoor tips

There are many distractions outdoors, so having what you need to hand will help you concentrate on your subject—nothing is more offputting than having to juggle all your equipment. A basic checklist of materials is: a lightweight easel; one large brush (round or flat) for washes; one round brush for line and detail; a watercolor box with pans and a thumbhole (essential for work done while standing); water in a collapsible pot (always know where your water is, so hang the pot on your easel); watercolor block or paper stretched on a lightweight board; a pencil; a putty eraser; a craft knife or pencil sharpener.

pencils

Graphite pencils are graded from 8H (the hardest) to 8B (the softest). HB is the middle grade. Choose a range of pencils between HB and 6B. If you wish to eliminate all the finished pencil lines on your painting, use the

CHOOSING THE EASEL FOR YOU
For indoor work, choose an adjustable drawing board or desk easel (left). You can even prop up the end of a sheet of plywood with a pile of books to create a drawing board. For outdoor work, use an outdoor easel. This needs to be stable and lightweight, and either metal or wood.

softer grades and do not press hard on the paper. Unfortunately, pencil grades are not consistent across manufacturers, so 4B in one range may be the same as 2B in another; you will have to learn by trial and error.

For black lines, use carbon or charcoal pencils. These are good for dramatic marks that remain in the finished picture and also avoid the gray shine produced by graphite. However, they are harder remove.

Watersoluble pencils can often be used to produce additional emphasis or to disguise hard edges where a wash is not satisfactory. Try them all.

erasers

There are several materials used for erasing or softening pencil marks, the most useful of which is the putty eraser. This has flat edges and so can be pulled across your whole painting or kneaded into a point for cleaning up small areas. Use a plastic eraser to remove more stubborn marks, but take care not to abrade the paper. Adhesive tack dabbed repeatedly on one spot will gently soften pencil marks without removing them completely. Other erasers are encased in wood like a pencil and are gritty and abrasive—these work well to lift light spots of paint from areas that will not lift with water.

ABOVE The putty eraser is an indispensable part of an artist's equipment. The large block can be squeezed into any shape to provide just the area you need. Keep your putty eraser clean by keeping it in its original box as the surface will naturally pick up dust. Use it to clean your paper before you start.

BELOW Experiment with the variety of pencils on sale to find the brand you like best. The feel of the pencil on the page is very important, so once you have found a brand you like, stick to it. For watercolor sketching, carefully sharpen your pencils with a craft knife and leave a long lead exposed.

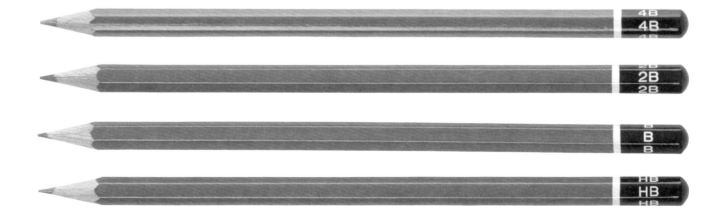

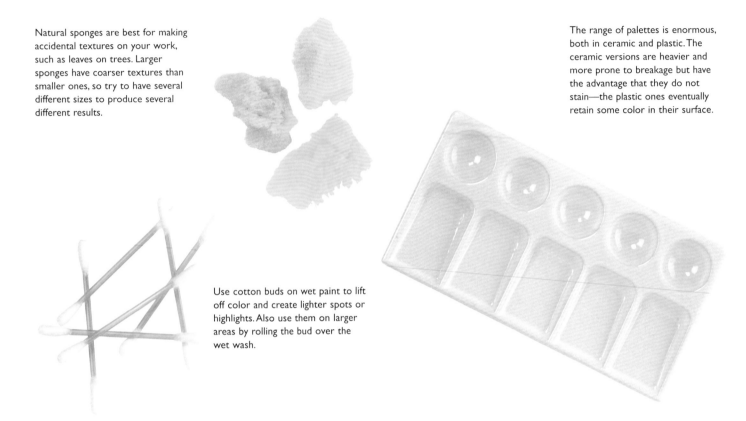

Natural sponges are best for making accidental textures on your work, such as leaves on trees. Larger sponges have coarser textures than smaller ones, so try to have several different sizes to produce several different results.

The range of palettes is enormous, both in ceramic and plastic. The ceramic versions are heavier and more prone to breakage but have the advantage that they do not stain—the plastic ones eventually retain some color in their surface.

Use cotton buds on wet paint to lift off color and create lighter spots or highlights. Also use them on larger areas by rolling the bud over the wet wash.

brushes, sponges, and manipulating color

Over the centuries, almost every kind of hair, bristle, and fiber has been used to make brushes. However, it is generally recognized that the tail hair of the sable (a member of the weasel family) is the best for watercolor brushes. These hairs are fine but tough, designed by nature to stand abrasion on rocks and ice. The Kolinsky variety is regarded as the very best. Unsurprisingly, sable brushes are expensive.

Synthetic fibers are the main alternative to sable and have now reached a very high standard, but there are some important differences. Synthetic fibers (or "filaments") are made by stretching nylon fibers to breaking point while they are still viscous. This means that the tips of the fibers are the weakest parts, making them inclined to wear out. By contrast,

sable is toughest and most resilient at the tip. Also, being hair, it has a scaly surface, which helps the brush to hold more liquid. The advantage of synthetic brushes is their comparatively low price. For this reason, only consider buying two small sable brushes to start.

There are three main types of brush, all named after their shapes—round or pointed (a general-use brush), flat (usually a large brush for washes), and "mop" (a large, round brush, again for washes). Brush sizes are usually denoted by a measurement or by a number. Large wash brushes, designed to apply lots of color quickly to paper, are often measured in inches, such as ¼in or 1in. Smaller brushes are often numbered, with size 14 being among the largest and size 0 among the smallest. A small, flat hog hair brush, more usually

associated with oil painting, is handy for scrubbing out color.

Brushes are not the only way to apply color to the page. Natural sponge is a great way to create "accidental" patterns, and is especially useful for creating free, detailed areas of foliage, which could not be created by painting individual leaves. Have a few different sizes ready—larger sponges create different textures than smaller ones.

No colors can be applied without mixing them first with water, and for this you need a palette. These are plastic or ceramic and come in a variety of shapes and sizes—plastic versions are more suitable for transporting because they are light and less breakable. Larger versions are more useful when mixing lots of paint, or when working with other materials, such as large sponges.

As well as applying color, effects can also be created by "masking" an area of paper to stop paint reaching it, or removing paint to create highlights. Use masking fluid or a wax candle for masking, and cotton buds for lifting off small areas of paint. For lifting off larger areas, use kitchen tissue. You can

WHICH BRUSHES TO BUY

Choose two "round" (or "pointed") brushes of different sizes that carry lots of color but which come to a point when loaded. These can be synthetic or sable, according to your budget. You also need two "flat" brushes for washes, $1/2$ in and 1 in wide, as well as one large, round "mop" brush with soft bristles. This brush can either be synthetic or made from squirrel hair. A small, flat hog hair brush is handy for scrubbing out color.

When buying a round brush, ask for a sample, dip it in water and, holding the end of the handle, flick it downward. Discard any brush where the hair does not come to a neat point. Do the same with flat brushes, which should come to a smooth, flat edge. Also take the ferrule in one hand and twist the handle with the other. If you can feel any movement, do not buy the brush.

ANATOMY OF A BRUSH

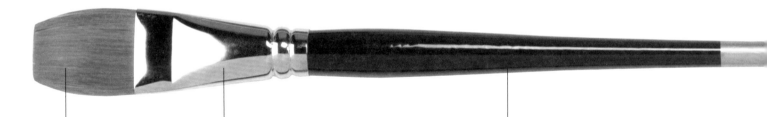

HAIRS
Many kinds of animal hair have been used to make brushes, the best of which is sable. A wide variety of synthetic fibers is also available, which now compare well with sable hairs.

FERRULE
The ferrule is the metal tube that holds the hair and attaches them to the handle. Avoid brushes that have a seam or join on the ferrule—these don't grip the hairs or wood well.

HANDLE
Handles are often made from wood that has been varnished to make it watertight. The brush handle is usually widest at the ferrule, the point at which you usually hold the brush.

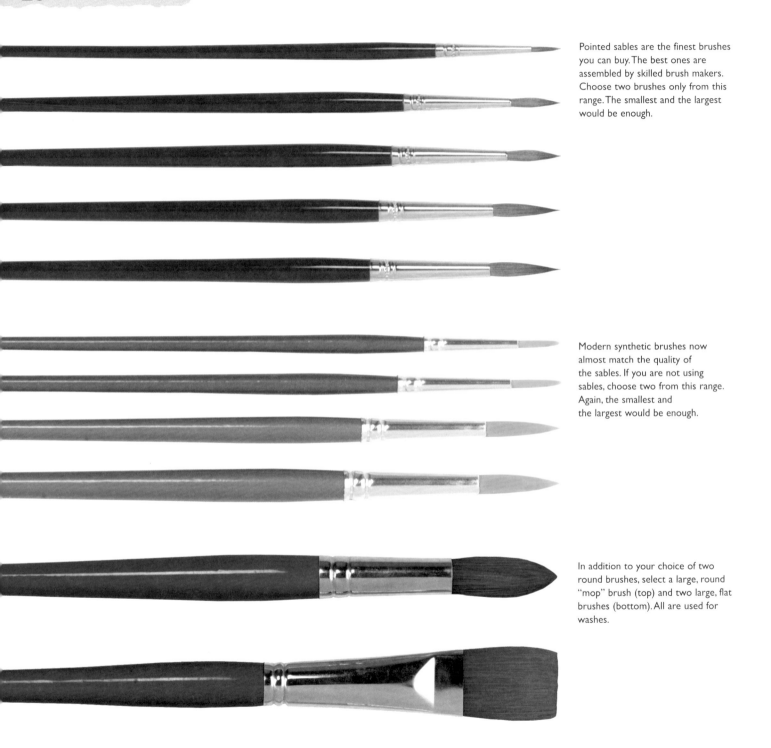

Pointed sables are the finest brushes you can buy. The best ones are assembled by skilled brush makers. Choose two brushes only from this range. The smallest and the largest would be enough.

Modern synthetic brushes now almost match the quality of the sables. If you are not using sables, choose two from this range. Again, the smallest and the largest would be enough.

In addition to your choice of two round brushes, select a large, round "mop" brush (top) and two large, flat brushes (bottom). All are used for washes.

also work designs into wet paint using the handle of a brush, but to do this add gum arabic to the paint to slow down the drying process.

other accessories

Before you can start painting, you will need to fix your paper to something solid. A sheet of plywood and some masking tape is ideal for this. When you want to change your colors, you will need to rinse your brush. A simple jam jar filled with water will do, though a collapsible water pot works best outdoors.

Watercolors take time to dry. This can make applying one wash over another very time consuming. Speed up the process with a hairdryer, but be careful not to blow unwanted paint into other areas of your work. Last, make sure that your workspace is adequately lit. This will not only avoid eyestrain, but allow you to see colors as they really are. Either sit by a window, or use a daylight simulation bulb in a desk lamp—it can be very disheartening to see your work change color in "real" light.

Flat, hog hair brushes like the ones on the left are very useful. These brushes are not used for applying watercolors, but for scrubbing out areas where the paint is too dark. Use a synthetic brush for this purpose.

BRUSH CARE

If you purchase a good range of brushes and take care of them as you use them, they should last a lifetime. In fact, you need to do very little to keep them in good condition.

Always rinse your brushes in plenty of clean water after painting. From time to time, squeeze a little washing up liquid or rub a small amount soft soap onto your fingers and roll the brush between your forefinger and thumb where the hairs meet the ferrule. This is because paint builds up under the ferrule as you use the brush, stopping the hairs returning to their proper shape.

Never leave brushes standing in your water jar with the bristles facing down. This causes the points to curl and, although they usually straighten after a while, they are difficult to use while the hairs are curved. Do not discard brushes if they lose their point completely—they are often useful as wash brushes.

Take care not to ruffle the hairs when carrying your brushes by using a brush case, which is simply a cylindrical metal tube with a lid, or by securing your brushes with elastic bands to a stiff piece of cardboard.

If the handle of a favorite brush becomes loose, scratch off the varnish and float the brush in water overnight. With luck, the wood will expand and the handle will tighten again. You may have to repeat this as the wood dries. If this does not work, gently hammer the point of a nail in several places round the neck of the ferrule. This pushes a burr of metal into the wooden handle and sometimes cures the movement.

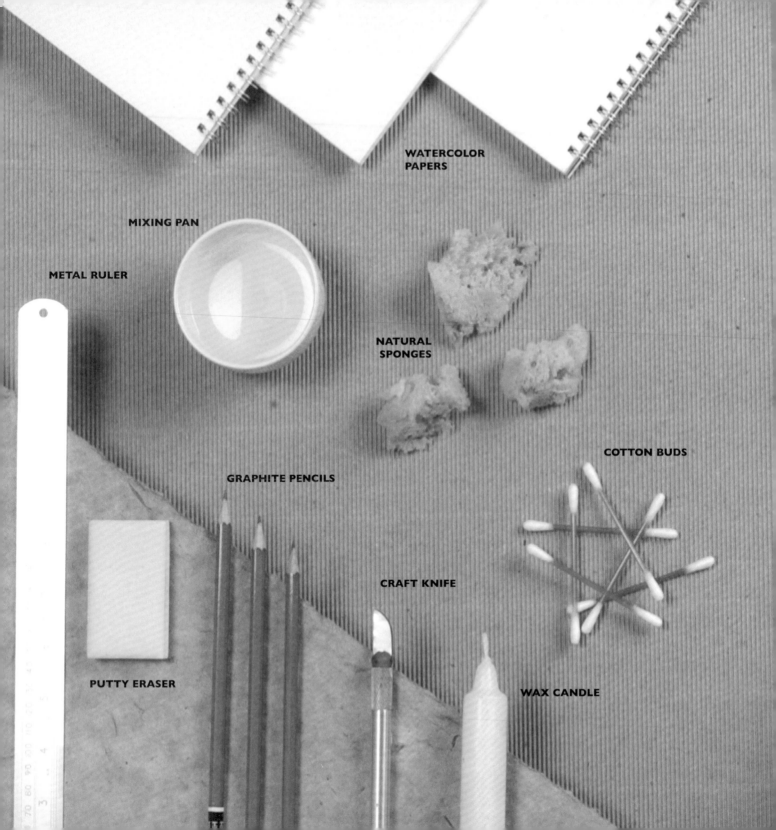

WATERCOLOR
PAPERS

MIXING PAN

METAL RULER

NATURAL
SPONGES

COTTON BUDS

GRAPHITE PENCILS

CRAFT KNIFE

PUTTY ERASER

WAX CANDLE

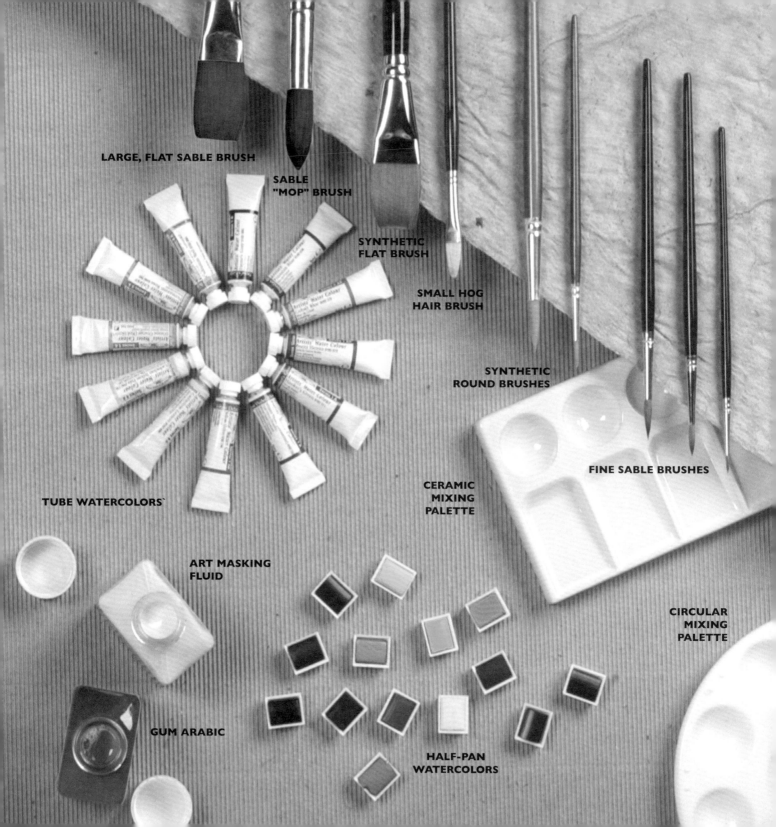

LARGE, FLAT SABLE BRUSH

SABLE "MOP" BRUSH

SYNTHETIC FLAT BRUSH

SMALL HOG HAIR BRUSH

SYNTHETIC ROUND BRUSHES

FINE SABLE BRUSHES

TUBE WATERCOLORS`

ART MASKING FLUID

CERAMIC MIXING PALETTE

CIRCULAR MIXING PALETTE

GUM ARABIC

HALF-PAN WATERCOLORS

materials and equipment—acrylic

Getting started in acrylics does not involve buying a great deal of equipment. Buy a couple of brushes, a few tubes of paint, and a pad of paper or a couple of canvas boards, and you are ready to start. You may find that you have most of the other materials you may find useful, such as pencils and charcoal, already. These are inexpensive to add to your painting kit. If you do not want to spend more, you can always use a small brush and dilute paint as your drawing tool, as is the case in project 6. You can work almost anywhere and the results are highly durable. Experiment with how paints handle by using them directly from the tube, then dilute with a little water and look at the differences in the marks and finishes you can achieve.

As a general rule, buy the miminum you need to get you started and then add to your materials and equipment as you work out what suits your subject matter and ways of working.

paints

Acrylic paints are vibrant, water-soluble, permanant when dry, and will not yellow with age. Without becoming too technical, it is the new artificial organic pigments prepared in the laboratory that have brought a new range of brilliant and deep colors to the artist's palette. They are more permanent and stable than any other pigments. Phthalo, cyanine, quinacridone, azo, and naphthol are the names associated with these pure new colors. Unlike oil painting, where the pigments are mixed with any number of combinations of oils, essences and resins, and the exact mixtures require some skill and training, acrylics are mixed with a single polymer emulsion. This liquid, which is milky-white when fluid mixes readily with any amount of water so that acrylic colors can be diluted to thin washes like watercolors or used straight from the tube like oils, and every degree of mix in between. Even the thickest applications of acrylic will not crack. The polymer resin also carries the traditional mineral pigments used in the older painting media. It can even cope with the addition of texturing materials such as sand, glass, and metal powders and, since it dries crystal clear, reveals their reflective appearance. Perhaps its great advantage over oils is that it dries so quickly that many layers of thick paint can be applied and even glazed and scumbled within a single day without the risk of wrinkling or cracking. However, if you find that this does not suit your way of working, retarding liquids can be added to slow down the drying process.

Acrylics allow almost any method of application by brush, knife, or squeegee and can be diluted for spraying. With acrylics, almost any alteration can be made by repainting over what has already been done, without technical difficulties. This cannot be said of oils, watercolor, or gouache.

You do not need an enormous number of acrylic paint colors to create works of art with plenty of contrast in terms of subject matter and color use. The eight projects in this book were painted using only 12 main colors, with the addition of black and white. If you are new to the medium, buy a set of 10–12 artists' quality colors and add more colors as your work evolves. The color needs of a landscape painter, for example, are different from those of a portrait painter.

PAINTING OUTDOORS

Painting from nature is a great way to improve your skills. Sun and cloud constantly change the landscape, allowing you to pick and choose what you include in your artwork. A great advantage of acrylics is their quick drying time, which makes them very suitable for painting outdoors, since you are unlikely to have to carry wet artwork home. Take a portable easel, a large and a fine brush, one or two canvas boards or a couple of sheets of acrylic paper, your paints, and a disposable palette. Make sure you have a folding container for water and hook it onto your easel so that you don't accidentally knock it over.

grounds or supports

A wide variety of surfaces are suitable for acrylic painting. These pages present the most common, and then offer a few pointers on less usual, but also successful, surfaces.

canvas

For artists who choose to use acrylics as quick-drying oil paints, canvas is the most popular surface. The finest and most expensive canvases are made from linen, but cotton, which was introduced later and is not quite so durable, is also excellent as a support. Both these materials are produced in grades from very fine, where the threads of the weave hardly affect the painting surface, to really coarse textures that break up the

paint into dots. For extremely large areas, such as scenery painting, hessian is often used as a cheap alternative to canvas. Canvas is usually supplied tacked to light wooden frames that can be tightened by tapping small wedges into the corners. You can also buy canvas by the yard, and stretch it yourself.

Canvas boards are widely available in all grades and sizes. They are made by gluing canvas to a heavy cardboard base and are a convenient and light alternative to stretched canvas for small- to medium-sized works, up to approximately 24 × 20 in (600 × 500mm): larger-sized boards have a tendancy to

OPPOSITE Canvas, tacked to a stretcher for tightening, is available in many sizes, and is usually sold primed and ready for painting. Canvas boards too are sold in many different shapes and sizes. Boards are also usually primed and ready to paint on, and can be tinted any color.

BELOW Papers suitable for acrylic painting are sold as individual sheets and in pads of many different sizes and weights. A good general weight is 150 lb (250 gsm). These are ready to paint on immediately. Other papers need sizing and priming before paint is applied.

warp. Canvas boards can be cut down to a smaller size with a craft knife if you wish to alter your composition.

panels

Large wooden panels, which were in use before canvas became popular, were always unstable and expensive to make. Masonite was often used as an alternative, but this has been superseded by an excellent modern replacement material, MDF (medium density fiberboard). MDF is inert,

does not warp, does not attract insects, and if properly sealed and primed, is a fine support for all artists who prefer a smooth surface to work on. When primed with gesso (plaster and glue) it provides a surface comparable to those used by the Old Masters.

paper and card

Paper and card are delightful to paint on, and provided they are sized with glue to prevent paint soaking into them, are technically sound. Watercolor papers can be used, but need to be stretched before you start work. You can also buy pads of acrylic paper, which need no preparation before you start.

other surfaces

Any non-greasy surface is suitable for acrylic paints. Many fine pictures have been painted on copper, and aluminium, provided that it has a "tooth," can also be used. Acrylics can also be painted onto glass, fabrics, and furniture.

A smooth flat surface is useful for laying out and mixing your paints. An artist's palette in wood is one of the most common types, and the thumbhole is useful, especially if you stand to work. Palettes designed specifically for acrylics are also available in plastic, with wells to hold colors from the tube, and areas for mixing.

There are gels and retardants that slow the drying time of acrylics, to give you longer to move your paint around on your support. A flow enhancer may improve paint movement. Acrylics can also be mixed with a gloss or matte varnish to dry to a clear and glossy or dull finish. The best way to find out whether these products are useful is to practice with them.

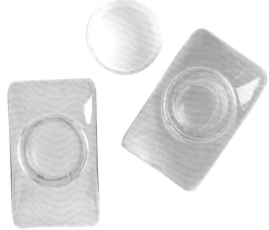

Palette knives are useful for mixing paint on the palette, in addition to applying paint to board or canvas. The trowel-shaped models are lightweight and flexible. The edge of the knife should be smooth to lift paint easily and apply it to your painting surface.

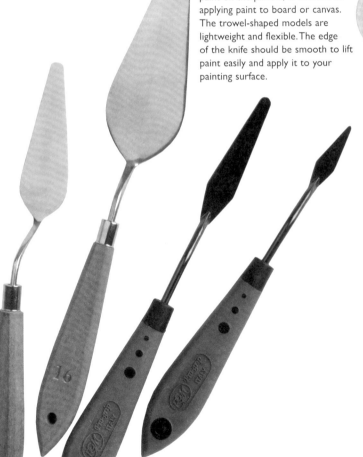

palettes

Medium-sized rectangular palettes with a thumbhole are the most practical. They are sold in wood, and obviously the reddish color will affect the way you see your colors when you are mixing them on the palette. The wood color matched the tinted canvases used in the past but is not helpful if you work on a white canvas. A good alternative is a white plastic palette of the same size. Choose one with tray indentations if you work with fairly loose paint. If you have a painting room, a sheet of heavy glass laid on a table is ideal and you can put a sheet of colored paper to match the tint of your canvas underneath it. If your sessions are frequently interrupted, consider a moisture-retaining palette.

palette knives

Like oils, acrylic paints can be spread or manipulated using knives or spatulas, in metal or wood. A whole range of knives

shaped like miniature trowels can be used to develop a style in which a whole picture is painted without brushes, or with minimal brushwork. The combined use of brushes, with palette knives being used to add emphasis of solid color, is very effective in achieving dramatic results. Knives were most

famously used by Gustave Courbet (1819–77) who is credited with the development of the trowel-shaped blade and offset handle, which gives greater ease of paint handling.

brushes

The most popular brushes for acrylic painting are made from hoghairs. These are stiff yet springy and will either smooth the paint into place or plow through the paint to move it. They are made in many shapes and sizes: round, flat, and filbert are the main types to consider. Filberts are the full-bodied, oval-sectioned brushes that come to a point.

Brushes for acrylic painting are produced to the same quality standards as those for watercolor. Generally, they have longer handles to allow you to paint standing back from your work to monitor its progress as you go. Buy fewer, good-quality brushes, rather than putting together a comprehensive collection of cheaper ones. All artists develop their favorite brushes, and use them time and again, regardless of subject, so you may find you have a box-full of brushes you seldom use.

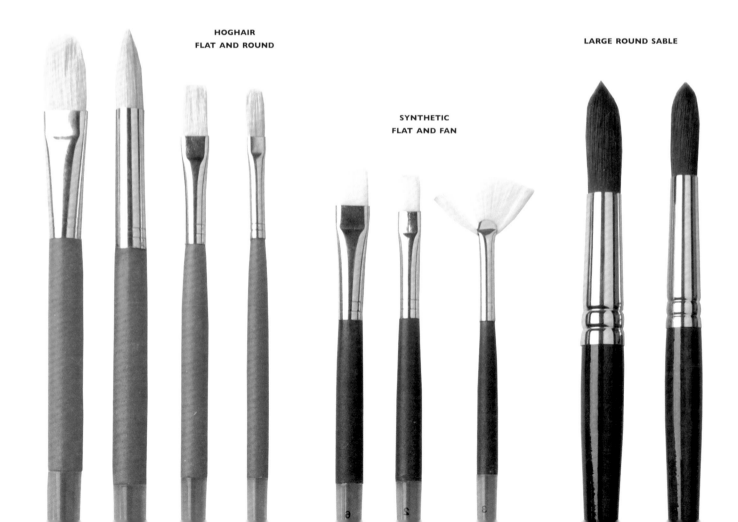

HOGHAIR
FLAT AND ROUND

SYNTHETIC
FLAT AND FAN

LARGE ROUND SABLE

ANATOMY OF A BRUSH

HAIRS

Many kinds of animal hair have been used to make brushes, the best of which is sable. A wide variety of synthetic fibers is also available, which now compare well with sable hairs.

FERRULE

The ferrule is the metal tube that holds the hair and attaches them to the handle. Avoid brushes that have a seam or join on the ferrule—these don't grip the hairs or wood well.

HANDLE

Handles are often made from wood that has been varnished to make it watertight. The brush handle is usually widest at the ferrule, the point at which you usually hold the brush.

FLAT AND ROUND SABLE

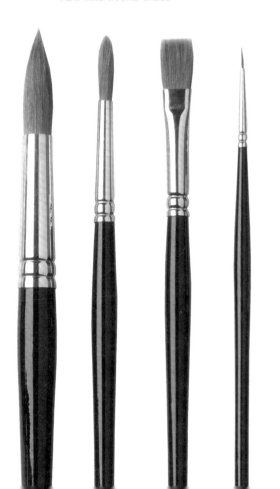

WHICH BRUSHES TO BUY

Choose a small selection of hoghair brushes, say two each of flat, round, and filbert of a size that you feel comfortable with. You will also need a medium-sized round sable and a long-haired "rigger" brush in sable or synthetic fiber. A couple of decorator's brushes are useful and inexpensive, especially if you plan to work in a large scale.

When buying a round brush, ask for a sample, dip it in water and, holding the end of the handle, flick it downward. Discard any brush where the hair does not come to a neat point. Do the same with flat brushes, which should come to a smooth, flat edge. Also take the ferrule in one hand and twist the handle with the other. If you can feel any movement, do not buy the brush.

Note that you can use your watercolor brushes for acrylic paints, but you will not get the same "response" if you then go back to using them for watercolor.

BRUSH CARE

If you purchase a good range of brushes and take care of them as you use them, they should last a lifetime. One of the most important things to remember about acrylic paints is that, although they are water based, they are water resistant when dry, so if you let paint dry on a brush, it can be difficult to remove. For this reason, don't leave a brush with paint on it to harden.

While painting, soak your brushes in water or solvent so that the paint does not dry in the bristles. It is well worth buying a brush holder to hold your brushes in liquid, without bending the bristles. Never leave brushes standing in your water jar with the bristles facing down. This causes the points to curl and, although they usually straighten after a while, they are difficult to use while the hairs are curved. Do not discard brushes if they lose their point completely—they can still be used to lay washes, as you would in watercolor.

After a painting session, wipe any excess paint from your brushes using a rag or some kitchen paper. Always rinse your brushes in plenty of lukewarm water until the water runs clear: very hot water can damage the ferrule. If a color has dried on a brush, use an artist's brush cleaner to remove it. When the brush is clean, blot any excess water with a towel, reshape the hairs between your finger and thumb, and leave to dry, standing upright on its handle.

Take care not to ruffle the hairs when carrying your brushes by using a brush case, which is simply a cylindrical metal tube with a lid, or by securing your brushes with elastic bands to a stiff piece of cardboard.

Try a few of each before buying the whole range. Sable and synthetic hair brushes are all useful to painters in acrylics, especially those who choose to work with colors of a more liquid consistency.

Kolinsky is the name given to the sables of the highest quality. Another type called "mongoose" is useful because these have the softness of sable and springiness of hoghairs. There are also synthetic brushes that closely match these qualities, usually at a fraction of the price. Very long-haired brushes in sable, called riggers, are used for drawing out fine lines.

It is useful to include a few decorators' brushes up to about 3 in (75 mm) wide for priming and tinting backgrounds. Of the many technical brushes that exist for the subtle blending of paint, the fan brush in hog, sable, and synthetic, and the "badger" blender are the most useful. Buy a few that take your fancy and practice with them until you understand their quaities and what they can be used for.

easels

If you are planning on working on large pieces, or on portraits, you may find it most comfortable to do some of the work standing. If that is the case, you will need to secure your work so that it does not wobble or shake. The classic studio easel has a ratchet mechanism, a tilting frame with winding handles, and locking castors so that it can be wheeled around the studio, but for most people such elaborate pieces of furniture are unnecessary, although they certainly look impressive in the studio.

More usual and essential for serious work is the radial easel, which can cope with pictures up to 3ft (1m) square. A tripod sketching easel is adequate for most small pictures. The metal ones are more stable owing to their extra weight and rigidity, but less good for outdoor work. Camera tripods with a drawing board bolted to the camera plate are a good alternative.

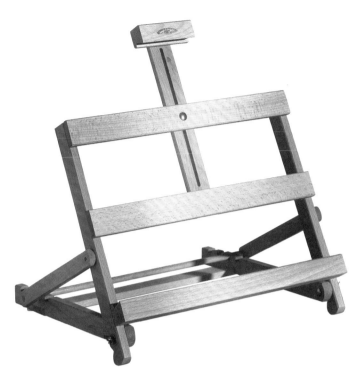

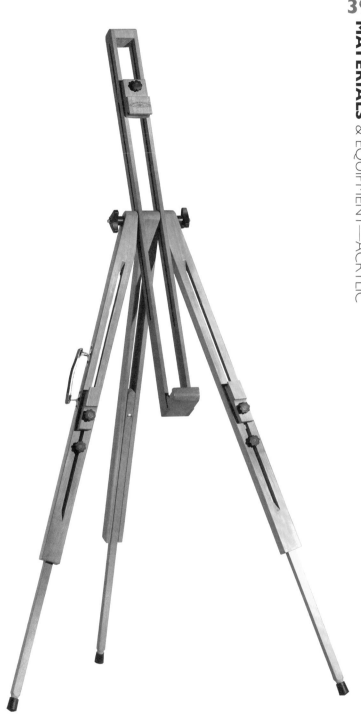

A tabletop easel is ideal for smaller works. If you are working on paper, tape your paper to a drawing board and lean on the easel. Choose a model with two or three angles of adjustment to meet your precise needs.

A floor-standing easel is a good investment if you are going to be doing a lot of painting. Choose a model with an adjustable angle of working, and with adjustabe legs so that you can work standing or sitting, and can compensate for any unevenness in the floor.

A desktop easel is useful if you prefer to sit at a table to paint, and are working only on small to medium pieces. These have the advantage that you can fold them away for storage when you are not painting.

other useful equipment

A desk light is an essential for color mixing in dim light, and can also help you to orchestrate the lighting of your still life compositions. Finally, pencils, chalks, charcoal, and a putty eraser may all prove useful.

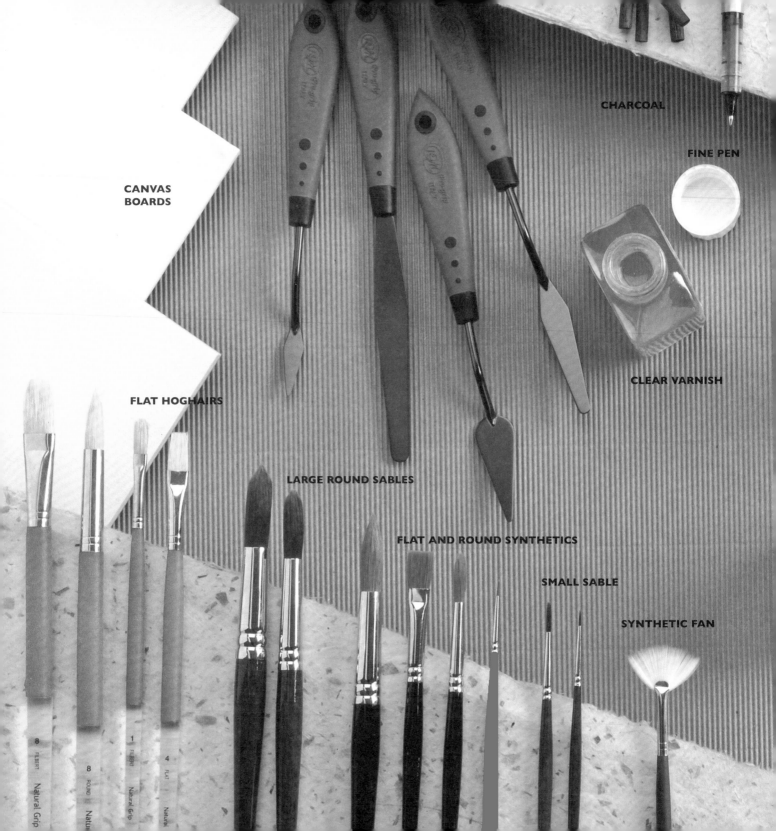

CANVAS
BOARDS

CHARCOAL

FINE PEN

CLEAR VARNISH

FLAT HOGHAIRS

LARGE ROUND SABLES

FLAT AND ROUND SYNTHETICS

SMALL SABLE

SYNTHETIC FAN

8

8

1

4

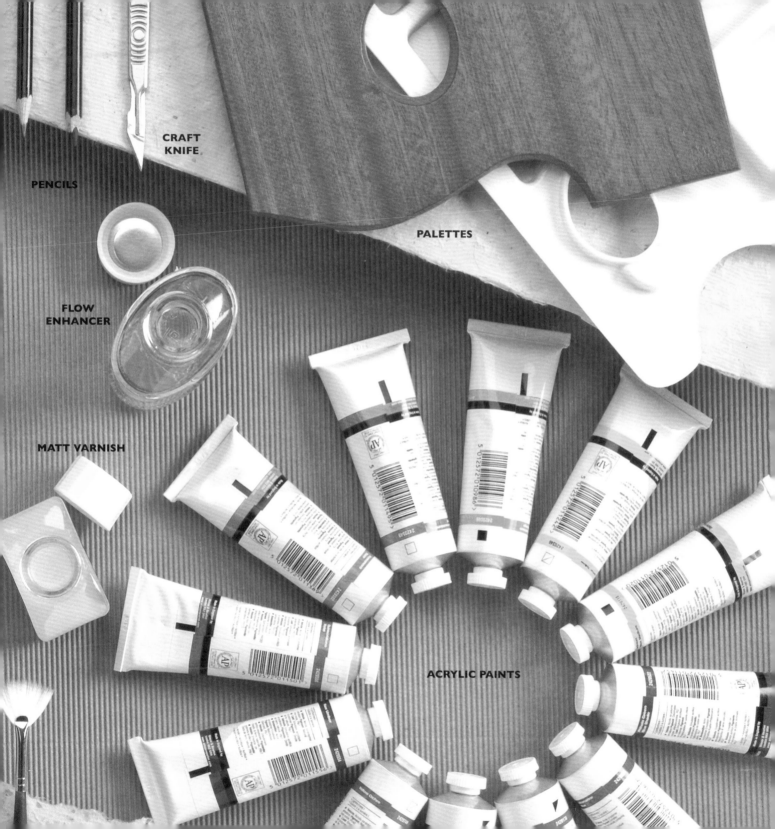

CRAFT
KNIFE

PENCILS

PALETTES

FLOW
ENHANCER

MATT VARNISH

ACRYLIC PAINTS

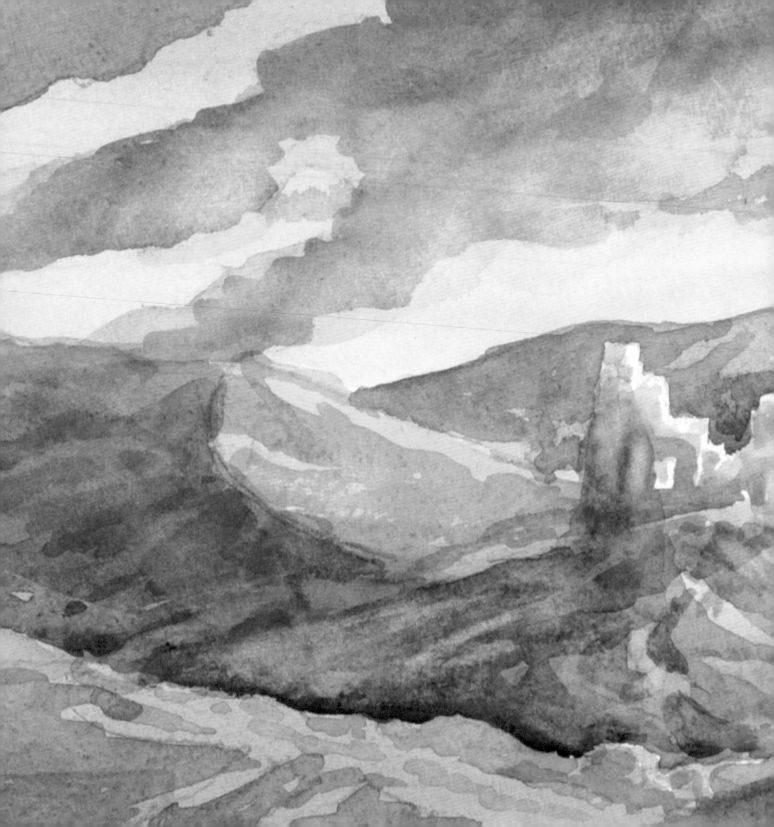

watercolor techniques

Before you can put brush to paper, you need to know how and where to start. This section gives clear advice on the main watercolor painting techniques: preparing your paper, controlling your brush, and mixing your colors. It also illustrates many of the innovative ways you can apply color to paper.

basic techniques

Watercolor is one the simplest of the painting media but at the same time, is probably the most subtle and sensitive to personal interpretation. The basic technique of watercolor is the laying of transparent washes on white paper; the white paper represents light and every application of paint gradually darkens the picture. Once the white of the paper glowing through the paint is lost, the watercolor has been overworked. To work well, you need paper that is as white as possible and will stay white over time. The range of papers developed to meet this need is very wide and there are papers to suit every type of painting. Also, laying flat washes is not easy at first but it is a basic technique that can quickly be learned with practice, along with handling the softhaired brushes that work so well with waterbased colors.

For the most part, watercolor papers need to be soaked with water then "stretched" on board and left to dry (see p. 51). This is

CONTROLLING THE MARKS YOU MAKE

All brushes have their own handling characteristics according to their shape, hair type, and size. As with a tennis racket or golf club, you will need to get to know just what your brushes will, or will not, do. The types illustrated throughout this book may be all you need for your watercolor art, but experiment with different combinations of brushes and papers. With practice, you will develop your own touch.

BELOW The wide, flat brush is used for applying washes, making rectangular marks, and drawing fine lines with its edge. Hold this brush sideways in a pen grip where the handle bulges.

BELOW A good round brush will come to a point when loaded with paint. Hold this brush with an angled pen grip, toward the end of the handle.

BELOW This brush, called a "rigger," draws fine lines. The long hairs carry lots of paint—you will surprised at how much. Hold this brush as you would a pen, near the ferrule.

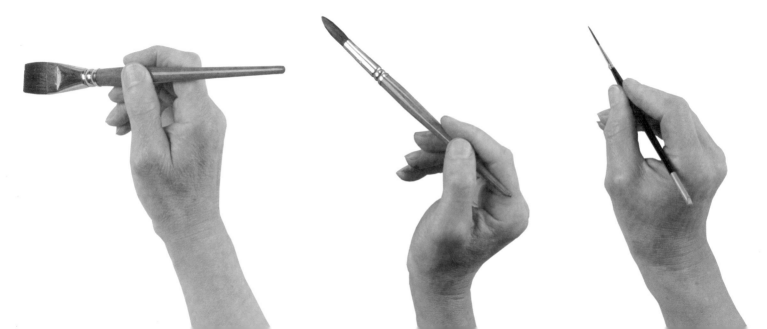

STIPPLING

1 Add a base color of permanent rose to the paper, painting it in the shape of a strawberry. Decide where your light source is, then darken your mix slightly. Start stippling on the shadow side of the fruit, dabbing on spots of color with the point of the brush.

2 Work your way around the side of the fruit toward the top. Stippling works well from dark to light—create darker areas by adding larger dots, closer together. As you work toward the lighter areas, use fewer, smaller dots, farther apart.

3 Increase the effect by using a smaller-tipped brush to create smaller dots. This adds a fine level of detail to your work and helps you control the tone between light and dark more accurately. It also helps blend the light and dark areas together in the viewer's eye.

4 You are not limited to using one color only—stippling can be built up using a spectrum of colors, but bear in mind that the tone of each color needs to be the same in order for the effect to look smooth. Also, stippling is best suited to small areas—large areas are hard to fill.

your starting point; paper that has not been stretched will buckle when wet paint is applied to it. Not only will you need to control your paint across the paper, but up- and downhill as well—an impossible task and a waste of good paper.

brush control

A basic set of brushes (see pp. 16–29) is all you need to get started. In general, the softer the hairs, the more water the brush will hold, but large, soft brushes are very floppy when wet— although they cover large areas, you will have very little control over shape or drawing. They are good for large, wet-in-wet subjects and free abstracts. The best of the synthetics (or sable and synthetic mixes) have a good spring to them and are very durable. Apply your brushes carefully to the paper until you know how much bounce there is in the hairs. Try using each brush

flooded with color and carry on painting until there is so little paint left on the brush that it hardly marks the paper. In this way, you will learn how each brush performs and you will start to develop your own personal touch.

color selection

There are hundreds of watercolors available but their basic formula has remained unchanged since the 18th century. Raw pigments are ground very finely and mixed with gum arabic and water to form a stiff paste. After drying, "pan" colors can be dissolved by applying a wet brush. The more finely the pigment is ground, the more color comes out. Cheap watercolors often contain too much gum and not enough pigment. The result is that your work becomes sticky and the color is streaky.

The use of the colors shown on the wheel will cover most of

SPATTERING

 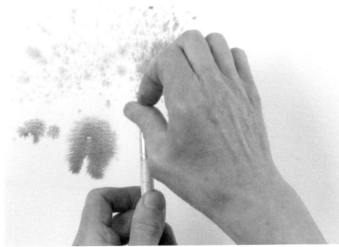

1 First, lay down a wash of clear water across the page with a wide, flat brush. Apply the water by pulling the brush across the paper in horizontal strokes to form bands. This is the technique for applying any flat wash to paper.

2 Dip a stiff hog hair brush into your paint. Don't mix the paint too thickly, or it will tend to stick to the brush. Then pull your index finger across the hairs. It is important that you only pull your finger toward you—otherwise, you will cover yourself in paint.

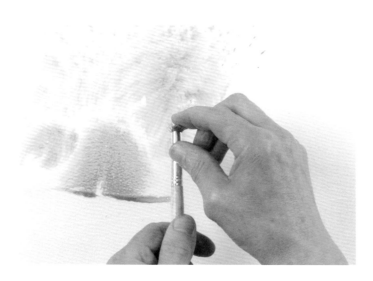

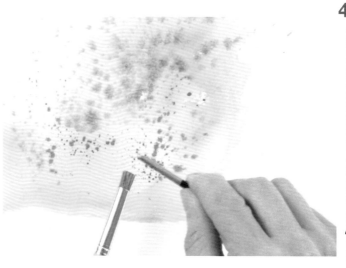

3 This creates an explosion of color across the page, which expands and merges as it spreads in the water. Repeat the spattering process to increase the effect. The overall result is to liven up an otherwise flat color with a textured effect.

4 As well as using your finger, you can also use the handle of another brush. As before, simply pull the handle toward you to spatter the paint over the paper. Successive applications of spattered paint creates more and more texture on the paper.

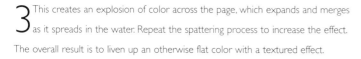

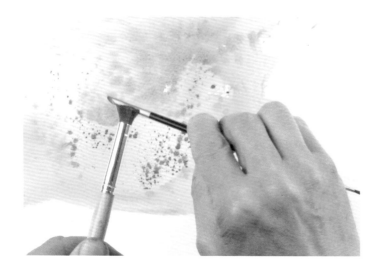

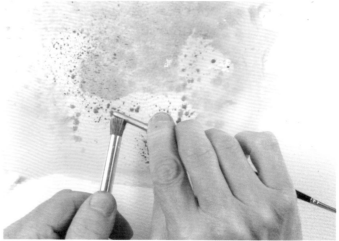

5 You don't have to stick to the same color all the way through. In fact, you can add almost any colors you like, building them up one after the other. As a guide, though, you should only use colors with the same tonal range—this will give your image a more unified look.

6 Add the last color, in this case violet, by dipping just a few bristles on the edge of the brush into the paint and carefully spattering it with the handle of the brush. This creates a lighter spray of paint across the page, in contrast to the larger drops underneath.

USING A SYNTHETIC SPONGE

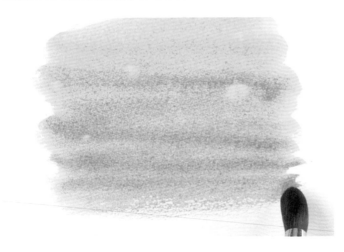

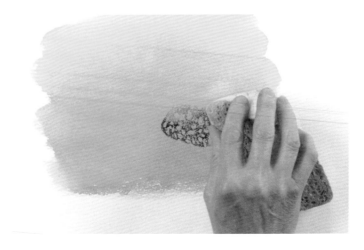

1 Apply a flat wash of color with the mop brush, pulling it across the paper in horizontal bands. Here, we have used burnt sienna as the wash color. Pick up any unwanted drips with the point of the brush to create a smooth, flat color.

2 Let the paint dry thoroughly. Then make a darker mix of your paint by adding, for example, a little cobalt blue. Dip your synthetic sponge into the mix and start dabbing it onto the wash. The pattern of the sponge is printed onto the paper.

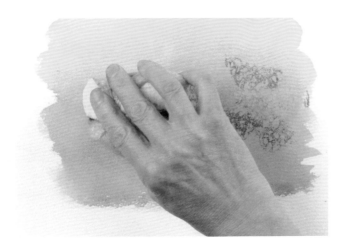

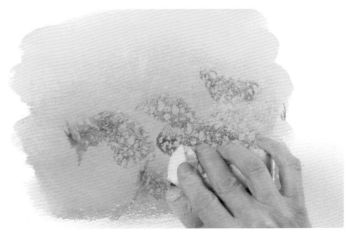

3 Make sure that your mix is quite thick and that the surface of the sponge is not saturated with paint. This will stop the paint running and also stops it smearing as you apply it to the paper, both of which will ruin the patterned effect.

4 Synthetic sponges produce a predictable print across the page. This can be very useful when you need regularity in your work, but for a more random pattern, such as that needed to produce foliage on a tree, use natural sponge—its surface is never regular.

the mixes you will need and the way to get the mixes you want is shown in the projects. This will give you the confidence to know how your mixes are going to turn out—soon you will be able to move on to making your own. Work for some time with a limited palette until you know the results of all the mixes, then start again with another palette of your own choosing. This will help you develop—don't just rely on the same old favorites. You may then to decide to add further colors—ultramarine blue and viridian (a deep strong green) are the ones to choose. Practice playfully with your paints and your brushes, sponges, kitchen roll, pencils and paper before you attempt the projects. This will allow you to do the mechanical things almost automatically.

color mixing

Getting the color mix that will give you the finished result you want depends on two things—the amount of color and the

amount of water. Have a clean pan or reservoir in your palette ready for each color. Put a little clean water in each but not too much—it is easy to add more water to a strong mix but a waste of paint to tint large amounts of water, creating a mix you will never use up. Take your brush, dip it in your water pot then stroke it firmly across your desired watercolor pan. You will need to do this several times until the color begins to dissolve. If you are using tube colors, squeeze a bit of paint about the size of a pea onto the rim of your pan. Don't forget to replace the lid on the tube.

Put the brush carrying the color into your wet pan and stir until all the paint is dissolved. In the case of tube colors, check that there are no bits of solid paint sticking to the brush hairs. Test your mix on a piece of scrap paper, or better still, keep a little book for all your test patches and label each mix with its component colors. If the color is too pale, add more color to

USING SEA SALT

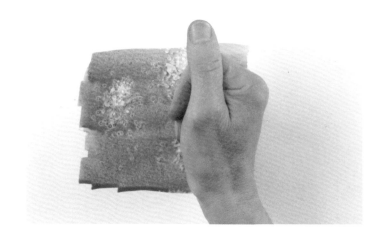

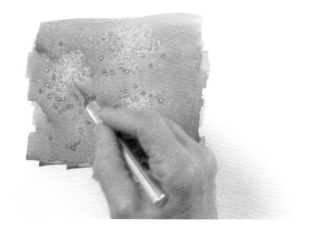

1 Apply a flat wash by painting horizontal bands of color across the paper. Plan where you want the salt to go before you start, then drop small amounts of it onto the surface of the wet paint. Don't use too much—just enough to cover the paper.

2 Let the paint dry thoroughly then scratch off the salt carefully with the point of craft knife. The salt crystals will absorb the paint as it dries. The paper underneath is left patterned and textured, according to how much salt you use and the proximity of the crystals to each other.

your pan; if it is too strong, add more water. Leave your results to dry. The most important thing to notice is that watercolors always dry lighter than the color of the wet paint would suggest. This is more noticeable in some colors than in others—you will gradually learn how each one behaves.

To mix two colors to make a third, wash your brush, dip it in the clean water again and apply it to the next color pan. Add this to the color already in your palette, stir thoroughly, then test it on some scrap paper. In this way, practice color mixing until you feel that you are in control. Change the water in your pot frequently or have one pot for clean water and one to wash your brushes in. Try to achieve your colors with a mix of only two paints (three at most)—this will keep your washes clean and attractive.

experimentation

Watercolor is the one painting medium where the paint is meant to move about after you have put it on the paper. It does this in unpredictable and beautiful ways. Experiment wholeheartedly and don't be afraid to make a mess. This example shows the rewards of experimentation: Take some Payne's gray and ultramarine and drop each color separately onto wet paper, leaving a gap in between each color. Take your drawing board and, holding it at arms length, raise it to shoulder height then bring it down quickly. Repeat this several times until the paint begins to flick off into the air. Lay your paper flat and allow it to dry. The result will be a windswept sky that no brush could paint.

WAX RESIST

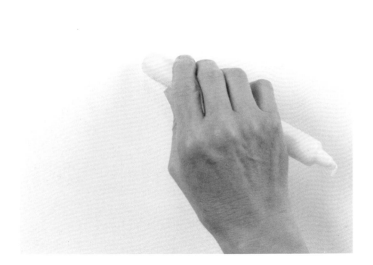

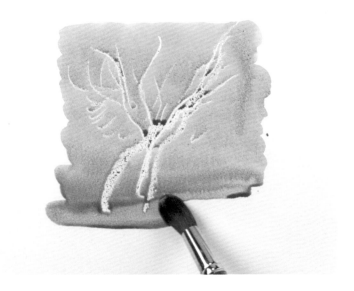

1 Using the end of a standard household candle, scratch the pattern you want to "resist" the paint onto the paper. You need not press too hard—the rough surface of the watercolor paper will easily remove enough wax to create the effect.

2 Apply a wash of paint over the wax resist. The pattern underneath shows through the paint. Notice how even the thin lines show through and how the paint gathers in the joins between the lines of wax, adding more texture to the image.

STRETCHING WATERCOLOR PAPER

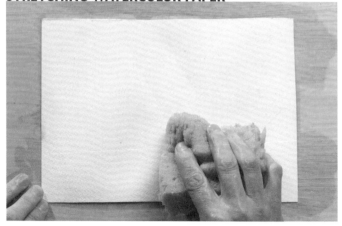

1 Put your watercolor paper on your board. If the paper has a watermark, put this facing upward. Then, with a clean sponge, thoroughly soak the paper in water. Make sure that the water has soaked through to the other side, turning the paper over if necessary.

2 Smooth the wet paper over the board to make sure that no air bubbles are trapped underneath. Then cut, or simply tear, four strips of gummed tape. Wet each strip with the sponge before applying it to the edges of your paper.

3 Apply the gummed tape with roughly half its width on the board and half its width on the paper. Stick down each edge of the paper to the board, starting with the two longest sides. Try and keep the paper taut to make sure there are no corrugations.

4 Stick down the two shortest sides in the same way, smoothing out the tape with the tips of your fingers. Leave the paper to dry flat at room temperature. Do not leave it next to a heat source or the gummed tape may lift, allowing the paper to buckle.

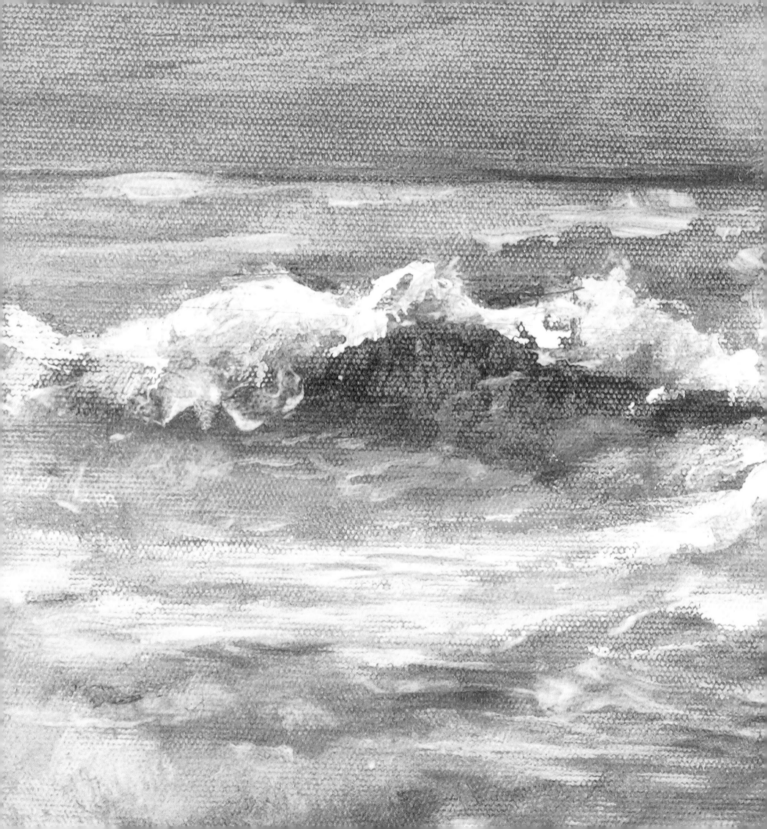

acrylic techniques

Before you can put brush to paper or canvas, you need to know how and where to start. This section gives clear advice on the main techniques you will need to master to paint using acrylics: making and controlling marks; understanding transparency and opacity; mixing tones; and preparing your papers, grounds, and supports, ready to start painting.

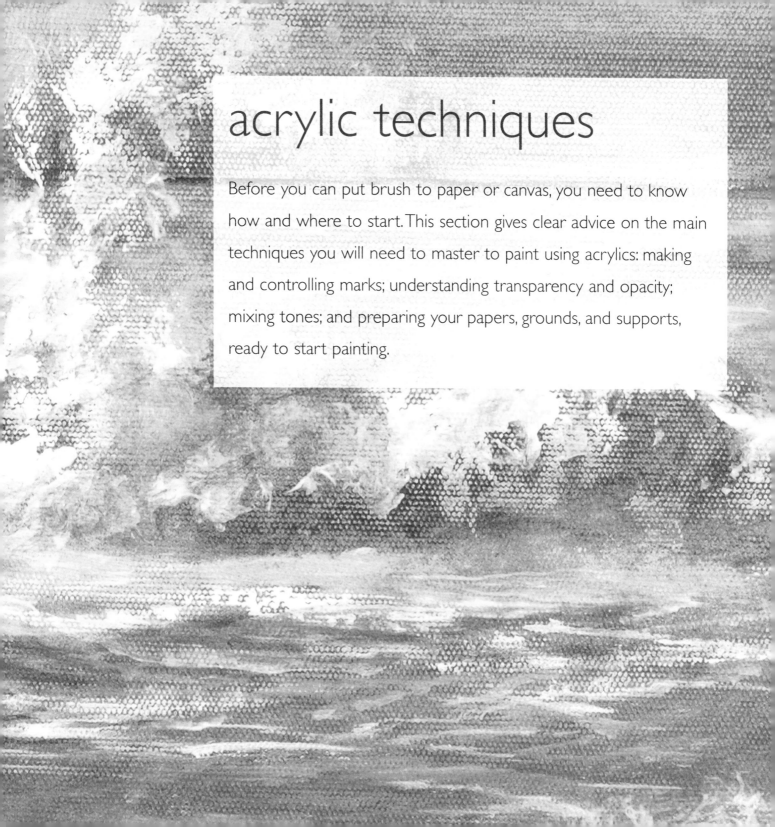

basic techniques

The basic technique for acrylic painting is simple. Add water to any color or combination of colors, just as they come from the tube, and apply with brushes, knives, spatulas, and even your fingers, if you wish. Alternatively, squeeze your tubes straight onto the canvas and then begin to manipulate colors using tools of your chioce. There is hardly a style of painting to which acrylic paints cannot be adapted—from fine detailed botanical, natural history, or architectural illustration to large abstract works featuring blocks of solid color, and every kind of representative art in between, as the projects in the rest of the book demonstrate. Acrylics are far easier than watercolors for the beginner, since contrast alterations can be made without detriment to the finished result. Whole passages can be covered with solid white paint and repainted to match the rest of the picture. This would not be possible in watercolor, which is a purely transparent medium, or with oils, where the drying times would make the method risky. With gouache, more than one layer

CONTROLLING THE MARKS YOU MAKE

It may be banal to say that all painting depends on getting the paint exactly where you want it in your picture. But controlling this one task is essential to expressing your intentions in paint. Your brushes, how you hold them, their size, shape, and stiffness, as well as the amount of paint you load them with all contribute to your touch on the canvas and give a unique character which marks out your work from all the others, even at an early stage in your painting life. There is no substitute for practicing making marks.

Flat hoghair brushes are versitile tools for use with acrylics. Here three different grips for different strokes are shown. On the left, the brush is held in the middle of the handle with finger and thumb on top, and the second finger underneath. In the center the brush is held lightly for moving from side to side, and on the right, a firm pen grip crushes the bristles for stippling marks.

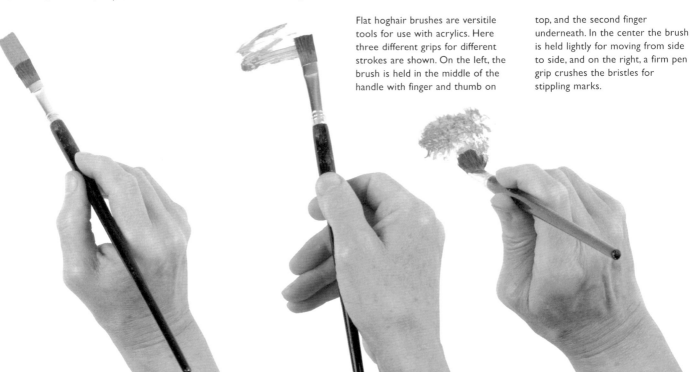

STIPPLING

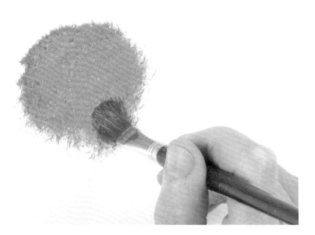

For stippling and covering areas with textured color but without directional strokes, hold the brush with a pen grip at the broadest part of the handle right above the ferrule, and tap repeatedly downward.

LIFTING OUT

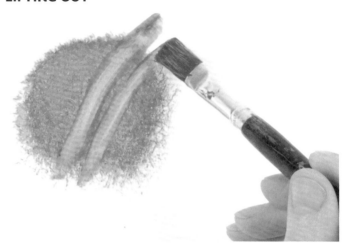

While the patch of paint is still wet, dip the clean brush in water and, using the edge of the bristles, clear out lines and shapes. If necessary, repeat these movements until the canvas appears again.

On the far left, the brush is held toward the far end of the handle to give you greater pressure to push the paint on. In the center, the side of the bristles are gently tapped, without pressure, to give broken marks. The third example shows angling the edge of the brush to make lines. Here hold the thickest part of the handle.

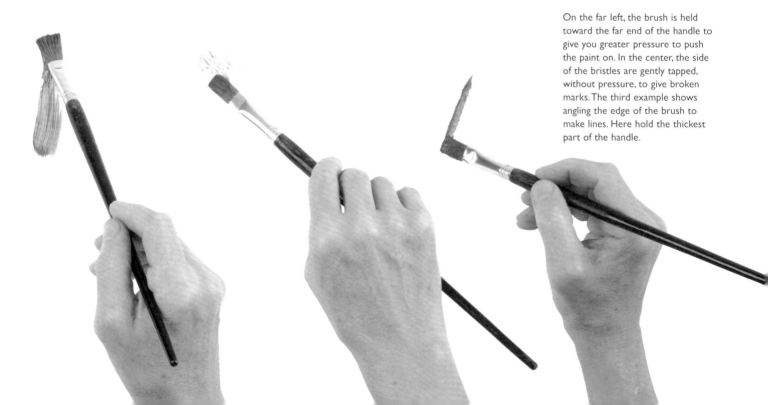

of paint is liable to flaking, which is not a worry with acrylic, since flaking hardly ever occurs. In addition, acrylics will adhere to almost all surfaces from smooth illustration board to highly textured canvas. You can also prime metal, wood, and other surfaces with some "tooth" to take acrylic paints with some success.

color selection

With the range of acrylic paints available today, you should have no difficulties in furnishing your palette with all the colors on the color wheel illustrated on the cover of this book. In addition to this basic spectrum of colors, there are many that can be substituted to give a completely different color selection so that sets of three primaries can be put together to express your intention for any type of picture. For instance, if you wish to paint a rich sunset, you would need to be very careful about the type

of red you select as your first primary color. Whether you select a purply red like alizarin crimson or Bengal rose, or an orange red like vermilion or Winsor red, this will influence your choice of blue. In turn, these two colors help you to decide which yellow to add to your blue and red. Plan your choices before you start to paint and visualize the finished result you hope for.

Painting plenty of color patches on a scrap canvas is a good start to any picture you may wish to work on. In doing this you may find a whole gamut of colors you have never used before, or realize that very few colors will produce all the tints you need. As you gain experience you will develop a preference for certain groups of colors, as in music a composer will often have a favorite key. As time goes by, people often have a few favorite colors which suit their subject matter and which can make their work highly personal and individual. The possibilities for your

TRANSPARENCY

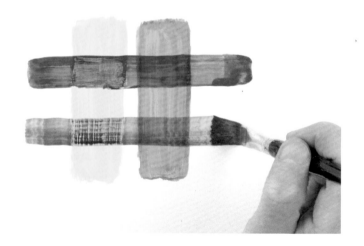

1 Because of the way pigments are carried in ploymer acrylic gel, these paints can show wonderful clear transparency on a white surface. This color patch shows the color well watered down. Lay alongside the first stroke a stronger wash of the same color.

2 When the first patches are dry, cross with bands of another color. The brush's hairs make striations in the color, which add different textures to each cross stroke. Continue to make these patterns with other colors so that you know the look of different mixtures.

UNDERSTANDING ACRYLIC OPACITY

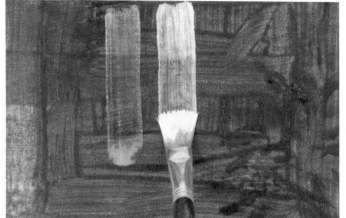

1 Put down a dark background without adding white to your color. The covering of the ground will be uneven because of the stiffness of the brush and the fact that paint and water do not mix evenly. The full effect will be seen when opaque paints containing white are laid over it.

2 Mix your light paint, this time containing white, and lay a flat stripe. Now add a little more white to the stripe next to it. As the color patches dry, you will begin to get a feel for how much of the background color shows through.

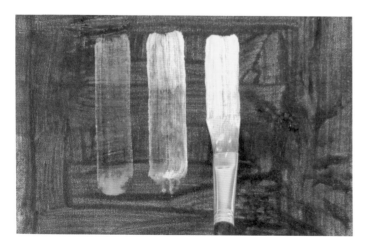

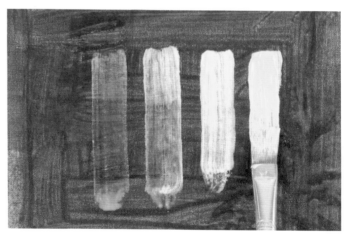

3 Now lay a stripe with a little more white in it. The increased opacity almost hides the textures underneath, but is still being influenced by the background. The point here is that acrylic has a tendency to become more transparent as it dries, giving many unexpected effects.

4 Using these effects to your advantage requires an awareness of the continued presence of textures from the background. Finally, lay a stripe of yellow mixed with enough white to achieve complete opacity, obscuring completely the textured background.

MIXING THE TONAL RANGE

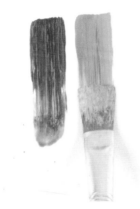

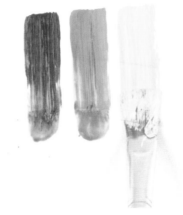

1 Using your paint directly from the tube gives the strongest tint of any color but as you drag the paint, some lighter tones will show through where the paint is thin. It may take several layers to make the color solid.

2 Lay stripes with progressively more water mixed with the color until it diminishes to a point where it disappears. This exercise tells you a lot about how paints behave and how colors have different staining power.

USING A PALETTE KNIFE

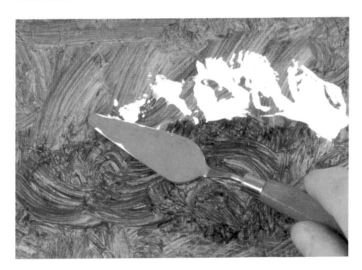

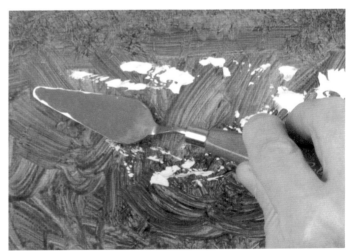

1 Palette knife painting can work well on a light ground, but its most dramatic use is layering light paint on a darker underpainting. Here lots of texture has been left underneath the white paint, in the textured and tinted ground.

2 Much of the fun in palette knife painting is choosing different shaped blades, holding them lightly, and bouncing on the canvas to make repetitions of the blade profile until the paint is all wiped from the blade and the canvas has taken on suggestive shapes.

particular approach to color are infinite. They will define how you develop as an artist, and what sort of artist you eventually become.

color mixing

When using the color wheel, make some patches with the color name indicated on the wheel. This will show exactly how two colors in your palette, made by a particular company and applied on a particular surface, will actually look when you include them in a composition. The color wheel gives an instant guide to color combinations and can be used by aligning two colors on the outer rim and checking what color mix they will give. Alternatively, seek the color mix you want in the inner windows and then check which named colors are needed to make it. It will not color match exactly because printing on paper is not the same as paint on canvas, but you can learn the guiding principles

of color mixing from the color wheel and be able to reproduce them with confidence in your own paintings and sketches.

If you use mixed media, record which makes and colors of felt-tipped pens, inks, and other materials you use, so that you always have some reference to work from.

brushes and knives

Choose your brushes with care, but don't buy too many at first until you know which you like to work with. Round brushes tend to leave ridges in the paint on either side of each stroke. Flat brushes are very versitile as shown on pp. 32–33, and filberts will place paint accurately as well as having good blending and covering capabilities. This general advice holds true for knives, too: do not buy too many to begin with. Get to know how one or two work, and add to them as you develop as an artist.

USING DIFFERENT MEDIA

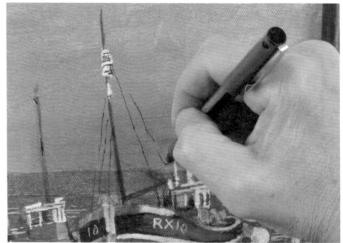

1 Acrylic paint can be augmented by many other media. Here a black crayon is being used to add some small shadow details. Take into account when trying this technique that these marks may be dissolved if you put a varnish over them.

2 Here a felt-tipped pen is being used to add rigging detail. The pigments in these pens vary, so you will have to experiment and find some that adhere to the paint. These work better on areas that contain less white in the paint.

experimentation

The aim of this techniques section is to give as much practical advice as is possible within the format of the book. The instruction manual aspect of this book is designed, like a cookbook, to give you the simple recipes that will help you to achieve your personal artistic satisfaction. Once you have gained all you can by working through the projects, using them to develop your skills and perhaps gaining an insight into the way you would alter the subjects, the most exciting adventures with paint can begin. For it is not until you choose and decide on every aspect of your work for yourself that the artist you are will appear in your work. What makes you want to paint? Is it the desire to capture some aspect of nature, or is it the subject you love, or wish to preserve for future reference? Only you can answer this, of course. But, whatever you are prompted to paint, experiment as much as you can for experiments are often the key to giving new insights into ways of expressing yourself. Keep a sketchbook and take it with you when you are out and about to record what you see. Add color notes as you work. Never destroy your experiments and test pieces, stick them into a notebook so that you can browse through them at any time. Keep all your color-matching tests with every color clearly labeled with the color name and the manufacturer's name. You can then reproduce exactly a favorite tint that you used long ago. Without it, color memory fades like a musical sound.

PREPARING A DARK GROUND

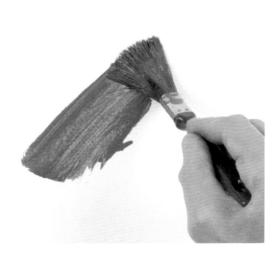

1 Starting with your light white surface, first check that it is as smooth as you wish, as any blemishes will show through to the final picture. Mix up plenty of paint and use a decorator's brush big enough to cover the canvas quickly.

2 Cover the whole canvas as quickly as possible. Your aim is simply to get some paint over the canvas, using a fully loaded brush. At this stage, you cannot have too much paint on your brush. Spread it out to cover all areas.

3 Now begin vigorously to spread the paint in all directions, making sure by firm brush pressure that no air bubbles are trapped and there are no areas of canvas grain left uncovered. Don't worry too much about the unevenness of coverage at this stage.

4 With long continuous parallel strokes from edge to edge begin the process of smoothing out the paint to a fairly even tone. This will start to have the effect of eliminating texture as you work.

5 Drag your brush across at right angles to your previous marks so that any lines in the paint cancel out the previous ones. You could leave the surface with this "woven" texture, if that will suit the painting you have in mind.

6 Turn your canvas and once again draw the brush lightly across as right angles to the previous strokes until you achieve a finish that pleases you. Remember that the texture you decide upon will influence your finished picture.

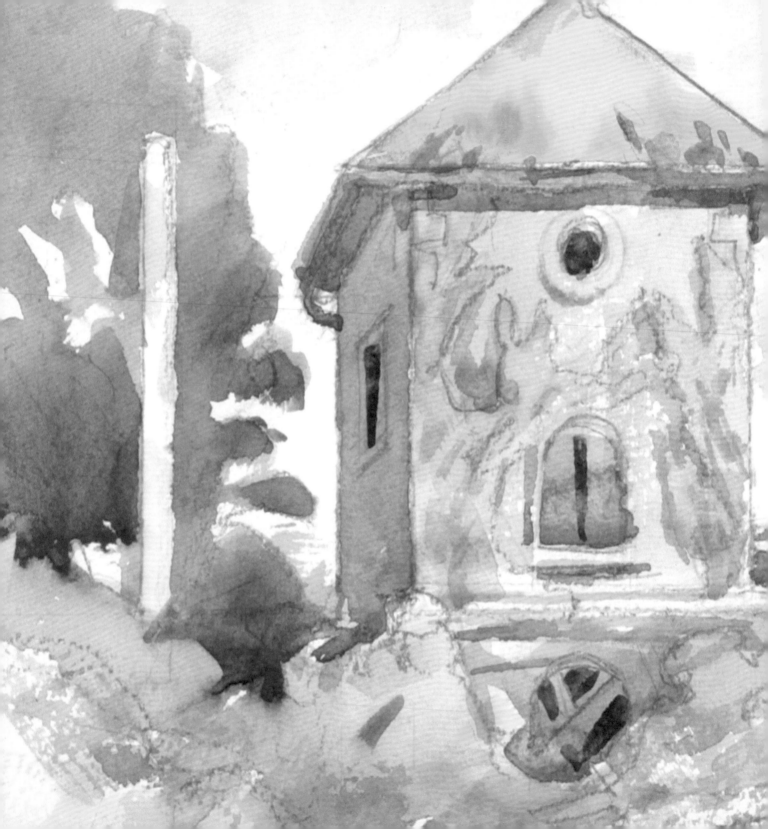

the watercolor projects

Being able to capture the essence of a scene is the skill
all artists seek to master. These projects take you step-by-step
through a wide range of different subjects, from still lifes to
distant landscapes, using a range of techniques that will help
you develop your talent as an artist.

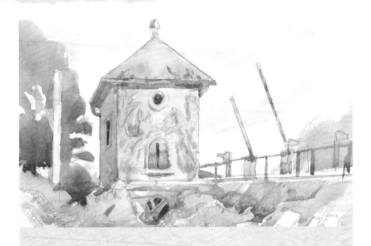

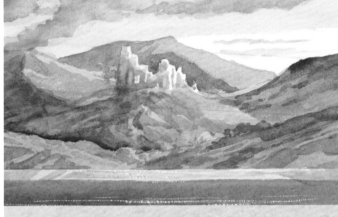

project 1
signal box

All great art starts with a great sketch. Choose an effective viewing angle, then capture the mood of a scene using basic colors.

project 2
castle ruins

Building up color is a key technique in watercolor. Lay flat washes to build up tone, then create highlight areas.

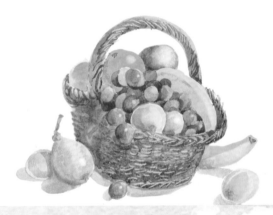

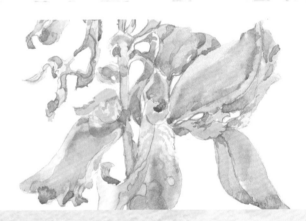

project 3
still life

Create a visually interesting composition then build up precise colors and a balanced range of shadow tones.

project 4
purple iris

Flowers are delicate and beautiful. Careful color mixing will help capture the detail of each petal while retaining the natural rhythm of the lines.

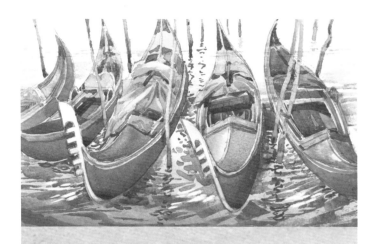

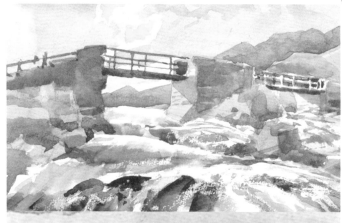

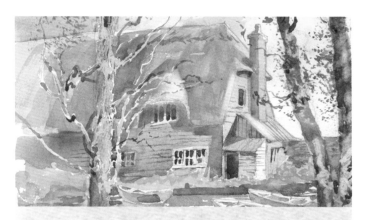

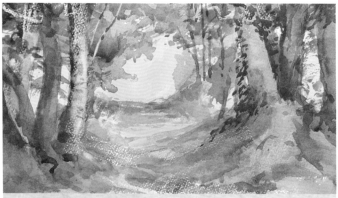

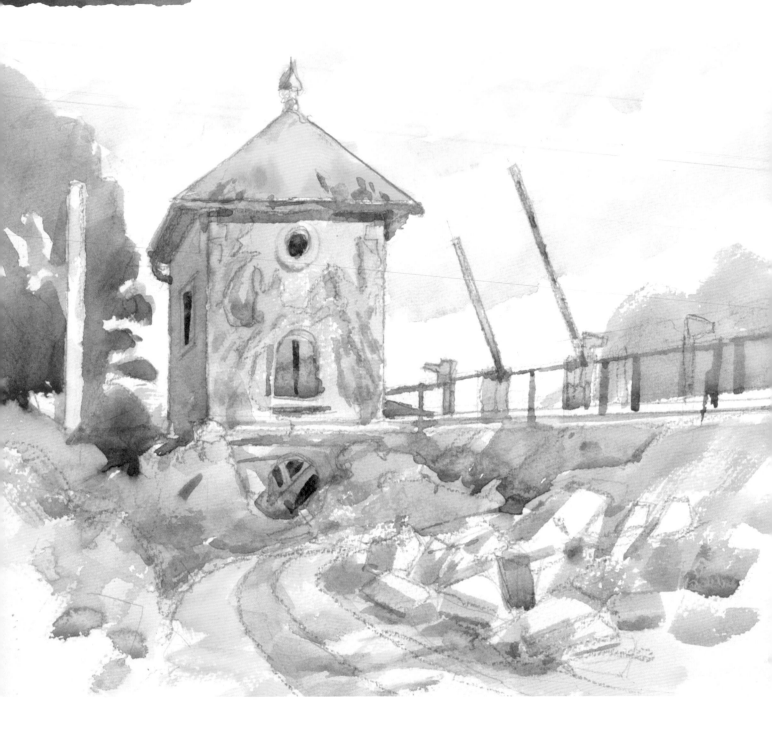

1
signal box

john barber
15 x 20 in (380 x 500 mm)

The basis for any great painting is a good sketch, which captures the essence of a subject without the fine detail. Sketching is the first skill all artists have to master and this project will show you how to construct an accurate pencil drawing and then lay down basic colors. It will also encourage you to think about how to create a strong impact on the viewer through your choice of angles and eye lines. You will then see how to apply your watercolors to capture the mood generated by your subject, picking out areas of light and shade, contrasts, reflections, and any accent colors and interesting features that will give your work the visual impact it needs to be successful.

WHAT YOU WILL NEED

Rough surface watercolor paper
Graphite pencil, 6B
Flat brush, 1in (2.5 cm), sable or synthetic
Round brush, no. 5 or 6, sable or synthetic

COLOR MIXES

1 Payne's gray
3 Cobalt blue
4 Violet
10 Yellow ocher
12 Hooker's green

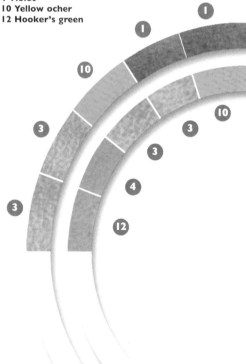

TECHNIQUES FOR THE PROJECT

Sketching with a pencil
Laying a flat wash
Working wet-on-dry

FLAT WASHES AND WORKING WET-ON-DRY

In most contexts, "flat wash" is the term used to describe paint laid over an area of paper that is too large to be filled by only one brush stroke, making it very useful for skies, mountains, and seascapes. It can also be used more generally to describe any brush stroke that covers any area of paper, no matter how small. Whatever the exact definition, flat washes need to be laid down quickly, particularly if you are using several brush strokes. If you are too slow, or run out or have to mix more paint, the first brush stroke will dry, producing an unwanted hard edge when the next stroke is laid next to it.

Watercolors are inclined to drip and this is very noticeable on all flat washes. These drips can often be turned to your advantage, but if you need a crisp edge, for example, where the sky meets the roofline of a house, you will need to stop them. Do this by tilting your paper, or by picking up the excess paint with the tip of the brush. In any case, make sure you know where your colors are going before you start painting.

Once the flat wash is dry, you can lay new washes on top of it. This is called working wet-on-dry and is a classic way of building up new colors and textures.

1 Mix lots of color to avoid running out. Then decide where you are going to apply the wash, and which areas it should not run into.

Load your mop brush and start working from the top in horizontal bands across the paper.

2 As soon as one band is completed, immediately move on to laying down the next, working in the same direction.

Make sure that there is no gap of white paper showing through between the bands of color.

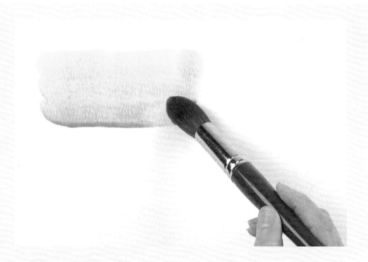

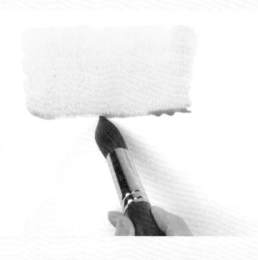

3 Immediately add a third band, working in the same direction as before. Continue working down the paper until the whole area you wish to cover has been filled. Check that all the areas are complete and that there are no white gaps.

4 To maintain a perfectly even tone on the flat wash, pick up the drips that form along the bottom edge of each band with the tip of the brush. This is especially important on the last band where unwanted dripping paint can run over your work.

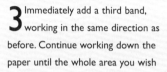

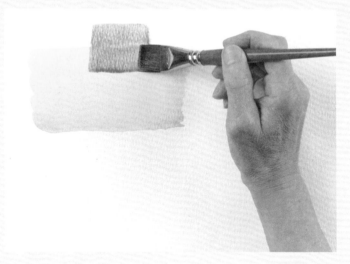

5 Let the bands of paint dry thoroughly. You should now have a flat wash with an even tone and no hard edges. Mix a new color, and apply this as a flat wash over the edge of the previous wash, in exactly the same way, using the flat brush.

6 You can see how laying down successive flat washes, one on top of the other, builds up new colors and textures on the paper. Applying a new wash over an existing dry one is a key watercolor technique and is called working "wet-on-dry."

1
signal box

The first part of creating a good sketch is making sure that you get proportions and perspectives right. This means that you need to take some time to think about the technicalities of what you see. Here, the scene is constructed around the principle of one-point perspective, with the eye- and roof-line all leading to the same point. Use the soft graphite pencil to lightly draw the lines.

REMEMBER

When sketching landscapes, look for simple shapes seen against the sky, which is usually always the lightest part of a painting. This makes the shapes easier to draw accurately. Paint buildings, trees, and hills as darker, flat shapes. The right shape or silhouette will often give enough visual information without the need for adding further detail.

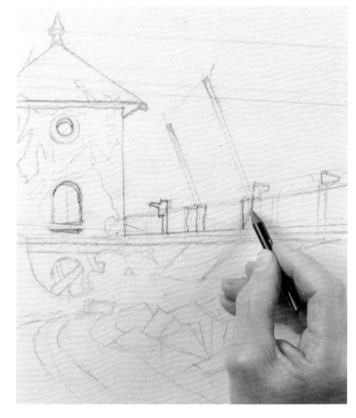

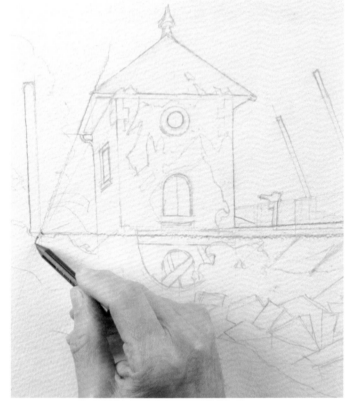

The composition works well because of the low eye-level—the viewer is looking up from below at the scene. Once the light sketch is completed, start to finalize the most prominent lines by working over them again with the pencil.

RIGHT Work your way down the sketch to the stones. Try to make sure that your lines highlight the three-dimensional quality of the stones and the random patterns they make.

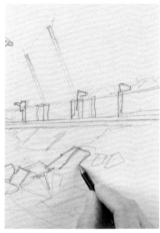

STEP 1 ▶▶

STEP 2 ▶▶

Once you are satisfied that your perspectives are correct, finalize all the straight lines on the signal box, starting with the pitch of the roof. Even though these are straight lines, work freehand (rather than with a ruler) to create a slightly uneven, tumbledown look.

BE CONFIDENT

Allow your brush to move freely and let accidental marks become part of your painting. Record your first impressions only, stopping the moment the object is recognizable—this will keep your work lively. If it goes adrift, stop sketching and start again. Above all, avoid trying to rescue your sketch by adding detail.

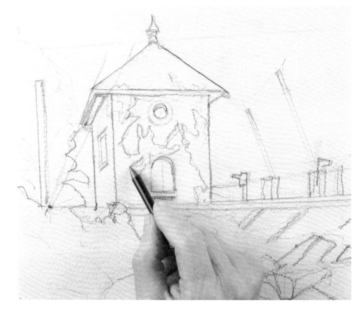

Build up some detail on the front of the signal box. Again, because the building is old, add to the tumbledown look by sketching in lines to indicate foliage growing up the walls.

①	PAYNE'S GRAY	80%
⑩	YELLOW OCHER	20%

RIGHT Establish where your light source is and work out which parts of the signal box will be in shadow. Here, the side wall of the building, the eaves, the windows, and the doorway all need to carry darker tones than areas of the sketch in light. Use the flat brush to apply a mix of Payne's gray and yellow ocher in these shadow areas.

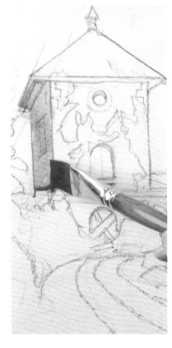

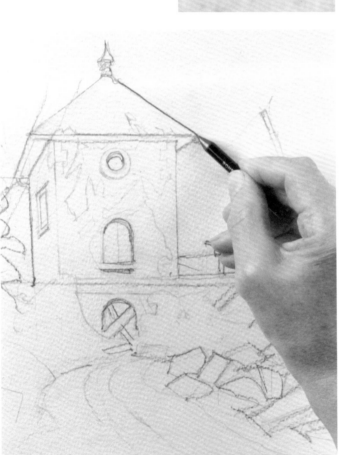

STEP 3 ▸▸

STEP 4 ▸▸

signal box

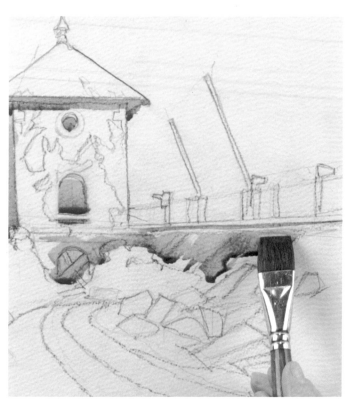

RIGHT Add a little more yellow ocher to the mix and apply it to the tree, which is in the shadow of the signal box. Then mix a light wash of Payne's gray and cobalt blue for the top half of the tree and the ground underneath it. Both these areas are in light.

3		COBALT BLUE	90%
1		PAYNE'S GRAY	10%

Mix cobalt blue with only a little Payne's gray for shadow on the stones. Also put touches of this mix on the shadow areas of the building.

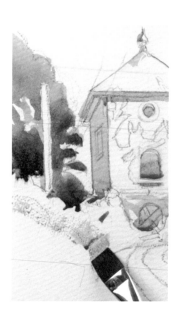

Use the same mix under the eaves, in the windows, and in the doorway, as well as along the railway embankment.

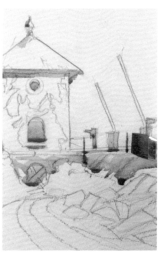

RIGHT Color the railings next to the railway line, again using the same mix. Create the upright fence posts by simply holding the brush vertically and touching the paper with the edge.

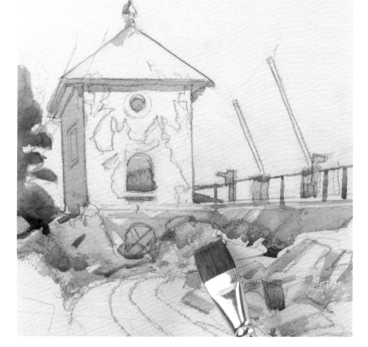

STEP 5 ▸▸

STEP 6 ▸▸

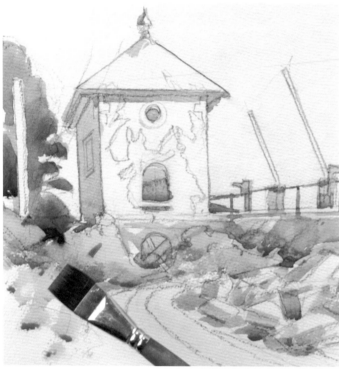

RIGHT The front wall of the signal box is also in light, so use the same gray color you used on the side wall, but lighten it with a little water. Apply more paint to the areas that will be darkened by the foliage.

❶	PAYNE'S GRAY	80%
❿	YELLOW OCHER	30%

Build up the color of the foliage by adding a little more yellow ocher to the gray mix, to produce a dark gray-green color. Apply this with the edge of the brush.

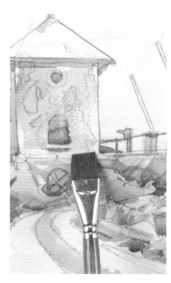

❸	YELLOW OCHER	90%
❶	COBALT BLUE	10%

The foliage at the front of the building is a soft green—mix yellow ocher and cobalt blue to create this color. Since this area is in light, keep the color light. This mix creates a good contrast with the darker, mostly cooler, tones around it.

TRICK OF THE TRADE

Watercolor washes look much lighter when dry than the wet paint would suggest. Avoid any surprises by testing your color mixing on a piece of the same paper you are painting on. Do this for each mix and let it dry before applying it to your picture. In this way, you will learn how colors change from wet to dry.

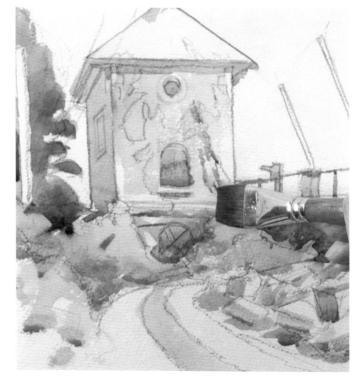

STEP 7 ▸▸

STEP 8 ▸▸

signal box

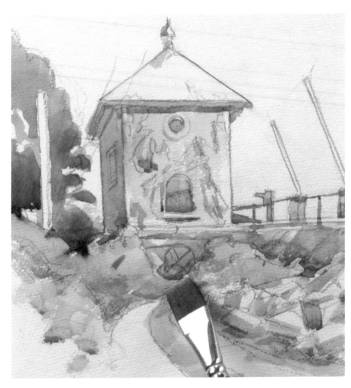

RIGHT While the paint is still wet, add more of the same color. This deepens the tone and creates extra texture on the roof. Try not to add too much paint—only enough to break up the flat color of the first wash.

3 YELLOW OCHER 90%
1 COBALT BLUE 10%

Mix more of the soft green you first used on the foreground foliage and add patches of it to the front of the signal box, running it down over the yellow underneath. This helps "ground" the building.

8 CADMIUM YELLOW 10%

Add a little cadmium yellow to the soft green color you mixed for the foreground foliage and apply it to the pathway. Also use it to build up texture on the soft green areas.

11 BURNT SIENNA 100%

RIGHT Complete the roof by using a light wash of burnt sienna. Not only does this color indicate terra-cotta tiles but it immediately warms the scene.

RIGHT Add a little more violet to the mix, and again work in bands. Leave white areas in between the bands of color to hint at high, wispy cloud.

Alternatively, paint a few bands of clean, clear water across the paper. While the paper is still wet, drop a little of the mix onto it. The paint will run in random patterns within each band of water—this is called the wet-in-wet technique.

Tie in the color of the roof to the front of the signal box by adding small dashes of the burnt sienna mix to the foliage on the front of the building. Also add it to the path to create the look of red soil.

③ ▬▬▬ COBALT BLUE 80%

④ ▬▬▬ VIOLET 30%

RIGHT For the sky, mix a light wash of cobalt blue and violet and apply a band of color across the paper, heading toward the vanishing point. Try not to overelaborate here—this is only a sketch.

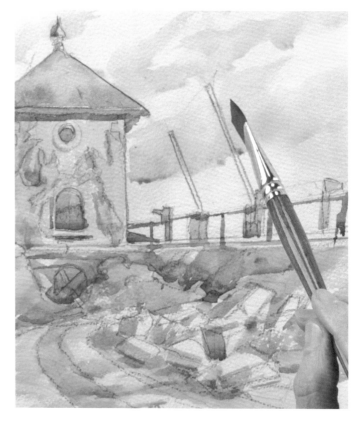

STEP 11 ▶▶

STEP 12 ▶▶

1
signal box

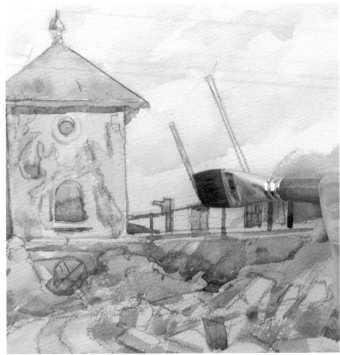

You now have all the main elements of the scene captured on the page. All that remains to do now is to build up a little detail. First, add a light mix of Payne's gray to the barriers.

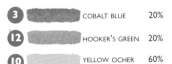

3	COBALT BLUE	20%
12	HOOKER'S GREEN	20%
10	YELLOW OCHER	60%

RIGHT Then build up the shape of the trees beyond the railway line using a mix of cobalt blue, Hooker's green, and yellow ocher. Add a little more color to the barriers to darken them.

STEP 13 ▸▸

1 PAYNE'S GRAY 100%

Add in areas of very dark contrast. These are useful for drawing the viewer's eye to detail, but because they are so strong, keep them to a minimum. Start by adding Payne's gray to the foreground shape using only the corner of the brush.

TRICK OF THE TRADE

If a wash dries to a shade much darker than you anticipated, brush over it with clean water and leave it for a few seconds. Press kitchen paper or other absorbent tissue firmly onto the wet area and a little paint will come off. You can repeat this as many times as you need to.

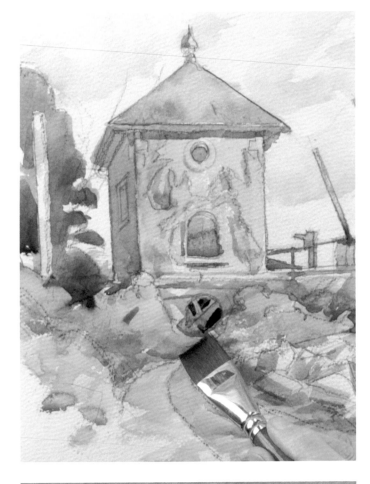

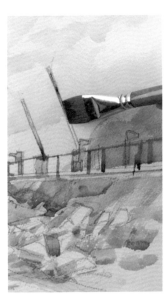

STEP 14 ▸▸

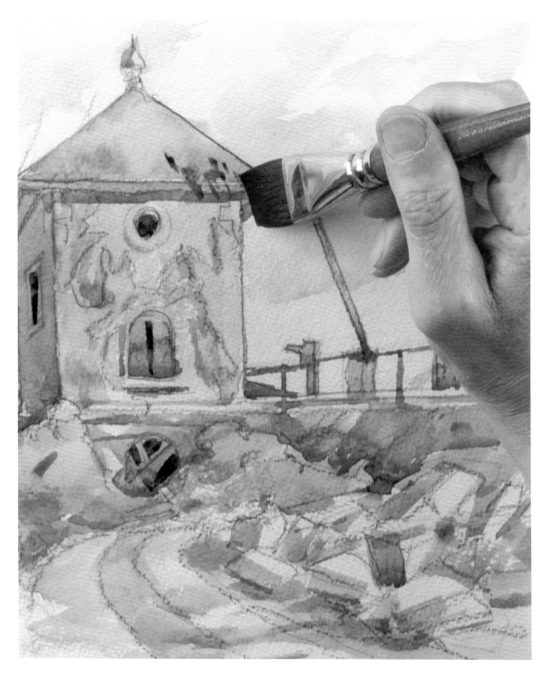

TRICK OF THE TRADE

When painting buildings, try pressing a quilted or textured tissue onto a wet wash that covers a roof or wall. The texture on the tissue will produce light random patterns that suggest tiles or bricks in a much more natural way than drawing detailed lines of bricks. Then give some of these light patches a tiny cast shadow on one edge.

LEFT Add the same color to the windows and doorway of the signal box. Also add it to the edge of the roof to hint at broken tiles. This is visually more interesting than a perfect roof.

Finish your sketch by adding touches of dark shadow under the eaves, applying the same color with the round brush.

STEP 15

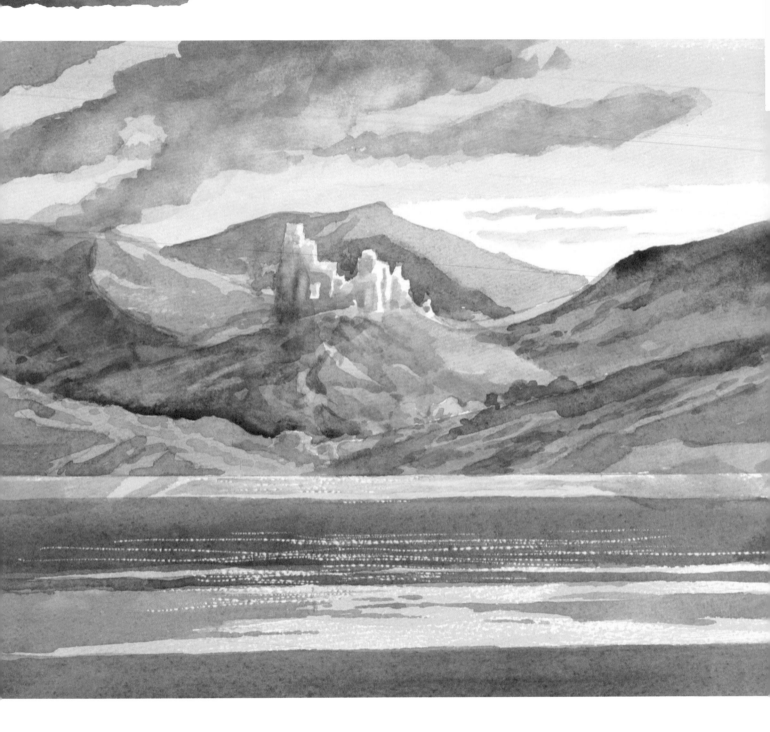

2

castle ruins

john barber
16 x 20 in (400 x 500 mm)

Building up colors and tying them all together convincingly is a key skill in watercolor painting. In this project, you will see how to do this, using simple flat washes applied to the areas marked out in your pencil sketch. Since watercolors are transparent, you cannot add lighter colors over darker ones—they would be invisible. So this project will show you another key principle in watercolor painting—building up color by applying darker washes over lighter ones. You will also learn how to create areas of tone and texture within flat washes by lifting off some of the paint, and how to create areas of sparkling, reflected light by scratching off some of the paint to reveal the white paper underneath.

TECHNIQUES FOR THE PROJECT

Laying a flat wash
Lifting off
Scratching off

WHAT YOU WILL NEED

Rough surface watercolor paper
Graphite pencil, 6B
Flat brush, 1in (2.5 cm), sable or synthetic
Round brush, no. 5 or 6, sable or synthetic
Kitchen paper
Eraser
Craft knife

COLOR MIXES

1 Payne's gray
2 Prussian blue
3 Cobalt blue
4 Violet
10 Yellow ocher
11 Burnt sienna
12 Hooker's green

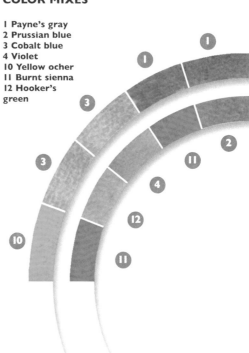

LIFTING OFF

Lifting off is the process of removing dry or wet paint from the paper and can produce some dramatic results.

When used on dry paint, lifting off is often used as a correction technique to soften hard edges between flat washes. This is done by applying a little clean water to the hard edge, then with a soft brush, rubbing the paper gently until both colors start to lift off and blend together. Alternatively, lifting off on dry paint can be used as a technique for creating new shapes and textures that would be difficult to reproduce with brush strokes. In this instance, apply a little clean water with a soft brush to the area to be worked on. Rub the brush over the paint until it starts

to lift off. Dab away the wet paint with kitchen paper to reveal the paper underneath. You can also dry your brush and use the bristles to lift off the wet paint. The paper never returns to its original white color but leaving a hint of the original color behind works to your advantage. Lifting off in this example is very useful for creating highlights and lightening muddy colors.

Lifting off wet paint is a valuable creative skill in itself. Apply paint to the paper and, before it is dry, dab some of it away with kitchen paper to leave a textured, irregular pattern behind. This technique is great for skies—many complex cloud shapes can be created using this method.

1 Lay down your flat wash and any other techniques you wish to use over the top of it. Then apply a little clean water with the flat brush to the area you wish to work on and rub it over the paint until it starts to lift and the white paper appears.

2 Immediately dab away the excess paint and water with a little kitchen paper. Make sure that your kitchen paper is absorbent and is not the type that leaves fluffy residue behind. Also, remove the kitchen paper quickly—don't press and hold.

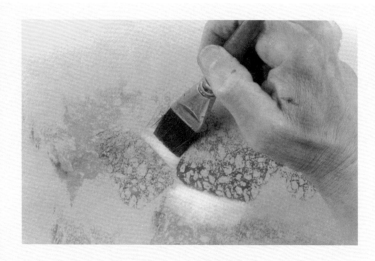

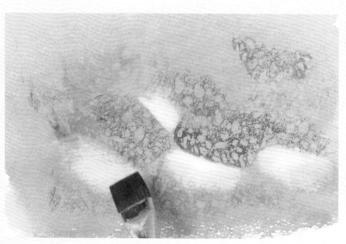

3 By applying just a little water with the brush, you can remove very detailed areas of paint. In this way, you can start to introduce shapes into your compositions that would not be possible using a brush and watercolors alone.

4 In this example, we have added texture and pattern to the paper with a synthetic sponge, which produces a printing effect. You can highlight these shapes by lifting off, leaving white areas of paper that outline the sponge work.

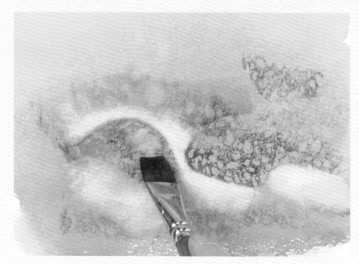

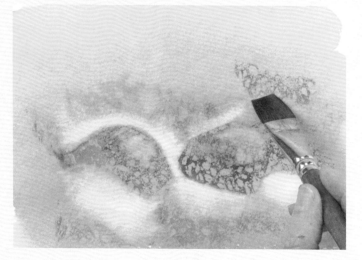

5 In the same way, lifting off can also be used for creating highlights. Lift off a little paint using water applied with a soft brush. Work in a gentle circular motion and dab away the lifted paint with a tissue. This effect gives flat artwork more depth.

6 Lifting off is very useful for softening hard edges. Apply a little water with the brush to the hard edge and gently rub over it. As the paint lifts off, move it around with the corner of the brush until you achieve the softer edge you want.

2
castle ruins

Start your sketch using the graphite pencil. Tilt the pencil so you are using the side of the lead more than the point. This creates more of a tone than a line—the ruin and the hills do not need to be precisely defined. However, use a ruler for the shore—this works best as a sharp, accurate line. Lastly, draw in the shapes for the clouds. Make sure you plan where they are going to appear—this will help when you come to paint.

REMEMBER

The far edge of any flat surface will appear as a horizontal line, even the base of flowerbed against a strip of grass a few yards away. So make the far side of the lake a ruled straight line. When you put a mat around your picture, this line will be parallel to the bottom edge. If your water line is titled or ragged, it will not look convincing.

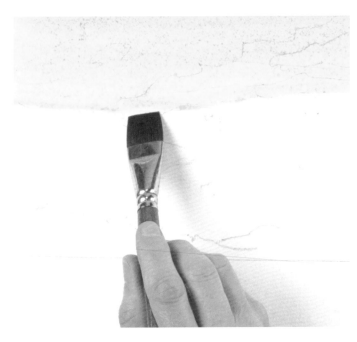

| 1 | | PAYNE'S GRAY | 20% |
| 2 | | PRUSSIAN BLUE | 80% |

Apply a flat wash of Payne's gray and Prussian blue for the sky, using the flat brush. Work in stripes across the page, starting at the top and working down.

| 3 | | COBALT BLUE | 100% |

RIGHT Use a touch of cobalt blue for the distant clouds, using the tip of the round brush. Then darken your first mix with more Payne's gray. Apply this to the top cloud, keeping to the lines of your pencil sketch. Add more water to lighten the mix for the right-hand cloud.

STEP 1 ▸▸

STEP 2 ▸▸

Add a little more water to the same mix and apply this to the hills on either side of the ruin. Lighten the mix for the last time for the ground under the castle—the color is now faint. As you get toward the bottom edge, add a little more paint to darken the scene as it runs down to the shoreline.

BE CONFIDENT

Pick up your painting and tilt it so that the drips of paint at the bottom of a wash stay in the right place. This will give a dark, crisp edge a more effective contrast with the area next to it. If the paint looks as if it will run down the paper, stand your painting on its side and let the drips run off, or lie it flat until dry.

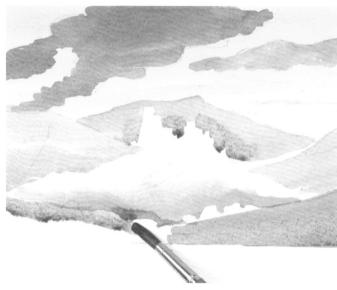

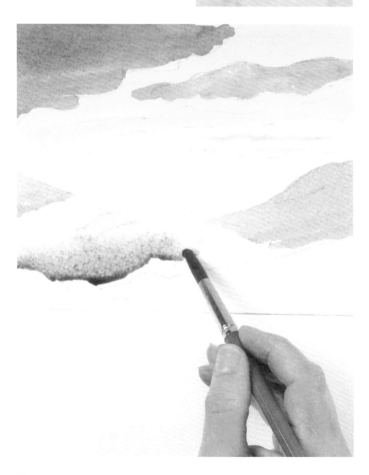

| 3 | COBALT BLUE | 80% |
| 4 | VIOLET | 20% |

Mix cobalt blue with a little violet for the mountain behind the ruin, leaving a white edge to suggest reflected light and to lead the viewer's eye to the focal point. Darken the mix with more violet and add this behind the ruin to highlight it. Then mix Payne's gray, burnt sienna, and violet, and add this to the foreground hills.

| 1 | PAYNE'S GRAY | 10% |
| 2 | PRUSSIAN BLUE | 90% |

RIGHT Apply a flat wash of Prussian blue and a little Payne's gray to the lake by quickly pulling the flat brush over the paper. This leaves some of the white paper showing through and hints at sparkle coming off the water.

STEP 3

STEP 4

2
castle ruins

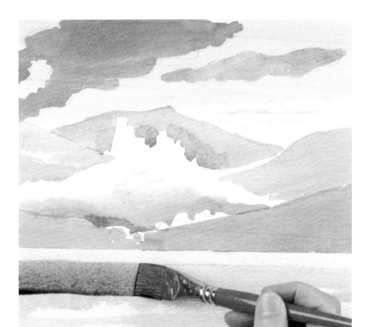

RIGHT Using the pencil, add some outlines to the hillsides. These outlines are useful guides to help you work up areas of texture and shading.

Start applying this texture and shading using a flat wash of Payne's gray on the left-hand hills, as well as smaller areas of color under the ruin. You don't have to stick precisely to the pencil lines you have just drawn—they are just a useful guide.

1		PAYNE'S GRAY	40%
2		PRUSSIAN BLUE	60%

With a pencil, mark horizontal bands across the lake to indicate where the dark reflection of the sky will fall. Add a mix of Payne's gray and Prussian blue in a line right across the paper. Repeat this line twice over, in varying widths.

RIGHT Apply the same mix to the ruin with the round brush. Then darken the color with a little more Payne's gray and add this to the shadow side of the ruin, running it down into the hill. Leave the edges of the ruin white to suggest reflected light.

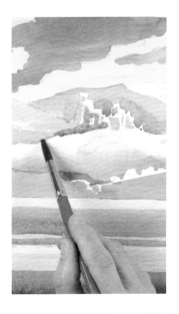

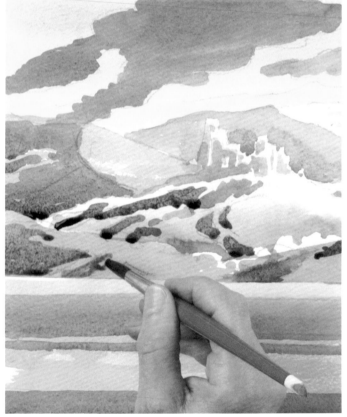

STEP 5 ▶▶

STEP 6 ▶▶

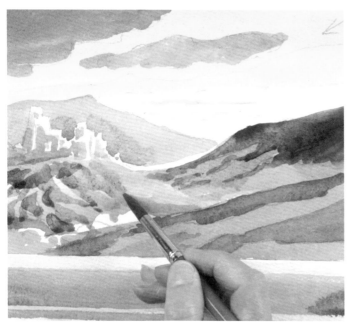

RIGHT Further darken the left-hand hill with a strong mix of Payne's gray. This adds a dramatic area of shading that can be worked into later.

| **11** | | BURNT SIENNA | 80% |
| **10** | | YELLOW OCHER | 30% |

Mix burnt sienna and yellow ocher and apply it to the area above the near hills on the right to add a hint of yellow sunlight.

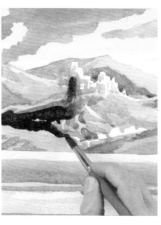

| **2** | | COBALT BLUE | 20% |
| **12** | | HOOKER'S GREEN | 80% |

Darken the right-hand hills with Payne's gray—this contrasts well against the sky. Add a muted green wash to the hills to warm them by mixing Hooker's green and cobalt blue. Then add some burnt sienna to the green mix and apply this to the hill on the left, before mixing in some violet for the area under the ruin.

RIGHT Lastly, use Payne's gray for building up shadow on the mountain behind the ruin. This matches the dark color of the sky behind. Work the color down to the right.

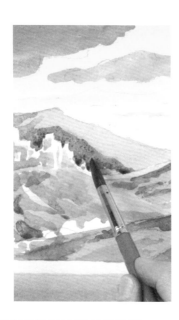

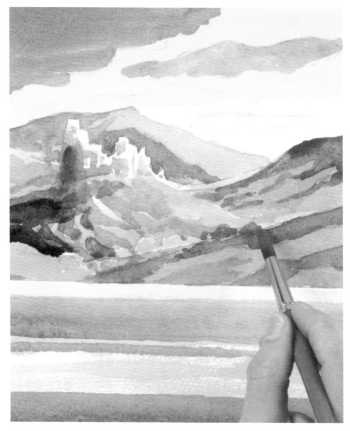

STEP 7 ▶▶

STEP 8 ▶▶

2
castle ruins

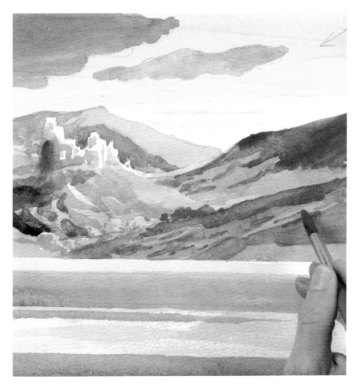

RIGHT Lighten the underside of the clouds by applying clean water and lifting out the wet color with some kitchen paper. This softens the color, makes the cloud reflect the color of the sky, and balances the cloud with the color of the landscape.

Soften any hard edges on the hills on the right by rubbing a little clean water over the edges between light and dark.

 BURNT SIENNA 10%

Add a little more burnt sienna to the mix and work it down the light parts of the foreground hill. Apply the color in touches and run it over parts of the darker washes to help blend it all together.

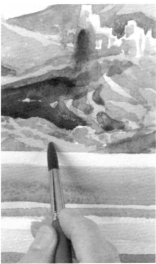

RIGHT Continue adding areas of warm yellow down to the shoreline. By making these lines irregular, you can hint at low-level foliage heading down to the lake.

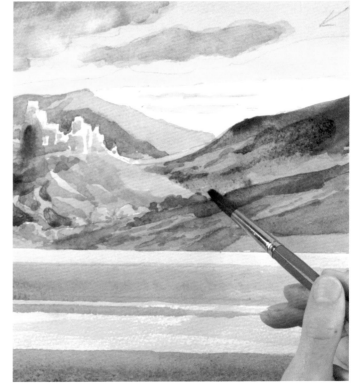

STEP 9 ▶▶

STEP 10 ▶▶

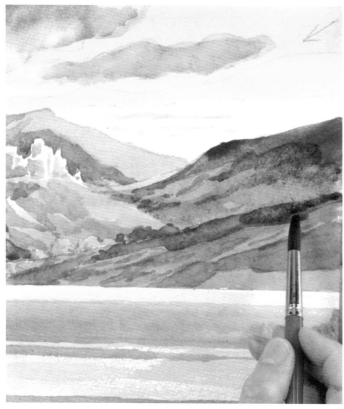

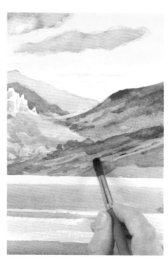

RIGHT Work your way around the hard edges, blending them together. You don't have to do too much of this—just enough to soften and blend the colors together. Then use the color on the brush to add extra detail to the hillside.

Lift off some of the very dark Payne's gray under the ruin in the same way, using the color on the brush to slightly darken the white outline of the building.

Once some of the paint has lifted off, flatten the brush and, using only the side, gently blend the colors together.

RIGHT Use the color that comes off on the brush to add extra detail and texture to the hillside. This also helps to blend the color.

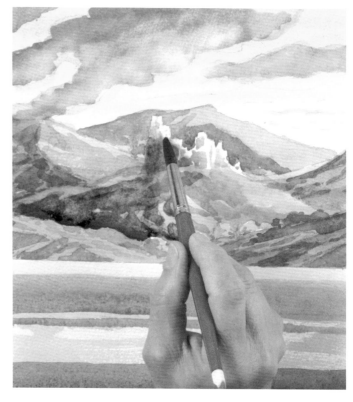

STEP 11 ▸▸

STEP 12 ▸▸

2
castle ruins

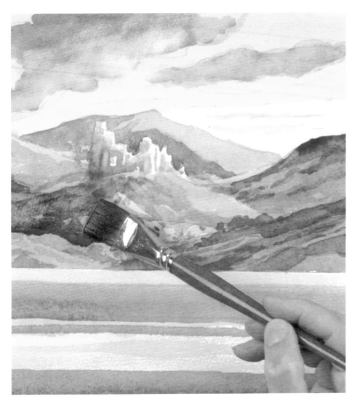

① ▬▬▬▬ PAYNE'S GRAY 100%

Go back over the dark wash you applied to the lake, to accurately tie it in to the tones of the landscape. Work a strong wash of Payne's gray over the original band of color. Create textures in the wash by applying a second layer over the wet first layer. This is not easy, but try to work confidently. Do not go back over your work.

TRICK OF THE TRADE

For a stormy sky, apply a dark gray wash over the whole sky area. While the wash is still wet, rub a stiff brush on a bar of soap then swirl it around in the wash to form clouds. Take the brush away and the soap will continue to move the paint around. Then wash your brush thoroughly.

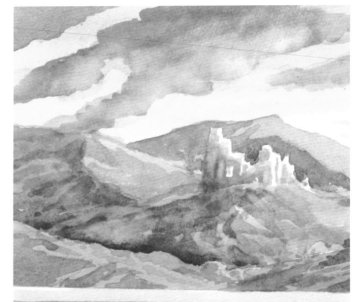

Soften the whole of the dark area to the left of the ruin by applying water with the flat brush and lifting off some of the color with kitchen paper. This creates effective, textured areas of light within dark.

RIGHT Rub out pencil lines where visible. Do this gently so as not to scuff the paper or wear away the paint.

STEP 13 ▸▸

STEP 14 ▸▸

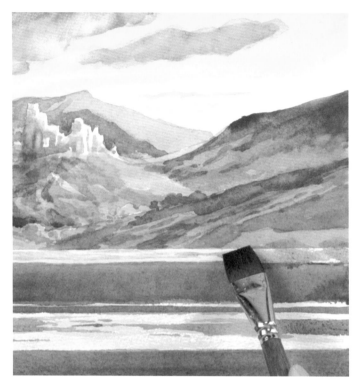

3 COBALT BLUE 100%

Take a step back from your work and check the overall effect of what you have created. Here, we have worked back over the hills on the left of the ruin with a light mix of cobalt blue. This has cooled this side of the hill, throwing it into a shadow that contrasts more strongly with the green beyond it. Also soften up any further hard edges on the clouds and the hills by applying clean water and lifting off the wet paint with kitchen paper.

TRICK OF THE TRADE

When your picture is finished and completely dry, you can remove any surplus pencil marks by rolling a piece of adhesive tack over the surface. This will not lighten delicate washes in the way that rubbing with an eraser can sometimes do. The early watercolorists used fresh breadcrumbs to do this job.

For a clever piece of detail, add a light mix of Payne's gray to the edge of the lake to hint at the reflection of the ruin. Then lift off some of the color of the foreground hills and blend it with the water. Keep these as small touches only.

RIGHT With the edge of the craft knife, scratch off some of the color in the dark areas of the water. This reveals the white paper underneath and adds to the sparkle effect.

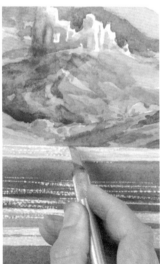

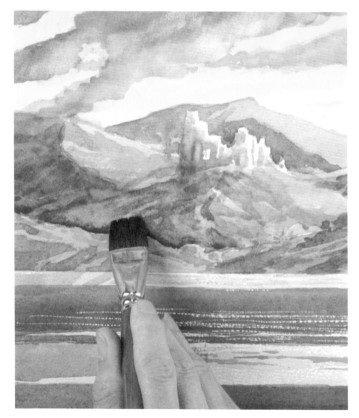

STEP 15 ▶▶

STEP 16

3
still life

john barber
15 x 20 in (380 x 500 mm)

The great joy of painting still life is the high degree of control you can exercise over the composition. The items to be painted, the lighting, the arrangement, the background colors, even the amount of time you spend painting can all be fixed, in stark contrast to trying to capture changing landscapes or moving figures. Because your subject does not move, you can arrange almost anything you like, but it is best if you have a theme running through your work. The theme of this project is fruit, and you will see how to create a visually interesting arrangement, build up precise, detailed colors, develop a balanced range of shadow tones, and use different materials and techniques to make your watercolors effective.

WHAT YOU WILL NEED
Rough surface watercolor paper
Graphite pencil, 6B
Round brush, no. 5 or 6, sable or synthetic
Flat brush, 1in (2.5 cm), sable or synthetic
Fine brush, no. 1 or 2, sable or synthetic
Eraser
Gum arabic
Kitchen paper and craft knife

COLOR MIXES

1 Payne's gray
3 Cobalt blue
4 Violet
5 Permanent rose
7 Orange
8 Cadmium yellow
11 Burnt sienna
12 Hooker's green

TECHNIQUES FOR THE PROJECT

Using gum arabic
Lifting off
Working wet-in-wet

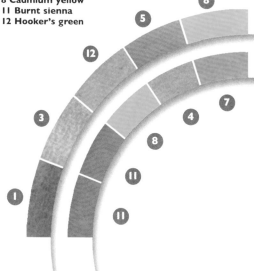

USING GUM ARABIC

Gum arabic is a liquid that can be added to watercolor paints (or to gouache) to help bind the pigment. The result of this is that paint becomes less runny, more controllable, and dries less quickly. This means that you can create different effects in the paint that would not otherwise be possible with standard wet washes.

Gum arabic comes in a bottle and is easy to use. Once you have mixed your paints, add the gum to the mix and stir it in with the brush. Exactly how much gum to use depends on the consistency you want to achieve and the amount of paint you have mixed. This means that you will have to experiment to find the right amount but as a rough guide, three or four drops will be enough to cover an area of a few square inches.

Use your mix of paint and gum arabic to color very small parts of your work as the gum will stop paint from running from one area to another. You can also create precise highlights and other shapes by working into the paint while it is still wet with the handle of a brush.

You can easily lift off paint and gum arabic using water and kitchen paper, because the gum is water soluble. This is very useful if you need to lighten dark colors.

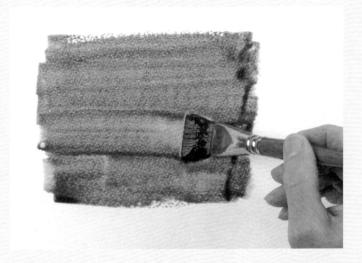

1 Mix your wash in the usual way, making sure you have enough to paint to cover the area you are working on. Add a few drops of gum arabic to the mix and apply your color to the paper using a flat brush. The paint will be thicker than usual.

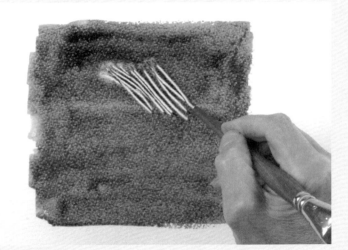

2 While the paint is still wet, turn the brush around and, with the point of the handle, start working patterns and shapes onto the paper. The paint comes off very easily, leaving paper that is almost untouched showing through.

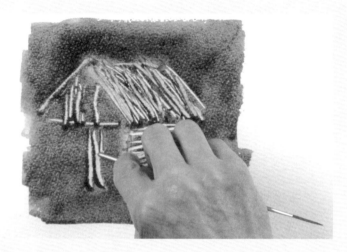

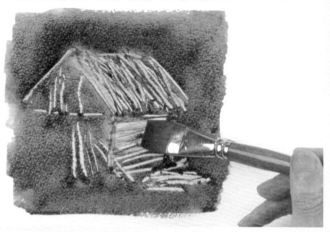

3 You can build up any shape or pattern you like in the paint. Here we have created the rough outline of a wooden shed. However, you can use your paint and gum arabic mix in smaller quantities and create highlights in specific parts of your work.

4 Gum arabic increases the drying time for paint, making it very forgiving to work with. For example, if you find that the shapes you have worked into the paint are too stark, you can gently blend them together using the brush.

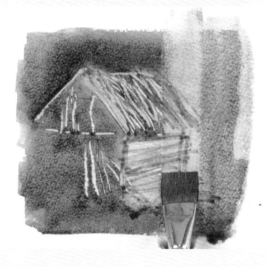

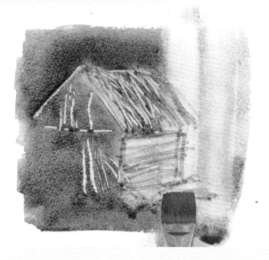

5 Gum arabic is water soluble, so once the paint dries, you can work into it again to lift off paint. This means that you can lighten the color of the paint if it is too dark. Apply water with a brush and run it over your work to remove the paint.

6 Lift off the paint as necessary to achieve the look you want. It is possible to lift almost all the paint off the paper using a wet brush and kitchen paper to dab away the excess water. Use this property to create lots of different effects.

Sketch in the outline of the basket first, including the sections at the back that will be covered over when you apply the watercolors. Then add in the shapes for the fruit, accurately relating them to one another. This gives the composition a tight, cohesive look, rather than just a collection of random outlines.

REMEMBER

You start composing your picture from the moment you place the first object on the table, so take some time to arrange the objects as an attractive ensemble. When you settle on an arrangement you like, move around and view it from different angles. You may find a better composition or you may discover several other pictures.

STEP 1 ▶▶

| 8 | | CADMIUM YELLOW | 90% |
| 7 | | ORANGE | 100% |

Make a light mix of cadmium yellow and apply it as a flat wash to the banana, using the round brush. Use more paint along the bottom edge, which is in shadow. Add a little orange to the mix and apply this to the orange itself. Then lighten the mix with water and apply it to the red apples.

| 5 | | PERMANENT ROSE | 100% |

RIGHT Wet a couple of small areas on the apples and drop in some pure permanent rose, wet-in-wet. This gives the fruit a ripe look.

STEP 2 ▶▶

⑤ PERMANENT ROSE 90%

④ VIOLET 10%

RIGHT Mix permanent rose with a little violet to color the grapes. Add the color as a flat wash, being careful not to paint outside the pencil lines—your washes need to be applied accurately in this project.

Start to build up shadow on the underside of the grapes, wet-in-wet. Add small areas of clean water to the wash and drop in more of the same mix. You can build up areas of shadow and texture very effectively using this technique.

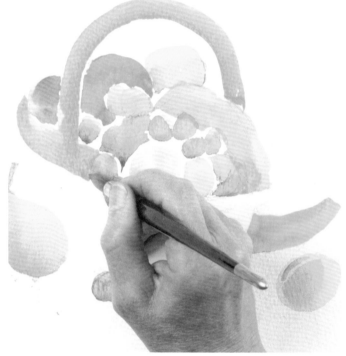

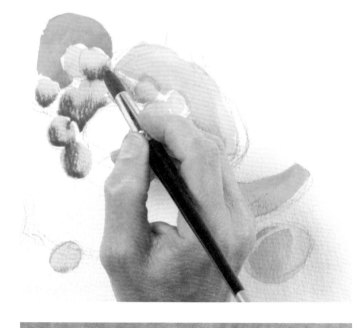

① HOOKER'S GREEN 90%

⑩ CADMIUM YELLOW 10%

Mix Hooker's green with a touch of cadmium yellow and add it to the apples at the front and back of the basket and to the pear on the table. As before, use the wet-in-wet technique for creating shade on the underside of both pieces of fruit. Once the paint is dry, gently erase any visible pencil lines and add a flat wash of yellow ocher to the whole of the basket, starting with the handle and the rim.

BE CONFIDENT

Try dropping color into a wet wash and letting it run. This wet-in-wet technique is often a more successful method of applying detailed color than careful copying of mottling on fruit or leaves. An exciting quality of watercolor is what happens after the color is on the paper. Be bold and improvise with the marks you have made.

STEP 3

STEP 4

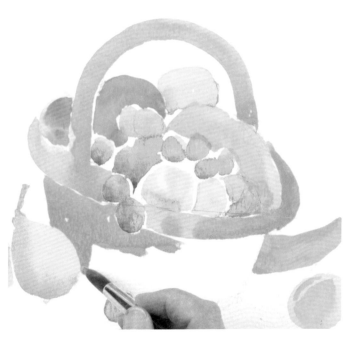

Use this mix to add shadow to the side of the apple at the front of the basket. Make sure that all your shadow areas match up. This means that you must know where the light source is—in this project, the light is coming from the right. However, creating shadows will produce some hard edges, which you will need to soften. This is done by gently rubbing a soft brush loaded with water over the hard edges. As the water starts to lift the paint off, the brush mixes the two colors together slightly, blending one into the other. Don't overdo this or the edges will look smudged.

Then add more yellow ocher to the mix to darken it. Apply this darker color around the handle and the rim to build up texture and shading in these areas. With the same mix, apply a flat wash to the body of the basket.

1	PAYNE'S GRAY	5%
5	PERMANENT ROSE	55%
4	VIOLET	40%

RIGHT Mix permanent rose, violet, and a touch of Payne's gray to build up the shadow areas between the grapes. Use the tip of the brush for accuracy.

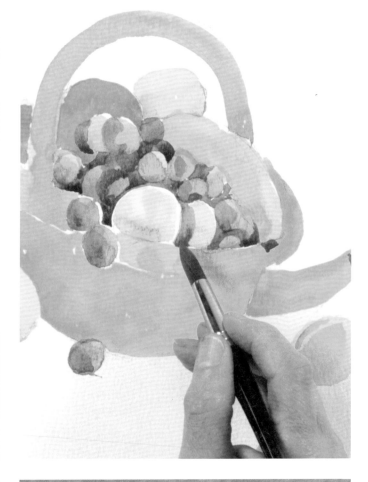

STEP 5 ▸▸

STEP 6 ▸▸

⑤ 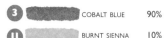 PERMANENT ROSE 100%

RIGHT Add a little permanent rose to the peach at the front of the basket. This adds a little extra shading and texture and emphasizes the ripe look.

Create some areas of reflected light. Apply clean water along the top edge of the banana in the basket, using the flat brush. Lift off the paint with some kitchen paper. The yellow-white band left behind is an effective highlight. Repeat the process on the other banana.

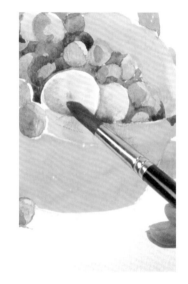

③ COBALT BLUE 90%

⑪ BURNT SIENNA 10%

Using the round brush, build up touches of shadow on each piece of fruit, the basket, and the fruit on the table. First, use a mix of cobalt blue with a little burnt sienna for touches of lilac-gray shading on the handle, the rim, and the left-hand side of the basket. Use this color for the drop shadow under the fruit on the table. Then wet the pear with a little water and, wet-in-wet, use the tip of the brush to drop some burnt sienna into it to create a speckled effect.

TRICK OF THE TRADE

A wash of burnt sienna and cobalt blue can be mixed to obtain a wide range of cool or warm grays. Choose a gray to suit the tone of your picture and paint the shadow side (and the cast shadow) of each object with this one tint. This will unify your work and show the 3-D effect created by light coming from one source.

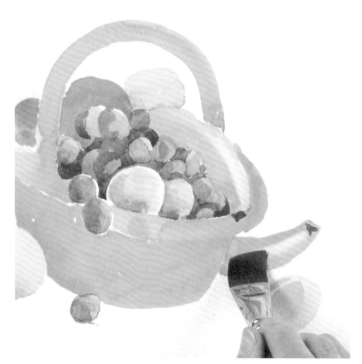

STEP 7 ▸▸

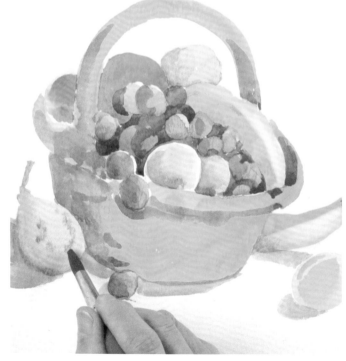

STEP 8 ▸▸

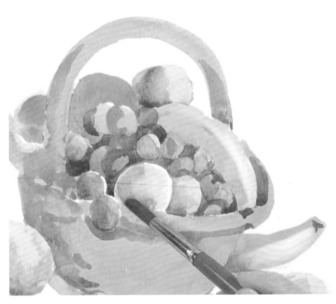

RIGHT Because the gum arabic keeps the paint wet for longer, you can then scratch the pattern of the weave into the paint. Do this with the end of the brush handle and only in areas where light would reflect off the weave.

If the paint starts to dry before you finish the pattern of the weave, wet it on the paper with a little clean water. This will lift the paint enough for you to start working with the end of the brush again.

| 1 | | HOOKER'S GREEN | 80% |
| 10 | | CADMIUM YELLOW | 20% |

Add shading to the apple at the back of the basket with a stronger mix of Hooker's green and cadmium yellow than you used earlier. Then build up some color on the peach at the front with a light mix of yellow ocher. Finish off any shading, for example, using permanent rose.

| 1 | | PAYNE'S GRAY | 30% |
| 11 | | BURNT SIENNA | 70% |

RIGHT Drop some gum arabic into a mix of Payne's gray and burnt sienna. Apply this color to the rim and front of the basket using the flat brush.

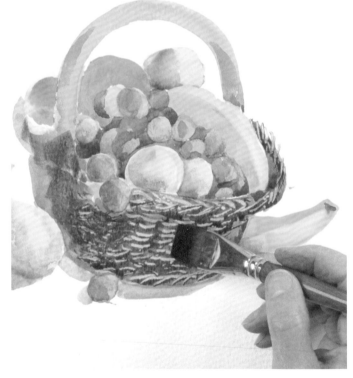

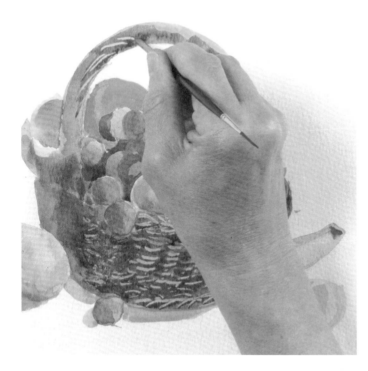

Take a step back from your work and check to see how strong the color on the basket is. If it is too dark, you can lighten it. Let the existing paint dry, then add a wash of water over the top. As the paint starts to lift off, dab up the excess with some kitchen paper. You can then scratch the pattern of the weave back into the wet paint. Do this as necessary until you get the shade you need.

TRICK OF THE TRADE

Experiment with different kinds of water-resisting liquids to create accidental-looking textures. A few drops of washing up liquid or baby oil in a small amount of water will give a wide variety of streaks and spots, depending on how much you use. Combine these with touches of a wax candle or scratching off with a blade.

Apply the same mix over the top section of the handle. Because the handle is mostly in light, it doesn't need to be as dark as the rest of the basket and the weave is not as prominent.

RIGHT As you work around the handle, the left-hand side gradually falls into shadow, and the weave becomes darker. Paint on the pattern of the weave with the round brush.

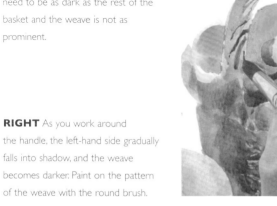

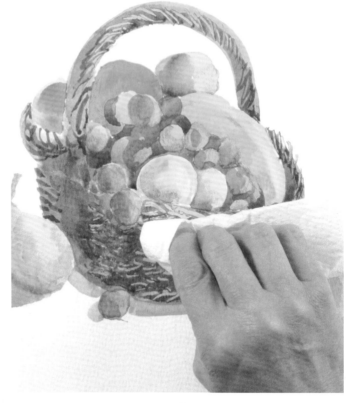

STEP 11 ▶▶

STEP 12 ▶▶

3
still life

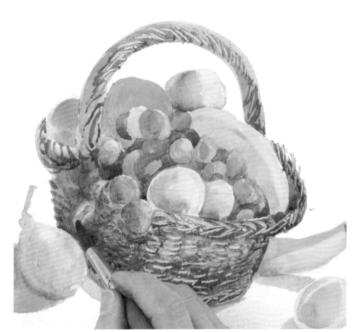

 VIOLET

Repeat this detailed shading on the grapes, using the round brush. Use a strong mix of pure violet but use it sparingly—there is already a lot of subtle shading here that will be lost if you add too much dark color. You can also paint in an extra grape or two just using the violet color. This adds a little more depth to the image. Add some final touches to the peaches using the same color.

TRICK OF THE TRADE

You can lift off color on your entire painting, not just specific areas, by applying water right across the paper. You will lose some of the crispness of the original washes but many delicate shades will remain as a basis for recoloring. You can lift off as many times as you need to achieve a result that you are happy with.

Add some small details to your work. First, lift off some of the dark mix on the side of the basket by applying water with the round brush to remove the paint. Add a faint line of the green mix you used earlier to indicate a small leaf.

 HOOKER'S GREEN 80%

CADMIUM YELLOW 20%

RIGHT Build up some detailed areas of shadow on the pear, just along the edge and the stalk, using the fine brush and the same color mix as the leaf.

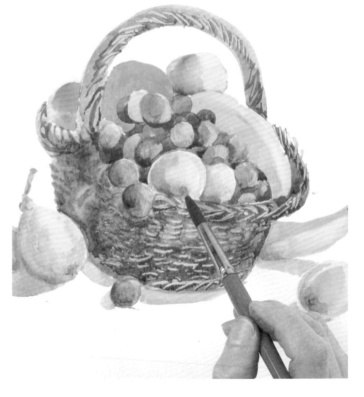

Take a look around your painting and see where the paint has strayed outside your pencil sketch. Clean up these areas and any other mistakes by scratching off the paint with the blade of a craft knife. The thick watercolor paper is capable of withstanding this but be careful not to scratch too hard.

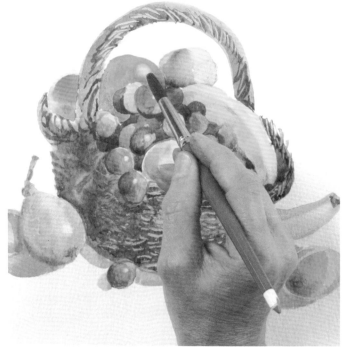

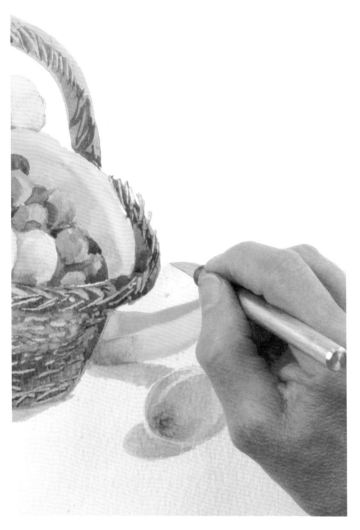

Add highlight areas to the fruit by lifting off some of the paint with water and a round brush, using a circular motion to create a round reflection. Make sure you rinse your brush thoroughly so as not to pull paint from one piece of fruit to the next. Also, don't add too many highlights or they will become too prominent.

RIGHT Tidy up any last pieces of shading, such as the green around the edge of the apple, with the fine brush.

STEP 15 ▶▶

STEP 16

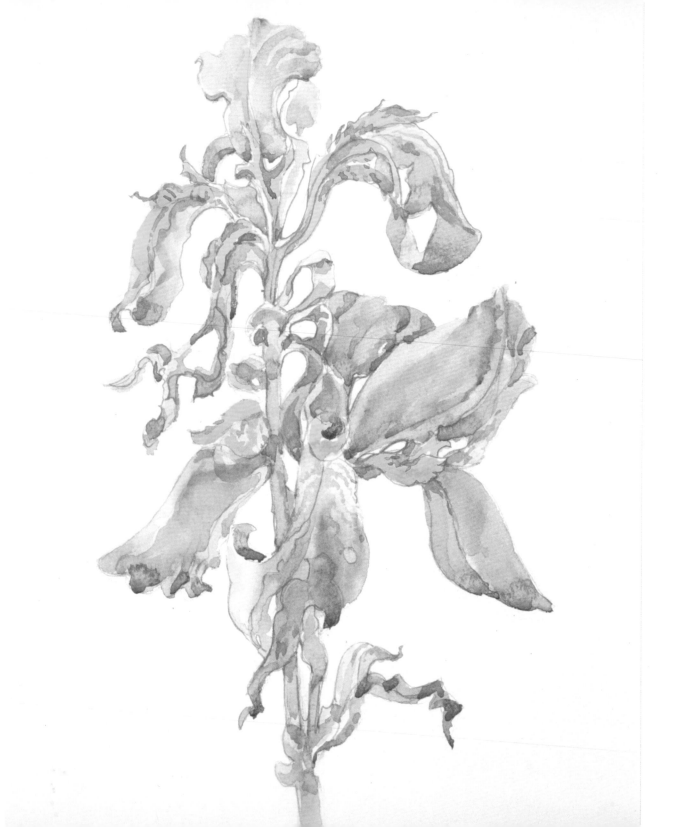

4
purple iris

john barber
20 x 13 in (500 x 330mm)

Flowers are complex, delicate, and beautiful. They are also natural, living, and full of color. These qualities combine to make them a challenge to paint—you need to balance the need to capture some detail with the need to preserve the rhythm of the lines, which can easily be lost by overworking the subject. To this end, a strong sketch is a good starting point for the purple iris in this project; it will also help you differentiate between the petals and the background when you start applying color. Soften these lines by using only one main color, with some sparing accent colors, to avoid overelaboration—too many colors will muddle your work and make you lose the delicacy you are trying to preserve.

WHAT YOU WILL NEED

Rough surface watercolor paper
Graphite pencils, 6B and 2B
Adhesive tack
Round brushes, no. 5 or 6, sable or synthetic
Eraser

COLOR MIXES

3 Cobalt blue
4 Violet
8 Cadmium yellow
9 Cadmium lemon
10 Yellow ocher

TECHNIQUES FOR THE PROJECT

Working wet-in-wet
Laying a flat wash
Lifting off

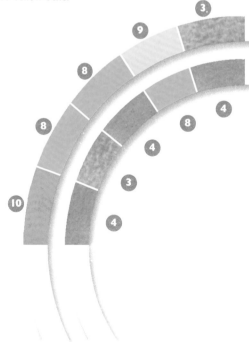

WORKING WET–IN–WET

Wet-in-wet means applying new wet paint on top of paint that has not yet dried. As well as adding one wet color on top of another, wet-in-wet can also mean applying wet paint on top of a wet base of clean water. Both produce the same effect of allowing colors to run over the paper.

The great advantage of this technique is that when one color is "dropped" into another there are no hard edges, unlike the effect produced by wet-on-dry, where hard edges have to be softened. With wet-in-wet, the colors run together at the edges, but don't fully mix, making this a valuable technique when you don't need crisp

edges. This means that wet-in-wet is a classic technique to use when you can afford to let the paint run. This is particularly useful for subjects that have subtle variations in tone and texture that cannot effectively be captured by applying flat washes. Wet-in-wet is best used on flower petals, skies and clouds, and scenes involving water, where not only is it useful for coloring the water itself, but also for adding the colors of the river bed.

Practice wet-in-wet first on a piece of scrap paper, as it can be hard, but fun, to control. Also, use it sparingly—used too often, it can make your work look formless.

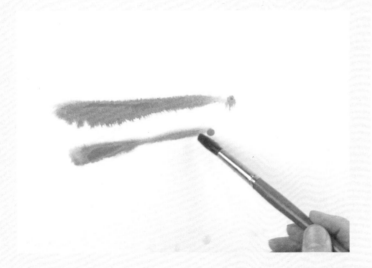

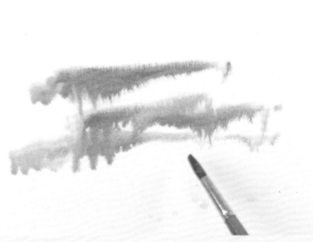

1 Mix two separate watercolor washes, in this case, violet and permanent rose. Lay down a couple of small lines of violet with a round brush. Load another round brush with permanent rose and dab it onto the wet violet paint.

2 Both colors start to run down the paper. The permanent rose runs ("bleeds") into the wet violet and starts to spread and merge. Although the colors bleed into each other, they do not fully mix, leaving both colors still visible.

3 The violet has spread across the paper, with a hint of permanent rose in it. You can see how effective wet-in-wet is for creating areas of subtle tone and color, from faint violet at the bottom left corner to a stronger pink color at the top.

4 Allow the paint to dry, then add a layer of clean water over small areas of the dry paint with the flat brush. While the water is still wet, drop in a mix of violet and burnt sienna. The paint runs over the wet areas, further building up color.

5 Add more small areas of water over the dry paint and drop in more of the violet and burnt sienna mix. You will see that the paint only runs over wet areas—it does not drip down the paper in the way that a flat wash does.

6 Last, you can gently manipulate and move the wet color on the paper using the tip of a round brush. You can even blow gently on the paper to move the paint around. You can clearly see the graduations in color from dark to light.

4
purple iris

Before you start sketching, study the way the lines of the flower interconnect and flow. Then start sketching using the 6B graphite pencil. The pencil lines are an integral part of the composition, so draw them firmly. Strongly outline the areas where the white paper will show through. This will help you tell the difference between the petals and the background when it is time to apply color.

REMEMBER

Capturing the rhythm of the lines is more important than accurately recording every last detail. If you can manage to capture this rhythm, you will achieve a result that looks more like a flower than one produced by a fully accurate drawing—too much detail in a subject such as a flower creates a stilted composition.

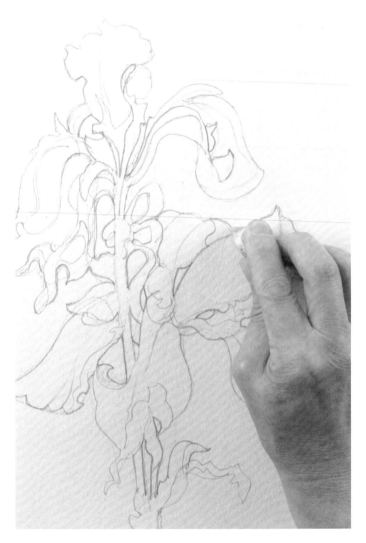

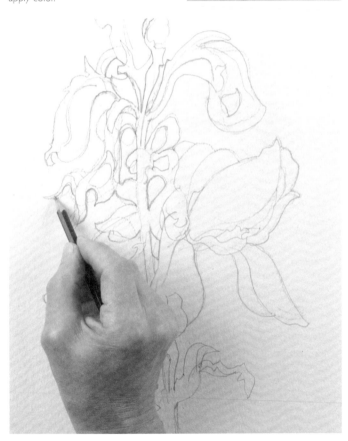

Your pencil lines may look heavy at first, but once you start applying paint, the color will blend them into the background. Look around your sketch and see how it is coming together.

Tidy up any areas where the pencil lines look confused or messy with some adhesive tack. This method of erasing leaves no marks.

STEP 1 ▶▶

STEP 2 ▶▶

4 ▬▬▬▬ VIOLET 100%

Start applying color to the petals using the wet-in-wet technique. First apply a wash of clean, clear water to one petal only. Remember to apply the water accurately within the pencil lines you have drawn for that one petal. Then, using the round brush, drop on a strong mix of pure violet to the wet paper.

TRICK OF THE TRADE

Color will only run where the paper is wet, so do not worry that the paint will run outside your pencil lines. You can manipulate this characteristic to your advantage by leaving the top or edge of a petal dry. This will create an instant white highlight, since the paint will not stray into a dry area.

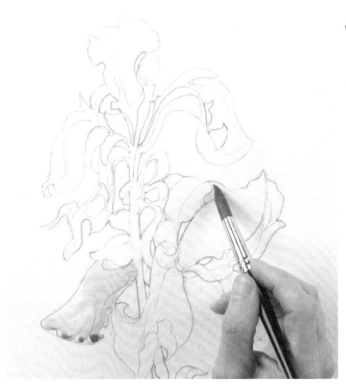

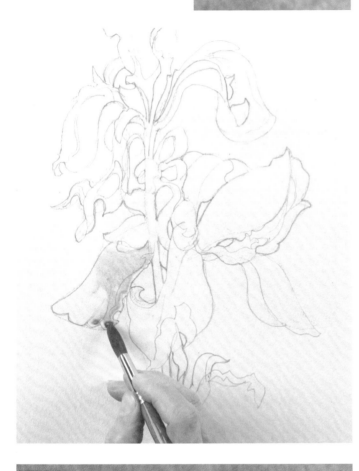

Work around different parts of the sketch, one petal at a time, applying color as you go. This is better than concentrating on applying color in one area only—you may find that you end up using too much and have to start over.

RIGHT Continue to apply a wash of water first, then drop in the violet paint. You will find that if you apply the water carefully you can create detailed areas of color.

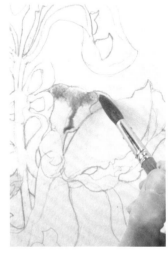

STEP 3 ▶▶

STEP 4 ▶▶

4
purple iris

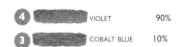 VIOLET 90%

COBALT BLUE 10%

RIGHT Add a little cobalt blue to the violet mix to create a slightly cooler, more blue color. Apply this wet-in-wet to the petals on the right of the flower.

Thin down this cooler blue mix with a little water to produce a lighter blue color and apply it wet-in-wet to the top petals, which are faint and delicate.

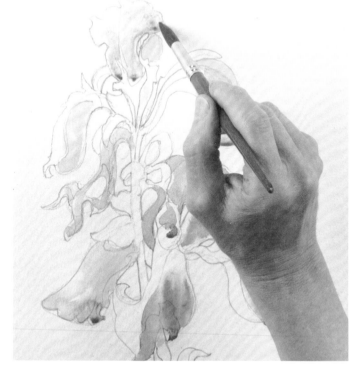

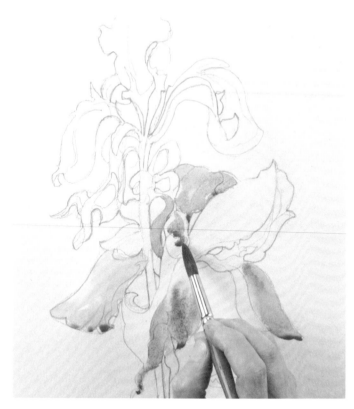

Not every petal has to be colored using the wet-in-wet technique. To create some different textures and shades simply apply a flat wash of the same violet mix to some of the petals.

 VIOLET 100%

RIGHT Lighten the violet mix with a little water to create a pinker color. Apply this color wet-in-wet to create a different shade.

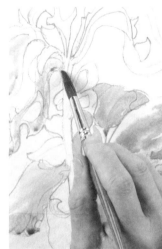

STEP 5 ▶▶

STEP 6 ▶▶

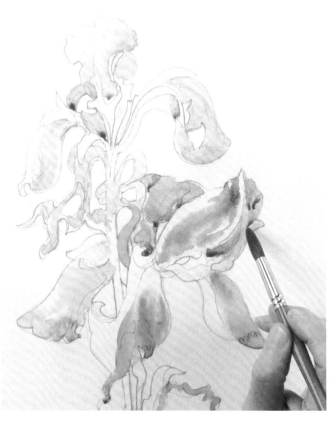

Work backward and forward between the violets and blues, applying a little at a time in specific areas, sometimes working wet-in-wet, at other times just applying small flat washes.

Work over the edges of the violet areas with this light blue mix and allow the two colors to blend together to build up deeper colors and more texture.

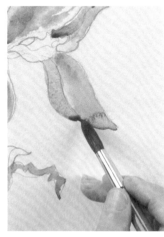

RIGHT In other areas, color individual petals with the light blue mix on its own. Here, the blue is applied side-by-side with the violet to create an area of subtle contrast.

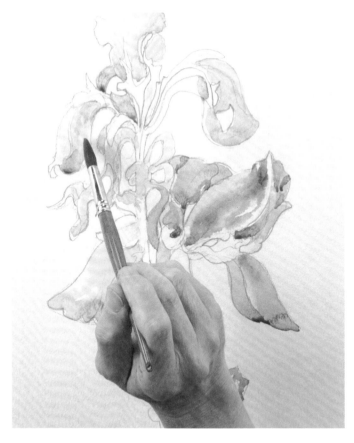

STEP 7 ▸▸

STEP 8 ▸▸

purple iris

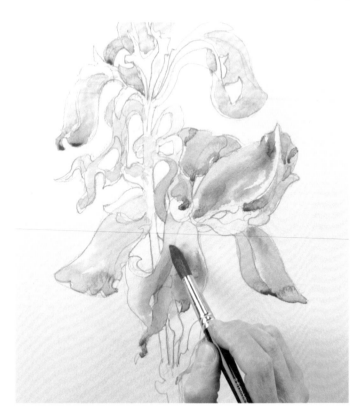

As you work, try to keep the darker tones nearer the bottom of the flower and the lighter tones nearer the top. This will make the iris look correctly weighted—warmer at the bottom, cooler at the top.

RIGHT Soften any hard edges between the colors by adding a little clean water to the edges with a round brush then blending the colors together.

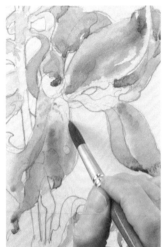

9	CADMIUM LEMON	**60%**
8	CADMIUM YELLOW	**40%**

RIGHT Mix two yellows—cadmium lemon and cadmium yellow—to form a bright accent color. Start applying this at the base of the petals.

Work your way around the flower adding the yellow mix. Where yellow and violet meet, wet the edge of the violet color with a round brush and clean water to lift the paint slightly. Dab a little of the yellow mix into the wet violet to blend the colors.

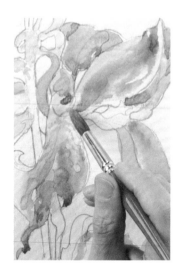

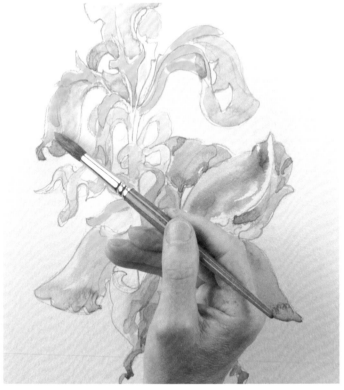

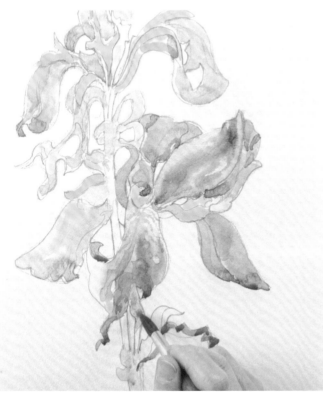

RIGHT The middle section of the flower is the densest part of the painting and needs detailed modeling. Start by using the wet-in-wet technique for small areas of detail— these do not have to be extensive.

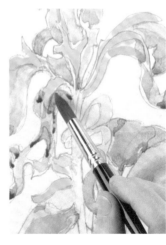

Build up further color in the middle section by adding small flat washes of the darker mix as well as using wet-in-wet. Using flat washes helps build a variety of textures.

| 3 | COBALT BLUE | 60% |
| 4 | VIOLET | 40% |

Make a strong mix of violet and cobalt blue. Start adding this darker tone sparingly to small sections of the bottom petals, where the colors are warmest.

RIGHT Work some of this darker mix onto the petals using wet-in-wet. With a round brush, apply clean water over the top of the existing violet color to lift the paint slightly, then drop on the darker mix.

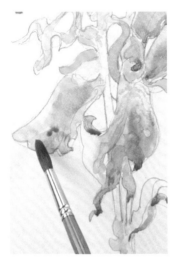

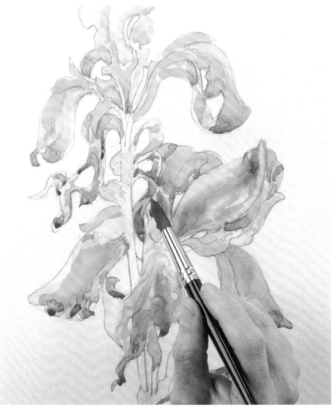

STEP 11 ▶▶

STEP 12 ▶▶

4
purple iris

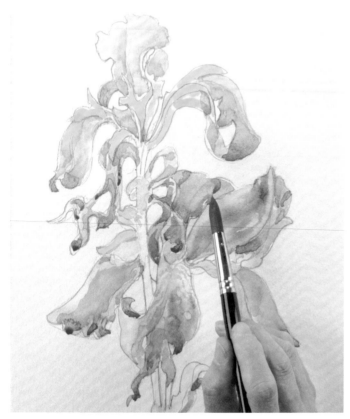

4		VIOLET	30%
8		CADMIUM YELLOW	70%

Mix some cadmium yellow and violet to create a light gray color. Apply this to the underside of the yellow stems to create shadow areas. This gives the yellow areas some depth, to match the depth of the blue and violet petals.

TRICK OF THE TRADE

As you add more areas of color using wet-in-wet, the brush you are applying the water with will start to pick up the blues and violets. Although you should usually be careful to use a clean brush, let this happen here—it will add a little extra variety to your color scheme.

Continue to switch between flat washes and wet-in-wet, but be careful not to apply too much paint. The effect you are looking for is a subtle one, with lots of different shades and tones blending together to create an overall impression.

RIGHT Take a step back from your work to see what the overall effect of the color scheme is. Finish off any small areas of detail, either working wet-in-wet or using a light wash.

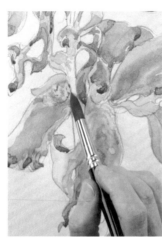

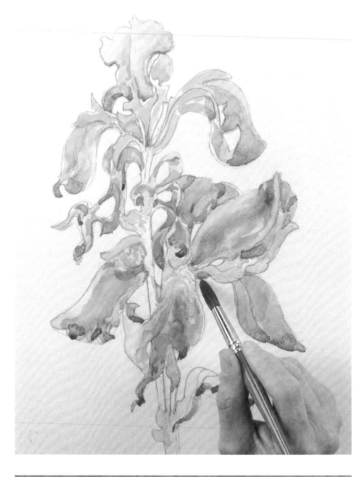

STEP 13 ▶▶

STEP 14 ▶▶

| 3 | COBALT BLUE | 20% |
| 8 | CADMIUM YELLOW | 80% |

Mix some cadmium yellow and cobalt blue to create a soft green. Try not to use too much yellow—the green should look muted so it does not attract attention away from the violets, blues, and yellows. Fill in the central stem of the flower with this soft green color.

RIGHT Blend the green into the rest of the color scheme by applying it over the yellow. This also helps build up a different green color—olive green.

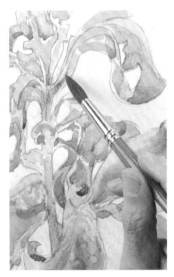

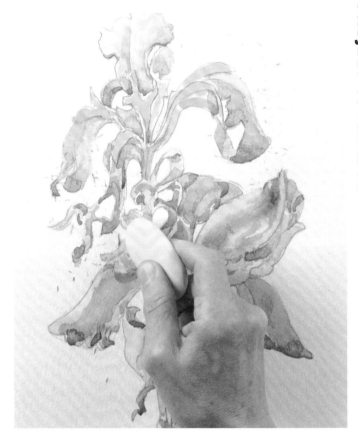

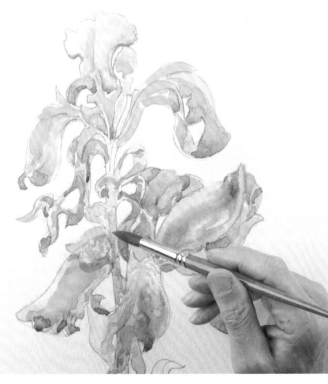

Clean up your painting by erasing all the pencil lines with a clean eraser. Work from the top down, gently erasing the lines as you go. Try not to rub too hard—you can scuff the surface of the paper.

TRICK OF THE TRADE

In a few places, soften the edges of the petals with clean water until they disappear and it is hard to see where the petal ends and the background begins. This is sometimes called "lost and found," and will give your work more depth and modeling. It is an important effect in all watercolor painting.

STEP 15 ▸▸

STEP 16 ▸▸

4
purple iris

| 10 | | YELLOW OCHER | 90% |
| 4 | | VIOLET | 10% |

RIGHT Start the last round of modeling on the flower to add a professional-looking level of detail. Mix some yellow ocher and violet to create a brownish color and add it to the yellow areas on the top left.

Work your way around to the right-hand side, then down to the bottom. Keep this shading to a minimum or you will lose the brightness of the original color.

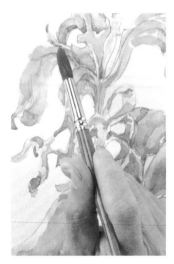

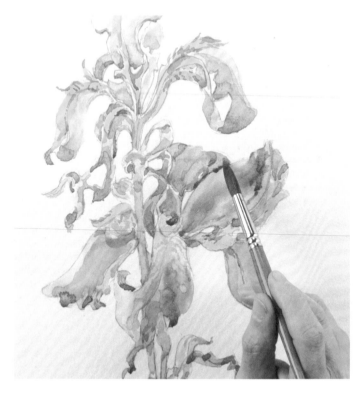

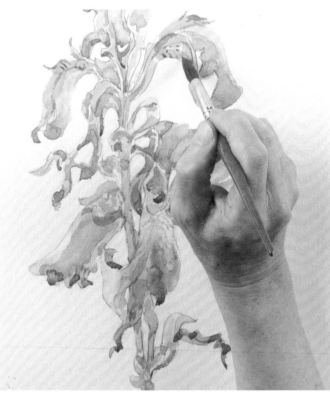

Add a final level of detail to the petal near the middle of the flower. The bottom of this petal is in shadow, so apply the same yellow mix sparingly just along its edge. This detail adds a little extra depth to the densest part of the flower.

TRICK OF THE TRADE

If your finished study looks too stark on the white paper, try dampening the background area and dropping in a few spots of a complementary color. This will highlight your subject while removing the glaring whiteness of the paper. Practice this on a piece of scrap paper—you will soon learn which colors work together.

STEP 17 ▶▶

STEP 18 ▶▶

3 ▬▬▬ COBALT BLUE 100%

Make a light mix of pure cobalt blue and add this to the top of the right-hand petal. As before, this is another level of detail as well as a strengthening line—the violet color is faint here and needs a little extra definition.

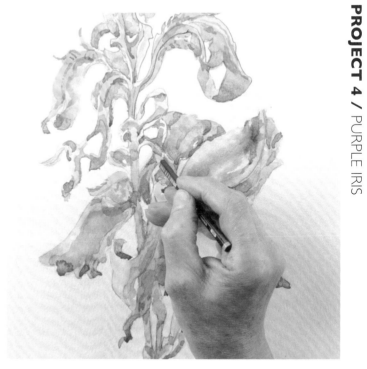

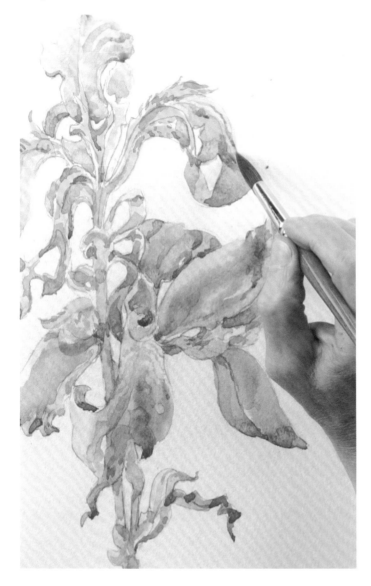

Let all the paint dry thoroughly. Then, using the 2B pencil, sketch around the most noteworthy outlines of the petals. Follow the edges accurately— the pencil lines are there to give the petals a hint of definition.

RIGHT You don't have to fill in every edge, especially where there is either strong color, or conversely, a delicate edge. Also try including small areas of untouched white paper within the pencil lines to create an instant white highlight on the edge of a petal. Soften any heavy pencil lines with adhesive tack.

STEP 19 ▸▸

STEP 20

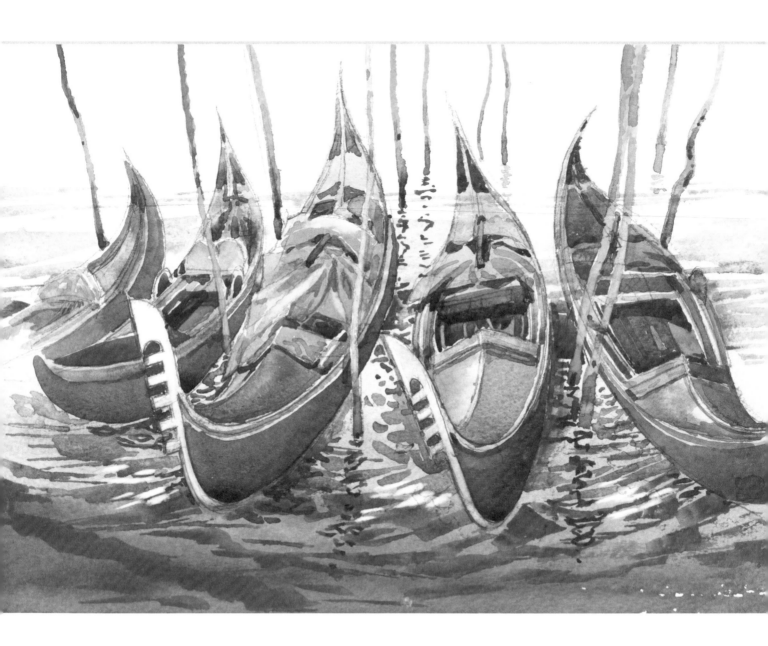

5
impressions of venice

john barber
11½ x 16 in (290 x 400 mm)

Watercolor painting essentially consists of building up a picture through laying a series of washes of paint diluted in various strengths with water. In this project, you will see how to paint two basic types of wash—the flat wash and the graduated wash. Flat washes are often used for backgrounds and artists often start with these to get some color on the paper. These may then be overlaid with detail, as is the case here with the gondolas. Graduated washes, in which the wash gradually differs in strength across the paper, are useful for water and to suggest recession and distance. They are used in this project to show the reflection of the sky in the water and the movement in the water itself.

WHAT YOU WILL NEED

Rough surface watercolor paper
Soft graphite pencil, 6B, and adhesive tack
Round brush, no. 5 or 6, sable or synthetic
Flat brushes, ½ in (1.3 cm) and 1 in (2.5 cm), sable or synthetic

COLOR MIXES

2 Prussian blue
3 Cobalt blue
4 Violet
5 Permanent rose
6 Cadmium red
8 Cadmium yellow
9 Cadmium lemon
11 Burnt sienna
12 Hooker's green

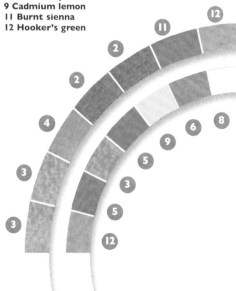

TECHNIQUES FOR THE PROJECT

Laying a flat wash
Laying a graduated wash
Working wet-on-dry

GRADUATED WASHES

The art of laying graduated washes is one of the most important skills you need to learn if you are to have a command over your painting. The aim is to make a smooth transition from dark to light, but the variations that occur in the actual flow of the paint are what makes the process so exciting and attractive. Eventually, you will develop your own ways of using the graduations to your advantage. In practice, you will need to learn the strength of your starting color and the quantity of paint you need to cover a given area. You can lay a graduated wash onto white paper and this will give you clear color. When you work over it, many different effects can be obtained. Even for experienced artists, the effects of laying one color over another are constantly surprising and are one of the great joys of watercolor painting. Depending on the type of paper you are using, the first wash will either not be moved by working over it, or will begin to dissolve as you apply more paint. Try different papers and check their capacity to absorb and retain paint. Being aware of how your materials react is an essential aspect of painting. As in cookery, the right ingredients in the right quantities, added at the right time, bring good results.

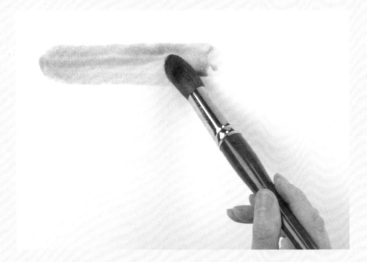

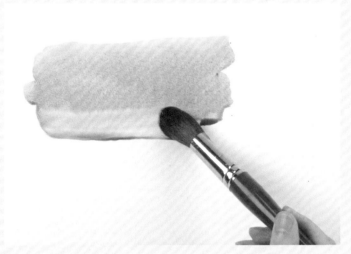

1 For graduated washes, mix a stronger color than for most flat washes. Load your mop brush with color and pull it across the paper from one side to the other, always working in the same direction—do not go backward and forward.

2 Now tilt your work slightly and begin to graduate your wash by dipping your brush in clean water and then into the paint mix you started with. Apply this to the bottom of the first horizontal band of color before it is dry.

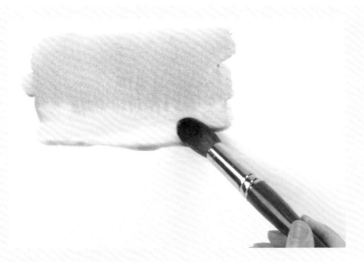

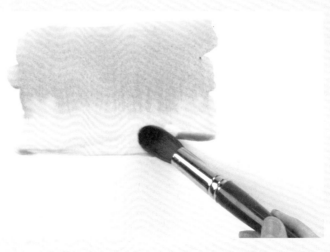

3 Repeat the process of dipping your brush in clean water each time before dipping it into the paint. By doing this, you gradually weaken the color in your palette and the wash becomes lighter. Keep your wash wet and flowing at this stage.

4 As you add more water to your palette, the lightening effect will become clearer. Load your brush generously and work across the paper. Keep the paint flowing so that the drip along the bottom looks as if it will run down the paper.

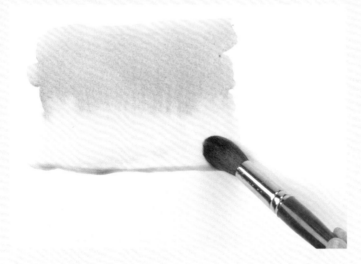

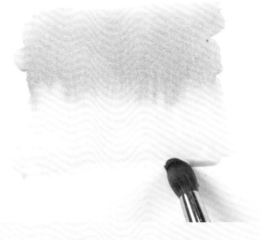

5 As you cover the paper, you will notice the strong paint at the top of your wash starting to run down and blend with the lighter tones lower down. Do not worry if the graduation is not smooth—these washes take time and practice to achieve.

6 As you reach the bottom of your wash, stop dipping your brush in the paint—just put it in water and draw it across the paper. With each stroke, the color will become fainter. When you are painting with clear water your wash is complete.

⁵impressions of venice

This is a fairly simple composition which owes its refinement to the lines of the gondolas rocking on the choppy waves. Sketch in the major lines using the graphite pencil, planning out the key elements of the composition and their relationship to each other. Soften any lines you are unhappy with using some adhesive tack. This is less harsh on the surface of the paper than using an eraser and does not remove the lines altogether, just knocks them back.

REMEMBER

You are in charge of your painting so do not be afraid to be bold. To help you with your confidence, plan where your washes are going to go before you apply them. Following through the stages in this project will also build your confidence but painting is also about trying things out for yourself, so move on to developing your own ideas.

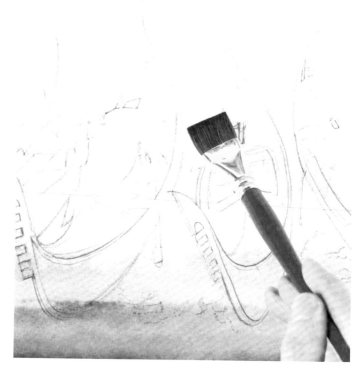

2 ▬▬▬ PRUSSIAN BLUE 100%

Turn your sketch upside down. Using the wide flat brush, apply a medium mix of Prussian blue in horizontal bands across the paper, adding more water for each band. Then turn the paper the right way up so the darkest color is now at the bottom.

RIGHT Add dashes of stronger Prussian blue to suggest choppy waves in the foreground. Keep your strokes fluid to get a good sense of movement into the water.

STEP 1 ▸▸

STEP 2 ▸▸

BE CONFIDENT

It is tempting to overwork watercolors but this results in muddy and obscured tones. The more you paint, the more you will appreciate how watercolors dry and how much paint to apply. Eventually you will become confident that your colors will dry as you want them to, although they may not look right while the paint is wet.

2 PRUSSIAN BLUE 100%

Define the edges of the gondolas with the same strong mix of Prussian blue. Instead of pulling the brush along the pencil line in one continuous stroke, place the edge of the brush on the line, one stroke at a time, to form a series of overlapping strokes. Work around the edges of all the gondolas in the same way.

Finish applying this pale green to the gondolas. Keep your work loose at this stage—if you attempt to make your work look too precise, your art will start to look wooden and stilted. Then darken your mix with a little more Hooker's green and add some slight shadow to the edges of the pale green. This gives your work some depth. The usual method of working with watercolors is to have the strongest tones nearest the foreground and the lightest ones farther in the distance.

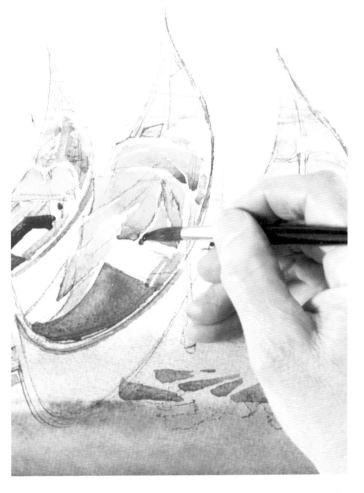

It is helpful to build up areas of the same color wherever they occur in the painting. The darker areas of the prow of the gondola match the color of the choppy waves in the lagoon, so use the same Prussian blue mix here, applied with the round brush.

9 CADMIUM LEMON 20%

12 HOOKER'S GREEN 80%

RIGHT When you have a good balance of different strength blues on your paper, move on to mixing colors for the green areas of the gondolas. The pale green here is a mix of Hooker's green and cadmium lemon.

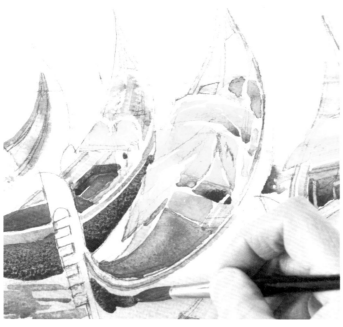

RIGHT Dab on small areas of the strong Prussian blue mix to the fretwork on the prows of the boats. These need to be applied fairly accurately, so don't let the paint run.

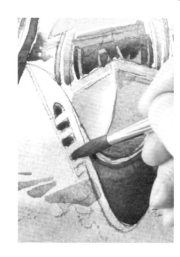

③ COBALT BLUE 100%

Build up the curved profiles of the gondolas using light mixes of cobalt blue. Don't worry if the lines are blurred in some places—this will add to the sense of movement. Use the medium flat brush here.

⑪ BURNT SIENNA 60%
⑥ CADMIUM RED 40%

Add some accent colors to the boats with some red tones. First, mix burnt sienna and cadmium red and apply this to the interior detail on the gondolas. Add some Payne's gray and cobalt blue to the mix to create a deep red for the gondola on the left. Then use a strong mix of Prussian blue for the sides of the boats.

RIGHT Apply the Prussian blue down to the water line. Note that the edges of the sides of the gondolas are mostly white to separate the mid-blues from the darker ones.

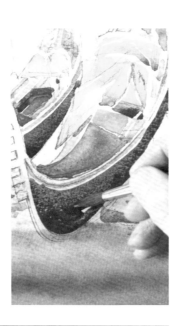

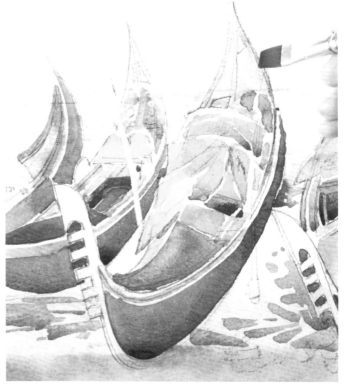

STEP 6 ▶▶

STEP 7 ▶▶

impressions of venice

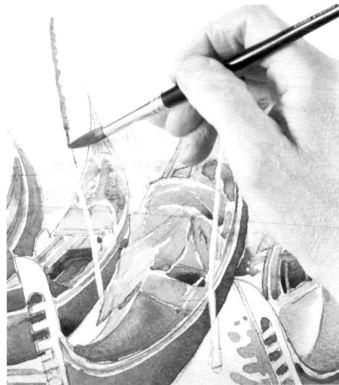

RIGHT Build up some tone on the mooring posts with a little permanent rose. The posts are set at different angles to the water and to each other and these help the rhythm and recession in the composition.

Add a second color to the posts, such as the red you mixed for the interior of the gondola. Adding small amounts of colors that are tonally different creates depth and texture to your work.

11		BURNT SIENNA	60%
6		CADMIUM RED	40%

Build up some more color in the interiors of the boats with touches of violet down the sides. Then start coloring the mooring posts with the mix of burnt sienna and cadmium red. Use the round brush here. Keep the lines fairly thin but don't be too concerned about keeping them straight—slightly crooked lines look more interesting than ones that are perfectly straight.

TRICK OF THE TRADE

Working with washes usually means working fairly fast, but that doesn't mean that there is no time to evaluate whether you are getting the effect you want. If you feel an area needs color, don't be afraid to add another wash after the first one is dry. Alternatively, you can lift off the whole of the wash and recolor it.

STEP 8 ▸▸

STEP 9 ▸▸

| 9 | | CADMIUM LEMON | 65% |
| 2 | | PRUSSIAN BLUE | 35% |

Using the same brush, build up dark green shadows—mixed from Prussian blue and cadmium lemon—to the interiors. Although you have already shaded the green areas, you will have to build up more color. Keep working around your painting and, as you build up shadow tones in one area, check that areas you have worked on previously still match up. Don't be afraid to go back and work further on earlier parts.

| 3 | | COBALT BLUE | 100% |
| 2 | | PRUSSIAN BLUE | 100% |

Using a pale cobalt blue wash, add color to the prow with the medium flat brush. If it was left white, it would be too stark, but the wash you use should be subtle—you are trying to suggest that the prow is white, but is gently reflecting the blue of the water. Continue to add pale Prussian blue and cobalt blue washes to build up the water and the gondolas. The same colors are used for both, so you have to create areas of light and shadow through clever mixing of your colors.

STEP 10 ▶▶

STEP 11 ▶▶

5
impressions of venice

(2) PRUSSIAN BLUE 45%

(5) PERMANENT ROSE 55%

Start adding some fine detail. Using a mix of Prussian blue and permanent rose, start to add more waves with the corner of the wide flat brush. Keep these waves simple—they are really no more than straight lines.

(4) VIOLET 40%

(3) COBALT BLUE 100%

RIGHT Work a light violet and cobalt blue mix onto the water under the edge of the boat. This suggests a little reflected light. These are small areas only so be careful not to overwork your painting at this stage.

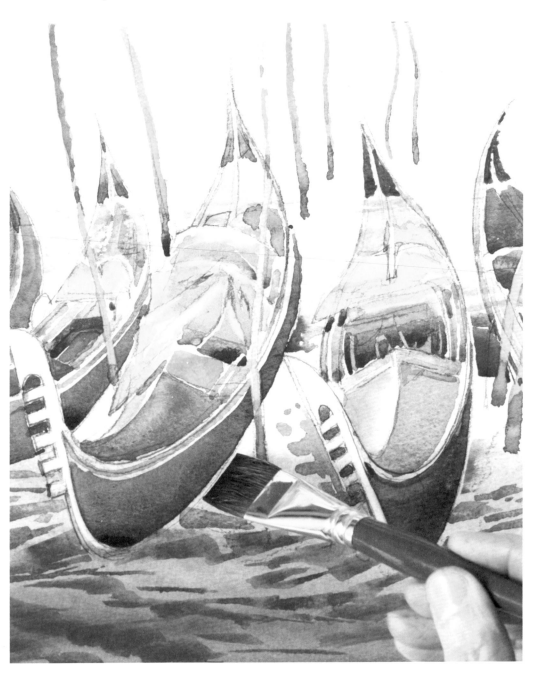

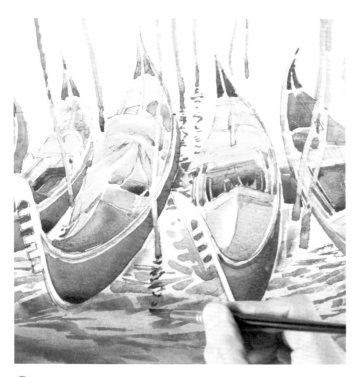

RIGHT Go back to the mix of permanent rose and cobalt blue and pick out small details on the prows of the gondolas. Keep the brush lightly loaded so as not to flood your work.

Build up any last areas of shading on the prows. There are now several different shades of blue used here, ranging from dark blue to almost white. Notice how this is achieved using very small amounts of paint.

| 3 | COBALT BLUE | 45% |
| 5 | PERMANENT ROSE | 55% |

Darken the bottom ends of the mooring posts using a mix of cobalt blue and permanent rose. This color ties the posts to the blue of the water and follows the principle that the nearer the posts are to the water, the stronger the color mix needs to be. Conversely, the top ends of the posts are paler. Then, with the same mix, add small irregular dashes to the water to suggest the reflection of the poles. Make each mark freely and do not go back over them. Use the round brush here.

BE CONFIDENT

Consider whether you are getting the sense of light and movement that you want into the water. If you are struggling, look at a photograph of the sea and examine where the areas of light and shade are and try to replicate this. This will help you to judge the precise shades you need and, equally importantly, where to place them for maximum effect.

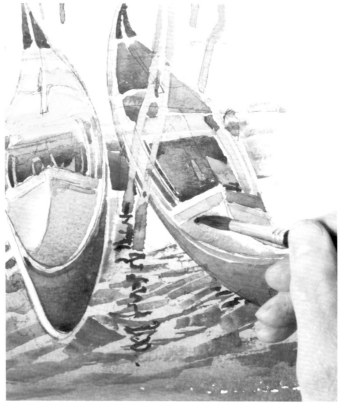

STEP 13

STEP 14

3 COBALT BLUE 25%

12 HOOKER'S GREEN 75%

RIGHT Mix cobalt blue and Hooker's green to make a blue-green to pick out more shadows on the interiors of the gondolas.

2 PRUSSIAN BLUE 45%

5 PERMANENT ROSE 55%

Mix Prussian blue and permanent rose for the high points of the stern. These, along with the underside of the prow in the foreground, are the areas of the composition that are in the greatest shadow.

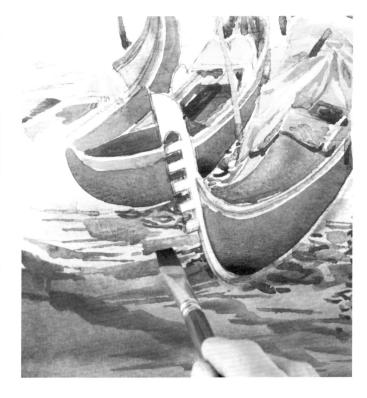

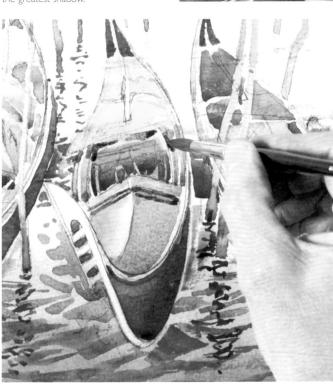

Using the same dark mix of Prussian blue and permanent rose and the medium flat brush, add the finishing touches to the waves in the foreground. These come just under the prows of the boats, where there is least light. Because they are so dark, use them sparingly—you do not want them to attract the viewer's attention too strongly.

TRICK OF THE TRADE

Don't be tempted to be frugal with your pigments. While it is true that good-quality paints can be expensive, there is nothing worse than running out of a color mix simply because you underestimated how much you would need. It is often the case that you want more of a shade as a painting progresses, so mix plenty of color.

STEP 15 ▸▸

STEP 16 ▸▸

Now dip your medium flat brush in clean water and apply it to the paper, moving it gently from side to side to lift out some of the color in between the boats. This creates sparkling highlights. As with applying dark shadow tones, do not overdo the highlight effect—a few light areas here and there will be enough. Also note how the water has been created by using only a few shades and strengths of color, and yet the overall effect is one of waves and movement. A restricted palette can often be a bonus in watercolor work as you resist the temptation to overmix, which can cause color to lose its vibrancy.

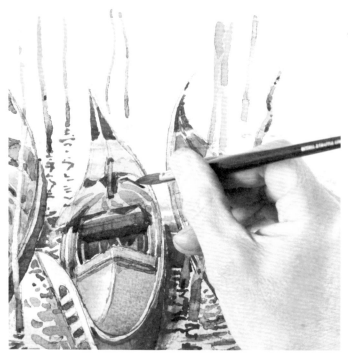

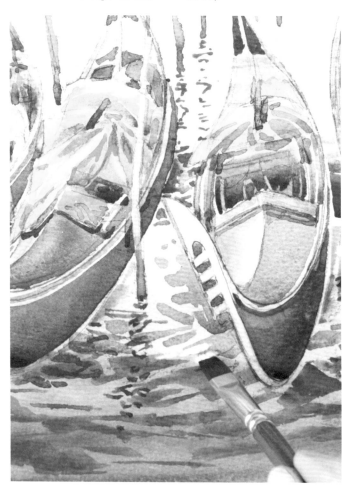

STEP 17 ▶▶

2		PRUSSIAN BLUE	45%
5		PERMANENT ROSE	55%

Use the round brush and a mix of Prussian blue and permanent rose to add the last details of the interiors. Don't add the same details to every boat—they should all have some individual characteristics.

RIGHT Take a final look at your finished work and make any final adjustments, then leave to dry. Do not consider making any changes, however minor, until your work has dried evenly.

STEP 18

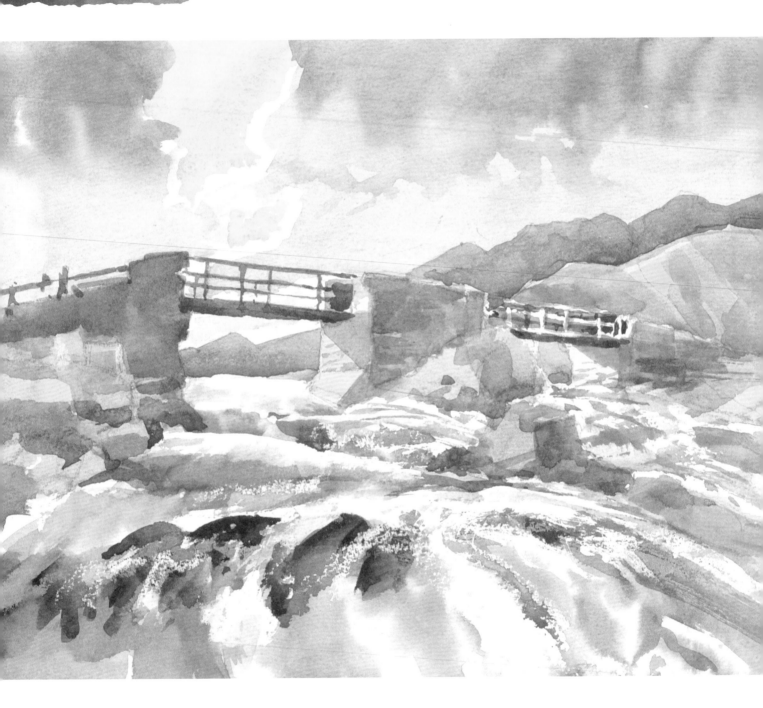

bridge at pont-y-garth

john barber
16 x 20 in (400 x 500 mm)

This project is a great exercise in painting that most fleeting of subjects—moving water. First, you will see how to mask out areas of paper to create the sparkling reflections that makes water so fascinating, as it picks up light from the sky and the color of the dark tones of the river bed. You will also learn how to create a brooding, dramatic sky. Working wet-in-wet is the best way to get high-quality results for both water and sky, since the paint is allowed to run (in a controlled way) in a variety of directions. However, as you will see, it is best not to overuse this technique, since capturing the impression of what you are looking at is more important than replicating every detail.

WHAT YOU WILL NEED

Rough surface watercolor paper
Graphite pencil, 6B
Masking fluid and wax candle
Old, small round brush, synthetic
Flat brush, 1in (2.5 cm), sable or synthetic
Round brushes, no. 5 or 6, sable or synthetic
Kitchen paper and eraser

COLOR MIXES

1 Payne's gray
3 Cobalt blue
4 Violet
10 Yellow ocher
11 Burnt sienna

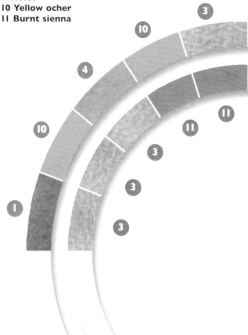

TECHNIQUES FOR THE PROJECT

Masking out with masking fluid and wax
Working wet-in-wet
Working wet-on-dry

MASKING OUT USING MASKING FLUID

Masking out is based on the idea that oil and water don't mix. This means that you can deliberately create a "mask" (also called a "resist") on specific areas of paper to cover it up from the paint you are applying on top of it—the paint is repelled and the paper underneath remains untouched.

Masking out can be done in two ways: Using masking fluid, or by using a wax candle. Masking fluid, featured here, comes in a bottle and is painted on with a brush. Once you allow it to dry, it completely seals off the paper underneath and dries to a rubbery consistency that can be simply rubbed off later using your fingers.

Because masking fluid is painted on, it produces a type of watercolor negative—you are creating areas of non-color, rather than areas of color. Also, because it is a painted medium you can mask out any area or any shape you like.

Masking out is ideal for creating highlights on your work, allowing you to capture the reflected light coming off leaves in a woodland scene or the sparkle seen on water in bright sunlight. It also has a more pragmatic use—you can use it to protect areas of your work where you do not want paint to run, which can then be worked on later.

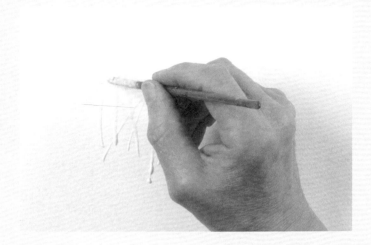

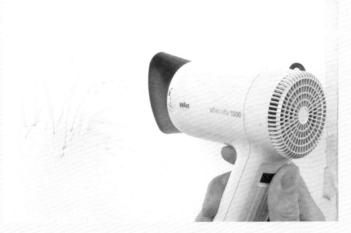

1 Paint on the masking fluid using a brush. Use an old or inexpensive brush to do this—the fluid tends to stick to the bristles and will eventually ruin a good brush. Paint on any shapes you like but try to stick to your original design.

2 To speed up the drying process, use a hairdryer. The fluid will dry to leave a yellow-colored residue. It does not matter that the residue is thicker in some areas than others as long as it covering the required areas of paper.

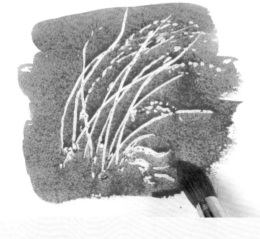

3 Mix some paint, in this case a deep red, and apply it over the masked-out area with a mop brush. You will quickly see that the paint covers the paper, but is repelled by the fluid, no matter how small the quantities of masking fluid are.

4 Finish applying the color to reveal the design you painted on with the masking fluid. In this case, the "negative" is a patch of reeds blowing in the wind. You can see how detailed the effects can become, down to the very small dots.

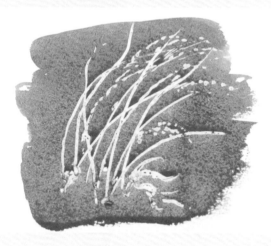

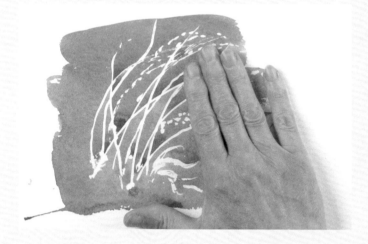

5 Take a step back to check the effect. One added feature of masking fluid is that the paint dries darker in the areas between the fluid because the mask stops the paint running down the paper. This creates a series of little graduated washes.

6 Leave the paint to dry thoroughly, including the drips of paint on the fluid. Then with clean hands, rub your fingers over the dry fluid to remove it. You may have to rub quite firmly—eventually the fluid with roll up into a ball.

6
bridge at pont-y-garth

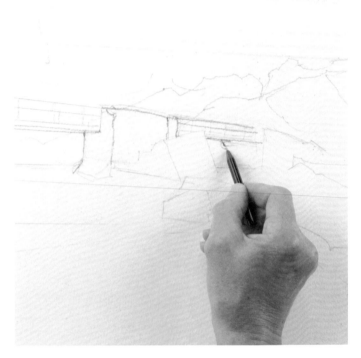

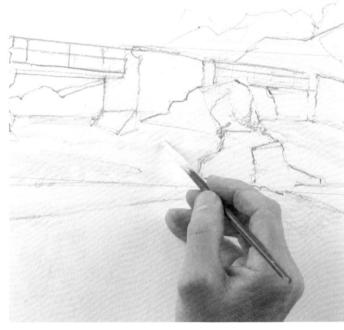

Sketch the details of your composition first, using the graphite pencil. The composition is roughly based on a diagonal cross, with the bridge, which is the focal point, at the center. This makes the eye level low, so the viewer is looking upward, an aspect that creates some drama in the image. Lightly sketch the lines first, then strengthen the most important ones, such as those marking out the bridge.

REMEMBER

Notice how to hold the pencil—grip it up the shaft. Your sketch should be made up of lightly drawn lines that give a clear outline of the scene but it does not have to be completely accurate. Holding the pencil in this way allows you to see exactly what you are doing without your own hand obscuring your view.

Apply the masking fluid to the foreground areas using the old brush. The fluid will create white areas that suggest the reflection of light coming off the water. Don't work too precisely—reflections tend to be random.

RIGHT Also use the wax candle for masking. The wax resists the paint on the "mounds" of the paper but allows it to flow into the "pits" in between— a very effective way of creating a sparkle effect on the water.

STEP 1 ▸▸

STEP 2 ▸▸

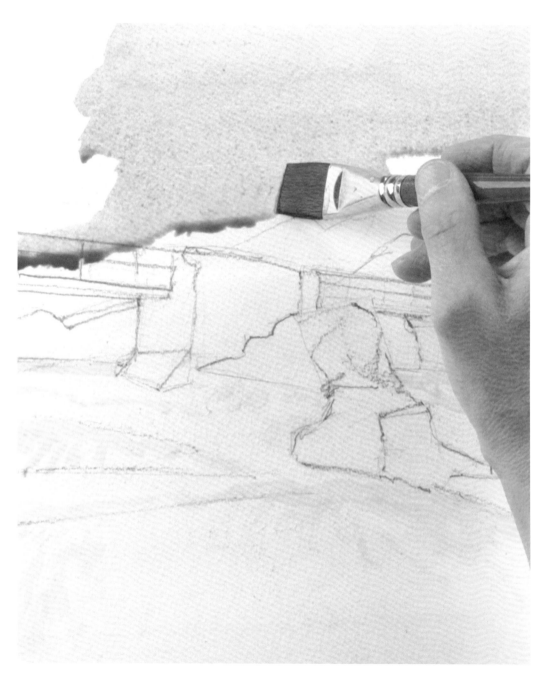

BE CONFIDENT

It can be tempting to be too timid when applying a flat wash—so much color is applied so quickly to the paper, and some of it drips down. To help overcome any anxiety, make sure you know where you are going to apply the paint before you start. This will give you the confidence to paint freely, knowing that you are less likely to make a mistake.

1		PAYNE'S GRAY	10%
3		COBALT BLUE	65%
4		BURNT SIENNA	25%

Apply a flat wash to the cloud on the right using the flat brush. The clouds are deliberately designed to look dark and dramatic, so use a mix of cobalt blue, burnt sienna, and Payne's gray. Work from the top down, leaving a white gap between your wash and the pencil lines that mark the edge of the cloud. Take the wash down past the horizon to make sure that all the white areas are covered. Then repeat on the left-hand cloud.

bridge at pont-y-garth

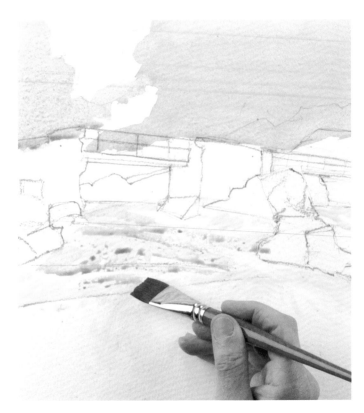

RIGHT Start to color the bridge, using a warmer gray created by adding a little more burnt sienna to the mix you used on the clouds. Don't be afraid to let the paint drip down a little—it will add extra texture to the next color to be applied.

 BURNT SIENNA

Add more burnt sienna to the mix to color the rocks. This warmer, redder color brings the rocks closer to the viewer's eye.

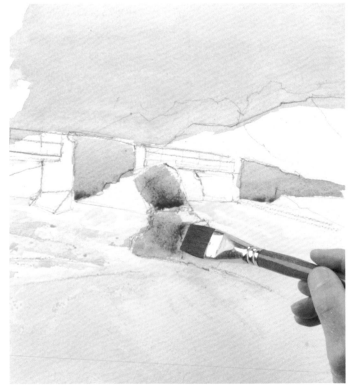

Because the water reflects the sky, apply the color you used on the clouds to the river, painting over the masked out area. Again, work from the top down. As you reach the bottom, add a little more water to the wash to lighten it.

RIGHT Allow the color to dry thoroughly, then mop off any excess paint from the mask with a little kitchen paper.

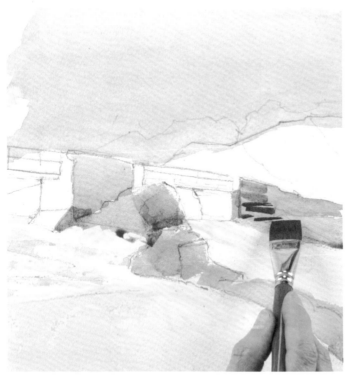

Apply most color to the stonework on the left-hand side of the bridge. This part of the stonework is most prominent and so carries the most color. This time, apply solid color using the full width of the brush, rather than small horizontal strokes.

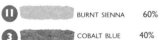

11	BURNT SIENNA	60%
3	COBALT BLUE	40%

Build up shadow on the rocks by again adding a little more burnt sienna to the mix. Then build up shadow on the stonework on the bridge by adding yet more burnt sienna, with some cobalt blue, to create a really strong color. Use horizontal strokes to hint at rough stonework.

RIGHT Repeat, using the same color and brush strokes, on the stonework that forms the mid-section of the bridge.

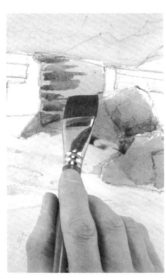

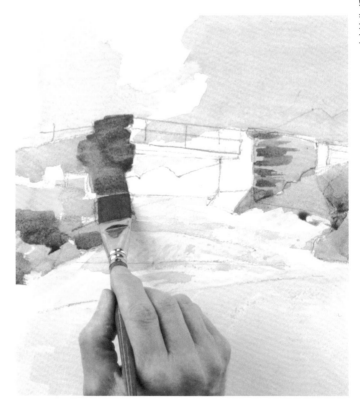

STEP 6 ▶▶

STEP 7 ▶▶

bridge at pont-y-garth

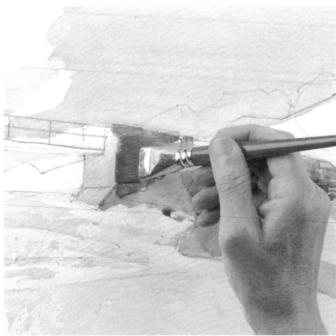

RIGHT Build up further color on the rocks closest to the viewer with strong red mix, containing more burnt sienna.

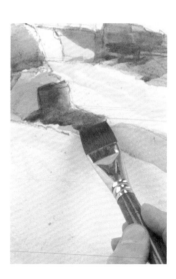

Finish off the shadow on the stonework using the color mix you used for the cloud. Notice how a little extra shadow detail is created at the foot of the stonework by adding this mix over the color of the stone.

10		YELLOW OCHER	45%
11		BURNT SIENNA	50%
3		COBALT BLUE	5%

The light source is at the top left, highlighting the stonework under the bridge. Color this using yellow ocher, burnt sienna, and a little cobalt blue, creating a light, warm color.

RIGHT Fill in a sharp shadow on the stonework under the bridge, using the mix you used for the clouds and water. This shadow needs to be painted accurately. Also take the wash onto the adjacent dark stonework to further build up color there.

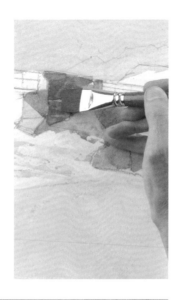

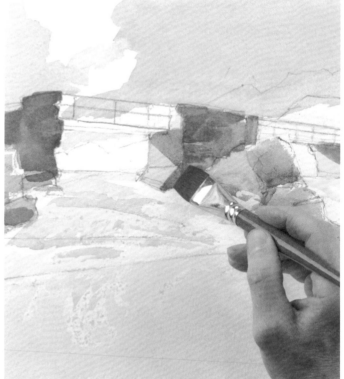

 ③ COBALT BLUE 100%

RIGHT Use pure cobalt blue to create the blue sky breaking out between the dark clouds. The outline of the blue sky should roughly mirror the shape of the edge of the clouds, with a white gap in between the two.

 ⑩ YELLOW OCHER 30%

Apply a flat wash of faint yellow ocher on the white of the sky. This indicates that sunlight is creeping around the edge of the dark clouds.

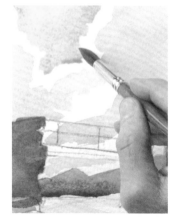

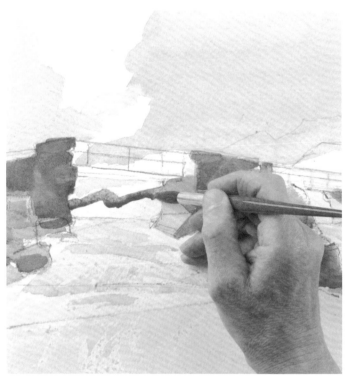

④ VIOLET 45%

③ COBALT BLUE 55%

Rub out any visible pencil lines on the clouds, then add in the blue mountains in the distance. Use the round brush here to apply a strong mix of violet and cobalt blue.

RIGHT The color mix gets darker around the bottom edge. To create this extra color, dab more paint into the first wash while it is still wet and let it diffuse. This is a variation on the wet-in-wet technique.

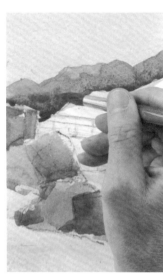

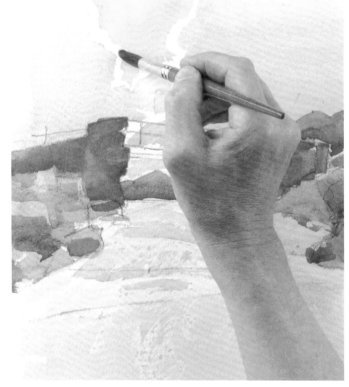

STEP 10 ▸▸

STEP 11 ▸▸

bridge at pont-y-garth

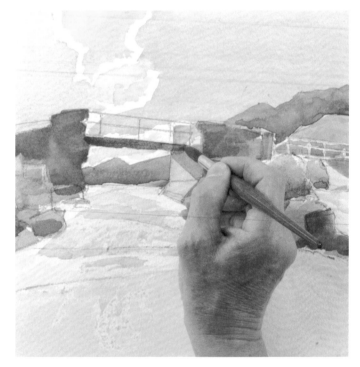

| ③ | COBALT BLUE | 40% |
| ⑪ | BURNT SIENNA | 60% |

Apply color to the underside of the bridge. Because the bridge is the focal point of the picture and is silhouetted against the sky, use a strong mix of dark colors—cobalt blue and burnt sienna.

RIGHT Paint the handrails using the same color, using the tip of the brush. Make the handrails appear asymmetrical—this gives them more visual interest than creating accurate, symmetrical lines.

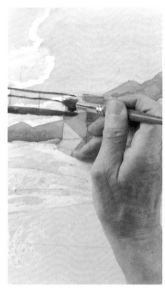

| ⑩ | YELLOW OCHER | 30% |
| ③ | COBALT BLUE | 40% |

Using wet-in-wet, create the shapes for the rocks in the river. Apply a wash of clean water to a small area then immediately drop in a mix of yellow ocher and cobalt blue. Make the mix strong as it will dissolve quickly on the wet paper. Repeat on all the river areas.

RIGHT Work in quick strokes, letting the color run. This produces the many colors you see when water runs over dark rocks. Pick up any excess with the flat brush.

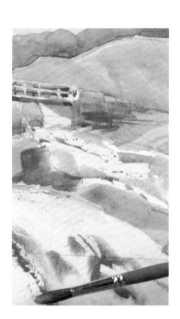

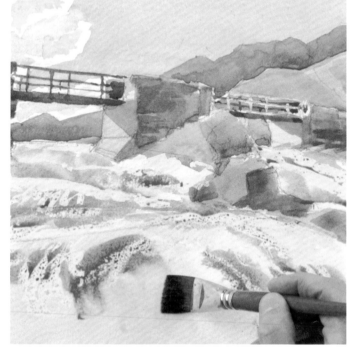

STEP 12 ▸▸

STEP 13 ▸▸

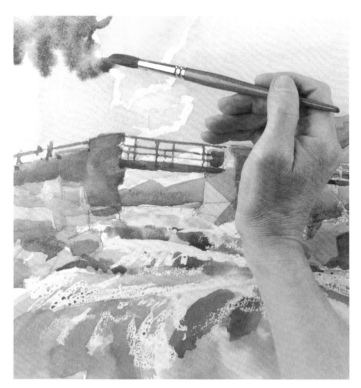

RIGHT Repeat the wet-in-wet process on the right-hand cloud using the round brush. Letting the paint spread where it will creates great depth and texture—perfect for a dramatic stormy sky.

Let all the paint dry thoroughly. Then rub the tips of your fingers over the masking fluid to remove it. It will roll up into a ball, leaving bright white paper underneath, ready to work on.

1 PAYNE'S GRAY 100%

Repeat the wet-in-wet process on the dark clouds to build up a dramatic stormy look. Apply clean water on the top half of the cloud area then add Payne's gray with the round brush. The color will not run beyond the edge of the wet area.

RIGHT Again, pick up any excess paint and water by gently dabbing it with the flat brush, but don't be too fussy.

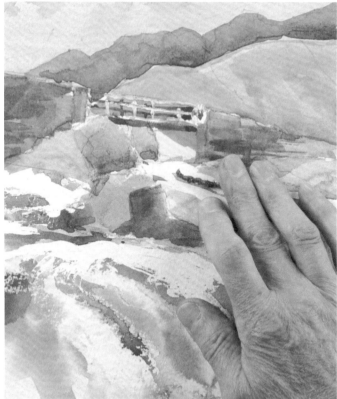

STEP 14 ▶▶

STEP 15 ▶▶

6
bridge at pont-y-garth

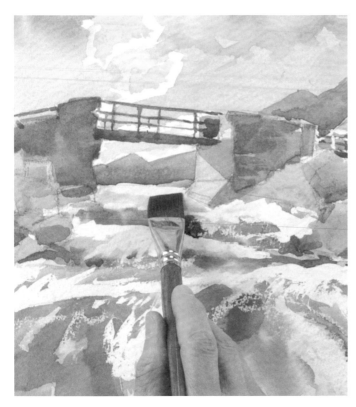

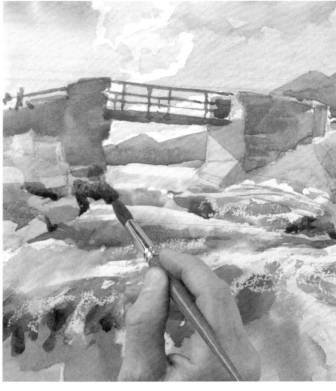

Start to work more color into the river. First, apply clean water over the hard edges of paint created by the masking fluid using the flat brush. Doing this softens the edges and adds to the feeling of moving water. This technique is called working wet-on-dry.

● ▬▬▬ PAYNE'S GRAY 100%

RIGHT Build up color by adding a light wash of Payne's gray. This brings all the colors together while still reflecting the color of the sky.

● ▬▬▬ PAYNE'S GRAY 100%

Work color into the river near the bridge using a strong mix of pure Payne's gray. This creates extra areas of shadow and contrasts with the lighter gray washes. Work fairly accurately with the round brush—your color build-up should be subtle, or else the dark colors will be the first things the viewer will see.

TRICK OF THE TRADE

As you build up your colors, no matter what technique you are using, take a step back from your painting to see how you are progressing. It is easy to get caught up in the fine detail and to forget to check how well you are capturing the essence of the overall scene. Too much detail will also detract from the focal point.

STEP 16 ▸▸

STEP 17 ▸▸

In the same way, work around the river adding the same dark color to the rocks. Be careful not to add too much. As before, the color is intended to be an accent shade only, to indicate dark rocks sticking up above the level of the water.

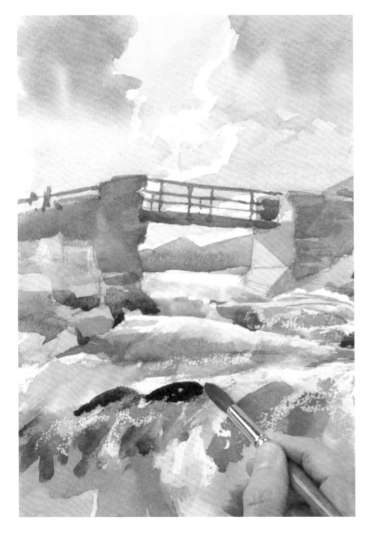

Clean up any detail around the handrail with the mix you used previously on this detail. Also use the same color to add small areas of detail to the brickwork behind the railing.

1		PAYNE'S GRAY	80%
3		COBALT BLUE	100%

RIGHT Finish off the composition by adding a cool blue reflection to the stonework on the underside of the bridge. Use a light mix of Payne's gray and cobalt blue for this—a perfect color for a reflection cast by water.

STEP 18 ▸▸

STEP 19

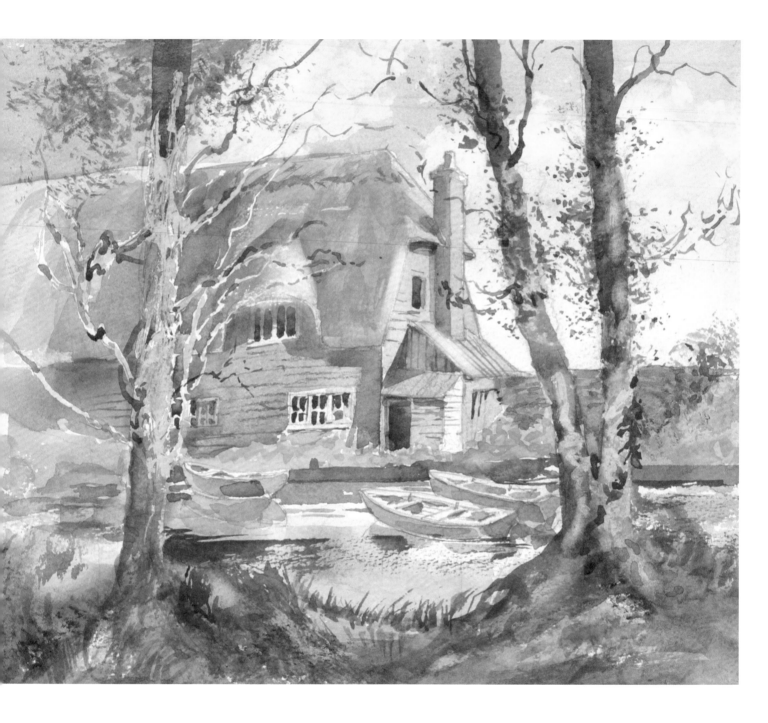

7
constable's granary

john barber
16 x 20 in (400 x 500 mm)

Old buildings often look as though they have grown out of the same ground as the trees and fields that surround them, and the granary in this project is an exercise in recreating this idea. First, you will see how to develop a visually interesting scene, with a view point that leads the eye through the trees to the building beyond. Buildings are brought to life by detail, so practice working accurately with your brush. It is also important that man-made objects blend with their natural environment, so try to achieve consistent tones with your colors. Lastly, the varied brushwork and techniques in this project create lots of textures and depth, to further breathe life into your work.

TECHNIQUES FOR THE PROJECT

Laying a graduated wash
Working with a dry brush and lifting off
Sponging

WHAT YOU WILL NEED

Rough surface watercolor paper
Graphite pencil, 6B
Masking fluid
Old, small round brush, synthetic
Flat brush, 1in (2.5 cm), sable or synthetic
Hog hair brush
Round brush, no. 5 or 6, sable or synthetic
Kitchen paper and natural sponge

COLOR MIXES

1 Payne's gray
2 Prussian blue
3 Cobalt blue
5 Permanent rose
8 Cadmium yellow
10 Yellow ocher
11 Burnt sienna

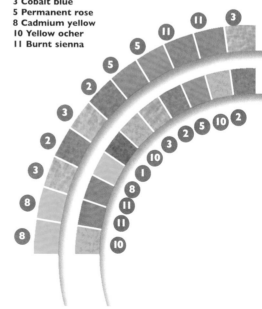

SPONGING WITH NATURAL SPONGE

A natural sponge is a great tool for any painter. Buy the largest one you can afford and treat it carefully: it will serve you for a lifetime. When you touch the painting with different parts of the sponge, you will get a great variety of small marks. By turning the sponge each time before putting it on the paper you will avoid any impression of "printing" or repetition of marks. The surface of the sponge is formed from many small cone-shaped points, each of which acts as an individual brush. When using a sponge mix up plenty of paint and make it stronger than you would for brush painting. Do not wet the sponge before putting it into the paint as this will dilute the crispness of the marks it makes. You will soon learn what sort of marks you get from different parts of your sponge and see where they can be applied to your picture. Sponge textures are useful on walls, trees, rocks, broken earth, paths, and many other features in your painting. Test it on scrap paper first to see what marks appear.

A wet sponge is ideal for removing paint or even wiping over a whole picture and leaving a pale trace of color for you to start working on again. When you have finished, wash your sponge under a tap.

1 Before using the sponge on a painting, try using it on various shapes that you have drawn as flat washes. Take a large mop brush and paint the shape of a tree, for example. This does not have to be a perfect flat wash.

2 It is good to let some drips dry along the bottom edge to give some modeling to your tree shape. There is no need to pencil the tree first or to copy the example closely. Even with a simple exercise like this it is better if you draw from nature.

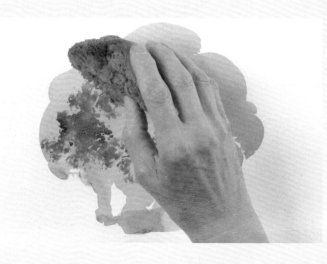

3 Once you have decided on your tree shape, let it dry completely. This basic wash should not be too dark otherwise the sponge marks will not show clearly on it. Add more paint to your mix, ready to start sponging.

4 Dab the sponge into the stiff paint and test on scrap paper. If you like what you see, dab lightly on your painting. Hold the sponge so that it just touches the paper. Repeat with a bouncing movement. Do not press or you will get one large blot.

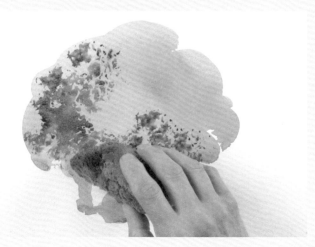

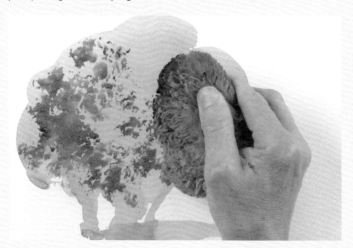

5 At first, keep your sponging to the dark side of the tree. Look at your first marks and judge whether you need more texture. As the paint dries on the sponge, it will make more delicate marks. Use this to add texture to the lighter side too.

6 Continue dabbing and rolling the sponge. Experiment until the sponge makes no more marks, or stop when the work is dry, then load your sponge and continue. Try dabbing on a wet wash with the sponge to make your textures fade and soften.

7
constable's granary

REMEMBER

Masking out is a valuable tool to use here. Apply it to the tree on the left-hand side. This is because you do not want the color applied to the granary to get caught up with the color of the tree. So masking out can also be used as a method for keeping two sets of colors separate so they can be worked on at different times.

Using the soft graphite pencil, lightly sketch in the lines for your composition, keeping your grip on the pencil relaxed. Some of the lines need to be fairly accurate, such as the lines for the granary, while others can be looser, such as the branches of the trees. Then work back over the most important lines, such as the roof line and the chimney of the granary.

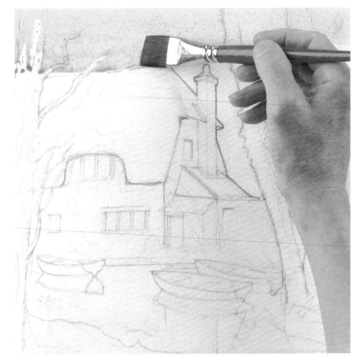

2 PRUSSIAN BLUE 100%

3 COBALT BLUE 100%

Apply the masking fluid with an old brush, then apply a flat wash of cobalt blue and Prussian blue to the sky using the flat brush, working in horizontal bands from the top down. As you get closer to the horizon, dilute the color with more water. This creates a graduated wash.

RIGHT Dab away some of the wet paint with kitchen paper. This is called lifting off, and here, it is perfect for creating the uneven textures of white clouds.

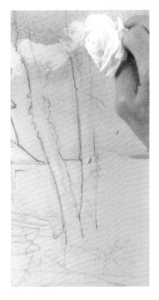

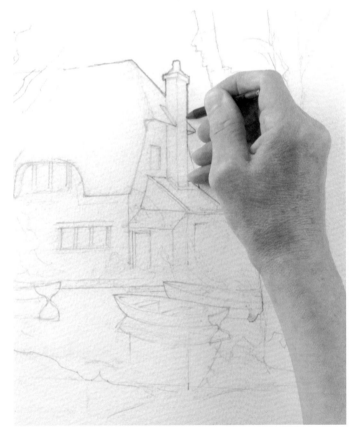

STEP 1 ▸▸

STEP 2 ▸▸

Lifting off the paint will, however, produce some hard edges on the clouds. To blend the sky and the clouds together, wet the hog hair brush with water and scrub it over the hard edges, soaking up the excess water with kitchen paper. The clouds should now have plenty of texture and depth.

BE CONFIDENT

Use the biggest brushes you can manage on a subject like this and live with the marks that they make. This will make your work lively and help you to be more confident in the way you handle the paint. A few dribbles of paint that you did not intend may give your art just the texture it needs.

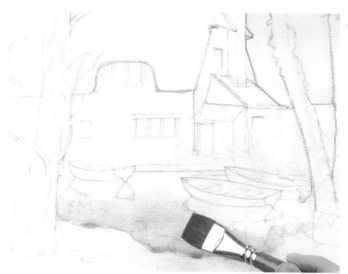

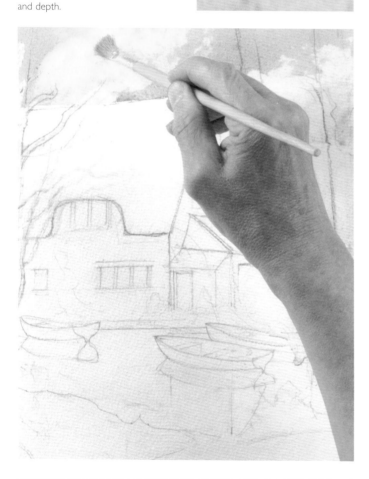

Since any expanse of water will partly reflect the color of the sky, apply the same blue mix that you used on the sky to the river, using the wet-in-wet technique. With the flat brush, apply a layer of clean water to the bottom section of the river area, then drop in the blue mix.

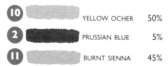

10	YELLOW OCHER	50%
2	PRUSSIAN BLUE	5%
11	BURNT SIENNA	45%

RIGHT Apply a flat wash of burnt sienna, yellow ocher, and a touch of Prussian blue to the roof of the house. The masking fluid will stop some of the paint reaching the paper underneath. Do not let the paint cross the pencil lines.

STEP 3 ▸▸

STEP 4 ▸▸

constable's granary

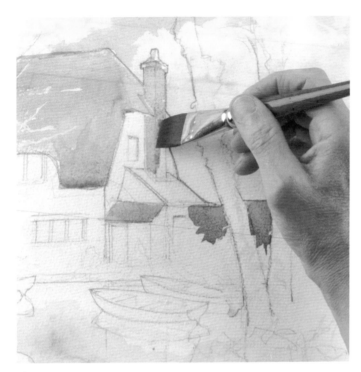

3 ◼◼◼◼ COBALT BLUE 20%

5 ◼◼◼◼ PERMANENT ROSE 80%

RIGHT Color the front wall of the granary using a mix of permanent rose and cobalt blue to create a warm violet color.

1 ◼◼◼◼ PAYNE'S GRAY 80%

Lighten this mix with a little more water and apply it to the end wall, which is in light. Then add shadow under the eaves and to the edges of the building using Payne's gray. Notice how the tonal values of all the colors used on the granary are the same strength.

5 ◼◼◼◼ PERMANENT ROSE 55%

11 ◼◼◼◼ BURNT SIENNA 40%

Start building up colors on the granary. Apply burnt sienna to the small roof and wall to the right of the building, using a slightly more dilute mix for the roof. Then add permanent rose to the burnt sienna and apply this pinker color to the chimney.

2 ◼◼◼◼ PRUSSIAN BLUE 100%

5 ◼◼◼◼ PERMANENT ROSE 55%

RIGHT Use permanent rose and Prussian blue for the roof under the chimney. This creates a good contrasting color.

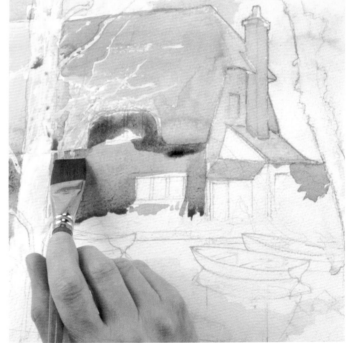

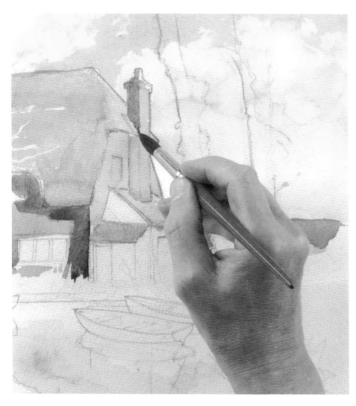

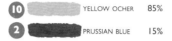

RIGHT The rooms inside the granary are unlit and so appear very dark. Use Payne's gray for these areas.

| 10 | | YELLOW OCHER | 85% |
| 2 | | PRUSSIAN BLUE | 15% |

Using wet-in-wet, apply the wash you used on the walls of the house on the river—the water reflects the color of the building. Do this by applying a wash of clean water and dropping the violet-colored mix into it. Then mix Prussian blue and yellow ocher for the grass and bushes.

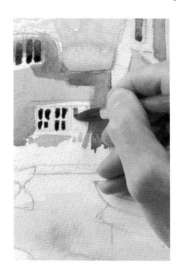

Continue to build up shadow on the house using the round brush for more accurate work. Keep your shadow areas consistent throughout. Here, we have used a mix of permanent rose, cobalt blue and Payne's gray to shade the front edge of the chimney.

RIGHT Continue the coloring process, working around the front of the granary. Use yellow ocher on the front of the small shed and gate.

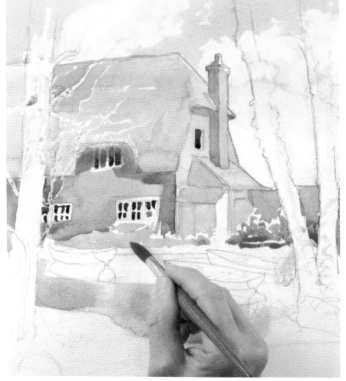

7
constable's granary

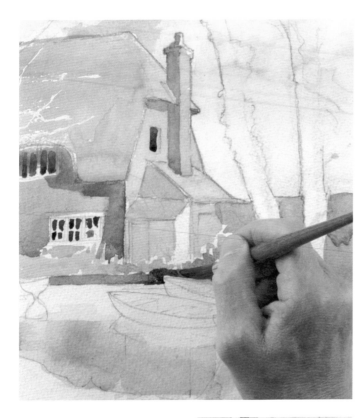

1		PAYNE'S GRAY	30%
3		COBALT BLUE	70%

RIGHT The building is the focal point of the painting, so keep the color of the boats paler. Use a light mix of cobalt blue and Payne's gray for the sides of the first boat.

Use a darker mix of the same colors for a touch of shading on the sides of the boat as well as some internal detail. Note how much of the boat is left uncolored to maintain the muted look.

Now you can start adding areas of detailed color. The dark wooden boards along the edge of the river are colored with a mix of the green you used on the grass and bush, and permanent rose.

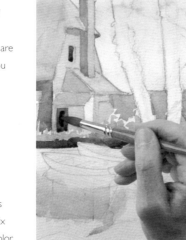

RIGHT Also use this color for the small door. Make sure your painting is very accurate in these areas—the mix should not run into other areas of color.

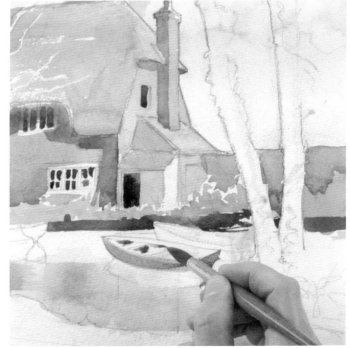

STEP 9 ▶▶

STEP 10 ▶▶

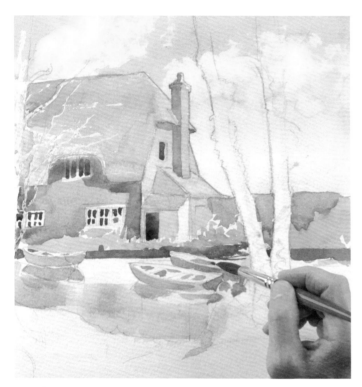

RIGHT For speed, try blowdrying your work to dry the paint quickly. Be careful not to blow any drips of paint around, however, as you may end up with unwanted paint in some areas.

Use the dry brush technique again on the thatch, using a slightly grayer mix of cobalt blue and burnt sienna. This will give extra texture to the thatch and emphasize any curved areas, such as those over the top windows.

8 CADMIUM YELLOW 40%

2 PRUSSIAN BLUE 60%

Build up reflections in the water by adding a little of the same gray mix to the river, just alongside the boat. Then, for variety, color the other boats, using a light mix of Prussian blue and cadmium yellow.

RIGHT Continue with the reflections by adding the green mix you used on the grass to the river using the dry brush technique. Load the brush with only a little paint and rub it across the surface of the paper.

STEP 11 ▸▸

STEP 12 ▸▸

TRICK OF THE TRADE

When sponging paint onto the paper, create plenty of strong color by mixing less water with more color than usual. Apply the color with a dry sponge, rotating it slightly in your hand before each dab. This will ensure a variety of marks and avoids a repetitive "printing" effect.

Add a little more Payne's gray to your mix, then apply the color to the tree on the right of the painting. Lift off some of the excess paint with a piece of kitchen paper but don't do this along the entire length of the trunk. This way you will get lots of different textures—perfect for an old tree.

3	COBALT BLUE	20%
11	BURNT SIENNA	80%

Finish the thatch on the roof with a darker mix of burnt sienna and cobalt blue around the tree. Add some small touches of detail to the roofline.

1	PAYNE'S GRAY	30%
3	COBALT BLUE	20%
11	BURNT SIENNA	50%

RIGHT Start coloring the trees. Here, we have used a mix of Payne's gray, cobalt blue, and burnt sienna on the tree trunk. Work the brush down from top to bottom, over the masking fluid, using the dry brush technique.

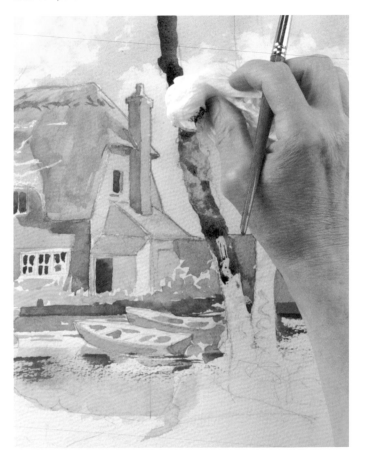

STEP 13 ▸▸

STEP 14 ▸▸

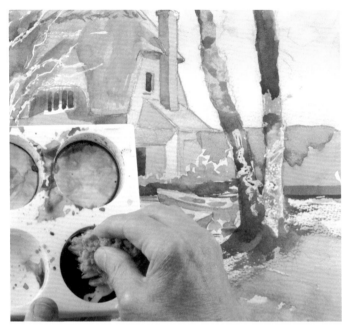

Let the paint dry thoroughly (use the hairdryer if necessary) then remove the masking fluid from the tree trunks. Make sure your hands are clean, then rub the pads of your fingers over the dry fluid. It will start to come off, balling up as it does so. The paper underneath should be white.

TRICK OF THE TRADE

Try using the sponge on both dry and wet washes. The sponged texture will stay crisp and dark on a dry surface but will spread softly and grow paler on a wet one. Wet the sky slightly then lightly sponge some green color onto the wet surface. Allow it to dry, then dab on the same color again. The result will be a fine variety of small leaves.

8	CADMIUM YELLOW	40%
3	COBALT BLUE	40%
11	BURNT SIENNA	60%

Create a muted foreground under the trees with cadmium yellow, burnt sienna, and cobalt blue, applied with a dry brush. Then mix Prussian blue, yellow ocher, and cadmium lemon to create a strong dark green for the foliage. Dip a natural sponge into the mix for the sponging technique.

RIGHT Press the sponge onto the paper, working along the length of the tree trunks. This hints at the foliage growing on the trees.

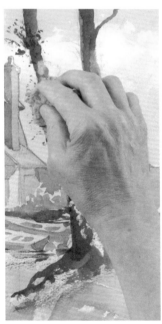

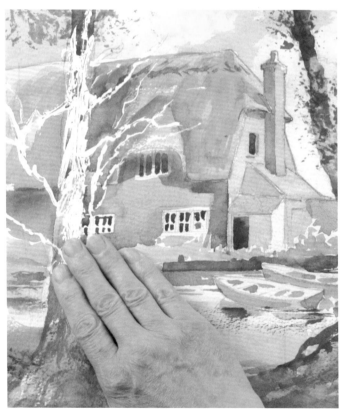

STEP 15 ▶▶

STEP 16 ▶▶

7
constable's granary

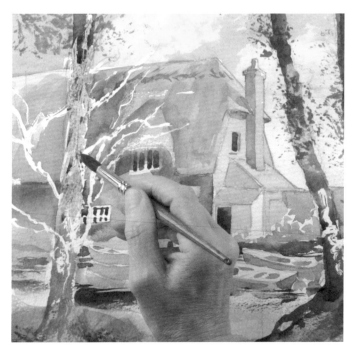

	BURNT SIENNA	55%
	COBALT BLUE	45%

Start working on the white areas left by the fluid to create new shades and textures. Use a light mix of cobalt blue and burnt sienna. Notice how the light area on the trunk deliberately falls in front of the building, so the building always remains the focal point. Use the round brush here.

RIGHT Add extra spots of color to the foliage by adding Payne's gray to the mix. Don't add too many extra leaves or the overall look will be too dark.

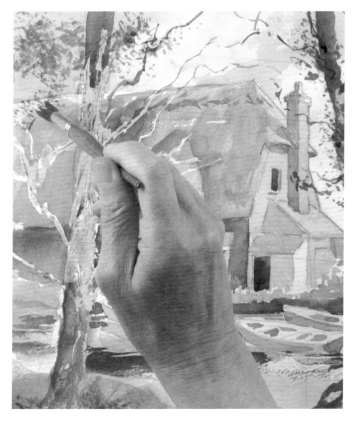

Add a final touch to the foliage on the trees with the dry brush technique. This time, however, instead of rubbing the brush over the paper, dab it tip first onto the paper so the hairs spread out. The small, random shapes this creates gives a good impression of foliage.

TRICK OF THE TRADE

If you feel unhappy with any part of your picture, sponge off the color with clean water. Your work will not disappear but will remain as a paler version of what was there before, enabling you to work it up again to harmonize it with the rest of the picture. Many of J.M.W. Turner's great watercolors were created in this way.

STEP 17 ▶▶

STEP 18 ▶▶

RIGHT Finish the granary with some fine, textured detail. Apply very thin lines of Payne's gray across the exterior of the building.

9		CADMIUM YELLOW	40%
10		YELLOW OCHER	40%
2		PRUSSIAN BLUE	20%

Build up color and detail on the foreground using the flat brush and a dark mix of cadmium yellow, yellow ocher, and Prussian blue. This is a good color for the dark grass around the base of the trees and at the edge of the water.

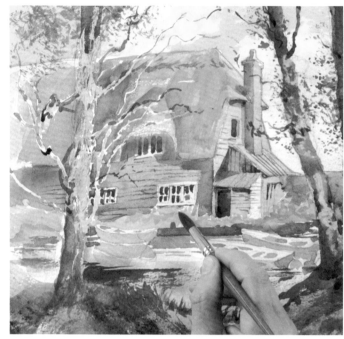

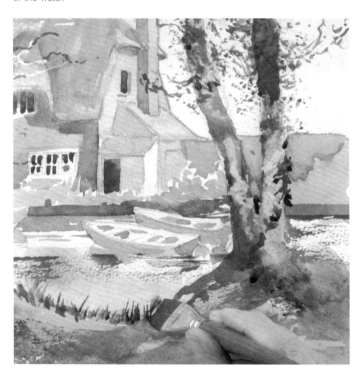

| 9 | | CADMIUM YELLOW | 40% |

Add a thin line of cadmium yellow with the round brush to brighten the foliage next to the granary. This is an effective accent color that creates a break between the building and the river.

RIGHT Lastly, lift off some of the dark foreground paint to create a stronger contrast between light and shade. Dip the hog brush in some water and scrub it over the darkest areas, such as at the base of the trees. Lift off the excess paint and water with some kitchen paper.

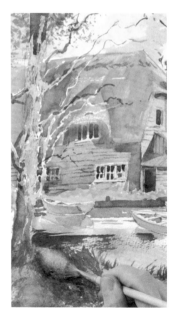

STEP 19 ▶▶

STEP 20

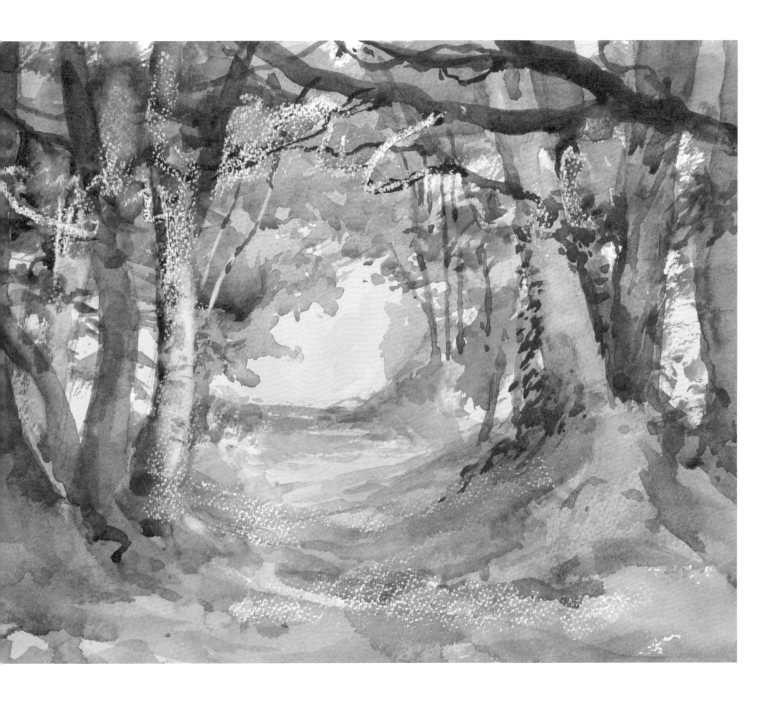

8
woodland glade

john barber
16 x 20 in (400 x 500 mm)

Trees and foliage are one of the most popular subjects for watercolor painting, yet are among the hardest to get right. The myriad numbers of leaves and branches all reflect different intensities of light and their shapes merge into one another in countless ways. This project shows you how to get the best from woodland scenes by demonstrating how to construct the basic shapes that characterize the natural environment. It then shows you how to build up the large number of tones that, added together, create the broad areas of color you see when you look at woodland. Last, it shows ways of picking out highlights and creating areas of contrast to add visual interest to your work.

WHAT YOU WILL NEED

Rough surface watercolor paper
Soft graphite pencils, 6B and 4B
Wax candle
Mop brush, sable or synthetic
Flat brush, 1in (2.5 cm), sable or synthetic
Round brushes, no. 5 or 6, sable or synthetic
Hog hair brush
Kitchen paper, natural sponge, and craft knife

COLOR MIXES

1 Payne's gray
3 Cobalt blue
8 Cadmium yellow
11 Burnt sienna

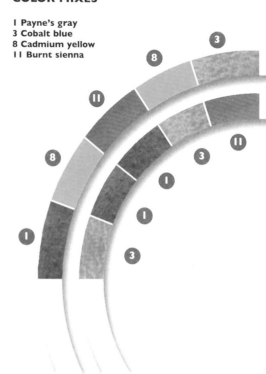

TECHNIQUES FOR THE PROJECT

Masking out with wax
Working wet-in-wet
Working with a dry brush

WORKING WITH A DRY BRUSH

By applying an almost dry brush to a dry flat wash, the brush hairs and the surface of the paper will give broken lines or spots of color. These can be used to create interest in flat areas, to model forms to give the impression of solidity, or indicate a third dimension. Old brushes are often useful in this technique as the hairs spread and deliver many fine dots. Wipe the side of the brush on your scrap paper until the hairs fan out so each hair can make a separate mark. You can also buy a fan brush, which has the hairs permanently spread out by a flat metal ferrule. These are very useful for depicting fur or foliage.

Experiment with swift strokes, barely touching the paper, or hit straight down on the paper, which makes marks with the sides of the hairs. In this technique you can work up fine detail and control tone accurately. If you overwork an area, you can dampen it and start again. Albrecht Durer (1471–1528) was a great master of dry brush detail but the American, Andrew Wyeth, has taken the technique even farther in our own time. As with all the techniques of painting, much can be learned by copying and from this you will learn what you need for your own personal style.

1 Apply a fairly pale wash to rough paper using a flat brush. You are not aiming to lay a smooth wash, just a background tone. You will notice that if you use a quick brush stroke, small amounts of air are trapped under the brush.

2 The edges of the paint break up on the texture of the rough watercolor paper. This is already painting in the dry brush manner, distinctly different from the crisp edge of flat washes. This can be clearly seen on the right of the illustration.

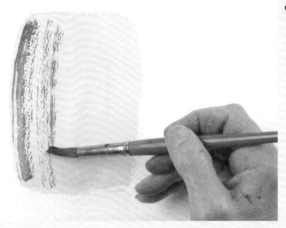

3 Make sure your background patch is dry before you begin overlaying dry brush marks. Dip a round brush in a darker wash and partly dry it on some kitchen paper. Using the side of the brush, pull it swiftly down the paper, without pressing hard.

4 Repeat this stroke many times until you get control over three things: the dryness of the brush, the pressure on the brush, and the speed of the brush movement. Practice will give you confidence in your work.

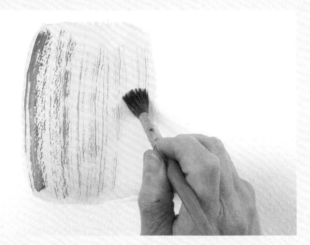

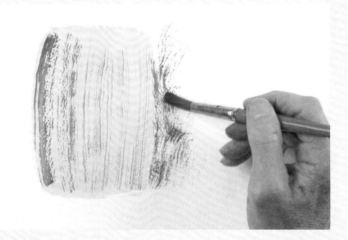

5 In this illustration, you will see how the brush is flattened to a fan shape so that each hair acts as a separate tiny brush. On smooth paper, this will produce fine continuous lines but here they are broken by the surface of the paper.

6 Begin to work toward the right, onto the white paper. Note the kind of textures your brush is making. Use the point of the brush as well as scrubbing with the side. Continue making marks until no more paint comes off the brush.

8
woodland glade

Sketch your scene with the soft graphite pencil. Keep your lines loose and relaxed for this sketch, only capturing the outlines of the main trees and loosely marking out areas of dense foliage. It is best not to try to sketch every leaf and branch—you are trying to capture an impression of what you are seeing, rather than record every detail.

REMEMBER

Because of the changing nature of dense woodland, no two artists will ever paint it in the same way. So it is best to regard this project as a way of working rather than something to be copied. This is exactly what will make your painting more personal and, with practice, will form the basis for your own unique style.

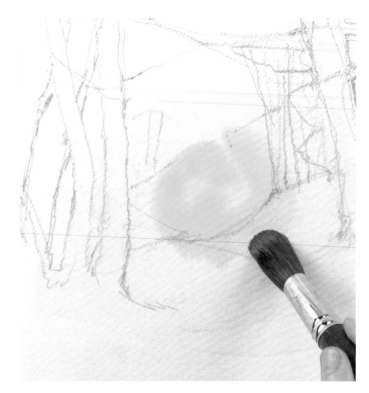

9 CADMIUM YELLOW 100%

Start painting the central area of your sketch—the focal point—with the mop brush. Lay down an area of clean water, then drop in some cadmium yellow, wet-in-wet.

RIGHT Mask out areas on the upper part of the foliage with the wax candle. Rub the candle over the paper in various random lines. This gives a deliberate "accidental" coverage rather than precise lines.

STEP 1 ▶▶

STEP 2 ▶▶

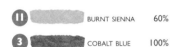 BURNT SIENNA 60%

COBALT BLUE 100%

Paint over the top part of the sketch with a mix of cobalt blue and burnt sienna. This produces a gray-green color, darker than the lighter yellow in the center. Apply darker colors closer to the edge of the painting to lead the viewer's eye into the middle of the image.

BE CONFIDENT

In a scene like this where the slightest breeze or change of light can alter everything you see, use the brush freely to capture a quick impression. Try loading the brush and using the curved side instead of the point, letting it roll on the paper. Relax your grip on the handle and be surprised by the results.

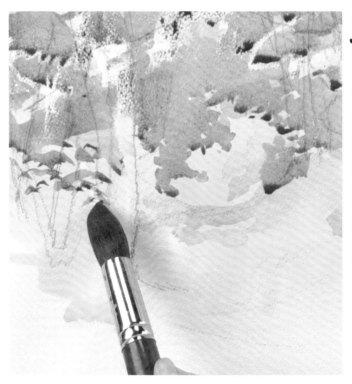

STEP 3 ▶▶

With the tip of the brush, add dabs of the gray-green mix over the top of the cadmium yellow to create a further green shade. This can be done fairly randomly, but don't overdo it. It is also a good way of practicing creating small areas of detail with a big brush.

RIGHT Build up color over the yellow by diluting the gray-green mix and applying it loosely with the flat brush.

STEP 4 ▶▶

8
woodland glade

🎵 ████████ BURNT SIENNA

RIGHT Apply different strengths of the same warm mix to the left-hand tree trunks, sometimes covering the whole of the trunk, sometimes just covering one edge. The mix on this trunk has more burnt sienna added for a redder look.

Dilute the red wash to create a different tone and apply this to the right-hand trunks. Overall, aim for a uniform color scheme that has interesting variations in tone.

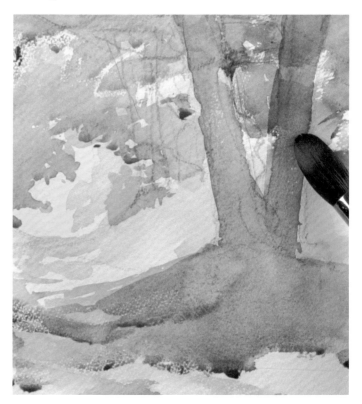

Add more burnt sienna to the gray-green mix to create a warmer shade and apply this to the bottom of the scene, wet-in-wet. Lay down a wash of clean water over the bottom of the painting and drop the warmer color into it using the mop brush.

RIGHT Notice how a variety of colors are created by the wet-in-wet technique, depending on where the paint runs over the different base colors. These variations create the vast range of tones you see when you look at woodland.

STEP 5 ▶▶

STEP 6 ▶▶

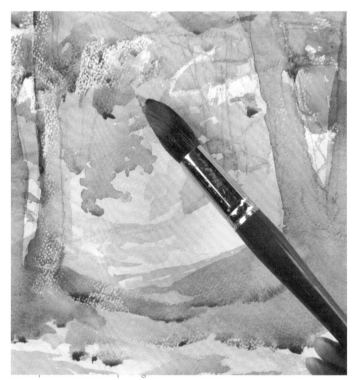

RIGHT Another way to create new colors is to mix together paint that is still wet on the paper. If you use the point of the round brush, you can also use this opportunity to create new shapes on the paper.

Take a step back from your work and see which areas need more work. Here, we have worked more color into the foliage at the bottom of the painting with the flat brush.

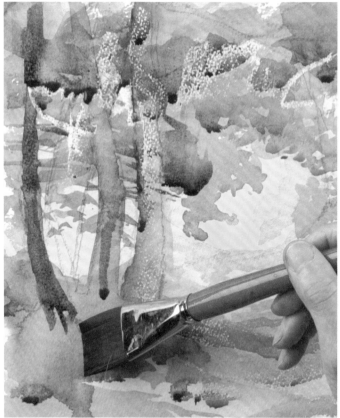

with the gray-green color you mixed earlier, but instead of applying another wash, use the dry brush technique. To do this, load the brush with only a little paint and drag the side of it over the paper. The rough surface will pick up the paint.

3 COBALT BLUE

RIGHT Add more cobalt blue to the mix and dip the edge of the flat brush into it. Edge paint onto the paper to form a series of short horizontal lines. These lines break up the more rounded vertical shapes.

STEP 7 ▶▶

STEP 8 ▶▶

8
woodland glade

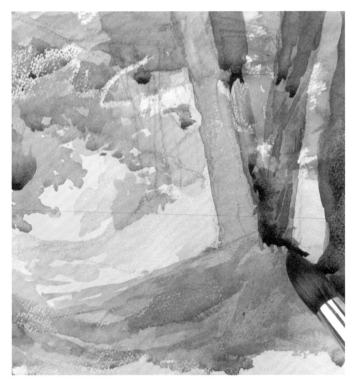

		BURNT SIENNA	60%
8		CADMIUM YELLOW	5%
3		COBALT BLUE	35%

RIGHT With the round brush, build up color in the middle of the painting using a light mix of cobalt blue, burnt sienna, and a touch of cadmium yellow. Again, graduate any hard edges in this part of your work and add some more detailed foliage with the point of the brush.

| | | BURNT SIENNA |

Add a little more burnt sienna to the mix and, using the dry brush technique, work more color into the base of the trees, again using the round brush.

 PAYNE'S GRAY

Darken the gray-green mix with Payne's gray and add this shadow color to selected parts of the painting, such as the base of the tree trunk, using the mop brush. These are the first of the dark shadows so use them sparingly—you can always add more later.

RIGHT Dilute this dark color slightly and use it to work up more shadows and to graduate any hard edges onto the tree trunks on the left-hand side of the image.

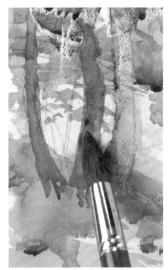

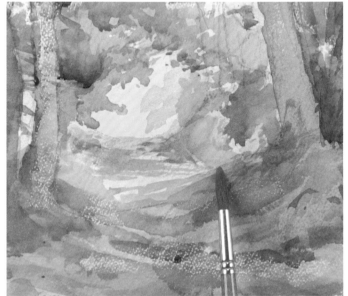

STEP 9

STEP 10

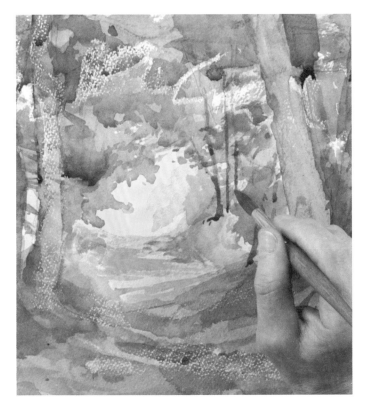

RIGHT Again, take a step back and decide where color needs to be built up further. Here, we have added more Payne's gray to the same mix, creating a dark color for the tree trunk on the left.

Touch up other areas around the tree trunks with this color. Notice how many colors are overlaid on top of each other and how this process creates the vast number of tones you need for a convincing painting.

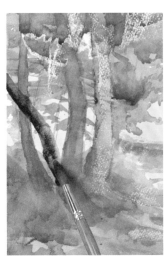

As well as constantly building up shades and colors, you can start adding small areas of detail. Add a little more cobalt blue, burnt sienna, and water to the same mix and paint on some thin vertical lines to indicate background trees. Hold the brush like a pen for accuracy.

RIGHT Work the paint down into the swirl of color in the middle of the image. This ties the bases of the trees neatly to the rest of the composition.

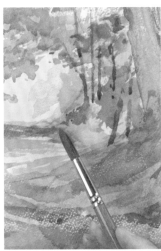

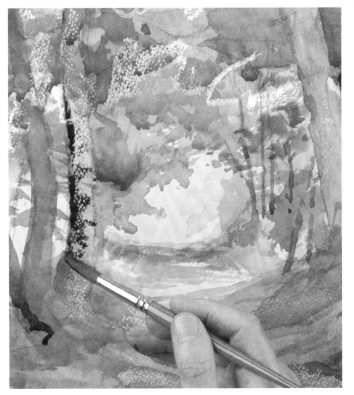

STEP 11 ▶▶

STEP 12 ▶▶

8
woodland glade

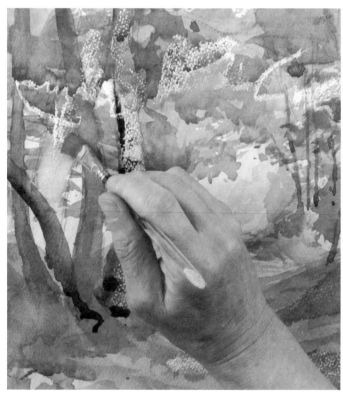

 PAYNE'S GRAY

Add some more texture to the trunks using a little Payne's gray. Then work your way around your artwork adding any extra areas of detail with the round brush.

TRICK OF THE TRADE

If you need to lighten an area of paint, like a tree-trunk, use a flat, short-haired hog or bristle brush (as used in oil painting) on wet paper. Work the brush backward and forward using the narrow edge like a small scrubbing brush. You may have to repeat this several times.

Create some lighter accent areas on the background. To do this, dip the hog hair brush in clean water and rub it over the paint. This will lift off the paint.

RIGHT Dab away areas of excess water with some kitchen paper. Work your way up the tree trunk, lifting off as you go. This creates the idea that a shaft of light has fallen between the branches of the trees and is highlighting one of the trunks.

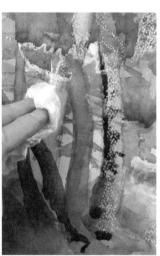

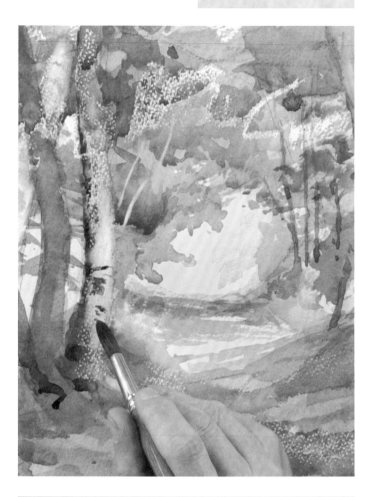

STEP 13 ▶▶

STEP 14 ▶▶

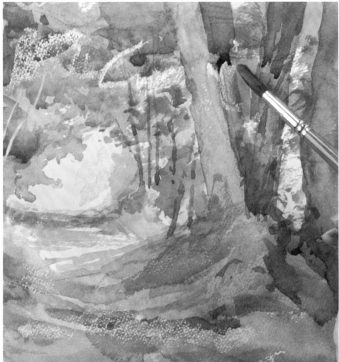

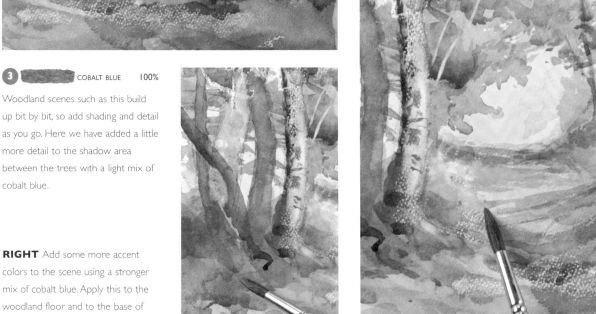

11 BURNT SIENNA 60%

Warm the scene with a light mix of burnt sienna, adding it to the bottom edge of the middle area. Putting this warmer color here helps lead the viewer's eye to the center of the scene.

TRICK OF THE TRADE

Dip an old toothbrush in paint and pull a brush handle across the bristles to spatter spots of paint onto your work. Mask all other areas to prevent the paint ending up in unwanted places. This technique is ideal for foliage and small flowers, with dozens of leaves and petals created in barely a few seconds.

3 COBALT BLUE 100%

Woodland scenes such as this build up bit by bit, so add shading and detail as you go. Here we have added a little more detail to the shadow area between the trees with a light mix of cobalt blue.

RIGHT Add some more accent colors to the scene using a stronger mix of cobalt blue. Apply this to the woodland floor and to the base of the tree trunks on the left-hand side.

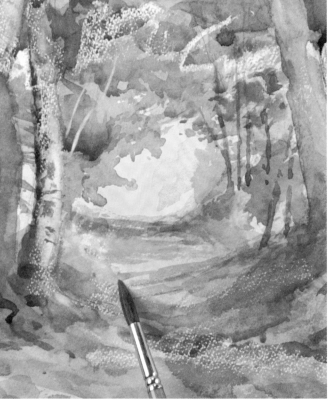

STEP 15 ▸▸

STEP 16 ▸▸

8
woodland glade

I	PAYNE'S GRAY	20%	
II	BURNT SIENNA	40%	
3	COBALT BLUE	40%	

RIGHT Mix some burnt sienna, cobalt blue, and Payne's gray. This creates a strong, dark color, perfect for creating foreground branches. Start by adding these in the top left of the painting.

Add more branches across the top right of your work. Paint them on in a variety of shapes and sizes. Add a little Payne's gray to the mix as you work to increase the variety of colors in this part of the image.

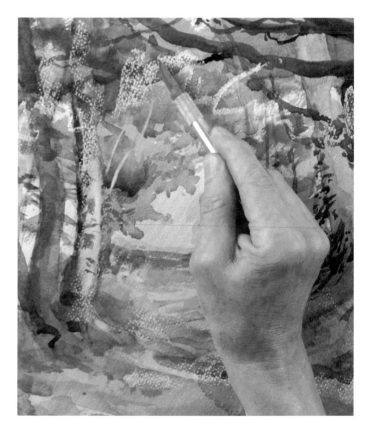

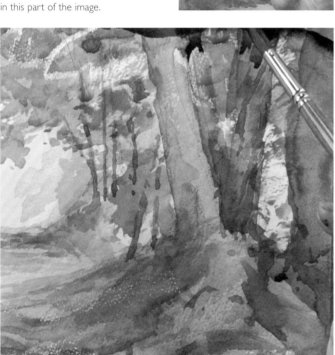

I	PAYNE'S GRAY	
3	COBALT BLUE	

Add some dashes of Payne's gray and cobalt blue to the tree trunks to indicate ivy, then scratch off small areas of paint with a craft knife. This is another technique for clearing an area of paper that is covered by several washes so you can build up finer detail with a smaller brush. Here, we have scratched off some small lines that can be worked up into branches.

TRICK OF THE TRADE

Try gently rubbing the paint on areas that have been overworked with a piece of fine sandpaper. This will bring up little specks of sparkling white paper, ideal for creating lots of areas of reflected light in one go. You can add a color wash over this if the effect is too obvious—the scratched spots will absorb the paint again.

STEP 17 ▸▸

STEP 18 ▸▸

RIGHT Fill in the scratched off areas you have just created with a mix of Payne's gray, burnt sienna, and cobalt blue. Use the tip of the brush to carefully add in the new branches.

You don't always have to build up color with paint and a brush—a 4B pencil works well for creating defined areas of detail, especially over the masked-out wax areas.

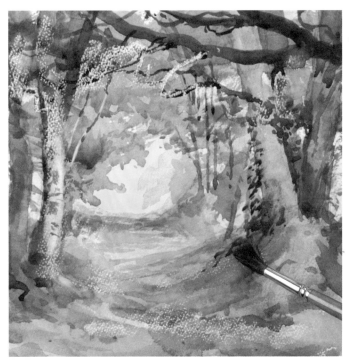

Because the painting is constructed of so many applications of color, you are bound to end up with some hard edges. Soften these with the edge of a round brush and a little water.

RIGHT Take a final look at your finished work and see where any areas of small detail can be added. Here, we have used the scratching off technique to create extra areas of highlight on the left-hand side of the woodland floor.

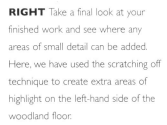

STEP 19 ▸▸

STEP 20

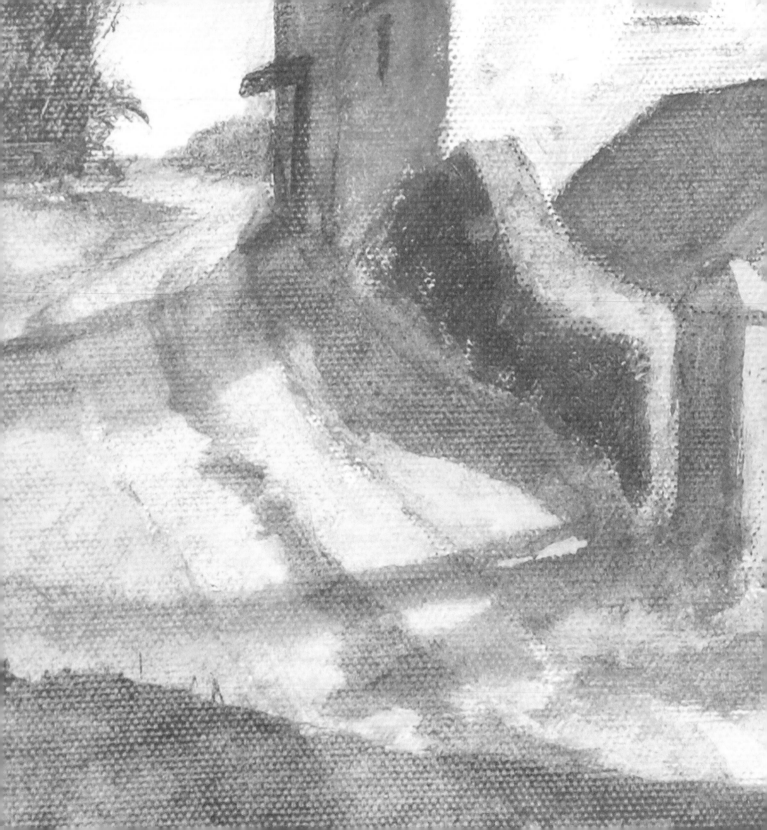

the acrylic projects

Being able to capture the essence of a scene is the skill
all artists seek to master. These projects take you step-by-step through
a wide range of different subjects, from still lifes to landscapes, using a
range of techniques that will help you develop your talent as an artist.

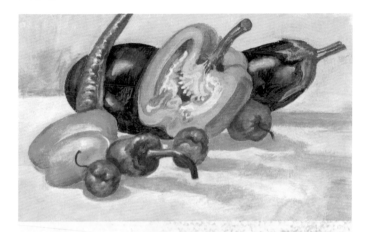

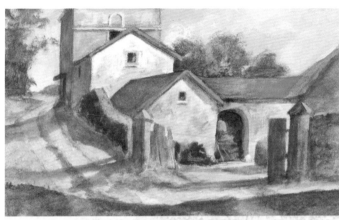

project 1 176
egglant with peppers

Arrange a group of simply shaped vegetables with a light to create highlights, then paint what you can see in front of you.

project 2 188
french farm buildings

Reduce farm buildings to a series of geometric shapes, then build the colors of crumbling masonry and roofs.

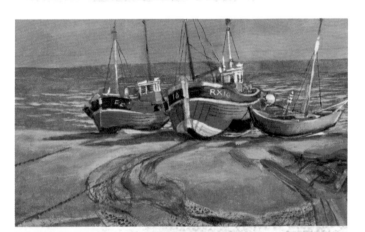

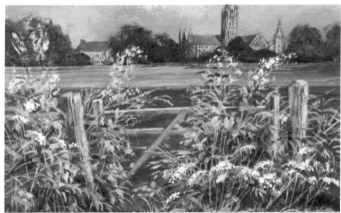

project 3 200
fishing boats

Boats are endlessly fascinating subjects for the artist. Paint the boats as simple shapes and use mixed media for the nets.

project 4 212
english meadow

Choose a low eye level to simplify architecture and concentrate the eye and your work on the flowers in the foreground.

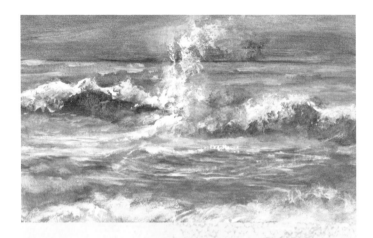

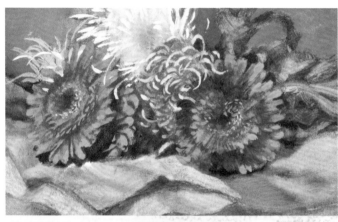

project 5 **226**
breaking wave

A combination of brush and palette knife painting is an excellent way to express the vigor and movement in the sea.

project 6 **240**
bunch of flowers

Arrange blooms of different colors and shapes, and build up color, light, and texture in a still life arrangement.

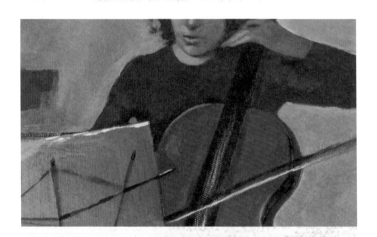

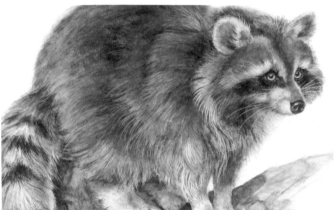

project 7 **254**
cellist

A limited warm palette, and working from dark to light, help to create simplified figures with little visual detail.

project 8 **268**
raccoon

Acrylics are the ideal medium for details of fur or feathers. Use few colors, and flick out white highlights using a scalpel.

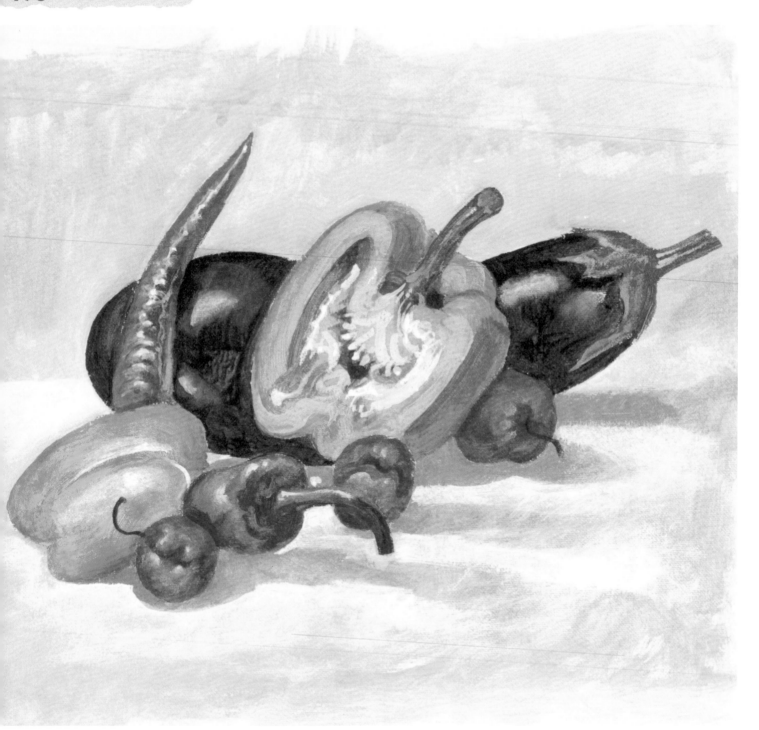

1

eggplant with peppers

john barber
9½ x 13½ in (240 x 340 mm)

Rounded, overlapping shapes, balanced by one or two profiled stems with strong contrasting colors, are enough subject matter for a still life study. If you only have a few vegetables on hand when planning your picture, slice one or more to reveal the inner surfaces and add interest and texture. Strong directional lighting will make your painting more dramatic and will show the pattern of light and shade more clearly. If you light your composition with a desk lamp, try out several angles until your still life is lit with a balance of light and cast shadows that pleases you. Arranging and painting still life subjects will teach you a great deal about balance and composition, and also develop your confidence as an artist.

WHAT YOU WILL NEED

Canvas board
Black chalk
Brushes: flat hoghairs nos 2, 4, 7, 8, and 10; round sables nos 2 and 6

COLOR MIXES

I Payne's gray
3 Burnt sienna
4 Yellow ocher
5 Cadmium lemon
6 Cadmium yellow
7 Orange
8 Cadmium red
10 Violet
12 Ultramarine

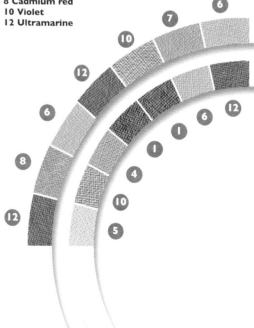

TECHNIQUES FOR THE PROJECT

Creating highlights
Arranging objects
Glazing

MODELING FORM

The technique of modeling form to suggest a third dimension is so universal in representative painting that it is almost a cliché, but the elements of middle tone, shadow, highlight, back lighting, and cast shadow are essential to such a variety of painting styles and subjects that it was used by every artist until the invention of photography. Chiaroscuro, the depiction of light and dark by shading, is the convention by which most people readily recognize objects in pictures. Brought to technical perfection, along with perspective, in the 16th century, it solved all the problems of depicting objects in space. It is not dependent on color. A green or red cow, painted in the correct tones of light and shade, would still be a recognizable cow. In preparation for tackling the still life project, go through the stages of painting a simple sphere in three dimensions. The first thing to decide in any scheme of light and shade is the position, imagined or real, of the light source. This must be checked throughout the painting. A simple device is to draw an arrow in pencil near the top of the picture to show where the light is coming from. The second is to establish the exact shape of the object and paint it in the middle tone. No amount of skill in shading will correct inaccurate drawing or make it convincing, but a correct silhouette will often save a badly modeled subject.

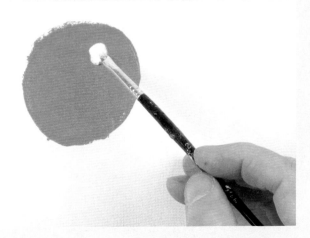

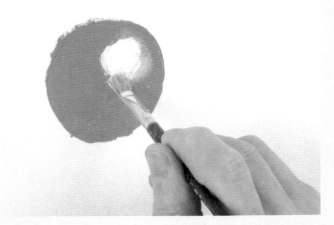

1 First put down a roughly circular disk of color for your fruit. This will remain your base color and much of it will remain untouched after this stage. Using a small, flat hoghair brush, place a spot of almost white paint at the top right.

2 Now with a larger, flat hoghair brush, which is slightly wet, work around the outside edges of your highlight, gradually making it bigger, but do not touch the center of the spot. Blend smoothly, keeping the surface damp.

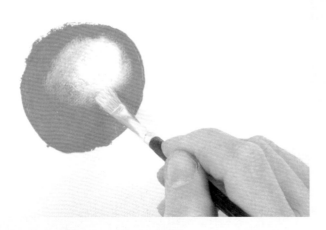

3 Gradually fade out the edge of the highlight by applying more water to your brush and blending the highlight away to nothing. Use a circling stroke for this so that the brushstrokes do not appear "stripey." Keep the light area away from the top edge.

4 Having painted the flat disk into the illusion of a sphere, you can now take your smallest hoghair brush and, opposite the source of light, which in this case, is coming from the top right, paint a curved line using your highlight color.

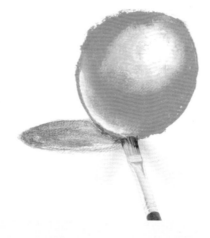

5 With a slightly larger brush, again dipped in water, blend the upper edge of the line into the dark background color. Do not let this band of color get too wide, as it will spoil the apparent roundness. If this does happen, wipe it out and start again.

6 Using Payne's gray and ultramarine, paint an oval on the left-hand side, making it darkest underneath the fruit. This will make the back-lit edge more effective. Observing where back lighting occurs will improve your painting.

eggplant with peppers

Arrange your composition, and sketch out the main lines in chalk. Look at the shapes of the objects, and the relationship between them. Look at how the objects cut into one another, and the shapes of the gaps between them to help you to draw them accurately. Once you start to paint, you can adjust the outlines of the vegetables if you find they are not quite right.

BUILDING IMPASTO

Do not be afraid of building up your color. The thickness of the paint can be part of the attraction of the finished painting. Load your brush and slide it over the canvas without pressing too hard so that the paint is left thick, and each brushmark is visible. Learn to value your marks and do not try to hide them.

| 6 | CADMIUM YELLOW | 80% |
| 12 | ULTRAMARINE | 20% |

Start by putting a flat color on all the vegetables. Paint fairly thickly from the start, using the color more or less straight from the tube, with only enough water to move it. Use the edge of a no. 10 brush and a mix of cadmium yellow and ultramarine for the long pepper. Use pure cadmium yellow for the two yellow peppers.

| 7 | ORANGE | 100% |

RIGHT Add some orange to the cadmium yellow to give it a more golden look, and use this for the outside of the pepper.

STEP 1 ▸▸

STEP 2 ▸▸

⑤ ▬▬▬ CADMIUM RED 100%

Next paint the small red chili peppers. Use pure cadmium red for these. Continue to use a large brush, no. 8, to keep plenty of vigor in your work. As you paint the third red chili, you will have the chance to clean up the profile of the yellow pepper.

SMOOTH CURVES

Try to get smooth curves when you are dealing with natural forms such as these vegetables. Their perfect smoothness and roundness, as well as their rich colors, are part of their appeal. If you are using a large brush to keep some vigor in your marks, use the corner of the brush when making detailed marks.

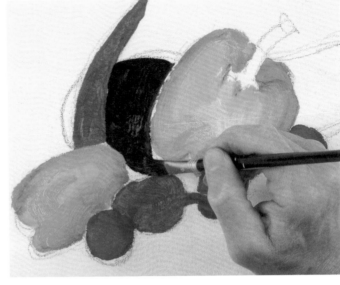

① ▬▬▬ PAYNE'S GRAY 20%

⑩ ▬▬▬ VIOLET 80%

Now mix up the color for the eggplant, which is going to be violet and Payne's gray. Leave the shape of the leaf covering and stalk at the end of the eggplant. Now draw the yellow pepper more carefully, noting the shapes within it. Go down to a smaller brush, a no. 7. Take some gold and get rid of the blank canvas between the objects.

③ ▬▬▬ BURNT SIENNA

RIGHT Go down to a no. 4 brush, and add some burnt sienna to the green used for the long pepper and add some shadow inside the cut pepper.

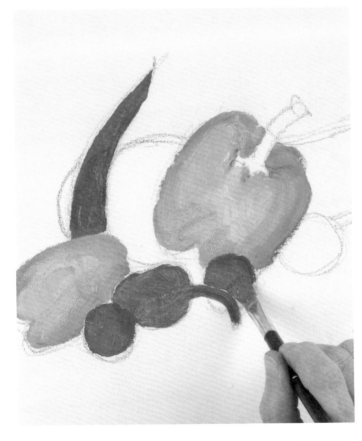

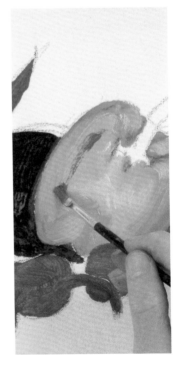

STEP 3 ▶▶

STEP 4 ▶▶

eggplant with peppers

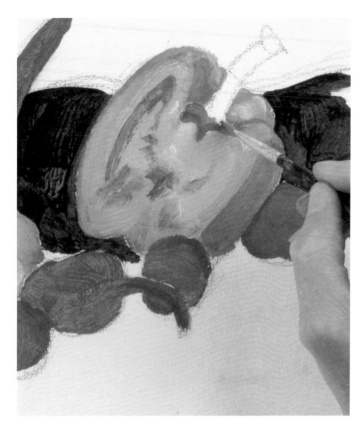

④ 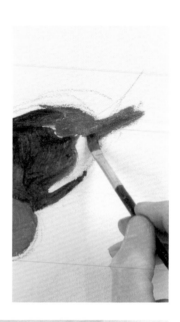 YELLOW OCHER

RIGHT Mix some yellow ocher to your green mix and use this to fill in the leaves and stalk of the eggplant.

⓪	⬜ WHITE	80%
①	⬛ PAYNE'S GRAY	10%
⑫	⬛ ULTRAMARINE	10%

Outline the whole grouping with a mix of Payne's gray, ultramarine, and white. This bluish neutral gray will help to establish the clean edges of the shapes, cover up the chalk marks, and also give a tone that will be retained as a shadow.

⑧ 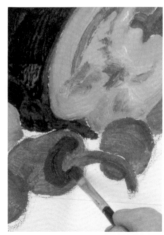 CADMIUM RED 100%

Work inside the cut face of the pepper. Add some red to the mix to get a darker tone, where the pepper is cut. Then build up the shape of the solid, uncut areas around the stalk.

⑫ ⬛ ULTRAMARINE 20%

RIGHT Add a little ultramarine to your green mix, and with the no. 4 brush create the shape of the pepper. Add more ultramarine and get some darks into the pepper.

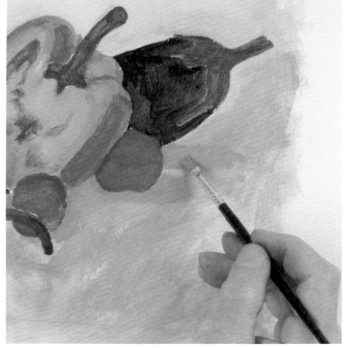

STEP 5 ▸▸

STEP 6 ▸▸

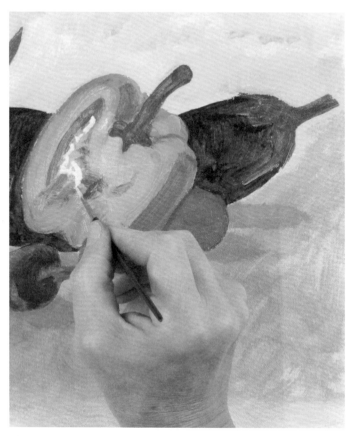

RIGHT Take the yellow you used for the pepper, add some white and a touch of yellow ocher, and use this color to start to add highlights on the pepper. Drag this on quite dry.

 6 CADMIUM YELLOW 80%

Continue to work inside the pepper, with fairly thick paint. Take some pure cadmium yellow and use this to define the shape of the pepper. There is now a ridge of paint, defining the edge of the pepper against the eggplant.

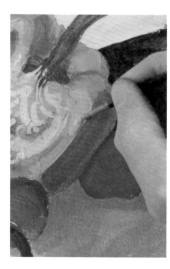

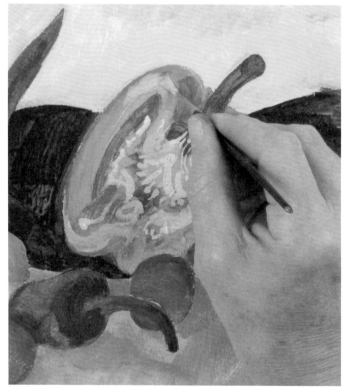

6 CADMIUM YELLOW 80%

0 WHITE 20%

Use your background color mixed with more ultramarine to create shadows under the forms. Leave some darker tones under the objects. Then, start to work up the lighter area in the center of the pepper. Add white to your cadmium yellow for this.

A NEUTRAL GROUND

With a subject such as this one, it is vital to cover the canvas around and between all the objects, in this case using a neutral gray tone. The reason for doing this is that with this subject, there will be glossy highlights. If there were canvas still showing, that would detract from the glossy highlights.

STEP 7 ▸▸

STEP 8 ▸▸

eggplant with peppers

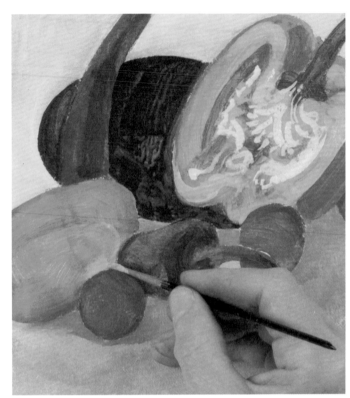

RIGHT Now start to work on some of the highlights to give the painting its sparkle. Use your green mix with a touch of white and yellow ocher, and add some highlights to the eggplant. Use the same mix to outline highlights on the leaves. Rub these with a hog brush to blend.

5		CADMIUM LEMON	90%
12		ULTRAMARINE	10%

Mix a brighter green using ultramarine and cadmium lemon, with white added and use this to work some modeling onto the stalk of the pepper.

Add highlights to the uncut pepper, building up the shape of the pepper. The soft brush drags color into paint that is already dry. Lift the area of eggplant where it is picking up color from the pepper, with a redder mix.

10		VIOLET	20%
8		CADMIUM RED	80%

RIGHT Indicate more modeling on the red chillis. Mix a touch of violet into cadmium red, for a darker red. Do not make this too stiff: it needs to be fairly runny.

Use the same mix to add highlights to the green pepper. Don't be too quick to blend all your marks. If a mark looks right, leave it as it is, without blending.

 0 ⬭ WHITE 20%

RIGHT Take a small sable brush no. 2, and a second sable no. 6 to blend with, and start to add touches of white. Squeeze out some pure titanium white. Look carefully to see the shapes of the highlights and add them as shapes. Don't make the highlights bigger than they are.

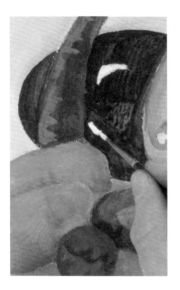

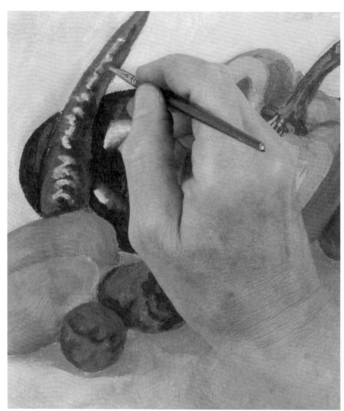

RIGHT Then start to blend the soft edges of the white highlights.

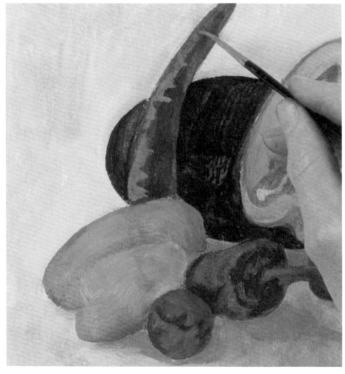

Work around your painting, picking out the highlights on all the vegetables in turn. When you have completed the eggplant, work the highlights and blend the red chillis, then the green chilli. Then, make the central area of the cut pepper a little brighter.

STEP 11 ▸▸

STEP 12 ▸▸

1
eggplant with peppers

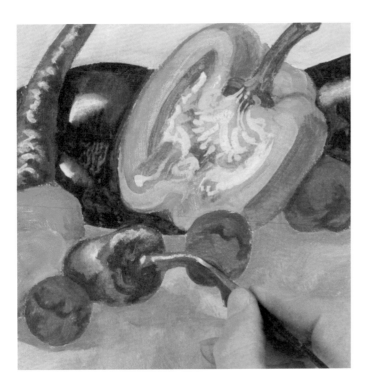

Glaze the peppers with the washy mix of cadmium red again. The stem of the red pepper has not been worked, so add some green here. Then, work the detail in the cut face of the pepper, re-establishing the drawing here.

GLAZING HIGHLIGHTS

Highlights are difficult to get right first time. It is easy to make them too white which fragments the color scheme and looks unnatural. Blending in often softens the highlight but weakens the effect by spreading it too far. With acrylics, it is easy to glaze a highlight after it is dry.

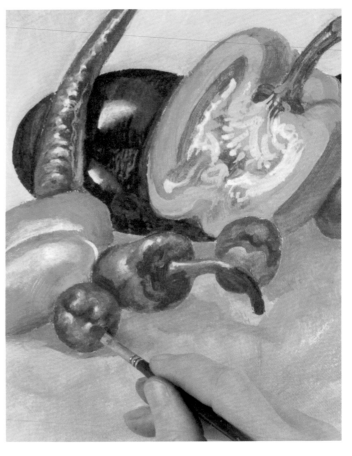

Now start to glaze over the highlights with their underlying color, so that the highlights are not too stark. Use a very clear color: this will prevent the highlights from appearing too chalky. Take a soft sable brush and paint the glaze over the highlight.

8 CADMIUM RED 100%

RIGHT Mix a thin wash of cadmium red, and use this over the highlights on the chilli peppers. If this tones them down too much, add more white.

STEP 13 ▸▸

STEP 14 ▸▸

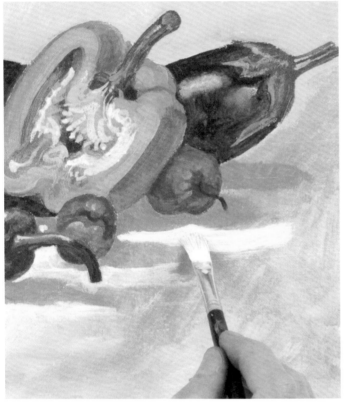

10 VIOLET 20%

Finally take some violet and tone down the highlights on the eggplant. Although the highlights on the eggplant are glossy, these are looking too white.

HAVE I FINISHED?

During the painting process pause frequently and look at what you have painted. You will soon learn what degree of finish you prefer or whether you like rather abstract suggestions about the subject matter. Ask yourself "Do I like it now?" If the answer is yes, then for you the picture is finished.

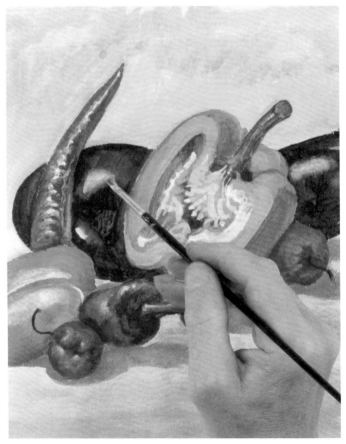

Take some white and a fairly small hog brush, and use it to lighten the foreground. Use a no. 7 for lightening, and a no. 2 to define areas.

4 YELLOW OCHER

RIGHT Add a touch of yellow ocher to the white so that it is not too stark and start to create areas of light and shadow. Blend the edges of the area so as not to get a hard edge.

STEP 15

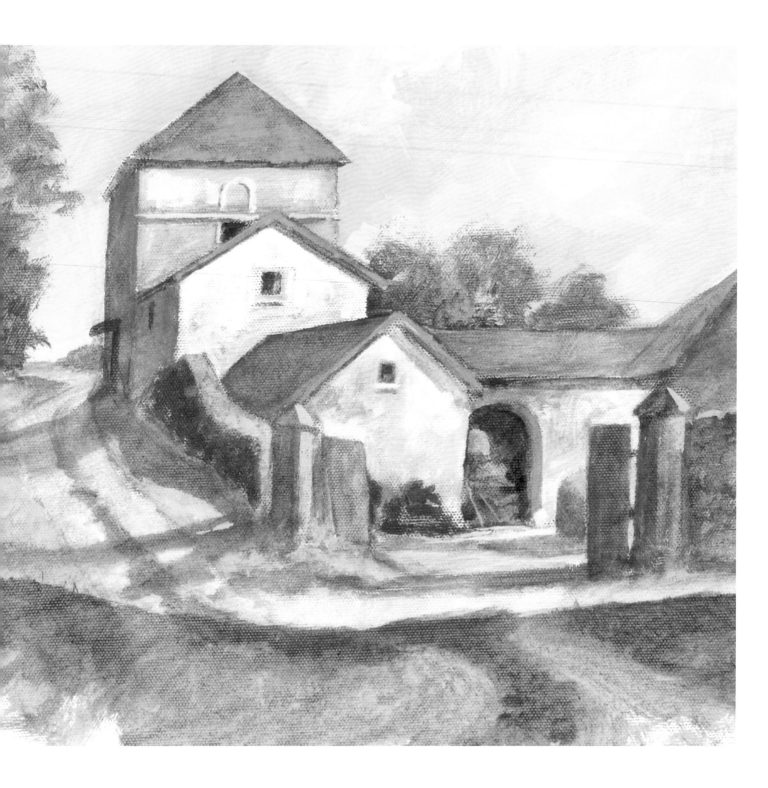

2
french farm buildings

john barber
9½ x 12¼ in (240 x 310 mm)

This project takes as its subject some old farm buildings grouped around a yard. The buildings in the grounds of the chateau at Rochebrunne in France are simple boxes with slanting roofs and small windows. There is no decoration or detail, just an arrangement of light and shadow. The repeated inverted "Vs" of the roofs are the main subject and the whole is anchored in the rectangle of the picture by the horizontal shadows and the roof on the right. Since even a thick coat of acrylic paint will dry during one painting session, you will be able to drag color across the lighter surfaces to suggest the broken textures of rendering and stone and signs of age which make ancient buildings so attractive to the painter.

WHAT YOU WILL NEED

Coarse-textured canvas board
Black chalk
Brushes: flat hoghairs nos 2, 5, 6, and 10; round sable no. 2
Mahl stick

COLOR MIXES

1 Payne's gray
2 Viridian
3 Burnt sienna
4 Yellow ocher
6 Cadmium lemon
8 Cadmium red
10 Violet
12 Ultramarine

TECHNIQUES FOR THE PROJECT

Drawing perspective
Texturing and scumbling
Glazing shadows

DETAILING BUILDINGS

The representation of buildings in your pictures is an important part of the techniques of landscape painting. If you can render a building or, more often, only a small part of one convincingly, then it will give your work a sense of scale and reality. The building should be painted more carefully than any other part of the picture because it is more difficult and it is the first thing that someone looking at a landscape will notice. Many amateur paintings are spoiled by the prominence of the buildings and the attempt to include too many details at a scale that their skill cannot cope with. When painting a landscape, they are often confused and unsure how to render masses of green trees, bushes, and fields, but once they spot a building their knowledge of what is there over-rules what they can actually see. Although the buildings in a landscape may be tiny, these painters put in glazing bars and windowsills that are so difficult to do at that scale that even Canaletto (1697–1768) would have avoided them. It is far better to keep the small dark marks that you can actually see. Buildings are basically boxes with holes in them, and a good exercise is to arrange a few plain cardboard boxes on a table top, and paint or draw them as simple shapes, noting the light and dark areas and cast shadows. You could even cut a few openings for doors and windows.

1 In neutral tones, establish a simple shape for the building using a medium flat hoghair brush. Use the flat edge of the brush to draw the straight edges. Hold the brush fairly upright to do this and pull the brush toward you.

2 Now take a small sable or soft hair brush and start to paint in the flat darker shapes that are in shadow. Adding in these darker areas immediately establishes for the viewer the direction from which the light is falling.

3 Begin to paint some detail on the light side of the building. The dark lines represent cast shadows so you will need to remember where the light is coming from. You only indicate shadows on the top and right-hand side of any feaure.

4 Work downward from the top of the building and hold your sable brush down near to the ferrule. This is more like a pen grip and will give you the control you will need when you want to make a series of small neat marks.

5 The tricky part of detailing buildings is drawing several shapes to look identical. Practice repetition of marks on scrap paper or the edge of your sketch. Your picture will work better if you ignore detail on the shadow side of the building.

6 In this exercise you will have gained experience in making controlled marks on a flat area. Try to paint with quick, flicking marks rather than going over them more than once. This is not easy so keep practicing to improve your skills.

french farm buildings

Draw the main lines of the composition using chalk. Concentrate on the large simple shapes of the rooftops, and the relationships between them, and the relationship between the roofs and the walls. Indicate where the shadows will fall by rubbing the chalk in with your finger to create dark patches. You are going to start your painting with the sky, which should be kept fairly light. Mix some violet, white, and Payne's gray, with a little ultramarine.

SHADOW AREAS

In this composition the shadow areas are going to be important, so they need to be planned and drawn in fairly accurately. Here a wash of Payne's gray and ultramarine, with no white added, allows this accurate drawing of shadows in order to fix the dark tones of the composition.

12		ULTRAMARINE	10%
1		PAYNE'S GRAY	5%
0		WHITE	80%
10		VIOLET	5%

Using a no. 10 brush, cover the sky area with this fairly strong mix to get rid of the lightness of the canvas. This starts to cut out the shapes of the buildings. Use the edge of the flat brush as a drawing instrument. Introduce more white into the sky color, for the clouds. Blend this in.

RIGHT With a wash of Payne's gray and ultramarine, and a no. 6 brush, start on the shadows. Use the edge of the brush for the straight lines.

STEP 1 ▸▸

STEP 2 ▸▸

Steady your hand on a mahl stick to help you to paint in these areas accurately. Work down the edge of the building, and add the gatepost. Indicate windows in all the buildings. Next, work on the shadows that are being cast on the path and grass. At this stage, note that the shadow that is being cast is darker than the object that is casting it. The gatepost is casting a shadow onto the path.

TRICK OF THE TRADE

It is a good idea to leave yourself one or two compositional notes as you work. You may or may not need them, but if you do, they are in place. In this painting, a compositional note was left in the archway, and was picked up later to help the overall effect: the shape could be a farm cart or old machinery.

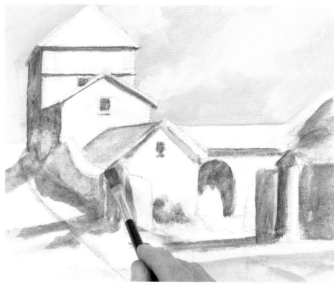

4 YELLOW OCHER 90%

3 BURNT SIENNA 10%

Leave part of the doorway white, then work a deep shadow along the barn roof. There is now a monochromatic image of light and shade in the picture. Next, establish the color of the buildings: mix yellow ocher with a touch of burnt sienna for those that are in the light. The paint is picking up some chalk, which is modifying its texture slightly. These variations are in keeping with old farm buildings.

RIGHT Now rub a thin wash of burnt sienna into the roofs, starting at the top and working down and across your painting.

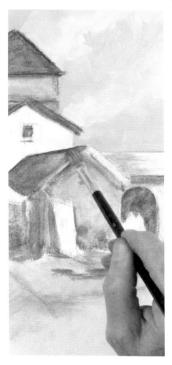

STEP 3 ▶▶

STEP 4 ▶▶

2
french farm buildings

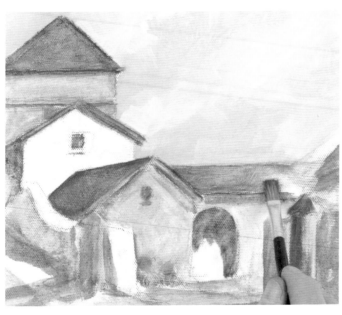

2 **VIRIDIAN** 10%

3 **BURNT SIENNA** 10%

RIGHT Add a touch of burnt sienna to viridian to modify it down from a tropical green. Also add some yellow ocher to this color mix, to create a second green. Work these into the foliage. Then, add some cadmium lemon to modify this some more.

Start to indicate the trees on the right-hand side. With the brush flat, rub your tree color into the sky to give some blurred shapes where the trees cut into the sky on the left. Use the side of the brush to cut the trees into the sky.

3 **BURNT SIENNA** 65%

8 **CADMIUM RED** 35%

Mix cadmium red and burnt sienna and, keeping the wash thin, use it to strengthen the color on some of the roofs.

1 **PAYNE'S GRAY** 20%

3 **BURNT SIENNA** 10%

RIGHT The next stage is to get some color onto the building on the left with the white end. This is a mix of burnt sienna and Payne's gray. Add a little more cadmium red, toned down with violet, to create the pink color of the door. Use the same color for the other door, but since this is in shadow, and so painted over the gray tone, the color is modified.

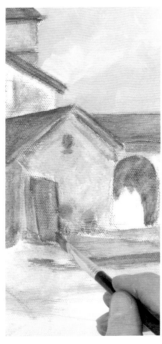

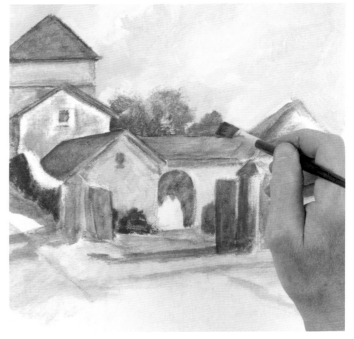

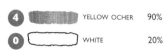

| 4 | YELLOW OCHER | 90% |
| 0 | WHITE | 20% |

RIGHT Using a mix of white and yellow ocher, start to look at the tone of the buildings, and begin to work with thicker color. Use this color mix all over the buildings, gradually building up color, making it more solid.

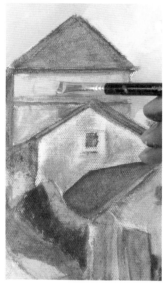

Cut out the arch more clearly. Work around the door, then add more white to the mix to indicate the gap between the gatepost and the door.

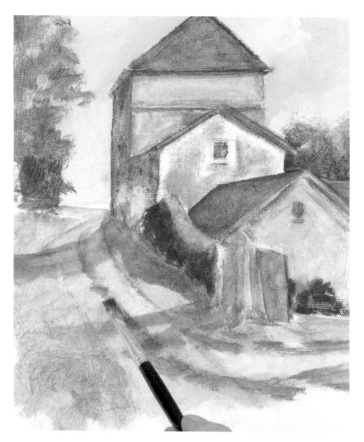

Next, paint all the areas of grass including the shadows. This gives areas of light and shade, without losing the basic shapes created in monochrome. Use this same color to indicate the curve on the path in the foreground. This line will lead the eye into the composition. Now start to build up areas of solid color. The trees that can be seen in the distance are going up a hill. This is important to get a sense of distance into the composition.

CHOOSING WHITES

You have the choice of several whites to use in your work. Decorator's white is good for covering canvas or board, to give you a background tint on which to work. Titanium white is pure color, and offers the best opacity. The color that is labeled "mixing white" flows more easily but is less opaque.

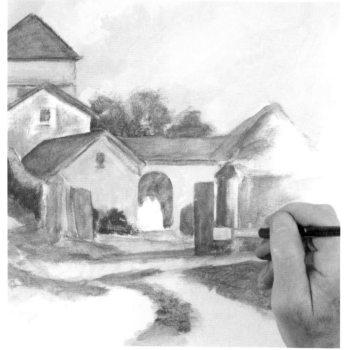

STEP 7 ▸▸

STEP 8 ▸▸

2
french farm buildings

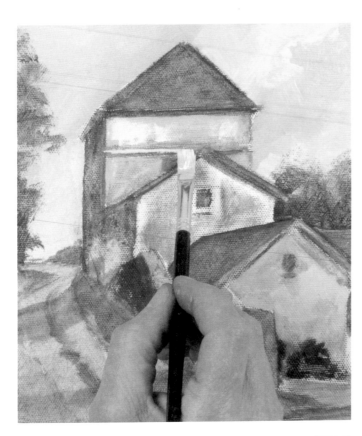

1 PAYNE'S GRAY

3 BURNT SIENNA

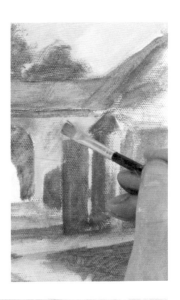

RIGHT Add some Payne's gray and burnt sienna to your white and yellow ocher mix and use this to tone down the end of the building on the right. Rub a little texture into the building.

Get a little opaque color into the shadow. This helps to solidify the buildings so that they do not appear as unrelated shapes.

Go back to the tallest building and make it lighter and also indicate the ridge of stonework that sits across it.

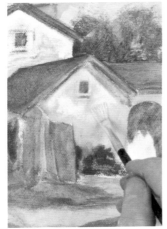

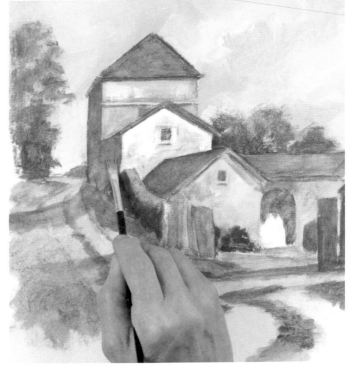

RIGHT Make the end wall lighter and more uniform in color. Continue to build up color, improving the shape of the window a little.

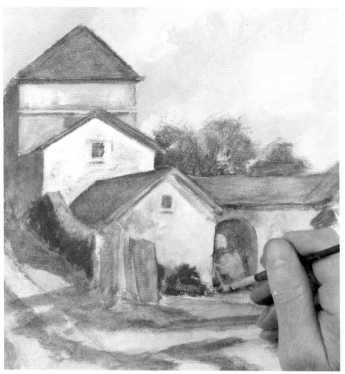

RIGHT There is a window to the side of the building on the left, so add this. Then darken the window in the center. All the shadows in the windows are worked in solid Payne's gray.

| **3** | BURNT SIENNA | 10% |
| **1** | PAYNE'S GRAY | 20% |

Use the same color to create the shadows in the archway. Then mix Payne's gray and burnt sienna to make a strong shadow across the center of the painting. All the large and small areas of shadow have now been re-defined.

| **1** | PAYNE'S GRAY | 20% |

Now turn to the arch. There may be an indication of an old farm cart here, so work this in Payne's gray to begin with. Darken the shadow cast by the roof of the building with the arch. Work around the arch to give greater definition to the cart. The roof of the main building is not symmetrical, so improve this by overpainting with your sky color.

RIGHT Draw the porch on the right angle, using your shadow color. Then work the doorway.

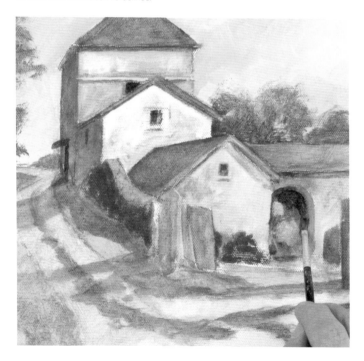

STEP 11 ▶▶

STEP 12 ▶▶

2
french farm buildings

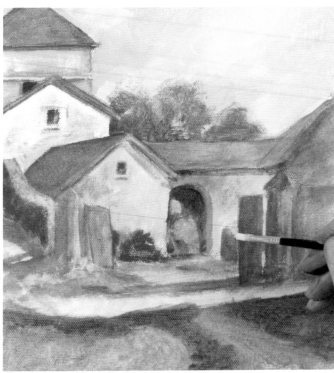

6	CADMIUM YELLOW	80%
3	BURNT SIENNA	10%
8	CADMIUM RED	100%

Indicate a stone to help to define the archway and some broken plaster above the gate. The end of the building needs to be even lighter. Then redden the gate. Add some cadmium red and burnt sienna, with a little cadmium yellow to the white and work down the roof using a no. 2 brush. Use the same color on the left-hand side of the closest roof.

BACKGROUND COLOR

In many compositions the underlying color of the canvas continues to play an important part, and sometimes you want blank canvas to show through. Avoid this in areas of shadow, however. It is far less critical in areas of light where it may contribute to the highlights.

Take a no. 2 hoghair brush, and indicate some light coming round behind the gatepost, and paint some lights on the path. Continue looking and building up areas of highlight. Define the edge of the gate, and the foliage next to it.

RIGHT Now sharpen up some of the solid colors, including the windows. Note that there is a light in the stonework above the ridge on the tallest building. Add lighter color to the sills and under the roof of the filled-in arch.

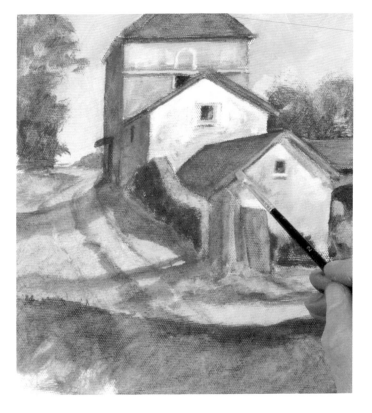

STEP 13 ▸▸

STEP 14 ▸▸

MAHL STICK

It is useful to have a straight edge or rule to lean on to steady your hand. Artists use a mahl stick, especially on larger pieces of work. This stick has padded ends so that the stick itself does not touch the canvas or board, and any existing paint is not disturbed. A mahl stick is being used in the photograph on the left.

LEFT Add a highlight coming down the gatepost. Then add a touch of green to the archway and tone down the area beneath the tree on the left. Work one or two marks into the shape in the archway. This needs to be unfocused, so don't overdo it.

Finally work one or two highlights into the yard floor.

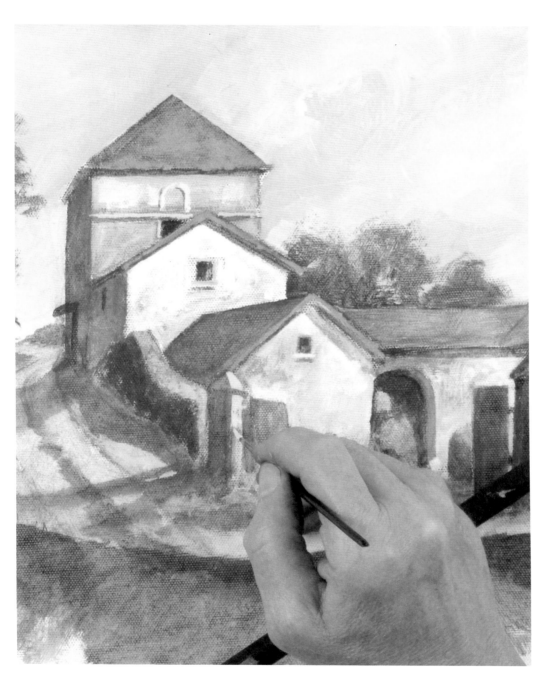

STEP 15 ▶▶ **STEP 16**

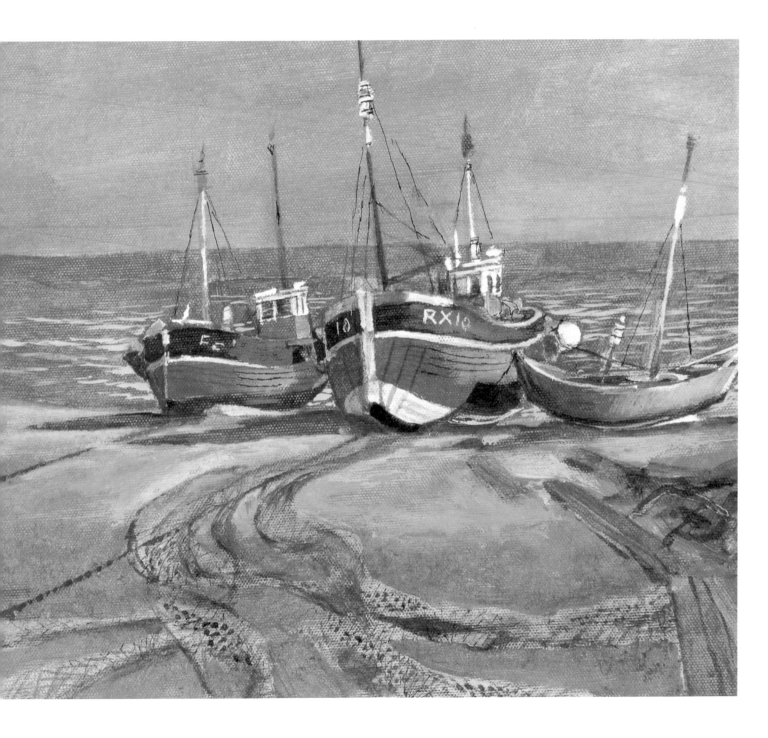

3
fishing boats

john barber
10½ x 13½ in (270 x 340 mm)

Boats have always appealed to artists as subject matter. Their large simple shapes have evolved to function so well in the water that they have a visual attraction whether in the water or out. Here are three English fishing boats pulled up on the beach with their nets spread out in the foreground. Their curved lines flow and interlock leading the eye around and making them into a single motif. In this project, concentrate on the shapes without detailing the working parts. There are many ways of using boats as part of a pictorial design and they do lend themselves to an abstract treatment, but you may develop the taste for accurate rendering of sails and rigging. If you do, this project shows you the basic techniques.

WHAT YOU WILL NEED

Canvas board
Graphite pencil, 4B
Brushes: flat hoghairs nos 4, 6, 7, and 11;
round sable no. 2
Mahl stick
Pen and ink

COLOR MIXES

1 **Payne's gray**
3 **Burnt sienna**
4 **Yellow ocher**
6 **Cadmium yellow**
8 **Cadmium red**
9 **Permanent rose**
12 **Ultramarine**

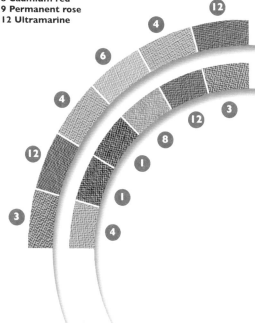

TECHNIQUES FOR THE PROJECT

Planning large shapes
Drawing straight lines
Using dry brush

DRY BRUSH

The essence of the exercises on this page is the use of paint that is straight from the tube, applied on a fairly coarse canvas so that the semi-dry state of the paint when it leaves the brush causes it to break up into small dots as it touches the raised part of the weave on the canvas. Whatever your subject, the exercises, which are simplified in these diagrams are vitally important to your development as a painter. Perhaps the thing that distinguishes one painter from another is their "touch," that is, the way the paint is handled and the sensitivity in the actual stroking of the brush on the surface of the picture. In this way, no two painters are exactly alike and in developing your own preferences for the kind of surface you like to paint on, the brushes you choose, and the way you mix the paints will express your own unique approach. The diagrams for the exercise give you a chance to explore your reactions to the way the paint behaves. Do these exercises many times, until you begin to feel the different results under your control. Before you tackle the project, make a sketch to try out the textures you wish to use. Tell yourself that it is only a sketch and it may well turn out better than a finished picture. The amateur is often less inhibited by formal training and so often produces unexpected, spontaneous, and visually exciting work.

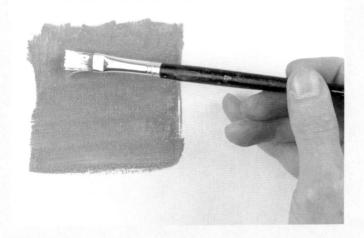

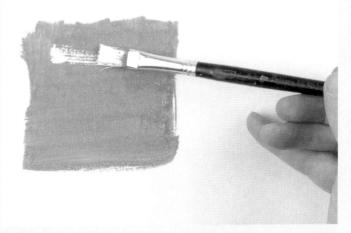

1 Make a medium-toned patch of flat color and let it dry. It need not be square as long as it is large enough for you to carry out the exercise. Any color you prefer will do as long as the tone is right. Load a small flat brush with stiff, light-colored paint.

2 Holding the brush lightly toward the tapering part of the handle, drag it quickly across the canvas. The aim is to make broken parallel lines with the semi-dry paint. Do this several times without adding paint to the brush until you get the feel of it.

3 With the same light hold on the brush handle, and a slightly darker toned paint, keep the side of the bristles flat on the surface. Swish it from side to side like a windshield wiper, leaving many fine spots of paint on the canvas texture.

4 Now experiment with dark paint on the mid-tone of the background. You could start a new patch to work on, if you prefer. This time push the brush away from you as you paint so that the bristles bend back and flick on tiny paint marks.

5 Build up your random strokes until your dark paint becomes a solid patch. Push the brush like a miniature broom and leave the edges fuzzy. This will help your understanding of dry on dry brushwork, as opposed to wet blending.

6 When your dark patch has dried, load your brush with white paint so that you have a large blob on one side of the bristles. Lower the brush. As you move the brush sideways, feel the drag on the paint as it makes ragged broken marks.

3
fishing boats

0	WHITE	20%
12	ULTRAMARINE	10%
3	BURNT SIENNA	10%

Begin by carefully drawing some boats. Use a 4B pencil to draw the lines of the boats accurately: these lines are an important part of the composition. Get rhythmic lines running through the boats. Having established the composition, look at the horizon and draw that in. The next thing to do is put in a tone for the sky, so mix up some ultramarine and burnt sienna, with plenty of white.

TINTED GROUNDS

Working on a tinted ground establishes the tone of your composition from the start. In this case, the canvas board was tinted with a mix of ultramarine and burnt sienna, and allowed to dry before work commenced. The color mix for the sky consisted of the same two colors, with white added, to pick up this underlying tone.

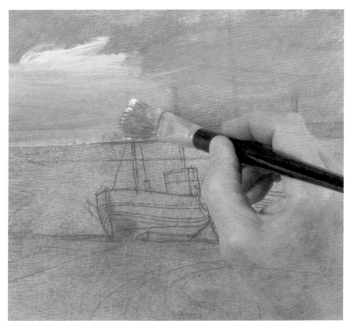

Paint the sky using the no. 11 brush. Use the color fairly thick and bring it down to create a reasonably straight skyline with hills in the distance.

4	YELLOW OCHER	90%
5	CADMIUM LEMON	90%
12	ULTRAMARINE	10%
1	PAYNE'S GRAY	20%

RIGHT Now add some Payne's gray to the mix, to get a gray for the headland in the distance. Bring the gray-green color of the sea behind the boats. Use a no. 7 brush and mix some yellow ocher, ultramarine, and Payne's gray, with a touch of cadmium lemon for a gray-green, fairly dull color.

STEP 1 ▸▸

STEP 2 ▸▸

RIGHT There will be flicks of sky blue added to the sea later. Work around the boats to get the background color sorted. Leave the details for later. Use the corner of the brush to get into angles. Work around the masts, so that you can still see your pencil drawing lines.

| 8 | CADMIUM RED | 100% |
| 6 | CADMIUM YELLOW | 80% |

Mix cadmium red and a little cadmium yellow to a slightly brick red color, and start on the boats. Use the paint mix full strength for a solid color. Use Payne's gray for the tops of the boats.

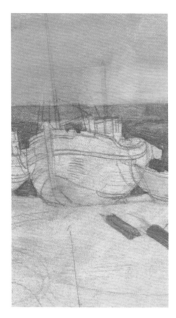

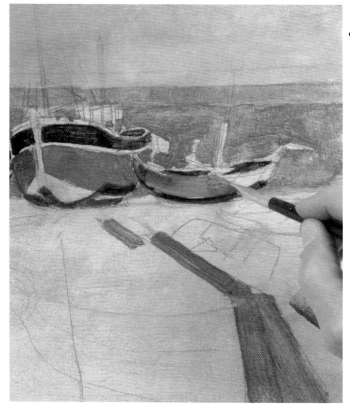

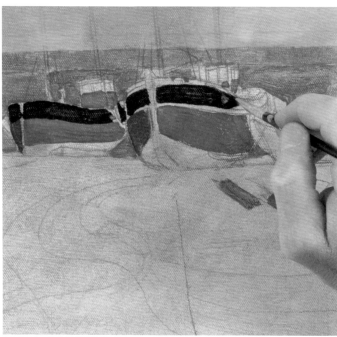

STEP 3 ▶▶

| 4 | YELLOW OCHER | 90% |
| 1 | PAYNE'S GRAY | 20% |

Choose a slightly smaller brush for more detailed areas. Take a no. 6 and mix yellow ocher and Payne's gray for the hull of the smallest of the three boats. This appears to be unpainted. Blend the color slightly into the dark paint while it is still wet.

BALANCING TONES

In a project like this with a narrow range of grays, the use of Payne's gray helps to get dark tones quickly. It contains black for toning down colors and its blue content prevents harshness, but if overused it can dull your colors. When you come to paint from nature, you should mix your neutrals from a wider range of colors.

STEP 4 ▶▶

fishing boats 3

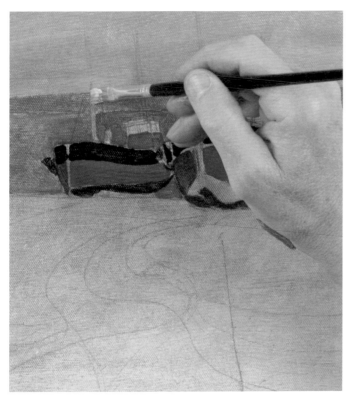

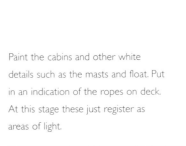

RIGHT Use the flat edge of the no. 4 brush for linework. Line the sides and tops of the boats, then paint the battens on the hulls.

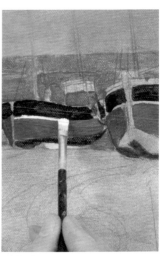

Paint the cabins and other white details such as the masts and float. Put in an indication of the ropes on deck. At this stage these just register as areas of light.

Add some white to your color mix, and use it for one or two details on the other boats, where there are lighter marks. Work around the canvas, looking for areas of light and add them in.

RIGHT Pull the white down in parallel lines to indicate the shape of the hull. Add some yellow ocher for the support for the boat, then go back to a smaller brush and use white for details.

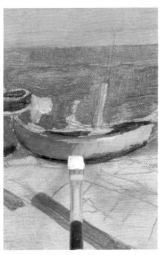

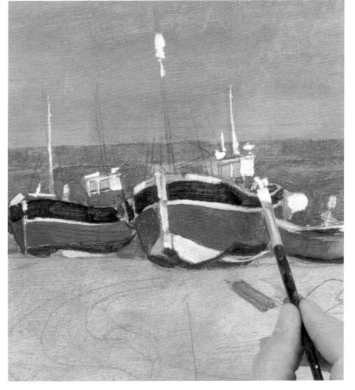

0		WHITE	5%
1		PAYNE'S GRAY	45%
12		ULTRAMARINE	50%

There are bright areas on all the boats. Define the right-hand side of the central boat, blending the color in. This starts to get some modeling into the boats. Mix a little ultramarine and Payne's gray, add a touch of white, and use this on the hulls. The color here is a very dark blue. Light red creates highlights in the deep red hulls, blue-gray creates highlights in the black areas of the hulls.

RHYTHMIC MARKS

When you have a color paint on your brush, it can give your painting and brushstrokes more rhythm if you use one color in most of the areas in which it will be needed, at least initially. The dynamism of this painting was helped by adding white touches across the canvas in quick succession. This established all the lightest tones.

RIGHT Create the white areas of the mast, which will then be refined and detailed.

Work the darks on the masts using Payne's gray to ghost them in at this stage, then put the windows into the cabin. Use a mahl stick to keep your hand off the canvas. Work the windows on the cabin of the left-hand boat. Add the reinforcing battens on the hull.

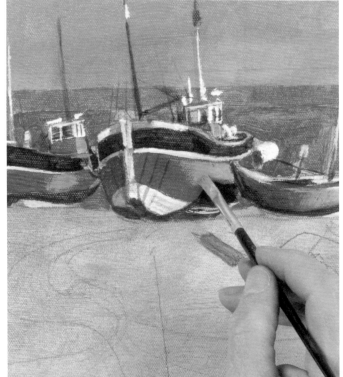

STEP 7 ▶▶

STEP 8 ▶▶

3
fishing boats

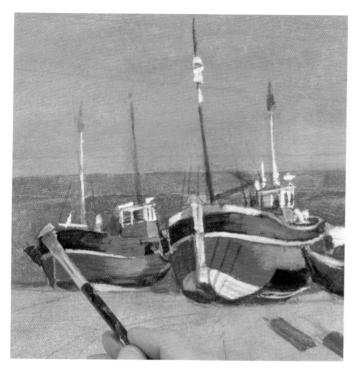

RIGHT Work the mechanism on the right-hand boat. (This might be used to haul up lobster pots.) Use white paint for this.

While you have white paint on the brush, work some details. Once you can recognize what an object is, leave it. What the mark contributes to the overall painting is more important than creating a painting full of detail.

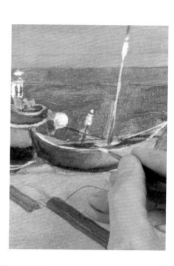

4 YELLOW OCHER

1 PAYNE'S GRAY **20%**

Now use some yellow ocher to warm some of the whites. Add a touch of Payne's gray and glaze over some of the bright whites, to lose some of their chalkiness. Work across the white areas with this color mix, to warm the white.

RIGHT There are numbers on the sides of the boats. Use a no. 2 pointed sable and pure white, very watery paint. Make the number on the central boat slightly stronger than the rest.

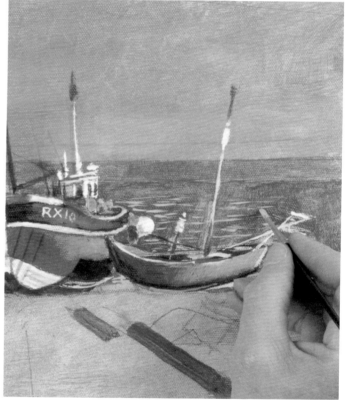

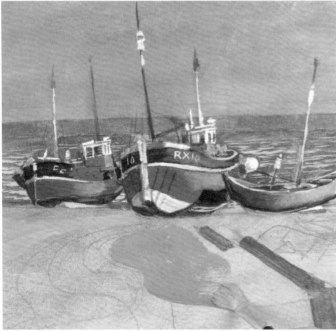

Indicate ripples, since the beach is not flat. Then work a few dark lines on the planking. Add a few more lines on the boats to indicate planks, masts, and other fine details using a pen. If you prefer to rule these in, you can, but often on a painting like this one, it works better if the lines are not too fine. If your marks are starting to look too neat, press down with your fingertip to soften them before the ink dries. Use the pen too to get some more detailing on the nets.

POSITIONAL DEVICE

With any painting, you are likely to want to draw your viewer's eye into the work, highlighting the areas that are of most interest. Positional devices allow you to do this. In this painting, the planked boardwalk, and ropes and nets on the beach all serve as positional devices to draw the eye to the main focus of the painting, the fishing boats.

| 3 | | BURNT SIENNA | 10% |
| 4 | | YELLOW OCHER | 90% |

Use a lot of yellow ocher and burnt sienna to indicate the gravelly areas of beach. On the beach there are fishing nets and the cables securing the boats snaking toward the viewer. Use a larger brush, a no. 8, and almost pure yellow ocher with very little mixing white. Work across the beach, adding color to the whole area, up to the boardwalk.

| I | | PAYNE'S GRAY | 20% |

RIGHT Glaze using pure Payne's gray to indicate the shadows being cast by the boats.

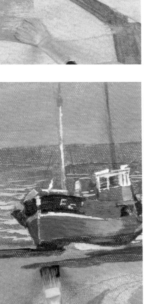

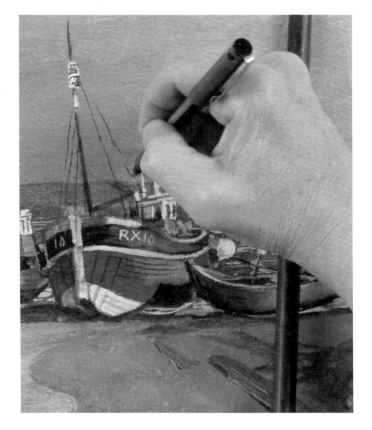

STEP 11 ▶▶

STEP 12 ▶▶

3
fishing boats

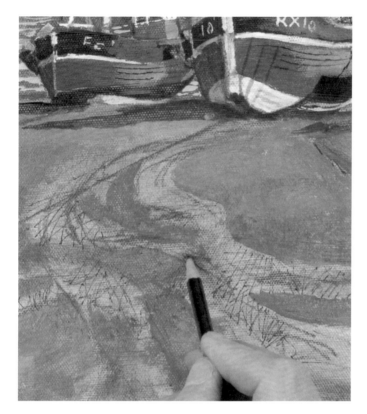

🔵 ⬜ WHITE 20%

4️⃣ 🟨 YELLOW OCHER 90%

Drag some Payne's gray into the beach to get a bit of texture. You do not want any detail of pebbles since the boats are not detailed. Take some pure burnt sienna and bounce it into the beach area. Don't make the changes of tone too dramatic, otherwise you risk detracting from the boats. Lighten some areas of beach to give a few highlights. Mix white and yellow ocher, and work some highlights at the top of the beach. Rub gently backward and forward to define the area more carefully.

PAINT CONSISTENCY

Knowing when your paint is the right consistency for your intentions is a matter of practice and judgment. You want your colors to cover your surface, but in a composition like this one, you want colors to glide into one another, so do not make your mixes too thick and stiff.

1️⃣ ⬛ PAYNE'S GRAY 20%

You can also use a pencil to indicate ropes and anchor chains. Take some Payne's gray and work it into the area of netting. This snakes down into the foreground.

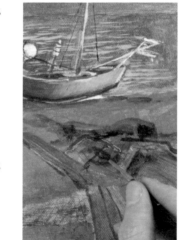

3️⃣ 🟫 BURNT SIENNA 10%

RIGHT Next take some burnt sienna and flick it into the area of the chains. Then work a few little details into the area of flotsam.

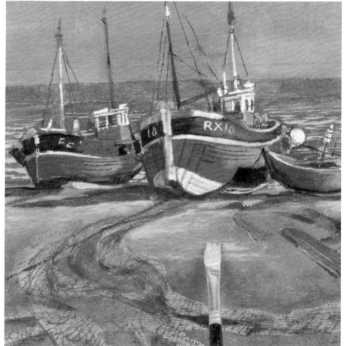

If, when you have put in your highlights, the beach area is starting to look too golden, put some underlying beach color back into it. Use fairly bold strokes. These brighter areas define the nets and bring the boats into sharper relief.

MIXED MEDIA

Using mixed media, such as the pen and ink here, adds a new texture to your painting. The quick-drying nature of acrylics makes them ideal for this: the paint is dry when you want to start pen and ink work.

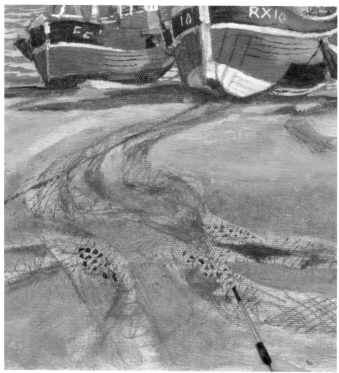

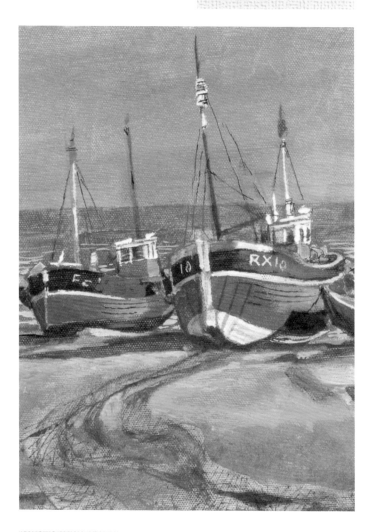

Use a fine brush to add a few more details into the nets. These marks give an indication of the texture of the nets.

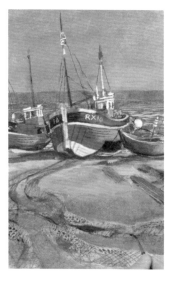

RIGHT Finally define the edge of this area of netting but do not make this too stark: you do not want to draw the eye too much into the foreground.

STEP 15 ▸▸

STEP 16

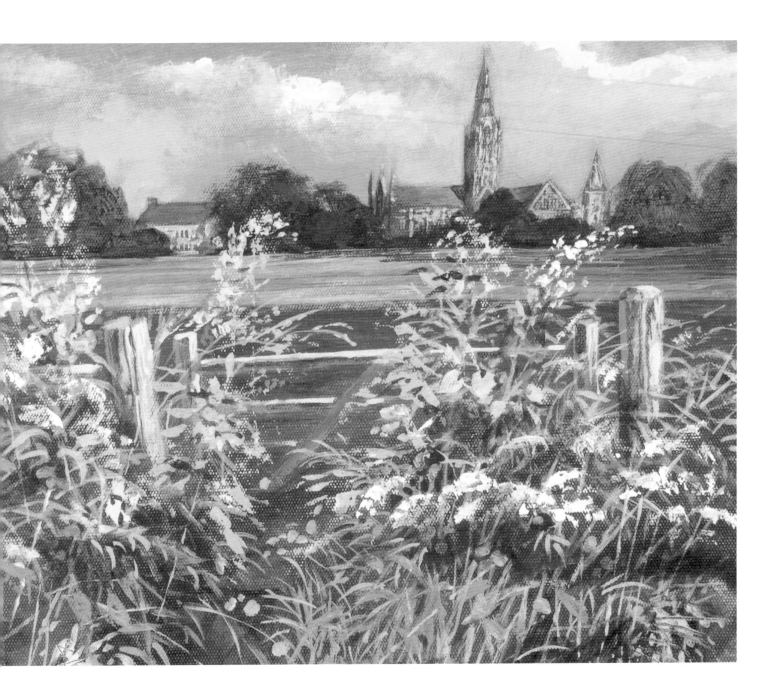

4
english meadow

john barber
10½ x 13¾ in (270 x 350 mm)

In this project with a very low eye level, the foreground plants take up most of the picture area and so become the main subject. In order that the eye remains focused on them, the buildings on the skyline must be kept simple, with only slight indications of architectural detail, and the trees rendered as simple silhouettes. This project explains how the various brush techniques can hint at the complex rhythms of the meadow plants. When looking for subject matter in the countryside, sitting down on a stool or on the ground will often show dramatic changes in scale and center of interest. Use your sketchbook to record the same scene from several angles and heights to suggest to you many different approaches to a subject.

WHAT YOU WILL NEED

Tinted canvas
Graphite pencil, 3B
Straight edge
Black chalk
Brushes: flat hoghairs nos 2, 3, 4, 7, and 9; round sables nos 2, 3, and 4
Palette knives

COLOR MIXES

1 Payne's gray
2 Viridian
3 Burnt sienna
4 Yellow ocher
5 Cadmium lemon
6 Cadmium yellow
8 Cadmium red
9 Permanent rose
11 Cobalt blue
12 Ultramarine

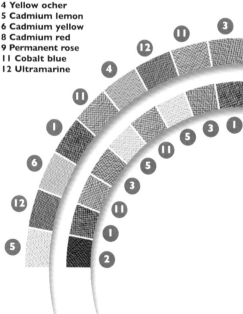

TECHNIQUES FOR THE PROJECT

Fine lining with sables
Painting with a palette knife

PAINTING WITH A KNIFE

Palette knife painting is more suited to acrylic paint than to any other medium. Because acrylics can be built up to great thickness without any technical problems, and they dry so quickly, many layers of paint can be applied to the picture surface in a single day. The term palette knife painting is perhaps a bit of a misnomer these days: some of the delicate blades that have been devised so that intricate work can be done entirely without the use of brushes, are more like surgical instruments. Indeed scalpels and all kinds of plastic spatulas can be used to apply paint to canvas or board. In short anything that will deposit paint exactly where you want it is the right thing for you to use. As with brushes, limiting yourself to one knife will limit you technically, but those very limitations will impose a style and teach you to be ingenious in your handling of the paint. Choose a large and a small knife to start with and then build up your range as you become more confident. The viscosity of the paint, so important in all painting, is especially so when spreading paint with a knife. A finished effect like colored butter has a unique esthetic appeal. For this reason, you may find that you need to modify your acrylics with water, flow enhancer, or gel medium.

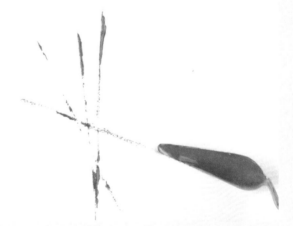

1 Mix up plenty of paint before you start palette knife painting. Take a small trowel-shaped palette knife and scrape some paint off the palette so that it is on the underside of the knife. Make sure that the paint is along the edge of the blade.

2 Apply the edge of the knife to the canvas and pull it toward you. If you wish to strengthen the line it makes, twist the blade so that more of the surface is in contact and a thicker line will appear. Practice making thick and thin lines.

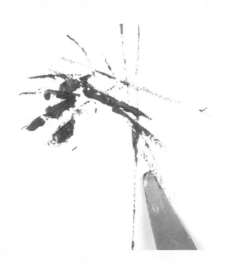

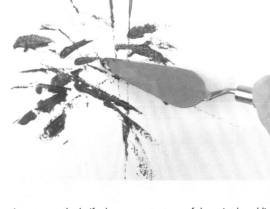

3 As you begin to use the flat of the blade, broader, wedge shapes will appear from under the knife. With knife painting, you will not see what

mark you have made until you move the blade. Hold the knife at the same angle to make an identical mark.

4 Continue to put the knife down at different angles, checking the results and getting the feel of the paint under the blade. Alter the

texture of the paint by adding some water to the color on the palette if the paint is not moving easily.

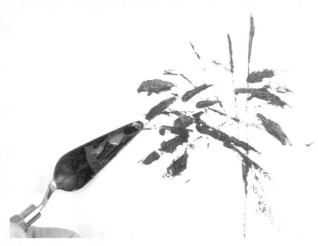

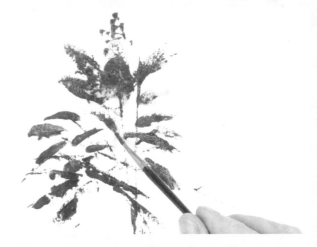

5 As your marks begin to form some sort of pattern, look to see what you can develop from them. If an image suggests itself, try to draw it

with more knife strokes. This sketch might be a plant so try some longer strokes like bamboo leaves.

6 Obviously there is a limit to the detail that can be rendered with a knife and, except in expert hands, it is a technique with an element of

chance in the finished result. Here add a few finer touches with a small sable to indicate stems.

4 english meadow

EYE LEVEL

Having established a dark tone on the canvas, coat the sky with white paint, then rub some ultramarine into it, to give you a clear sky. Draw on the dry sky using a soft graphite pencil. Get a detailed profile of what you can see in the distance. Check to make sure you are getting a true vertical for the center of the spire, using a straight edge. If the building looks to be tipping over later, it will distract you from the rest of the work.

This composition of a typical English landscape is going to have a low eye level. Although there are buildings in the distance, the real subject will be the foliage and plants in the meadow in the foreground. Establishing the horizon and the buildings is important. for the success of the composition, even though they are not the main subject.

0	WHITE	90%
3	BURNT SIENNA	5%
4	YELLOW OCHER	5%

Mix up a slightly creamy white for the clouds using titanium white, mixing white, burnt sienna, and yellow ocher.

Take nos 7 and 9 brushes and start to paint on the sky. Use the white paint fairly thin so that the sky shows through. Work the paint across the canvas to gradually build up banks of high cloud.

STEP 1 ▸▸

STEP 2 ▸▸

| 12 | ULTRAMARINE | 10% |
| 3 | BURNT SIENNA | 10% |

Now move down to a no. 4 flat brush and put the building in, using a warm gray mixed from burnt sienna and ultramarine, with a touch of yellow ocher and some titanium white added. The whole building can be worked as a silhouette, using the small brush to keep the outline clean. You do not need a lot of white in the mix at this point, just enough to cover the blue sky and establish the building's contours. Then put some tone on the adjacent roof.

ARCHITECTURE

In a painting like this one, you need to make simple marks on the building to suggest architectural detail. At this distance, you are simply catching the tops of the grain of canvas. This breaks up the paint, and can give a more convincing note than slavishly working details onto the buildings.

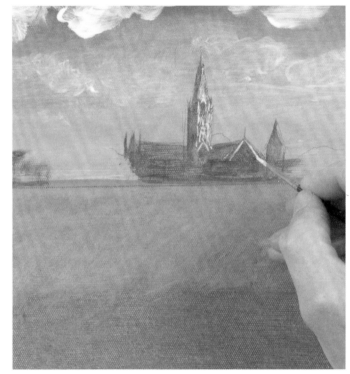

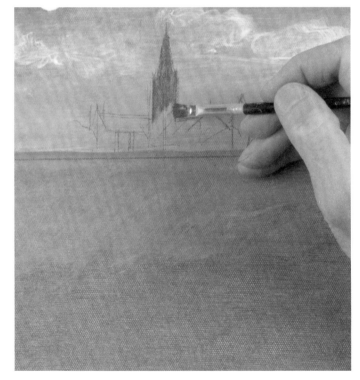

STEP 3 ▸▸

Take a pointed no. 2 sable to work the detail on the spire. Use the previous wash color, mixed with more white for a creamier color. Put a few details onto the church. Dragging the brush down gives a good hint at architectural detail. This might need more detail later on, but at this stage, you are establishing where the light is falling. The end of the building is in darkness but light is shining on the edge of the roof.

RIGHT Then add the side of the house.

STEP 4 ▸▸

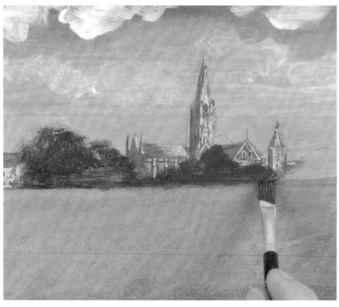

RIGHT Add more blue and white to the mix to create a stronger color, and scrub this into the canvas. This color will mostly be overpainted, but small areas will remain to form the gaps between the foreground foliage.

Put more cobalt to the mix as you work into the foreground. This color should not be too light. This color has some texture; it does not need to be flat. Only small areas of this will be visible when the foreground is painted in. Add some burnt sienna to the cobalt blue for the very bottom of the canvas, to get tone into this area.

| 12 | ULTRAMARINE | 25% |
| 5 | CADMIUM LEMON | 75% |

Move now to putting in the trees. Mix ultramarine and cadmium lemon, keeping plenty of blue in the mix as the trees are fairly dark. Establish the horizon at the edge of the meadow, and work up into the sky. Drag the paint to break up the outlines of the trees.

4	YELLOW OCHER	60%
11	COBALT BLUE	10%
6	CADMIUM YELLOW	30%

RIGHT Mix yellow ocher, cadmium yellow, and cobalt blue for the distant greens, and work across the canvas, adding in the edge of the meadow.

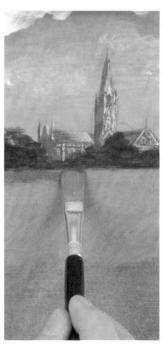

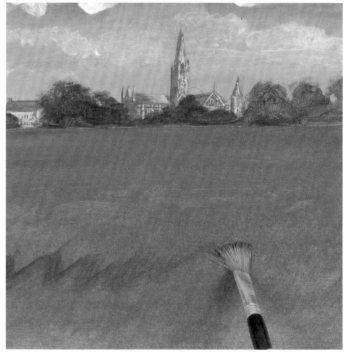

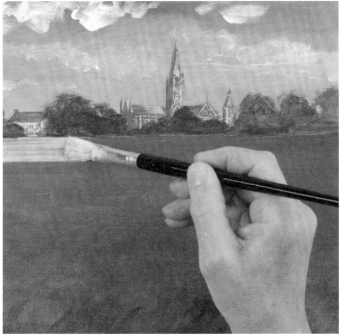

I		PAYNE'S GRAY	7%
3		BURNT SIENNA	10%
0		WHITE	80%
4		YELLOW OCHER	3%

Next, work in the horizontals of the gate, and finally add the diagonals. This completes the gate for the time being.

MAKING CHOICES

A picture feels balanced to the eye if one area only attracts attention. A strong landscape, a dramatic sky, and a detailed foreground will compete for attention. Choose one focus in your picture. If the foreground is your focus, suppress the background and keep the sky simple.

| 0 | | WHITE | 20% |
| 5 | | CADMIUM LEMON | 90% |

To lighten the meadow in the distance add a strip of white, cadmium lemon, and a touch of cobalt right across the painting.

RIGHT Indicate where the fence is going to be, using chalk. Take a no. 3 hog brush and mix Payne's gray, burnt sienna, and white, with a touch of yellow ocher to give a pale color. The Payne's gray adds coolness, to enhance the impression of old, weathered wood. Draw gateposts, then the verticals of the gate.

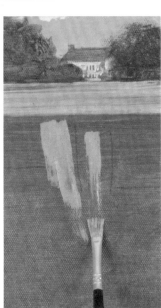

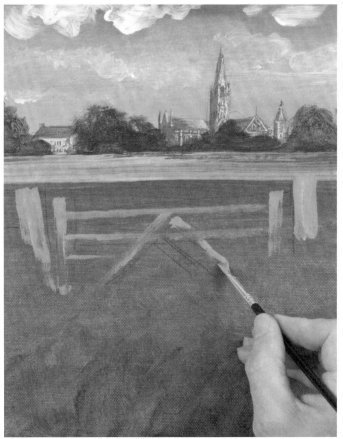

STEP 7 ▸▸

STEP 8 ▸▸

⁴ english meadow

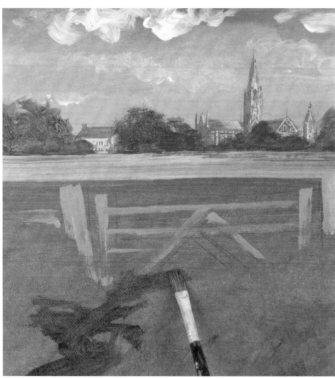

RIGHT Now start to make stronger marks. Use the grain of the canvas to break up the flower heads so that they don't look too contrived. Use the tips of the bristles to create blobs of color: you could spread these out using the end of the brush handle.

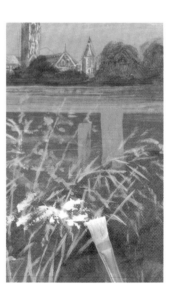

5 _____ CADMIUM LEMON 90%

Switch to a no. 2 sable and work in greater detail. With the sable brush and more liquid paint, you can move the paint further.

3 � BURNT SIENNA 30%
12 ▬▬▬ ULTRAMARINE 70%

Start adding darks in the foreground. Scrub in a mix of burnt sienna and ultramarine. If the foreground needs to be darker still, work over it again.

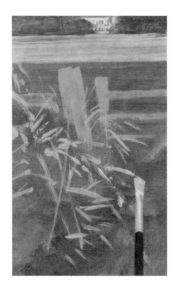

RIGHT Turn now to the foreground foliage. This is going to be quite complicated. You will need small hog brushes, nos 2, 3, and 4. With titanium white, start to indicate foliage. Make sharp, clean, small marks.

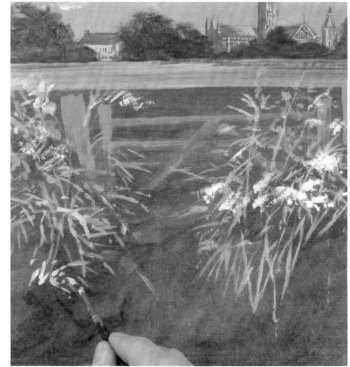

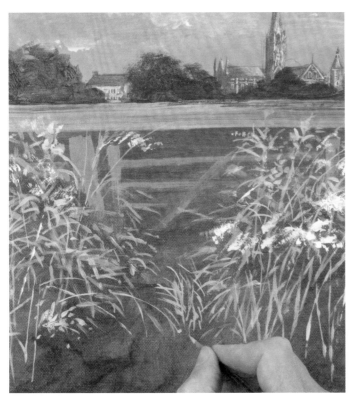

RIGHT Rub white paint onto the canvas, keeping your marks loose. Lighten the sky still further.

| 3 | BURNT SIENNA | 10% |
| 1 | PAYNE'S GRAY | 20% |

Next paint up a bit of the gate. A mix of Payne's gray and burnt sienna should give a good weathered look. Add a little ultramarine too.

Go back to the bluer foliage color and work this in with the sable, to give another tone for the leaves. Work around the foreground, adding in this color, to indicate different grasses.

| 0 | WHITE |
| 11 | COBALT BLUE |

RIGHT To lighten the sky, rub some white and cobalt blue into it. Work around the buildings.

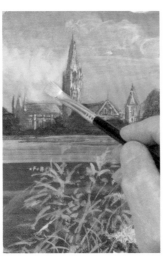

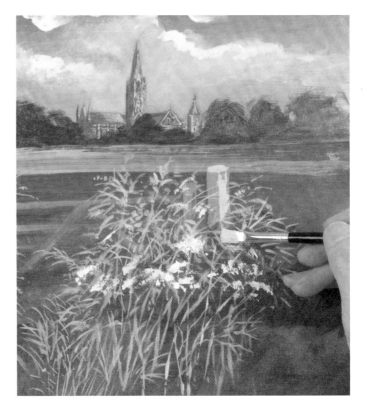

STEP 11 ▸▸

STEP 12 ▸▸

4
english meadow

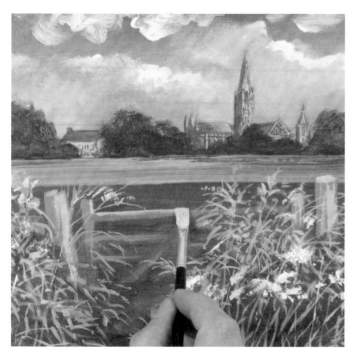

6 CADMIUM YELLOW

Marks made with a palette knife appear almost accidental. Now take some bright yellow and work this in.

NATURAL LOOK

Don't try to paint every detail of every stem when you paint flowers and grasses in scenes like this one. The important thing is to get a good rhythm to your marks. If you like a mark you make, and it has an appealing shape, leave it in the painting.

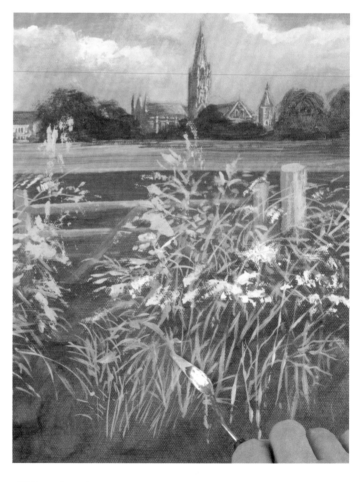

The light is coming from the right, so work highlights accordingly. Work along the horizontals of the gate, placing the lighter tones. Add highlights to the uprights, then get back to painting in the plants in the foreground.

11	COBALT BLUE	5%
6	CADMIUM YELLOW	25%
0	WHITE	70%

RIGHT Mix up some titanium white, cadmium yellow, and cobalt blue to create a yellow tone for some of the plants, and start to apply this using a palette knife.

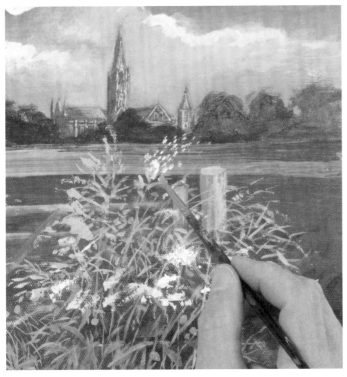

(9) PERMANENT ROSE 100%

Now take some pure permanent rose and use this here and there to give an indication of poppy heads. Then add some white to the color to make it more solid and dot this around, but don't overdo this. Add a touch of white to some cadmium yellow and use that to suggest some yellow flowers dotted in the meadow.

KNIFE AND BRUSH

Even when you put paint on with a palette knife, you can still work into it with a brush, moving it around and changing the shape of the marks. When paint is put on with a knife, it is likely to stay wetter for longer, so you can continue to work it.

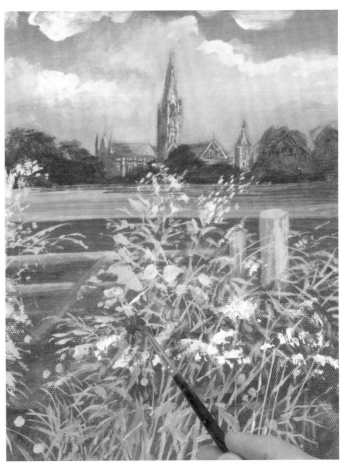

(3) BURNT SIENNA 10%

(2) VIRIDIAN 90%

For the seedheads, mix up some viridian with a touch of burnt sienna to tone it down, and apply using a hoghair brush, here and there. Avoid the temptation to get too detailed. You can overdraw as the painting progresses if you find it needs to be more detailed.

(0) WHITE 20%

RIGHT Add some whites, dragging the paint on with the palette knife.

STEP 15 ▶▶

STEP 16 ▶▶

RIGHT Add white to the cow parsley heads to model them more. Then start to break up the areas that are looking too solid using a mix of ultramarine and burnt sienna and work some darks here and there to indicate gaps between the grasses and flowers.

1	PAYNE'S GRAY	60%
3	BURNT SIENNA	40%

Now mix burnt sienna and Payne's gray to work some darks into the gate. Then add more titanium white to your gray mix and start to re-define some of the lights on the gate.

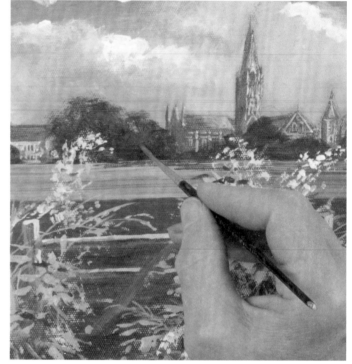

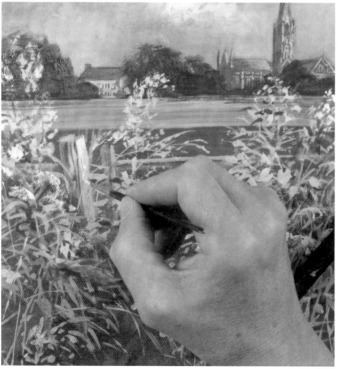

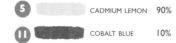

5	CADMIUM LEMON	90%
11	COBALT BLUE	10%

Take some cadmium lemon with a touch of cobalt blue added, and drag some green into the trees in the background. Be careful with this, as you do not want to bring these trees too far forward: they must stay in the background. There are areas of texture in the trees that you can leave to contribute to the modeling. Then mix some burnt sienna and white and use this to flick some red flowers into the foreground.

STAFFAGE

To add interest to your picture, try putting in figures and animals. Use tracing paper over the picture and sketch in the figures to scale. You then have the chance to slide them around to the best position before tracing them down. With acrylics you can always paint them out again if you don't like the way they look.

STEP 17 ▶▶

STEP 18 ▶▶

① ▬▬▬ PAYNE'S GRAY 40%

⑫ ▬▬▬ ULTRAMARINE 60%

Use this same color mix on the roof on the building on the left. Now take a creamy color and start to work a little more sunlight into the buildings. The roofs now need to be bluer. Mix a little ultramarine and Payne's gray and use this to make the lead on the roofs lighter and more blue. Then mix a glaze of viridian, cadmium yellow, and a touch of burnt sienna to take over parts of the foreground to give the effect of a change in light.

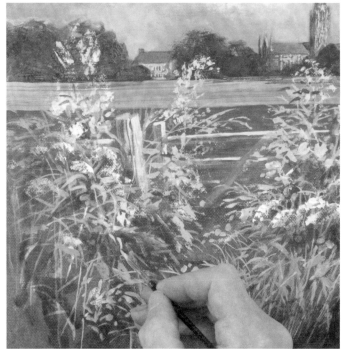

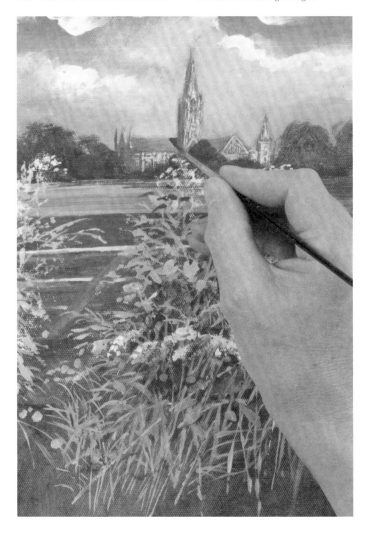

Go back to your cadmium lemon and white mix, with a touch of viridian, and add one or two more lights. Work lights coming out of the darks you have just added. This gives the foliage a more natural appearance. Bring some color into the foreground.

RIGHT Work some lights in the foreground, where the grasses are catching the light. Stand back and review your painting. At this stage, it was apparent that the viridian shadows were too strong a green, so these were overglazed with a touch of burnt sienna, to dull them down.

STEP 19 ▶▶

STEP 20

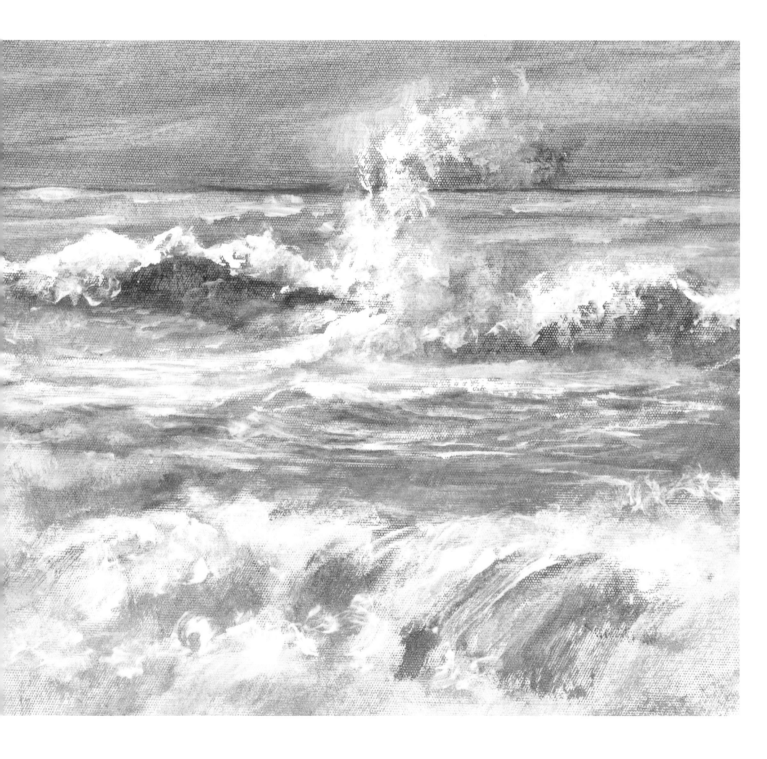

5
breaking wave

john barber
8½ x 12¼ in (220 x 310 mm)

Painting the sea allows you to experiment with brushwork and color in a very free manner. Since form is not so obvious and movement and light are never still, rapid and free paintmarks are best to capture some impression of the movement of water in any medium. With acrylics, you can pile on more paint or tone down your contrast until they seem right. This project demonstrates the importance of velocity in painting, that is, the speed that the brush is moving at when it leaves the paintmark on the canvas. Learning something about this aspect of painting by practicing free movements of your hand and brush is far more important for your development as a painter than strict copying of this painting.

TECHNIQUES FOR THE PROJECT

Very free brushwork
Palette knife painting
Scrubbing in color

WHAT YOU WILL NEED

Coarse-textured canvas board
Black crayon
Straight edge
**Brushes: flat hoghairs nos 5, 7, 9, 10, and 11;
flat sables nos 3 and 4**

COLOR MIXES

1 Payne's gray
2 Viridian
3 Burnt sienna
4 Yellow ocher
11 Cobalt blue
12 Ultramarine

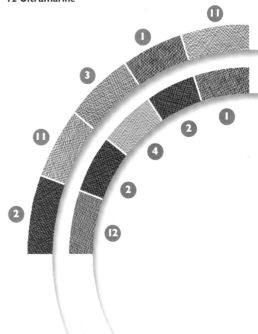

TRANSPARENT AND OPAQUE

The influence of the painting surface on the finished picture often passes unnoticed. What you choose for your support, or painting surface, is vital to the finished result. From the moment you take up a canvas or board and begin to consider the underpainting you should be gauging its influence on the picture you have in mind. A tinted ground in a neutral color is usually necessary for a picture which relies for its impact on the use of solid painting with a knife. By using an opaque color, without a mixture of white, for instance very dark green, as here, and vigorously scrubbing it onto the tinted ground, an impression of the turbulence and flow of water,

can be suggested. You can alter this as much as you like while the paint is still wet. Add water to your paint, to allow some parts to be transparent, and let the ground influence your finished color. When you are satisfied with the look of your waves, let them dry, then use these impressions to influence where you place your solid palette knife marks. Part of the powerful effect of applying paint with a knife is that the paint is laid on so thick that the weave of the canvas no longer moderates the surface so that paint appears brighter and, as it is raised up, it has edges that catch the light from all angles. Flat acrylic paint would not give the same effect.

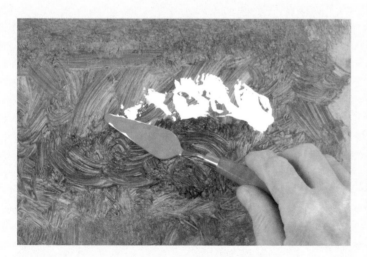

1 Scrub some dark green onto a tinted canvas with a stiff brush. This will leave lots of textures of crisp lines and some blurred areas. Mix some water with the paint to get this effect. When it is dry, add white with one stroke of your knife.

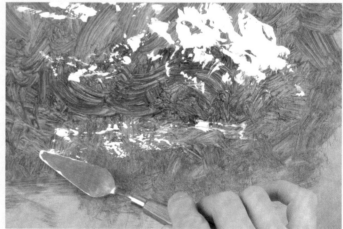

2 A lot of the excitement with this sort of painting is the uncertainty about what the paint will do. Some accidentals that look wrong at first will turn out to be exactly right if you change your mind about a subject. Move your knife and see what happens.

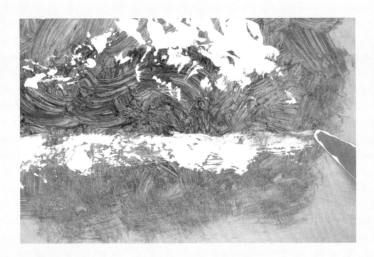

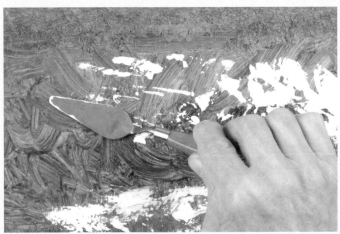

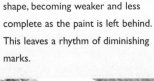

3 Your exercise will not look like this demonstration, so relax and enjoy what happens on your practice sheet. In step 2 the knife going from right to left hardly shed any paint; in this one going back with a little more pressure left a dramatic stripe.

4 Without reloading the knife, let it bounce about. Hold it very loosely so that each time the blade touches the canvas it makes its own shape, becoming weaker and less complete as the paint is left behind. This leaves a rhythm of diminishing marks.

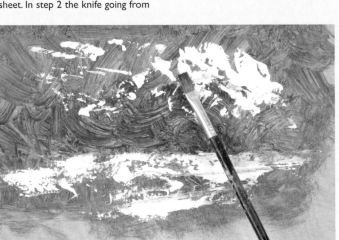

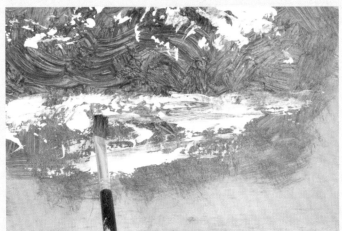

5 Take a small, dry flat hoghair brush and wipe it into the still-wet paint, and drag some of it onto the background. In this way you can begin to manipulate the accidental marks closer to your intentions. Here is a suggestion of a wave.

6 Finally, wet your brush in water and stroke it about on the light areas so that the palette knife marks begin to blur and soften. This gives you the option to continue your study with brush painting. Confidence with the knife will come gradually.

5 breaking wave

Start by deciding where your horizon is going to be, and rule it in using a straight edge and a black crayon. With a subject like this, the exact position of all the elements is not as important as it would be in an architectural drawing. Draw in your main shapes. The relationship between these shapes is going to be important. Indicate the rocks in the foreground. Lay out your palette: the main colors will be Payne's gray, ultramarine, cobalt blue, viridian, and burnt sienna.

WET CANVAS

Don't be afraid to use water directly onto your canvas to get the texture you want. However, be careful not to obscure any drawing marks you need. Some of your initial brushmarks may be left in the finished painting if they contribute to the overall shapes you are looking to create, such as the waves in this project.

I		PAYNE'S GRAY	20%
II		COBALT BLUE	80%

Use a medium-sized palette knife to mix Payne's gray and cobalt blue, dip your brush in water and mix to the consistency of a watercolor wash. Apply that to the sky area using a no. 11 brush. Work the brush parallel to the horizon. If you keep your brush going with the thin wash, you may have enough paint for the sky. Use the stiffness of the brush to spread the paint.

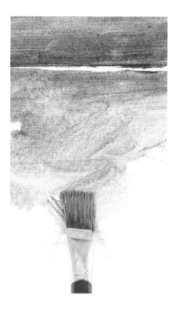

RIGHT Mix up a very thin wash of cobalt blue, brushing from your horizon line downward.

STEP 1 ▶▶

STEP 2 ▶▶

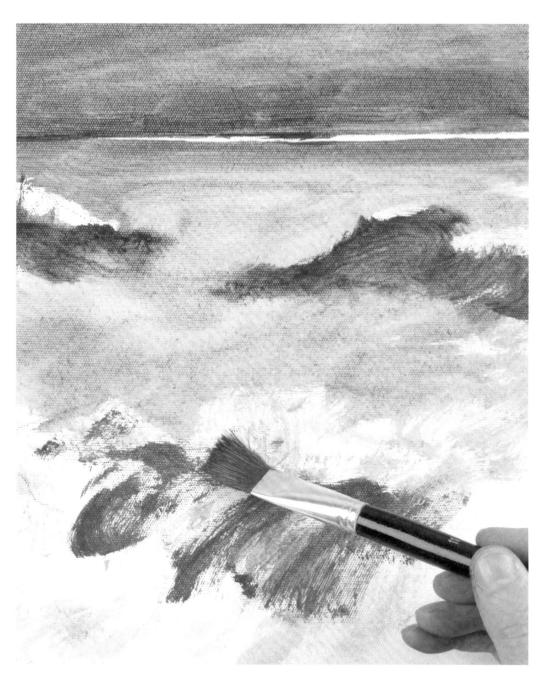

WATERY MARKS

With a subject like this one, in particular, be aware of the accidental nature of the marks you are making. Look for those marks that look as if they might be moving water, and leave them. Look at the rhythm of your brushstrokes: if you see one that looks wavelike, keep it for later and work it up into the finished painting.

1		PAYNE'S GRAY	10%
2		VIRIDIAN	90%

Add some Payne's gray to viridian on the palette. Then add some burnt sienna to the mix and use this to establish the dark areas. To this dark mix, add some more cobalt blue to establish the darks at the lower edge of the picture. Gradually make some dark marks into your color wash: this is still wet so the colors will run one into another.

5
breaking wave

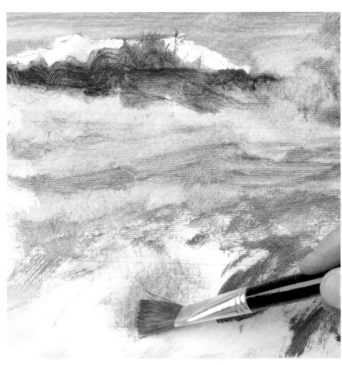

③ BURNT SIENNA 10%

④ YELLOW OCHER 90%

Introduce some warmer colors to indicate that the waves are dragging up color from the beach. Mix a thin wash of yellow ocher and burnt sienna and apply it using a no. 10 brush. Indicate where sunlight is falling under the shadow of a wave. If the underlying color is still a little wet you will get some blending. Gently apply a little cobalt blue and viridian to your remaining areas of white canvas so that the whites are not quite so stark. Mix a very thin wash, so that it is almost tinted water.

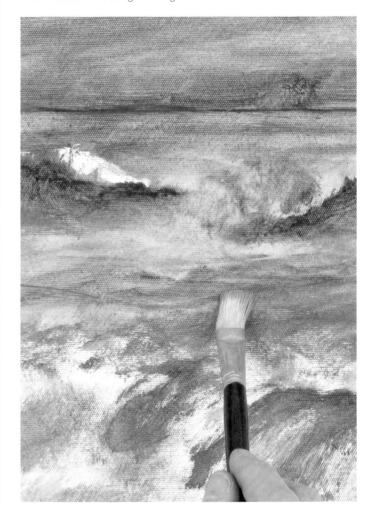

Now introduce some shadows into your plume of spray. At this stage every mark has some energy. Scrub an almost dry brush across to give yourself some tone. Gradually get some paint into every area of canvas.

RIGHT Blend a little color before the paint dries. The white line between sea and sky has now been obscured. In pulling the brush across the canvas, the sea has become slightly lighter than the sky: that is the effect you are looking for as it establishes the tones of the composition.

STEP 4 ▸▸

STEP 5 ▸▸

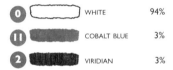

		WHITE	94%
11		COBALT BLUE	3%
2		VIRIDIAN	3%

RIGHT Wet the sea area. Take a no. 9 brush, and white with a touch of viridian and cobalt, and roll your brush across the caps of the waves. Keep the surface wet enough to allow you to move your brush across the canvas.

Hold the brush loosely up toward the end of the handle and let the weight of the brush on the canvas do some of the work. Don't try to copy too carefully, but where there are lighter areas of soft tone, get the maximum effect of your white.

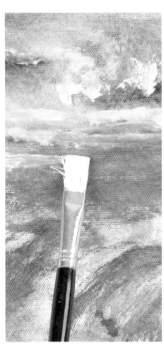

The accidental white patches are important in your composition but they need toning down. If you tone them down when the paint is almost dry, they remain but lose their harshness. When you start to add white, you will be able to pick these out. Cover any remaining areas of unpainted canvas.

| **0** | | WHITE | 95% |
| **2** | | VIRIDIAN | 5% |

RIGHT To establish some bright areas use pure white with a touch of viridian so that it is not too chalky looking.

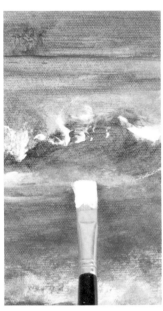

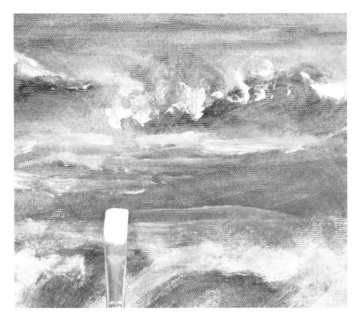

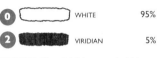

STEP 6 ▶▶

STEP 7 ▶▶
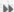

5
breaking wave

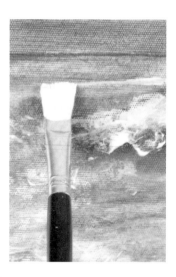

RIGHT Start to look in more detail. Look at the accidental marks to see how they can be manipulated to give the effect you are looking for. Use the flat edge of the brush to indicate the caps of the waves rolling in from the horizon.

Don't feel you have to use the whole edge of the brush, use the corner to get detailed marks. This gives you better marks than a small brush. The marks here are still random and spontaneous.

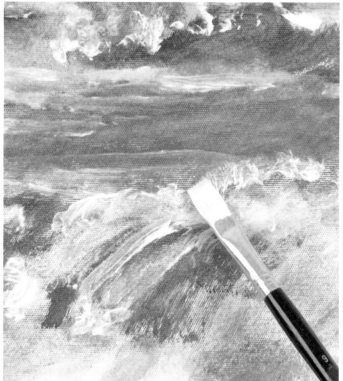

Take these marks up under the shadow of the wave. Don't worry if these areas get too light, they can be glazed back down again later. Work some light into the shadows: a blue glaze will be added later. Continue across the painting, creating foam highlights. Allow the paint to dry, then start to apply some more solid white. Use pure white and the no. 9 brush to get some solid whites into the painting.

TRICK OF THE TRADE

Timing is important with acrylics: when you start to overpaint using a wash, it may drag up too much underlying color. If this happens, leave an area and come back to it once it is completely dry. Remember that you can always wet an area again, if you want to create a more watery appearance in places.

STEP 8 ▶▶

STEP 9 ▶▶

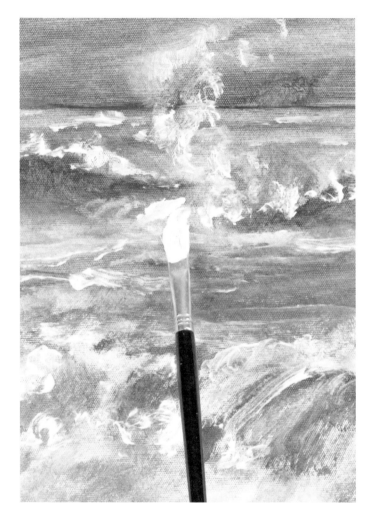

RIGHT Now is the time to put your larger brushes aside, and do some more detailed drawing work, to get the patterns of the waves. Flick paint into the waves in the foreground.

Start drawing the patterns of the lines of foam. Put your brush into water to wash the color out. Take a small sable brush, no. 2 or 3. Begin to make discrete little marks, bouncing about to get an idea of foam.

0 WHITE 20%

Add some white into the sky and blend that. Then, start work on modeling the plumes of spray going up. Wet this area of the canvas again. It's important that the color is dry before you start to add your white lights. However, to make white "melt" into the canvas, wet the canvas again. This will give a more subtle effect than simply applying paint to the dry canvas, but means that you do not pick up underlying color and modify your white in areas where you want to keep it clean and bright.

STEP 10 ▶▶

STEP 11 ▶▶

5
breaking wave

Use pure white and a larger, no. 9, brush to get some solid whites into the painting. Let your brush do the work, rolling it around to create movement in the shapes of the waves.

RIGHT By dragging pure white onto your canvas with an almost dry brush, you will find that the texture of the canvas influences your painting. Continue to drag white across the canvas.

BE BOLD

This subject is ideal for losing inhibitions. The very nature of the sea invites risk-taking by the painter. The more accidental your brushmarks appear, the more natural will be the effect. Let your brush plow through thick paint or slide through wet washes to suggest facets of the waves.

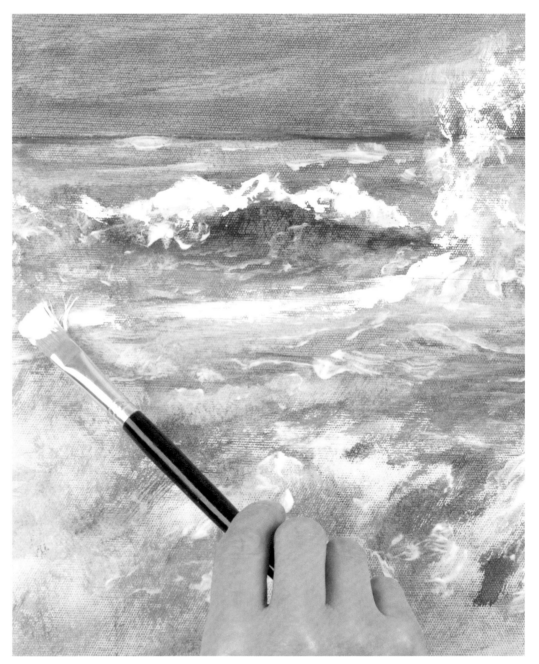

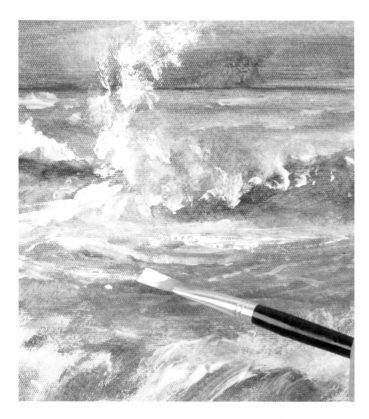

RIGHT Create the caps of the waves, with the hairs of the brush flat on the canvas.

| | | ULTRAMARINE | 30% |
| 2 | | VIRIDIAN | 70% |

Semi-dry paint breaks up to give a foamy effect to the water. Use the flat of the brush to blend the color a little. Now go back over the center of the canvas, where there is too much white. Paint a few darks into the waves using a mix of viridian and ultramarine: this is slightly cooler than cobalt to give a more purply effect.

The edge of your brush will allow you to make fine lines. This can be as effective as using a small brush in certain circumstances, as on the crests of these waves.

EASE OF USE

With acrylic paints, you have the opportunity to control the types of marks you make. If you want your paint to run more freely and create marks with movement and spontaneity, dip your brush in water. For more controlled marks keep it drier. Your marks can always be blended together simply by dragging your brush across them.

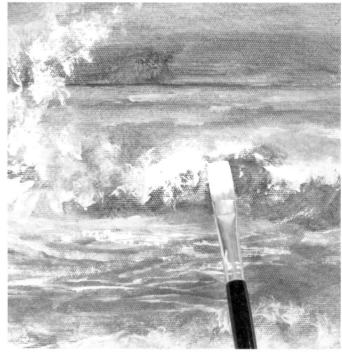

STEP 13　▸▸

STEP 14　▸▸

5
breaking wave

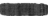

12 ULTRAMARINE 10%

RIGHT Make sure that your solid whites are dry before you start to glaze them with color. Take some ultramarine and water to make a wash consistency and use this to tone down areas that are looking too bright.

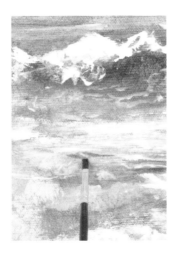

Use the same glaze to tone down the detail that is in the shadow of the rocks.

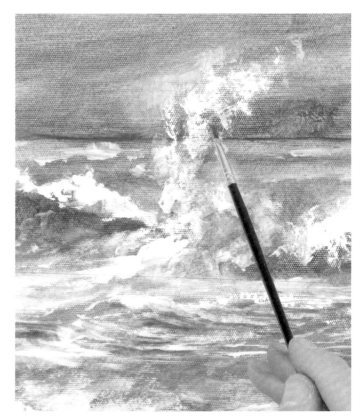

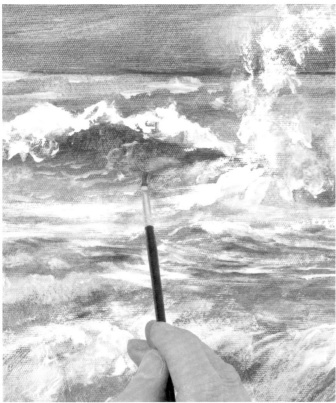

Bring the glaze over the pure whites of the waves to soften them down. Continue around your whites, gradually toning them down using a fine wash of ultramarine.

PAINTING OUT

If you find at the end of a project that you are unhappy with the result, mix up some ultramarine into a fairly strong wash and glaze it over the whole picture. This will bring all of the colors closer and tone down any harsh contrasts. While this is still wet, wipe clear some of your highlights, then let it dry.

STEP 15 ▶▶

STEP 16 ▶▶

The ultramarine glaze changes the color of your whites completely. Work over the crests of the waves. There are areas that need glazing in the top right of the painting and in the foreground. Then start to work the ultramarine glaze into the greener areas of the painting, running it around the rocks on the left, and then work the same color into the shadow on the right to make that more distinct. Establish a little more definition into the greener areas of the sea itself. Then, using the pure titanium white and a no. 4 brush, drag some pure white into the canvas to give the central wave a highlight.

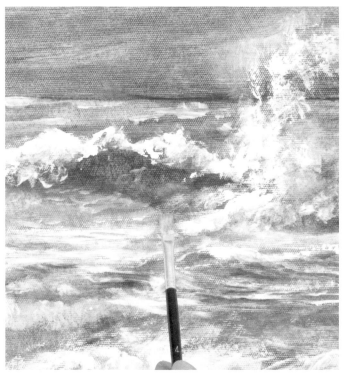

| 0 | WHITE | 20% |
| 4 | YELLOW OCHER | 90% |

Mix some yellow ocher with a little white and not too much water and use this to differentiate the flat water from the shadow under the wave. It's important to make sure this is a smooth line, to indicate that this is an area of cast shadow.

RIGHT Finally look around the canvas, and add touches of glaze where you need them.

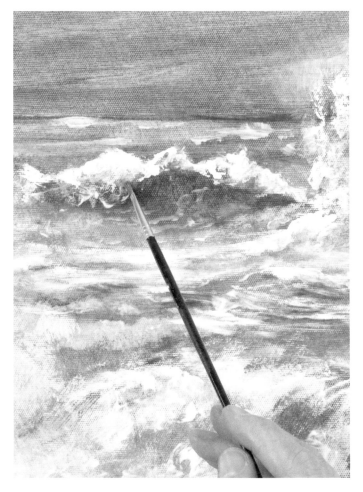

STEP 17 ▶▶

STEP 18

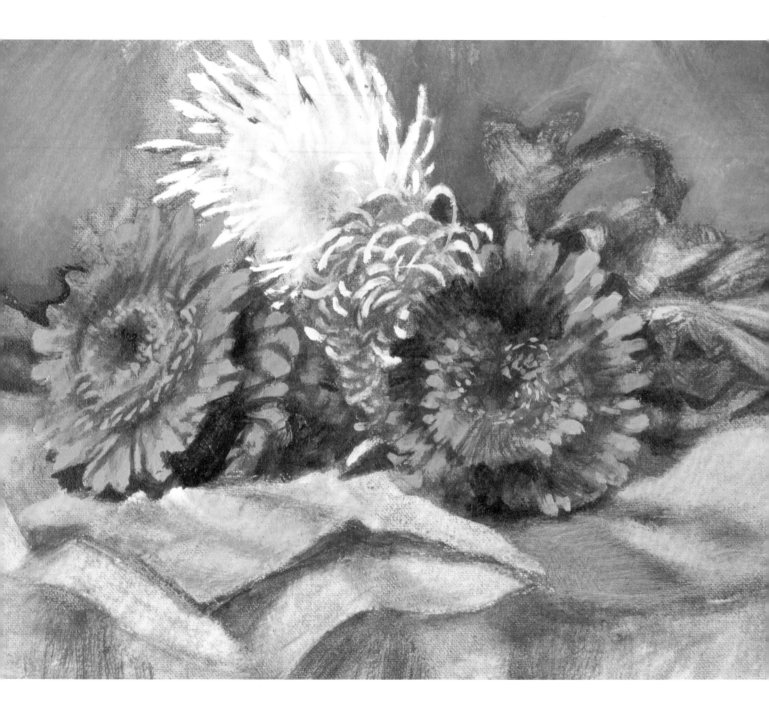

6

bunch of flowers

john barber
9 x 12 ¼ in (225 x 310 mm)

Flowers have been favorite subjects for artists since painting began. In this project the subject was not arranged, but an attempt was made to render the flowers just as they fell on the table with their wrapping paper under them. The main interest is the contrast between the strong disklike form of the red flowers and the spiraling white petals in the center. The concentric circles of petals, which get larger as they spread, are painted as blocks of color, particularly where they catch the light around the edges. Their lighter tone, although not closely detailed, provides more information about their structure. By contrast, the lighter flowers flow freely around, and define the shape of the orange flowers with points of light.

WHAT YOU WILL NEED

Canvas board
Brushes: flat hoghairs nos 2, 3, 4, 6, and 9; round sable no. 3
Kitchen paper

COLOR MIXES

1 Payne's gray
4 Yellow ocher
5 Cadmium lemon
6 Cadmium yellow
7 Orange
8 Cadmium red
10 Violet
12 Ultramarine

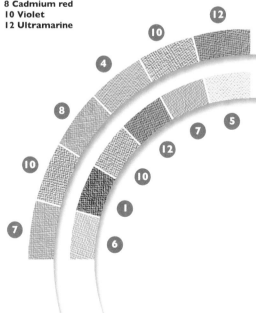

TECHNIQUES FOR THE PROJECT

Painting from dark to light
Glazing
Building solid highlights

PRECISE KNIFE PAINTING

The basic techniques of acrylic painting are simplified by the fact that the only substance needed to dilute your paint is water. Acrylics lend themselves to use in the early stages of a painting, when thin transparent washes, made from the paint as it comes from the tube, watered down as required, is all you need to get your canvas covered. If the paint is not thoroughly mixed, but allowed to be carried in the water, many textures of stripes and bubbles will be left when the water has dried. The exploitation of these qualities can give immediate results that are so attractive you may not want to elaborate any further. A

disadvantage is that it is difficult to lay a flat wash in transparent acrylic and, if you need an absolutely flat finish, the addition of some white is going to prove essential. Many areas in the bunch of flowers study have this first wash quality and, in a more finished picture, would be built up in solid layers of opaque paint to give more subtle modeling and color matching. However thick the paint on your more finished paintings, you still have the option of applying transparent glazes which are the same as your first washes at any time without running the risk of any technical problems.

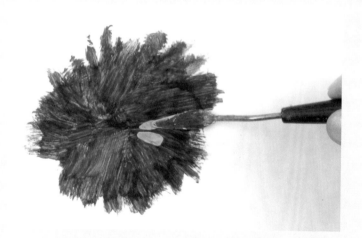

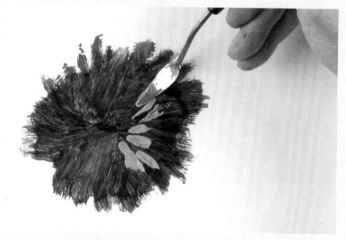

1 In this project, you will be working through the first stages of painting a blossom. Mix up your flower color without adding white and, with a small hog brush, drag each brushstroke out from the center so that any brushmarks will radiate outward.

2 Adding some white to your color mix will give you a tonal contrast for the next stage which is suggesting the light on each petal. Do not tidy up the darker color but concentrate on making petal shapes with the palette knife.

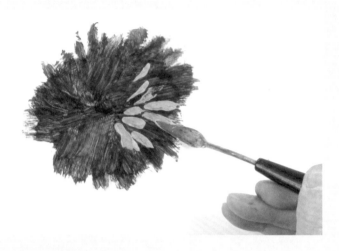

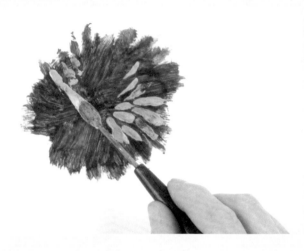

3 Now start making marks using your smallest palette knife. Gradually move around the flower. keeping the lighter patches separate at this stage. You will be adding some modeling onto the leaves later in the study.

4 Make distinct marks by touching the canvas firmly and then lifting the knife. Gradually add to the circle of marks. Turn the canvas around so that without moving your hand you can make the same shaped marks all around the flower.

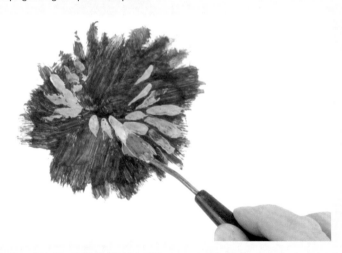

5 You have now reached the stage where your marks can be allowed to overlap or touch each other. Try to complete concentric circles as part of the practice. When they are dry, glaze background color over some of the lower petals.

6 This exercise has been designed to give you experience in controlling the palette knife before you tackle the project on the bunch of flowers when you will have the choice of using either brush or palette knife.

6
bunch of flowers

⑫ ▰▰▰ ULTRAMARINE

Sketch in the shapes of the flowers using a thin wash of ultramarine and a no. 4 flat hog to establish the main shapes on the canvas. This wash will dry very quickly. Indicate where the centers of the two orange flowers will appear.

ALLA PRIMA

For this painting, the color sketch is alla prima, literally at once. The color is painted wet, rather than built up in layers. However, by accenting the drawing with one or two main shadows, you are very early on establishing areas of light and shade.

It is important to establish the elliptical shapes of the flowers and the points from which the petals radiate.

RIGHT Use some of the blue to give an indication of tone, by applying it with a dry brush on its side. Indicate where the light is coming from, with an arrow. If you can see any areas of deep shadow, indicate them in blue.

STEP 1 ▸▸

STEP 2 ▸▸

MAKING MARKS

The marks you make will be dictated by the stiffness of the paint, the texture of the painting surface, the flexibility of the brush, and the speed of your hand. When you get all these under control, you will have found your "touch." This will affect the way you interpret your subject and will define your personal way of painting.

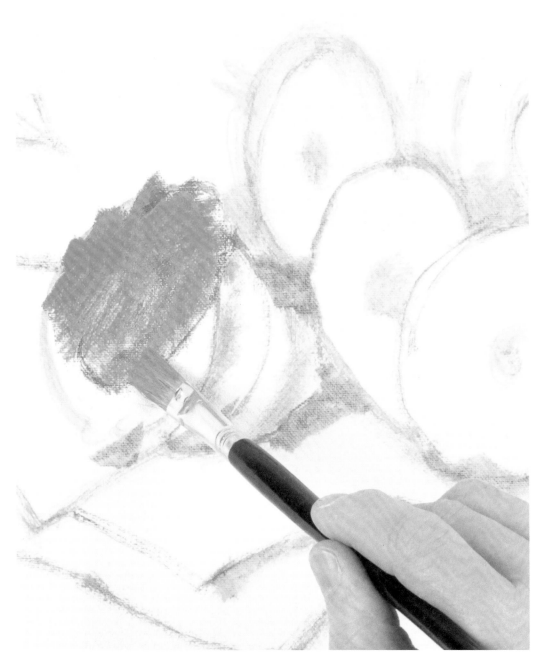

| 3 | | BURNT SIENNA | 10% |
| 7 | | ORANGE | 90% |

Now switch to a no. 9 brush and mix up the most powerful color in the composition, a deep orange. Check how that matches the flowers in front of you. Bearing in mind the direction of the petals, start to paint. The brushstrokes follow the direction of the petals, radiating out from the center. Trust your own judgment: if a radiating mark looks right, keep it in the composition and add to it. Where your orange paint covers the blue underdrawing, you are already creating your shadow color.

STEP 3 ▸▸

6
bunch of flowers

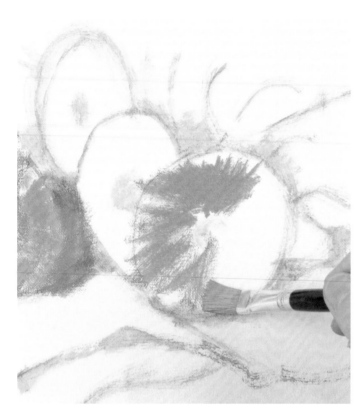

10	VIOLET	70%
7	ORANGE	30%

RIGHT Start to put the background color in as a thin wash, to help you to judge the strength of the flower color. This is a mix of violet and orange. Note how much brighter the orange looks once the violet paper is added.

The paper still has some folds and texture in it. The texture can be left or overpainted later. Use the violet to cut out the shapes of the leaves.

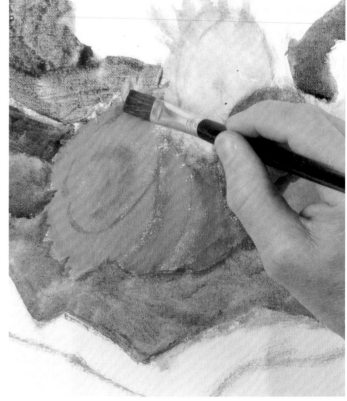

There are some areas of white canvas glinting through still. Don't worry too much about detail at this stage, but do look at the shape of the flowers and note that they are not perfect ellipses. The petals fall in a random way.

5	CADMIUM LEMON	85%
12	ULTRAMARINE	15%

RIGHT Work some darks into the green curly blossom. This is a mix of ultramarine and cadmium lemon and will be used for the green foliage.

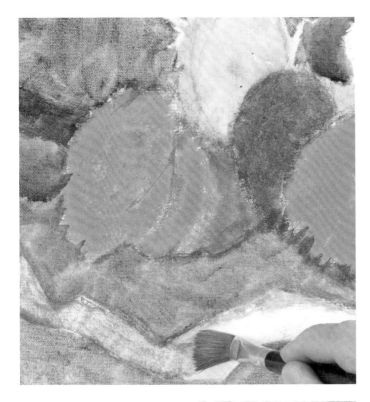

5 CADMIUM LEMON 100%

Note at this stage that there is a subtle double row of petals on the orange flowers, and that there are shadows on the left of the flowers and cast shadows on the right. Now, go back to the no. 4 brush and put a glow of cadmium lemon into the center of the white flower.

LIGHT AND SHADE

Don't be frightened to make full use of shadows in your compositions. In the early stages it is easy to be concerned that you are darkening all your "brights" too much, but here the brightness of the flowers will be recovered once you start to add white to your paint mixes. At the beginning of a composition, simply establish the pattern of light and shade.

Tone down the other piece of wrapping paper so that it is not too stark. Use a thin wash of background color with yellow ocher added. Apart from the leaves, all canvas now has some color on it.

RIGHT Make the darks stronger by adding a little violet to the orange. Use the no. 9 brush to keep a broad feeling to your brushstrokes. Build in some darks, using a stiffer mix of paint.

STEP 6 ▸▸

STEP 7 ▸▸

6

bunch of flowers

RIGHT Start looking at the edges of the petals against the background. Each brushstroke makes a petal. Use plenty of paint on each stroke, but do not blend at all at this stage. The paint now is used almost straight from the tube, with very little water.

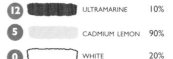

12	ULTRAMARINE	10%
5	CADMIUM LEMON	90%
0	WHITE	20%

Turn now to the bright green on the central flower. Mix up a light green using cadmium lemon, ultramarine, and mixing white.

4	YELLOW OCHER	90%
5	CADMIUM LEMON	90%
12	ULTRAMARINE	10%

Still using the no. 9 brush, mix yellow ocher, cadmium lemon, and ultramarine, and start to work on the leaves. The initial mix needed more ultramarine added to work effectively. This green has to be fairly dark as it has to cut out the flower.

RIGHT The next stage is to build up the orange flowers. For the first time white will be used. Take a no. 6, 4, and a 3 so that you can use one brushmark for each petal. Add mixing white to orange.

STEP 8 ▶▶

STEP 9 ▶▶

RIGHT Use the sable brush to draw with the paint, rather than for adding paint in large patches. Add a little more white to the mix and start to crisp up some of the marks against the other colors. Try to keep the brush relaxed in your hand.

As the effect of the water on the canvas is diminished as it dries, so the marks become crisper and you get a good mix of washy and solid marks.

0		WHITE	80%
5		CADMIUM LEMON	20%

Take a no. 2 hog with cadmium lemon and white, and no water, and look at some of the curved petals. Each time let the paint run. Keep repeating the beauty of the curves. Some of these curves cut back onto the green leaves.

RIGHT For fine brushstrokes use your sable. Some marks are thinner as they are going onto damp canvas. The petals just catch the light in different directions, creating the look of a curly mop.

STEP 10 ▶▶

STEP 11 ▶▶

RIGHT Work in some shadows using the glaze. The glaze re-establishes the shadow areas on both orange blooms. The glaze can be moderated by adding more red to it to get a more intense color onto the blooms.

Build up contrast by toning down areas, and then working them up again. Make sure there is enough water with the cadmium red to allow the underlying color to show through.

Turn to the white flower. Look again at where the light is coming from and start to add white petals. The shadows on this flower are already in place.

| 10 | VIOLET | 10% |
| 8 | CADMIUM RED | 90% |

RIGHT Now go back to the orange flowers, and mix a glaze to give a richness to them. Take some cadmium red with a touch of violet added, and plenty of water to make a thin wash, glaze over some areas of the flower. Dab with a cloth so that the effect is not too strong.

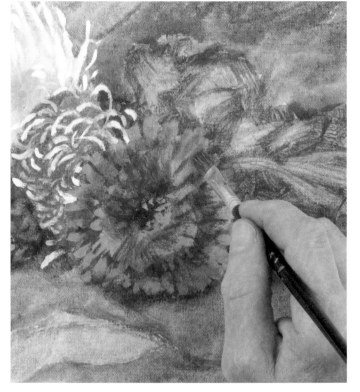

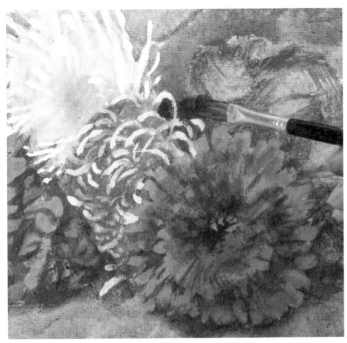

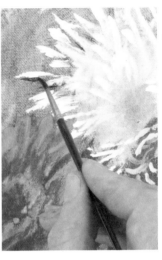

RIGHT Use some violet and a touch of Payne's gray to establish a few, not too strong, darks between the petals of the white flower. You can alter the shape of the petal, but don't overdo this, and keep plenty of water in the mix.

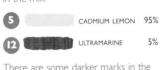

		CADMIUM LEMON	95%
12		ULTRAMARINE	5%

There are some darker marks in the center of the white flower. Mix ultramarine and lots of cadmium lemon so that the color is not too strong and add a few little green marks to the center of the flower.

5		CADMIUM LEMON	70%
12		ULTRAMARINE	20%
1		PAYNE'S GRAY	10%

Reinforce the shadows on the leaves at this point. Take the ultramarine and cadmium lemon mix, and add some Payne's gray to give a really dark color to contrast with the crispness of the petals. Pick out the dark shapes, sharpening them with the aid of the sable brush.

RIGHT Contrive the shadows on the leaves to outline the shape of the petals. Smooth some of these off with a dry brush. You do not want edges in the leaves.

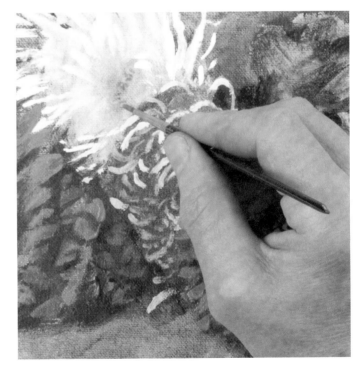

6

bunch of flowers

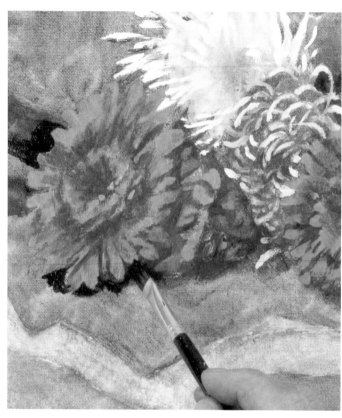

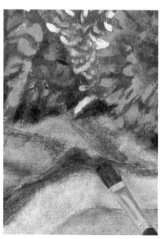

Strengthen the background to get some more contrast. Work a little more violet into the paper.

RIGHT Work the shadow of the paper. Keeping the background somber enhances the color of the flowers. Then rub some shadow color into the pale band under the paper.

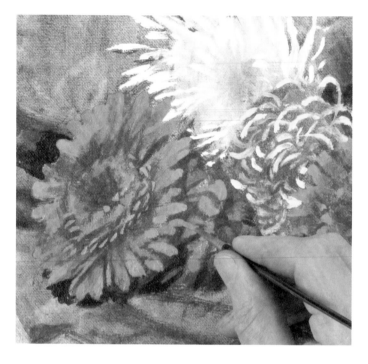

7		ORANGE	100%
0		WHITE	20%
6		CADMIUM YELLOW	80%

Now bring up the edges of some of the orange petals. Mix orange, white, and a little cadmium yellow for this and use a fairly stiff white to get some body into it. Half close your eyes as you look for the lightest areas. You do not want to become too botanical about this, but pick up highlights. Use the heel of the brush by the ferrule, and use the softness of the hairs to make your marks. Press the brush gently onto the canvas and drag almost pure color onto the canvas.

DRYING TIME

Take care, if your hand rests on the canvas, that it is doing so on a dry area. Often with acrylics you will find as you move from working on one area to another that the colors have dried, especially if they were not too thickly applied to start with. It is still worth checking, rather than risking smudges.

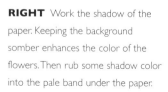

STEP 16 ▶▶

STEP 17 ▶▶

RIGHT Note that there are some yellow highlights in the center of the orange flowers. Stipple on pure cadmium yellow with a light touch.

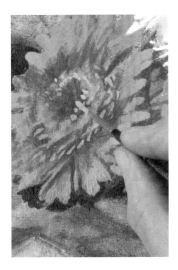

The violet is now looking a little flat. To remedy this, scumble in some white paint. Water the paint down well, and with a clean brush, lighten the tone of the violet. Scrub in some color, to alter the "feel" of the painting.

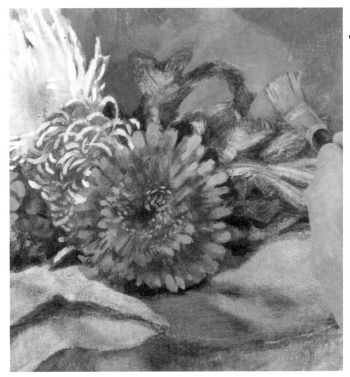

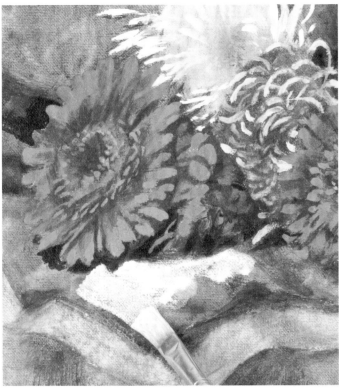

Neutralize the purple a little by scumbling on some Payne's gray: it is looking too powerful. The purple should not detract from the flowers, which are the main focus of the composition. Tone it down with ultramarine, then bring up the profile of the leaf.

RIGHT The two orange flowers are now looking too similar in size and shape, so scumble some color onto them, to cast shadows and make them look different.

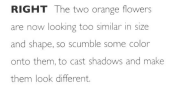

STEP 18 ▸▸

STEP 19

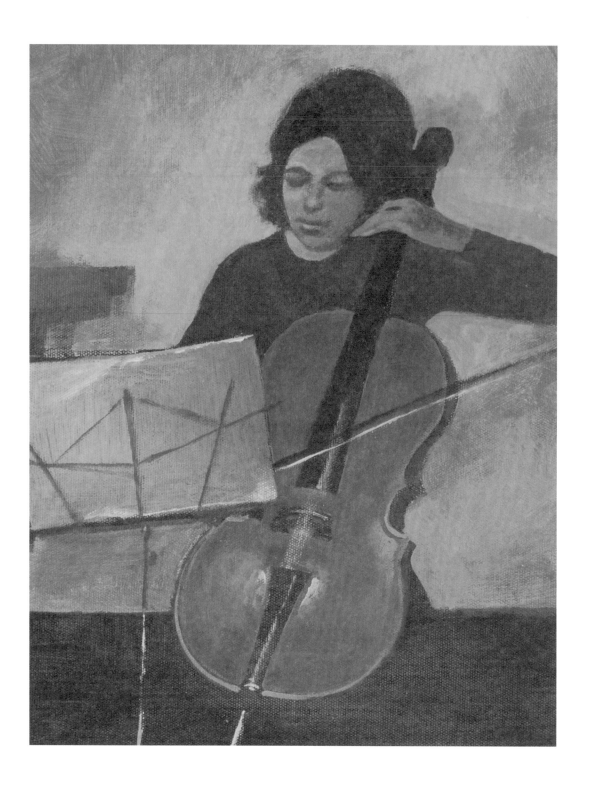

7
cellist

john barber
13½ x 10 in (340 x 250 mm)

From the start, the aim in this project is to reduce all the forms to flat areas with little or no modeling, and concentrate entirely on shapes, and especially how shapes sit in the background, and the spaces between them. These are sometimes referred to as "negative shapes." If you pay attention to those which surround the figure and judge them by their relation to the edges of your picture, you can constantly check their accuracy one against the other. In this project the player and the cello are almost a single shape with the face and hand no more detailed than the instrument. The diagonal angles of the bow and music stand steady the composition and show the only directional light in the picture.

WHAT YOU WILL NEED

Canvas board
Brushes: 1in. (25 mm) decorator's; flat hoghairs nos 7 and 12; pointed sable no. 3
White chalk
Kitchen paper
Mahl stick

COLOR MIXES

1 Payne's gray
3 Burnt sienna
4 Yellow ocher
7 Orange
8 Cadmium red

TECHNIQUES FOR THE PROJECT

Working from dark to light
Figure painting
Limited warm palette

PAINTING THE THIRD DIMENSION

Here in a simple and not over-elaborated exercise, the principles laid out in project 1 with the vegetable painting, are taken a stage further to cope with painting objects in three dimensions. A flat or textured area of ground tint outlined in light paint to accurately enclose the shape of a chosen object is easy to understand. A white line snaking out captures the object. By step 2, the method is probably quite clear. Properly understood, this method of realizing objects in painted space, coupled with careful study of the principle, as used by the Old Masters will give you an insight into the way many great painters worked. A simple jug or pot painted in this way can, in the hands of a skillful painter,

produce visually satisfying images with the power to calm the viewer. The great Spanish painter Diego Velásquez (1599–1660) perfectly realized the kitchen pots and pans in his pictures where they often grabbed the attention from his figures. He used the reverse technique from that shown here, outlining his pots in black to make the somber earth colors stand out against his dark background, as did Jean-Baptiste-Siméon Chardin (1699–1779) a century later, when they became his sole subject matter in some pictures. Even Pablo Picasso (1881–1973) in his "Classical" periods, used exactly the same technique for his monumental figures.

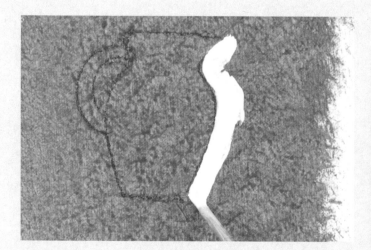

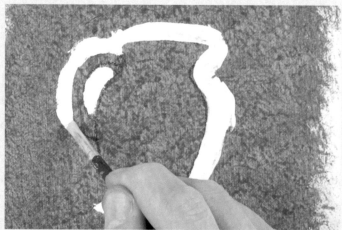

1 Tint a piece of canvas with a neutral color which will become the middle tone of your subject. Mix some water with your acrylic paint and stipple it on roughly. Draw the silhouette of a jug with charcoal or chalk. Start to outline it in white.

2 Using a small hoghair brush, work around the outline of your chosen subject. Load your brush well and use the side of the brush as your drawing tool to complete the outline of your shape. Fill in the space to create the shape for the handle.

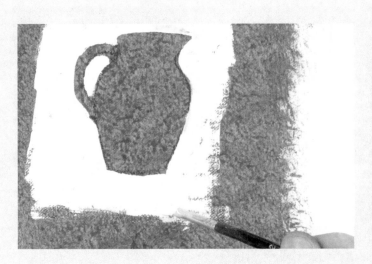

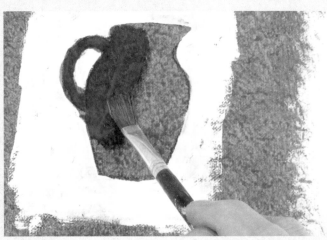

3 Cover the rest of the background with the light paint so that the form is isolated. At this point, the subject is clearly recognizable. An accurate flat shape tells us everything about the object, except the illusion of modeling.

4 Mix up a darker ultramarine color for your shadow area and paint down one side of the jug, taking care not to go over the edges. If you do paint into the white, retouch the light background later, when the paint is dry.

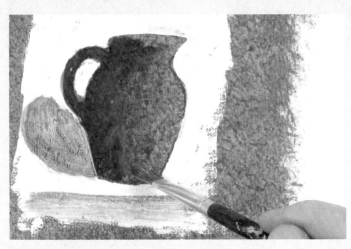

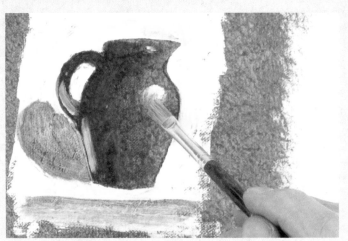

5 Before the dark shading color is dry, take a damp brush and blend down the right-hand side of the shadow. Try to get a smooth transition of tone so that the shadow fades out about halfway across the jug, following the curve of the outline.

6 Take your light background color and place highlights: a small crisp one on the near lip of the jug, and a large blended one on the shoulder. Blend a little back lighting on the handle and in the shadow. Add cast shadows to complete the exercise.

1		PAYNE'S GRAY	30%
3		BURNT SIENNA	70%

This study will be fairly monochromatic using a restricted palette, so start by tinting a canvas. Mix Payne's gray and burnt sienna and apply using a large brush. The background tint has no white in it, so the texture of the canvas is still visible. Cover the whole canvas, without being too precious about mixing the two colors. Both are applied to the canvas and will be mixed on the canvas.

FIGURE DRAWING

The purpose of this project is to show how far you can get with figure painting, without needing the level of skill required for portraiture. This essentially monochrome study is a series of shapes that give a lot of information about figures. There is very little detail in the face, body, or in the cello.

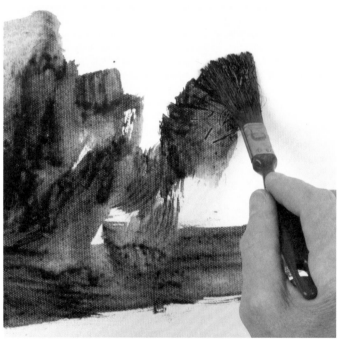

Work across and down the canvas, making the color more even. Wash some Payne's gray over the mix, to darken the canvas down even more. This project will be worked from dark to light. Once the background is dry, establish the main lines of the composition using white chalk.

4		YELLOW OCHER	15%
0		WHITE	80%
1		PAYNE'S GRAY	5%

RIGHT First, mix up a solid color of yellow ocher, titanium white, and Payne's gray. Starting with the shoulder, draw round the figure and the head.

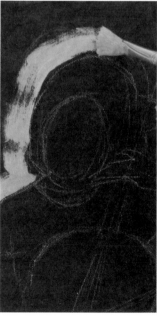

STEP 1 ▸▸

STEP 2 ▸▸

Then work around the cello and down the arm. This color mix will be the lightest tone in the painting. Make sure that your paint is stiff, but flows, and keep plenty on the brush. Use one corner of your flat brush as a drawing tool to define the lines of your composition. Work with a full brush to cover the background color well. Work around the other side of the cello. Add in the floor line, then work around the head, covering the background tint.

MARGIN FOR ERROR

With a composition like this one, it is worth leaving yourself a margin for error. You can make the main elements smaller by redefining their profiles later. In this painting, the cello was left larger than its finished size in the early stages and refined later, and the size and shape of the head were also adjusted.

		BURNT SIENNA	10%
3			
8		CADMIUM RED	100%

To this color mix, add some burnt sienna for the instrument. This needs to be a rich color, so add some cadmium red. Get the tone in here as a flat color. Once all the basic shapes are filled in, you can start to build up tones. Don't worry about the bow at the moment, but leave space for the bridge and sounding board. Use the edge of your flat brush as your drawing tool.

RIGHT Put a tone on the area of the music by mixing yellow ocher, Payne's gray, and white. This is in shadow so don't make the color mix too bright.

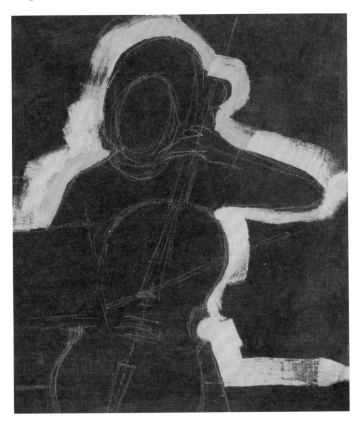

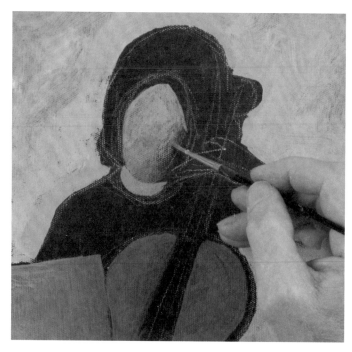

RIGHT To define the shapes of the flesh areas, use this same brown mix to create the shapes of the shadows. Work the areas around the eyes: these work simply as dark shapes, rather than as eyes or eyelashes.

Work into the side of the face, creating the shadow there.

3		BURNT SIENNA	10%
4		YELLOW OCHER	20%
0		WHITE	70%

Use a mix of burnt sienna, yellow ocher, and white for the areas in the light, then add a touch of Payne's gray for the shadow areas. Paint the face and neck.

RIGHT Draw the shape of the hand as accurately as you can. Take some burnt sienna and Payne's gray to mix a brown for the cellist's top: the color change is not going to be all that great. Work across her top and down the arm.

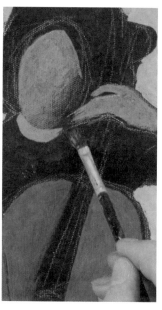

RIGHT Notice that the area of the neck is lighter than the face, because the neck is tilted up, while the face is tilted down. Now, add a slightly lighter tone to the fingers.

| 4 | | YELLOW OCHER | 80% |
| 0 | | WHITE | 20% |

Look again at the shape of the head. It is clear there is too much hair. Use yellow ocher and white to re-define the area of the hair. Outline the area that should not be hair, then fill it in.

Now the features are drawn in proportion, the face is clearly too large, so the hairline needs bringing down to make the face smaller. Go from the features of the face and the areas of shadow, and get the hair right. Her forehead is too high, and needs cutting down dramatically.

RIGHT There is a slight change of tone as you come down the nose. There is also a highlight on the lip although this is very subtle.

STEP 7 ▶▶

STEP 8 ▶▶

RIGHT Work the same reddish color mix over the right-hand side of the cello, to clarify the area where the body of the instrument is joined to its edge.

Wet the brush, touch it into the paint, and dab off some color, using paper towels, to get rid the chalk marks.

① PAYNE'S GRAY 15%

③ BURNT SIENNA 85%

Turn your attention to the cello next. Add some of your mix of Payne's gray and burnt sienna to the side of the cello, where it is in shadow. This also helps to define the shape of the instrument.

RIGHT Tone down the color of the cello, making it richer and redder by adding some cadmium red to your mix of burnt sienna and Payne's gray.

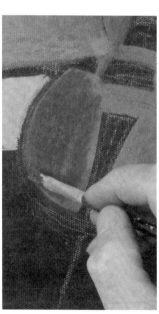

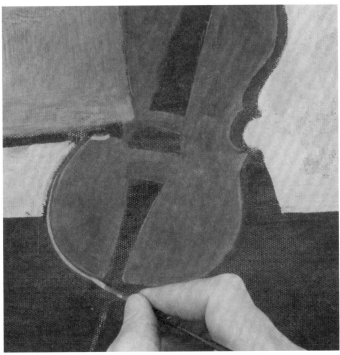

RIGHT Use a wet brush to tone in the color on the top right of the cello. The changes of tone in the polished wood are slight and mixed on the canvas.

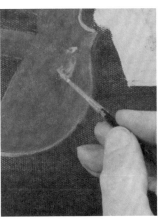

There is another highlight to the right of the scaleboard, so work this in: this too is a very slight color change.

4		YELLOW OCHER	35%
0		WHITE	60%
7		ORANGE	5%

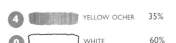

Mix yellow ocher and white, with a touch of orange, and use this to work some slight changes of tone on the cello. There is a highlight around the left-hand edge of the base of the cello.

RIGHT There is another highlight on the upper edge of the right-hand side of the instrument.

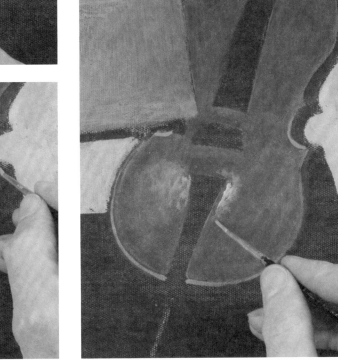

STEP 11 ▶▶

STEP 12 ▶▶

7
cellist

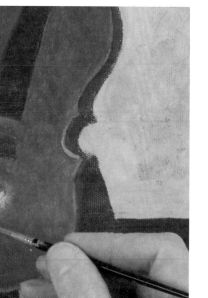

Blend color in the lightest areas. You are also creating the detail of the carving on the wood when you add color here.

SIMPLIFY IT

With a figure subject it is important to see the face and hands as simple shapes. A continual checking of the size and position of each color patch will enable you to get an overall balance. Once all the elements are worked up to a consistent level, you can elaborate further if you wish.

The brightest area on the cello is behind the scaleboard.

RIGHT Work over this line to sharpen it up. This is visually linked to the spike, which will be added in later.

STEP 13 ▸▸

STEP 14 ▸▸

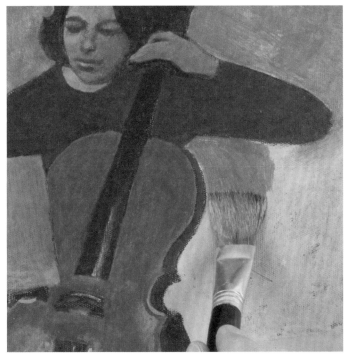

Now the shoulder looks too wide, so adjust that, and then work one or two highlights behind the figure. All the time you are adding paint, you are refining your drawing. Then turn to the spike and work that using the tips of the bristles. For the music stand, make a vertical and create legs.

CHANGE YOUR MIND

Acrylic paints let you change your mind as often as you wish and often re-painting seems to add to the attractiveness of the paint surface. If you paint in an opaque manner, using white in your mixes, there are advantages in layering your paint thickly. One is that acrylics do not peel when one layer is overlaid on another.

4	YELLOW OCHER	90%
1	PAYNE'S GRAY	10%

The background color is too harsh and needs to be toned down. Scumble in a gray tone. Mix some yellow ocher and Payne's gray and block this in, using a no. 12 flat hog brush. Once this background has been toned down, it can be pulled back by adding some white to it.

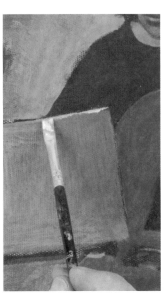

RIGHT Turn now to the music sheet and add highlights along the top edge, and in the bottom right-hand corner.

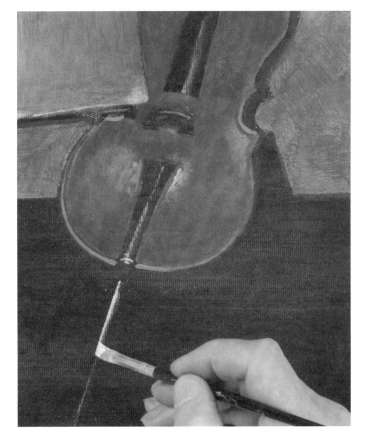

STEP 15 ▸▸

STEP 16 ▸▸

7
cellist

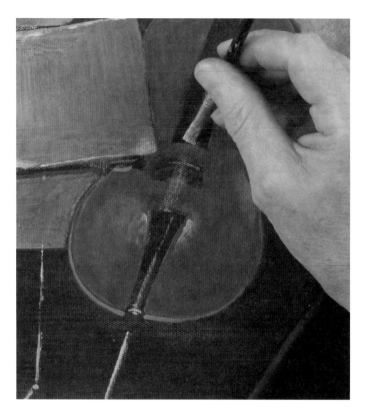

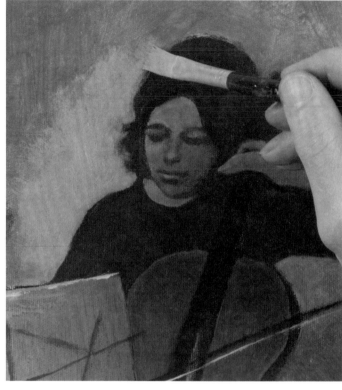

Indicate some strings with one long brushstroke: you may need to use a mahl stick or straight edge to steady your hand.

1 ██████ PAYNE'S GRAY

RIGHT Take some Payne's gray and draw in the darks on the music sheet.

1 ██████ PAYNE'S GRAY 20%

4 ██████ YELLOW OCHER 80%

Draw in the black line of the bow. Then slightly alter the cellist's top. Pick out some highlights on the arm, to define the forearm better. Then get some modeling into the body. Mix some yellow ocher and Payne's gray and use this to refine the shoulder some more. Then work around the head, improving the profile of the hair.

TRICK OF THE TRADE

Acrylics can be mixed with acrylic gel medium which lets them flow more easily without having to add too much water so that the color film becomes too thin. Another trick is to wet the canvas once your painting has dried, and paint into the damp canvas. This gives a soft, flowing effect to the paint, and makes it easier to blend your colors.

STEP 17 ▸▸

STEP 18 ▸▸

RIGHT Work down her shoulder, using your brush as a drawing tool to improve the shape of the upper arm.

Now that the painting is almost complete, it is clear that the hand appears to be in the wrong place, so bring it down the neck of the cello. Bringing this down means that the head of the cello also needs to come down. With acrylics, such "mistakes" are easy to rectify by overpainting. Add some darks to the hair. And then re-position the hand and make it smaller.

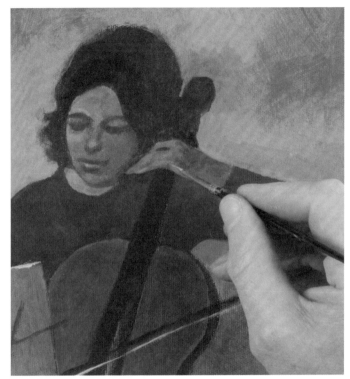

Add a little shadow on the back of the hand.

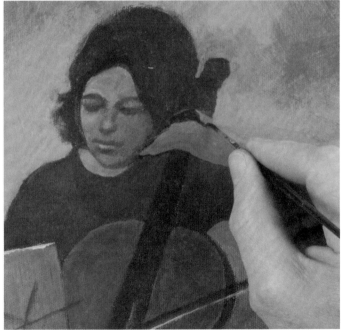

RIGHT Finally improve the outline of the top against the neck. Look again at your painting to check that you are satisfied. Although this painting seemed to be finished, on closer reflection it was apparent that the whole area of the hair was still too large, so that was reduced still further.

STEP 19 ▶▶

STEP 20

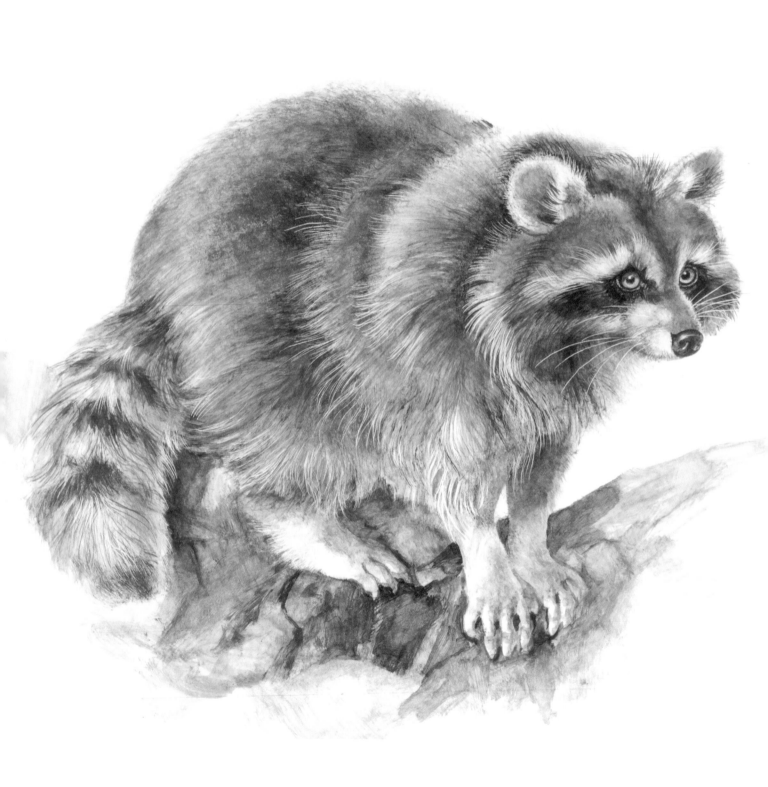

8

raccoon

john barber
13½ x 18 in (345 x 460 mm)

This project takes a more illustrative look at an appealing little animal with bandit mask and dainty white feet. The technique aims at a realistic rendering of fine detail in the features and the fur. The eyes in a portrait like this one are drawn very carefully and completed first. The disk of the eye and the shape of the pupil are important but the eye itself has no expression. It is muscles and color around the eye that hold the secret of expression. The textures of fur vary, but the dynamics of fur, the way it lies, divides, and sticks up on end, must be observed carefully. With a little practice drawing individual hairs is not so difficult but preserving a sense of the anatomy under the fur certainly is.

WHAT YOU WILL NEED

Smooth illustration board
Graphite pencil, 2B
Brushes: flat hoghairs nos 4, 6, and 7; round sables nos 2, 4, and 6
Craft knife

COLOR MIXES

1 Payne's gray
3 Burnt sienna
4 Yellow ocher
12 Ultramarine

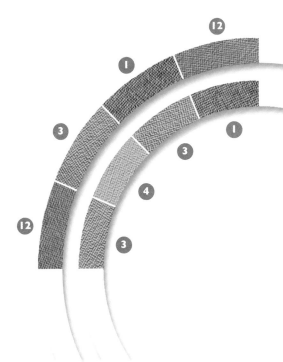

TECHNIQUES FOR THE PROJECT

Blending and stippling
Scratching back to surface
Wiping out

SCRATCHING THROUGH

This exercise introduces you to the technique of scratching into wet or dry paint, a procedure which like most of the advice in this book, has a long tradition of use in many kinds of picture-making. It was used a great deal in fresco mural work and is in essence a loose form of engraving, sometimes referred to as *sgraffito* work. When the tool is a pointed brush handle which must be used on wet paint, it scrapes through the paint to the surface of the panel. Lines made in this way are often accentuated by the line of wet paint pushed to one side by the scraping tool, so making the sense of depth doubly effective. Much used by 19th-century watercolorists, working with gum arabic to thicken their paint, it works even better with modern acrylics to develop detailed passages in foregrounds of fine-stemmed plants and grasses and in the depiction of fur and feathers. The use of stiff brushes to make many parallel lines on a smooth panel makes an ideal ground for elaborate linework drawn over it. The brush handle work is followed when the paint has dried completely by scraping through with the scalpel or craft knife, sometimes merely scratching and at others cutting in to the surface of the panel to reveal the pure white coating. Practice this until your scalpel lines are as predictable as your handwriting.

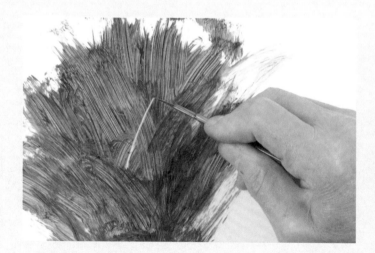

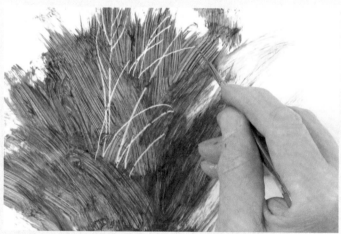

1 Start by using a stiff hoghair brush to push thin paint outward from a center point so that at the end of the stroke, the bristles leave a ragged edge. Textures like this are easy to do with acrylics, especially if the surface is smooth.

2 Do not mix the water too thoroughly with the paint While the paint is still wet, you can begin to scratch lines out of the background texture with a brush handle. As here a scalpel or craft knife can be used to create finer lines.

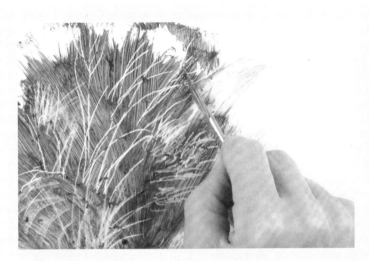

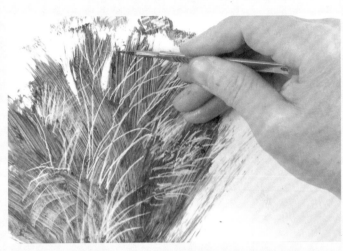

3 Continue to scratch radiating lines as if you were picking out blades of fine grasses. Starting at the base, swing your blade in a series of curves, making sure that some lines cross each other for even greater realism.

4 Now start adding some fine straight lines and short flicks. Join some lines at an angle to suggest dividing stems and some disconnected short strokes to suggest seeds. Don't plan it too carefully: just keep scratching and keep the marks lively.

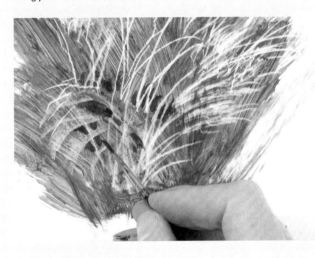

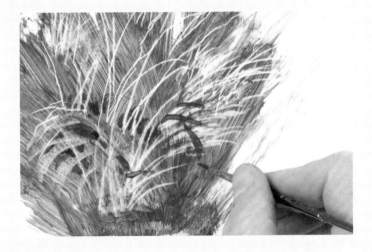

5 On the left, there are curved marks made with the side of the blade. These only scrape part of the paint for a lighter background shade. Take a small sable dipped in the background color and fill in some of the gaps and interstices.

6 By leaving the lines that most suggest blades of grass or leaves you can build up convincing detail in quite a short time. Finish by drawing with the brush a few dark lines across some of your scratched lines to give a sense of extra depth.

raccoon

Draw or trace your subject. Before starting to paint, check the accuracy of a tracing to make sure you have not missed any important lines, and refine the finer lines of the illustration. With most paintings your aim is to block in the main shapes, but with an animal study, block in the eyes and the shape of the head, to get the animal's character down first. This applies to portraits of both wild and domestic animals. Clean up any pencil marks in the eye.

CHOICE OF SURFACE

This project is worked on a smooth illustration board, that is nonabsorbent. On a smooth board, every brushstroke shows; on canvas, the brushstrokes are broken up, which helps with color blending. On this type of detailed illustration, however, you want every brushstroke to show, and not to break up.

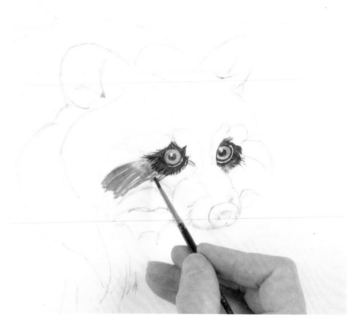

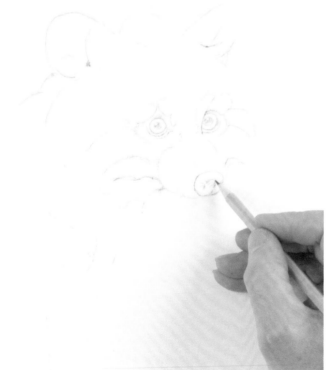

 3 BURNT SIENNA 10%

Burnt sienna is a pure red, so use a minimal amount of this for the eye. Put the pupils in, then outline the eye using Payne's gray. Begin to draw the dark outlines of the eyes, building up fine marks. Note that the paint here is a little stiffer than was used for the pupils. Then make a more watery mix and start to indicate fur.

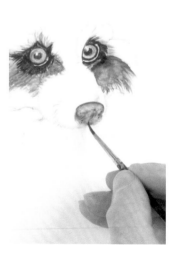

 1 PAYNE'S GRAY 20%

RIGHT Take your smallest sable and Payne's gray and color the nose. This establishes the head.

Now switch to a hoghair brush to start creating more vigorous marks. Take a no. 7, and use it in a stippling fashion to give a light gray to areas of the face. This defines the light and dark areas, but will not be the final color of the face. On the smooth surface each hair of a hog brush leaves a mark. Push the paint, rather than dragging it, always guiding your brush in the direction the fur is growing: keep reminding yourself what this is.

TRICK OF THE TRADE

Always have a spare piece of board of the same texture and absorbency as the one you are working on at hand. That way, you can test the strength of color and the texture of your brushmarks as you work, before you add them to the illustration board.

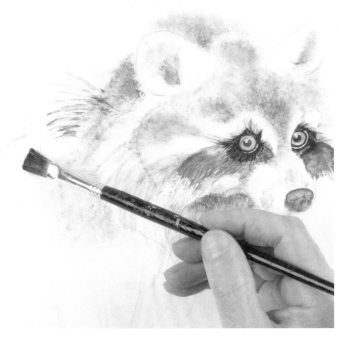

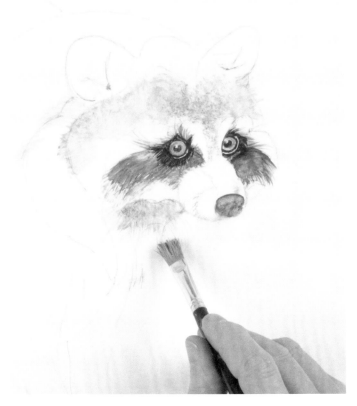

Work some shadow inside one ear, then the other. At the moment the board is acting as your white pigment, so some areas need to be preserved so that you can still see where the fur is white. Use the hog brush with stiffer paint, to work the hairs coming out from the head, since these are coarser in texture.

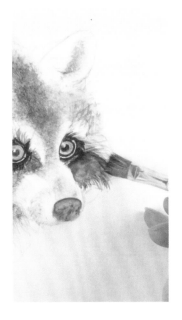

RIGHT Use a more stippling action down the nose. Stroke the paint into the white areas to make them less stark, but keep white showing through. Darken the area around the eye.

STEP 3 ▶▶

STEP 4 ▶▶

8
raccoon

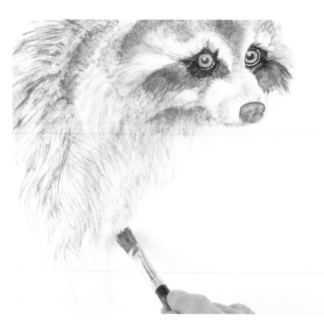

RIGHT The collar or ruff is defined by the marks you make now. Rub some color into them to define the light and dark areas, and give a degree of modeling.

Always follow the direction of the hairs, but keep the underlying anatomy of the body in mind as you start to build up the fur. The trick is to keep the brush moving, so that your marks do not lose vigor. Keep the brushmarks parallel and in the direction in which the fur is growing.

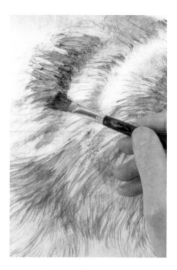

One of the advantages of using acrylics for this type of painting is that by the time you work back into it, it is dry so you are not lifting wet color, as you would in watercolor. If you make a mark that is too strong, dab it off with your finger straightaway. You can achieve almost microscopic texture on the hairs, where you need it.

RIGHT When you start to run out of paint on the brush, use it to add pigment to those areas that need a light touch, for example on the chest. Then define the feet as separate by creating the shadow between them.

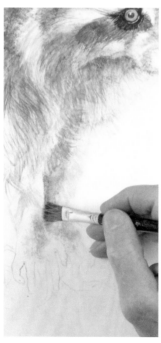

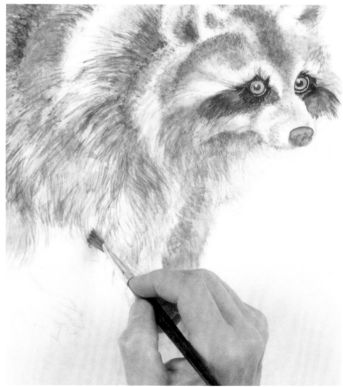

STEP 5 ▸▸

STEP 6 ▸▸

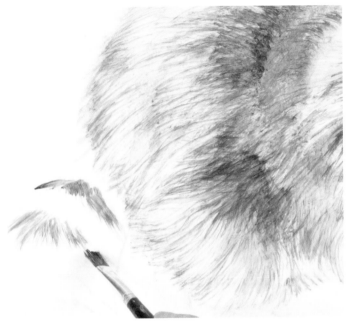

4 YELLOW OCHER 90%

RIGHT Put the Payne's gray aside for a time, and switch to a no. 6 hog brush. Take up some yellow ocher and start to add a thin wash into the areas of densest fur. You do not need much paint, as you do not want to obscure the light and shade you have built up, but even a little color changes the painting significantly. Dab color on, then smooth it out.

Create a fine stipple over the top of the head and down the nose.

1 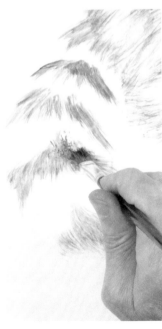 PAYNE'S GRAY 20%

What you have created at this stage are areas of light and shadow over the whole animal. Now indicate the dark bands on the tail, with almost solid Payne's gray. The tail is coming toward the viewer, so the hairs are pointing in that direction.

RIGHT Where the hair faces toward you, use the brush almost vertically to "bounce" paint onto the board. Drag some texture into the area of the light bands on the tail. Then indicate some texture in the foot area: this will be returned to later.

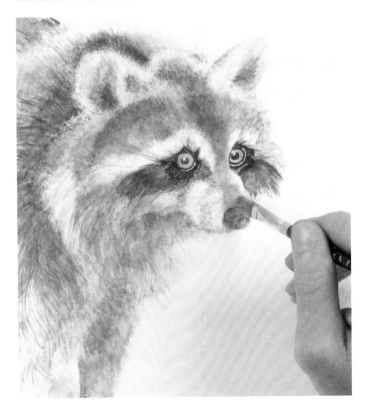

STEP 7 ▶▶

STEP 8 ▶▶

8
raccoon

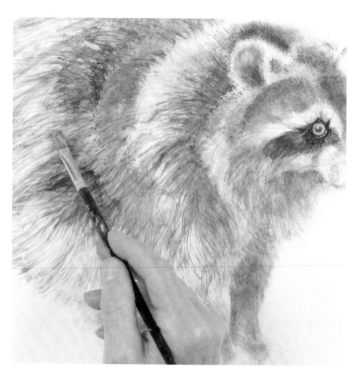

RIGHT Using the same color and a dry brush, and keeping your brush moving, create the darkest areas on the back of the animal. These touches of black give a solidity to the color.

Stippling with the black paint is gradually taking the overall tone of the painting down. This will allow you to add white highlights for the guard areas later.

Note that the color is not being used to render hairs at all: it is simply being used as a cloud of color over the hairs you have already worked. Push some color up into the ear, then work with freer strokes and a washy consistency over the back.

RIGHT Give the tail a little more modeling by working the same color into it. Then use a nearly dry brush with some pure black on it to define the areas of tail where the fur is almost pure black.

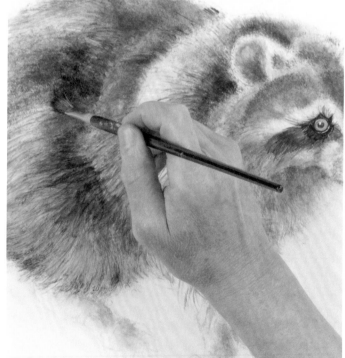

STEP 9 ▸▸

STEP 10 ▸▸

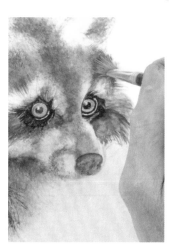

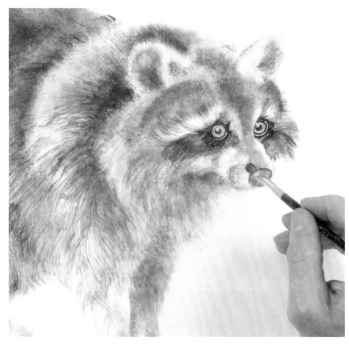

RIGHT Bring some darks up to where light edges have been left in the ears. The darkest area is behind the ear. Without outlining it, since the ear has lots of fine hairs, work some dark hairs into this area. Make the area above the eye slightly darker. This gives an edge to the facial hair.

3 BURNT SIENNA

Work some more stippling around the eye. Then add more burnt sienna into the area of the ears. The tuft that comes up is often quite reddish.

Move down to a no. 4 hog and start to work details in the finer areas such as on the head and around the eyes, again using black. Then sharpen the connection between the eye and muzzle.

RIGHT Add some black flicks into the chest and down the back and tail. Next work some more burnt sienna into the back to warm it a little. You need very little paint on the brush. Use the side of the brush and drag the paint in, building it up gradually. This warms the dark areas and gets rid of the cool airs.

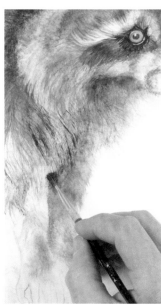

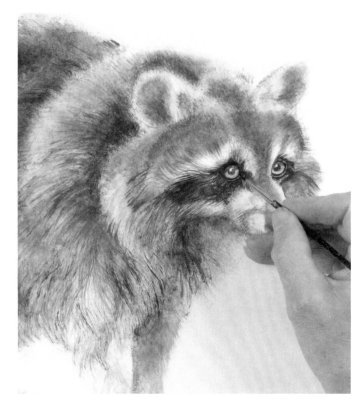

STEP 11 ▶▶

STEP 12 ▶▶

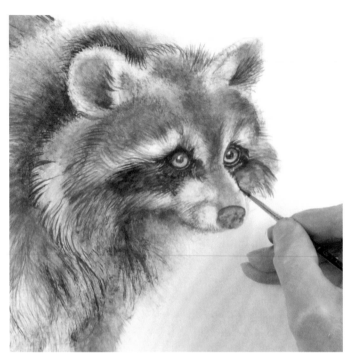

There is a lot of fine linear work in the tail. Use black to introduce these details. Keep the color fairly thin so that the lines stay fine. Thin your color out so that it is almost like a pale gray, and run parallel lines out in the direction of fur growth. You may need many hundreds of tiny parallel lines. Use the dark paint to superimpose a pattern over the soft tone you created previously.

STIPPLING TIPS

When working stippling such as that on the back of the raccoon in this project, always go to a new area, rather than overworking somewhere that is not yet dry, otherwise you risk moving the underlying paint. Keep looking at your work, to see a new area where you need the strength of color that is already on your brush, and move to that.

Use a very diluted black to create a gray to re-define some areas of your drawing. Then use the black to model the buttonlike nostrils. Use pure black and soften it, to keep the nose looking shiny. Next, work down the gap between the nostrils.

RIGHT Put some reddish-brown into the nose, to give the impression that it is coming toward you. There is a darkish area on the ear, so add some black here, over the burnt sienna.

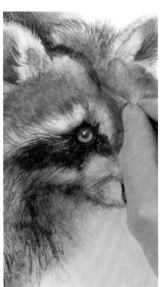

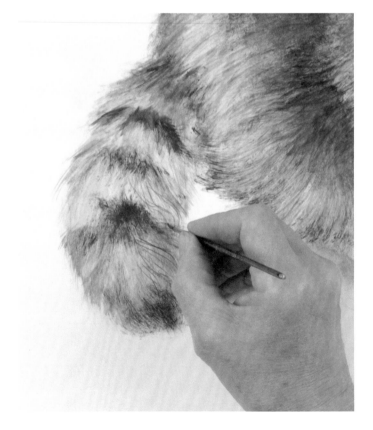

STEP 13 ▸▸

STEP 14 ▸▸

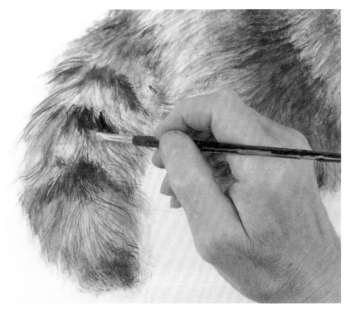

| | BURNT SIENNA | 10% |
| 12 | ULTRAMARINE | 10% |

Mix burnt sienna and ultramarine, and start to indicate a bit of background to anchor the raccoon. This mix can also be used to flick out the shadows of the hair. Work around and under the raccoon, flicking paint where it meets hair, and using broader strokes, blended with a tissue in larger, flatter areas. Work some glazing over the front limb, and stipple it away to re-find your original tonal painting. This softens the effect of the brushwork, and gives a nice deep tone. Then work the gaps between the toes.

TEMPERA TECHNIQUE

In egg tempera technique, the paint is laid in many layers of small spots, gradually building up color without blending. Acrylic painters can use this approach since their colors also dry quickly and are not affected when more layers are added. As in this project, the best results come from the use of transparent color over a white ground.

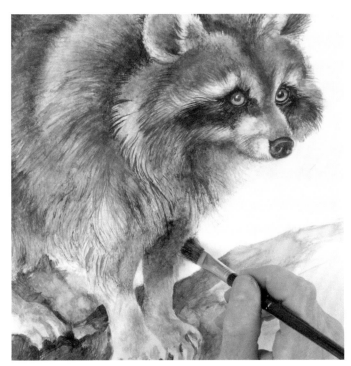

While the paint is still wet, use the hog brush to blend the color. Note that some of these marks are quite strong.

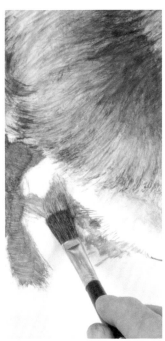

RIGHT Turn now to the "hands" and start to work some modeling into them. Use a soft no. 6 sable brush to blend, and a no. 2 pointed sable to give an indication of the white feet. Indicate some gray shadow. Start with the back feet, then move on to the shadows of the "fingers." The cast shadows define the shape of the fingers. Put some marks into the leg, keeping the flow of the hairs rhythmic.

STEP 15 ▸▸

STEP 16 ▸▸

RIGHT Now take a scalpel and start to scratch out highlights. Don't start in the most crucial area. When you are confident, move to the areas of highlight around the eyes. Scratch down the "beard," then down the chest.

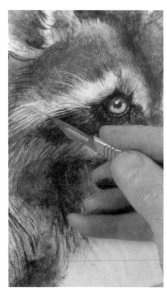

Keep your scratched marks going in the right direction for the growing fur. This may mean turning your work around. Either scratch out along your brushmarks, or alongside them.

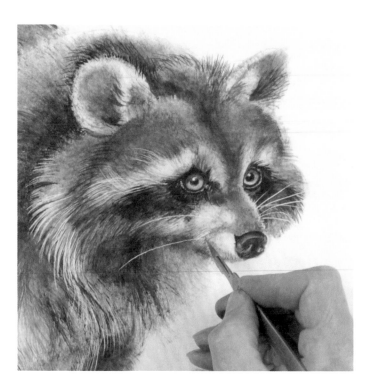

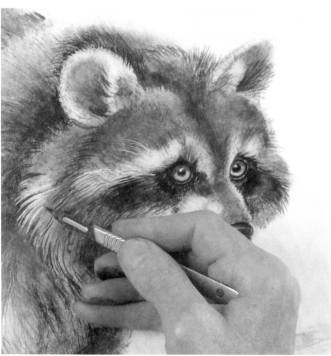

For the whiskers, put your blade firmly on the board, and in one movement flick out paint. If you don't like a line, paint over, let it dry, and start again. Aim for a mix of fine and coarse whiskers. Where a whisker extends outside the painting, add in a touch of dark paint later.

SCALPEL TECHNIQUES

Fit a new, sharp blade into your craft knife or scalpel. Paint a patch of black on a piece of spare board, and use this to practice flicking out scalpel marks. This will help you to get the right pressure and degree of movement you will need in your illustration. You can also use the flat blade of the scalpel as a clean-up tool but take care not to remove the board surface. From time to time flick off the paint shavings.

STEP 17 ▶▶

STEP 18 ▶▶

RIGHT Accentuate the animal's bandit mask and add a highlight to his nostril. There is a catch-all highlight in the nostril.

The leg hairs are long, and because raccoons spend time in water, they are often straggly. If you think you have overdone the scratching and it is starting to look too chalky, you can always work over it with paint again, to reestablish your darker areas. Work one or two long hairs, then scrape out some of the darker areas on the back.

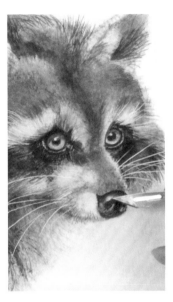

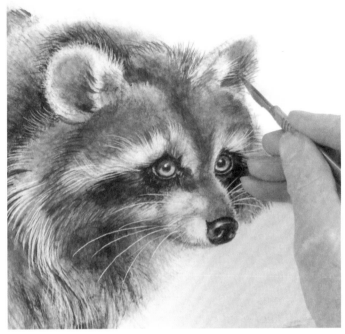

Take out some white highlights in the ear, then scrape out areas on the tail, and clean up around it to get back to your white board.

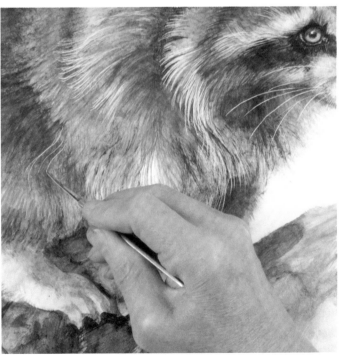

RIGHT Then turn to the toes, which are looking a little crude in comparison with the rest of the painting. Take a wash of yellow ocher and a touch of black, to model the feet a little more. You can also add some darks between the hairs to indicate that they might be wet.

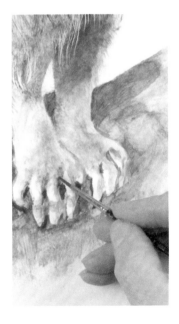

STEP 19 ▶▶

STEP 20

index